PATTERNS IN GAME DESIGN

STAFFAN BJÖRK

JUSSI HOLOPAINEN

CHARLES RIVER MEDIA, INC.
Hingham, Massachusetts

Publisher: Jenifer Niles
Cover Design: The Printed Image
Cover Image: © Jouka Mattila 2004

CHARLES RIVER MEDIA, INC.
10 Downer Avenue
Hingham, Massachusetts 02043
781-740-0400
781-740-8816 (FAX)
info@charlesriver.com
www.charlesriver.com

This book is printed on acid-free paper.

Staffan Björk and Jussi Holopainen. *Patterns in Game Design.*
ISBN: 1-58450-354-8

Library of Congress Cataloging-in-Publication Data
Bjork, Staffan.
 Patterns in game design / Staffan Bjork and Jussi Holopainen.
 p. cm.
 ISBN 1-58450-354-8 (pbk. with cd-rom : alk. paper)
 1. Computer games—Programming. I. Holopainen, Jussi. II. Title.
 QA76.76.C672B56 2005
 794.8'1526—dc22
 2004023500

Printed in the United States of America
04 7 6 5 4 3 2 First Edition

Contents

Acknowledgments

We would like to thank our families, friends, and colleagues who have supported the writing of this book in uncountable ways. We are especially grateful to Lennart Björk, Therese Bernander, Ciarán Harris, and Stephan Meyers who have helped with proofreading the chapters; Jussi Kuittinen who provided scripts for checking the internal consistency of our work and for creating the pattern collection on CD-ROM; Jouka Mattila for the cover image; and Greg Costikyan for valuable comments.

Part

I

Background

Part I of the book contains an introduction and three background chapters describing our approach to game design patterns. The first background chapter contains a descriptive framework explaining the invariant components of games useful from a design perspective. These components describe four different categories of gameplay: holistic, boundary, temporal, and structural. The categories reflect different views on how gameplay is constructed from physical and logical components. The next chapter describes the foundation of the game design patterns approach, including the motivation for our approach. The game design patterns build on and use the component framework to describe the characteristics of possible player interaction with the game and other players. The last chapter sketches out possible uses of game design patterns when performing analysis or design.

1 Introduction

This book gives you, as a reader, a tool for understanding and creating games. The tool is *game design patterns*, a collection of design choices possible in games. The patterns can help you make design choices when creating a game, understand how others' games work, or inspire game ideas. Examples of patterns include well-known concepts such as *Boss Monsters* and *Level* but also more abstract concepts such as *Hovering Closures* and *Trans-Game Information*.

There are of course many different types of tools one can create that can help in designing or analyzing games, but we have chosen to focus upon what we perceive to be the most essential part of game design: gameplay. For the sake of this discussion, we define gameplay simply as the structures of player interaction with the game system and with the other players in the game. Thus, gameplay includes the possibilities, results, and the reasons for the players to interact within the game. For example, the gameplay of *Space Invaders* consists of the player moving the ship left and right at the bottom of the screen, trying to shoot wave after wave of invaders and at the same time avoiding their incoming fire. A game may have many different parts that are interesting, novel, or well-designed, but if the gameplay does not share that attribute, something will be lacking. Similarly, a game might have bugs, design faults, lousy graphics or sound, or it might even be a rehash of other designs, but still provide excellent gameplay, which could still make it a good game. Thus, we see gameplay as the most important aspect of game design, although it has received little attention.

A LANGUAGE FOR TALKING ABOUT GAMEPLAY

Essential to the discussion of gameplay are the different aspects of gameplay that can exist. Understanding these aspects is important if one wants to go into details about a specific game one is playing, comparing two different games or genres, or when one wants to discuss benefits and disadvantages between two different design

options. However, there is a lack of terminology associated with the elements of gameplay. We offer a solution to this through the use of *game design patterns.*

Each pattern describes a part of the interaction possible in games, and together with other patterns they describe the possible gameplay in a game. We use the term game design patterns instead of gameplay patterns to stress that these are patterns of interaction which are intended by the game designers, and that the patterns aim to support not only analytic work but also creative design work. Thus, our description of a game design pattern does not only contain a description of the pattern and how it relates to other patterns, but also descriptions of choices one has to make when designing a game that uses the pattern.

WORDS OF WARNING

Having a language of gameplay that can be used for game design is not the total solution for designing good games. Having a language of game design does not guarantee that you will be able to design good or interesting games in the same way as knowing a foreign language such as French does not guarantee that one will say interesting things even if the pronunciation and grammar are correct. However, it does give you a tool to help your thinking and communication; a tool that can help you put words to an idea or concept and either write it down for future reference or express it to a colleague, boss, or investors.

For this reason, we do not attempt to define good gameplay or good games through our game design patterns. This is subjective and differs not only between people but changes over time due to experience and influence. Some of the patterns we have described are usually perceived as negative for gameplay—for example, the patterns *Analysis Paralysis* or *Downtime*. But as exceptions exist, a game design using a normally negative pattern in a positive way is probably novel or thought provoking. These "bad" game design patterns are also useful when trying to identify faults in a game design.

A QUICK TOUR

This book consists of two main parts. The short first part is a more theoretical part where we go through a framework for describing games and the template we use for our game design patterns. The second part, which is the majority of the book volume, is our collection of game design patterns. The pattern collection is divided into chapters based on what aspect of gameplay the patterns concern. You can read the patterns in any order, similar to how a dictionary or encyclopedia is used.

To get an initial feel for game design patterns, you may want to browse through the pattern collection after reading this chapter. If you are a more practically oriented reader, you may then want to try an identify patterns that are immediately useful for your current work or check if something you think may be a pattern is in the collection. The first part of the book can then be read later when you want an understanding of why we chose to structure our work in the way we did, how others have tackled similar problems, or the history of games. If instead you are a more theoretically oriented reader, the book begins with an overview of how games and gameplay have developed over time and then proceeds with various definitions of concepts such as game and play that have been made.

This book focuses on computer games, by which we mean not only PC games but all games using computers in one form or another, for several reasons. First, the use of computers gives a game designer a powerful tool that can be used to show images and animations, play sounds, support virtual worlds, connect players over a distance, allow virtual opponents, and enforce rules. Compared to other game forms such as board games and card games, the computer allows for a larger design space of possible game designs to be explored. Secondly, the computer game industry is the largest game industry with the largest projects, which means that this is the area where the need of tools for game design is most critical. Computer games are the most complex games to design and create, although not necessarily the most complex to play. Even though the focus is on computer games, some of the patterns are more fundamental, making them suitable for use in any type of game, e.g., board games or tabletop roleplaying games. This is because we believe that a good game designer should be knowledgeable about many game types, and our pattern collection supports this and can be for any kind of game.

A LANGUAGE FOR ALL

ON THE CD This book, and its companion CD-ROM, contains over 200 game design patterns. They should be seen as a resource that can be used if they are useful, ignored if they are not, and modified if that makes them suit a particular purpose. Using the analogy of a spoken language, we want game design patterns to be a living language, which means that game design patterns will evolve, transform, have dialects and slang, but—most important of all—allow us to talk about the essence of games and gameplay in as much detail and with as much clarity as we wish.

2 An Activity-Based Framework for Describing Games

In this chapter, we present a framework for describing games based upon the activities you as a player perform within them. The framework provides the concepts to talk about the first order of game design, the physical and logical components of a game that make gameplay possible. These basic components of games can then be used to describe the second order concepts, game design patterns, which are described in later chapters and constitute the main part of the book. These game design patterns provide proven examples of the relationships that can be created between game components and how these affect the gameplay.

Even though we present a framework for games, we do not try to formulate a definition of what game or play is. There are many existing definitions (including but not limited to [Huizinga50], [Caillois01], [Avedon&Sutton-Smith71], [Avedon71], [Parlett99], [Crawford84], [Costikyan94], [Costikyan02], [Zagal99], [Salen04], [Juul03], [Fullerton04], [Sutton-Smith97]), which all have their weaknesses and strengths. Instead of coming up with yet another definition that might further confuse rather than clarify, we present a model that to a certain extent is indifferent to the definition of what the games are or should be. This model, our component framework, and the patterns that build upon it contains assumptions of what games, play, and gameplay are, but these assumptions are implicit. We, however, rejected the possibility of starting from one specific definition so we could create tools for understanding and designing games that are independent of any definitions.

Defining games does have its place, so that when we encounter people doing an activity, we can determine if they are playing a game or doing something else altogether. It also allows us to disagree with people who describe something as a game when it does not fit our strict definition. It allows us as designers to judge if we actually have constructed a game or not. However, a definition of games does not help us make design decisions within the design space of all possible games. Just as having a definition of a house does not provide more than vague guidelines of how to build a house (it should have walls and a roof), having a definition of what a game is does not give us more than the most basic ideas of what a game should contain.

PARTS OF THE FRAMEWORK

Our framework is based on the assumption that playing a game can be described as *making changes in quantitative game states*, where each specific state is a collection of all values of all game elements and the relationships between them. For computer games this is always the case, as the software and the hardware running the game have to explicitly store the state. However, the game state does not have to be the same as the state of the program running the game. Settings, such as the sound level and the display resolution, are essential to the final gameplay experience, and are stored in the program state of a computer game, but are not part of the game state as defined here, as they have no direct effect on the game mechanics or on how the game is played. But what about the experiences and strategies of the players? Should these also be part of the game state? Regardless of the problems involved in measuring these quantitatively, we do not think they should be part of the game state. Experiences and strategies are essential parts of interaction and as such are related to the second order of game design.

Our framework divides game components into four categories: holistic, boundary, temporal, and structural. These reflect four possible ways of viewing the activity of playing a game, which can roughly be classified by their individual level of abstraction, with the more abstract categories building upon the more concrete ones by referring to the more concrete concepts in their individual descriptions. The holistic components describe how the activity of playing a game is separated from other activities, the boundary components limit the possible actions of the player within the game, the temporal components describe the flow of the game, and the structural components define the physical and logical elements necessary for containing and manipulating the game state. The relationships of the components are illustrated in Figure 2.1.

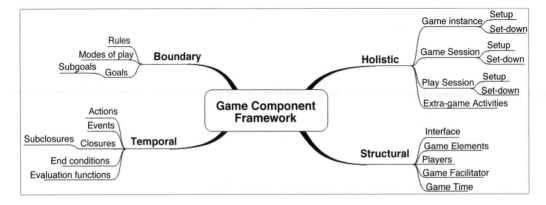

FIGURE 2.1 The components of the framework.

Holistic Components

The holistic components deal with the aspects of a game that are relevant when one looks upon the activity of playing games as an undividable activity. This view is most relevant when one is interested in the relations between the activity of playing a game and other activities. A *game instance* defines the complete collection of all components, actions, and events that take place during the playing of a single game. A *game session* is the whole activity of one player participating in such a game. A *play session* is the uninterrupted stretch of time when one player is actively playing a game. All these components may have specific *setup* and *set-down sessions*, the administrative actions players need to do before or after actual gameplay. Further, some games have interesting activities surrounding the actual playing of the game, and these are covered in the *extra-game activities* component. The relationships of these components are illustrated in Figure 2.2.

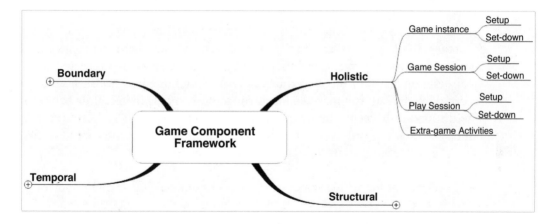

FIGURE 2.2 The holistic components.

GAME INSTANCE A game instance comprises the components, actions, and events that describe the specific play of a single game. Thus, the game instance describes the whole lifetime of the game including setup, all the actions of the participating players, ending the game, the determination of the final outcome, and any activities required to restore the game state before the next setup. Although the fundamental rules stay the same each time a game is played, the same pieces or game controls are not always used, and the players and their actions differ, making all game instances different. Even if the same players play the same game twice in a row and perform exactly the same actions, the players would have different gameplay experiences than they had the previous time.

Example: A game instance of *Chess* includes the players, the game board, and the pieces. However, it may also include the audience and the context in which the game is played, e.g., the final game in the World Chess Competition between an American and a Russian during the cold war.

Example: A game instance of the original coin-op *Asteroids* starts when the players insert coins and select the number of players. The actual gameplay continues until all players have run out of lives. If the players have played well, they get to choose a three-word handle, which is then shown in the high score list. Although the high score list is outside the actual gameplay, it is part of the total experience of playing a game of *Asteroids*.

Example: A game instance of a massively multiplayer online roleplaying game (MMORPG) such as *Ultima Online* is the whole history of that persistent world, beginning from the initiation of the server to the final server shutdown.

GAME SESSION A game session is the complete activity of one player playing a game, from the start of the actual gameplay to the last actions considered part of the game. The game session is player specific, so one game instance of *Chess* consists of two game sessions: one for each player. In cases when the game instance and the game sessions match exactly, it may be of little use to differentiate between the concepts. The distinction between the two is more pronounced in massively multiplayer online games, where the players start playing the game independently of each other, and the game sessions of the players may never overlap at all.

Example: Classic arcade games have game sessions starting from the choice of how many players will play until the eventual chance of choosing a name for the high score list.

Example: The game sessions in many tabletop and live-action roleplaying games are open ended, as there are no specific game rules to determine when the game ends; rather, the game sessions finish when players decide to stop playing (and stick to that decision) or when the people organizing the game stop maintaining it.

PLAY SESSION Although a game session describes the whole activity of one player playing a game, in many cases, especially for long and complex games, the time spent actually playing the game is divided into several different occasions. Each occasion is a play session, so a game session can be described as consisting of one or more play sessions. Similar to game sessions, play sessions are player dependent;

e.g., in online games, players may play the whole game without having overlapping play sessions with other players.

By controlling the moments when game pauses or saves can be made, the designers can control the length of play sessions. For example, shorter games can be made more intense by not allowing the player to differentiate between play and game sessions. Game design can heavily influence, although not actually force, what a play session should be by having specific save points create natural points at which players may choose to stop playing the game. Reaching these save points then becomes a subgoal in the game. In games where players can abandon the current game state and reload previous states, the time from the save point to when the reload takes place may be considered a separate play session, which does not become part of the overall game session.

> **Example:** Long and complex games, such as the *Zelda* series, are played over a long time, divided into several different play sessions. A number of these play sessions will not become part of the overall game session, as the game state will be abandoned when a player chooses whether to save the game or restart from an earlier position.

> **Example:** Massively multiplayer online games, such as *EverQuest* and *Ultima Online*, have individual play sessions for each player, while the game instance starts when the game server starts and ends when the company decides to shut down the game. The players' game sessions consist of all their play sessions, as they cannot abandon play sessions in favor of saved positions.

> **Example:** *Pac-Man* and other classic coin-op games that do not offer pausing capabilities have play sessions that are the same as the game sessions. This led one of the writers to spend more than six hours playing *Pac-Man* non-stop during his early teens to explore what would happen when the six-digit score display overflowed.

SETUP SESSION Each component described thus far includes a setup session. These setup sessions can in many cases seem trivial, but they can be ways for players to do creative work or to determine their play experiences, for instance by setting personal goals. For example, a game might have a set of gameplay options the players or game facilitators can choose from. Creative work is usually possible in instances where people can insert their own material into the game or alter the possible combinations of options in a game, for example, setting mutators in *Unreal Tournament* games. Just as game and play sessions can differ between players, the setup

sessions can differ between players, and several setup sessions might be necessary before the actual gameplay begins.

> **Example:** Setting up a game instance of an online game includes many decisions, for instance, which maps to use, banning or allowing certain actions or ways to access information, etc. Such decisions allow players to affect their gameplay experience but also affect the balance between the players or the ability to gain tactical advantages.

> **Example:** Being a game master for a roleplaying game usually requires reading prewritten adventures and campaign modules, creating your own plots and characters, or a combination of both. The primary reward for the game master for moderating the game can often be in seeing how the players enjoy the development of the planned experience, how the players surprise the game master by making unexpected choices, or how the players bring the predefined story to life.

> **Example:** Almost all MMORPGs offer the player the possibility of choosing and modifying the character before starting the first game session of playing the character.

SET-DOWN SESSION The act of collecting the components used in the game for storage and returning the game space to its previous state between game and play sessions is usually uninteresting from a game experience perspective. However, the set-down sessions can allow individual players to do individual administrative or planning activities.

In addition, when games provide the means to create narrative stories or the means to compare the game instance with other game instances of the same game, these activities belong to the set-down session. The comparison of different game instances is practically required in games that cannot be won to measure success relative to other game instances. Similarly, game instances need to be comparable for games to be played in tournament forms.

> **Example:** Selecting a handle for the high score list in *Asteroids* is a typical example of an activity in the set-down session. The activity is not part of the actual play session but provides the means to compare oneself with other players or compare oneself with previous games one has played.

> **Example:** The activities of raising or gaining skills and stats in roleplaying games, especially tabletop or live versions, are sometimes considered to be outside the actual play session. For tabletop versions, such activities usually

take place in the set-down session as records are usually kept by one person, and the activities do not take that much time. Live roleplaying games, due to their complexity and size, usually handle the character development as an extra-game activity.

EXTRA-GAME ACTIVITIES Many activities in games are not actually that much about playing the game itself or even preparing for playing the game. Of course, it could be argued that buying a new pair of tennis shoes is, in fact, part of the preparatory phase of playing a game of tennis. It can also be argued that getting your name in the high score list is sometimes an even more important aspect of playing than the game itself. The extra-game activities component of the framework contains all the activities related to the game that do not have a direct impact on the game (or the meta-game) state or players' strategies for a single game instance. The amount of extra-game activities is, of course, only limited by players' time, interest, and imagination, but the designers can provide mechanics within the game to support extra-game activities, which could have an impact on the overall gameplay experience.

> **Example:** *The Sims* allows players to make and distribute their own skins (modifications to the original graphics or original creations), and some players have set up Web sites with comic strips created by taking screenshots from the game. These activities do have a direct impact on the play experience and how a player actually plays the game; for example, much effort can be put into creating the right game state to take a screenshot, but this does not affect the game state or player strategies of a particular game instance directly. Even though the insertion of skins in *The Sims* changes the visual appearance of the game, it does not affect the game state by changing the characters stats or how the characters in the game react to each other. The line between extra-game and game activities is somewhat vague, especially in games that are more like toys to play with than typical games.

EXAMPLE OF HOLISTIC COMPONENTS IN A GAME In short, the game instance is the whole game, the game session is one player's participation and experience in that game, and the play session is one continuous session of a player actively participating in the game. It is true that in many games these sessions coincide, but this is not always the case, as the following example demonstrates.

John wants to play a game of a slow-moving turn-based multiplayer fantasy strategy PC game with his friends. He first configures the game parameters, selects the map he wants to play, and invites Bob, Mary, and Jean to the game. These activities are part of the game instance and also part of the setup session of the game

instance. It takes quite a lot of time to set up the whole game, so even this activity is split into three different setup sessions for John.

Bob accepts the invitation and logs in to John's server to the pre-created game account, selects Orcs as his starting position, and prepares to start playing. This setup session is the beginning of Bob's game session and is also his first play session in the game. Ten minutes later, Bob has an emergency call (Bob is a doctor) and he has to leave. So he won't annoy the other players, he cancels his starting position and informs John that he will not participate in the game. This set-down session ends Bob's game session.

Mary and Jean start their game sessions by accepting the invitation and verifying their starting positions. The game proper starts with the three remaining players (John is also playing) making their personal configurations. Mary logs out of the game after selecting the starting position (Dwarves), thus finishing her first play session. Jean stays online for awhile longer and makes her first turn. Jean's first play session is finished when she logs out.

Both Mary and John make their first turns a bit later, and the results are e-mailed to all participants. The next morning, Jean reads her results but decides to make her moves in the afternoon. This is, however, her second play session as reading the results is active participation in the game.

The players make their turns every now and then for several weeks. The game requires a lot of diplomacy and quite often, the players have IRC negotiations, which are also separate play sessions, even though no specific changes are made in the game state. Finally, the game ends when Jean reaches the required amount of victory points. This ends the game session for Jean and Mary. John starts the set-down session by registering the results and sending them to Jean and Mary. Shutting down the server completes John's set-down session and ends the game instance.

This example shows that the game instance, game session, and play session structures are not necessarily simple. The designers have to think about how the game instance and game sessions for each player are set up, how game sessions are structured to play sessions, and finally, how the game sessions and the game instance are finished in the set-down sessions.

Boundary Components

The boundary components are those that limit the activities of people playing games, either by only allowing certain actions or by making certain activities more rewarding. These types of components are most relevant when one is interested in defining the purposes for playing the game or defining what activities are not allowed when playing the game. This set of limitations can be seen as a social contract between the players that has to be satisfied while playing. This social contract has

been described as a "magic circle" in Johan Huizinga's *Homo Ludens* [Huizinga50] and *Rules of Play* [Salen04], a metaphor that indicates how game activities can be started or finished: players can actively enter the circle to begin playing and step outside the circle through performing forbidden actions. Games within games can be explained simply as circles within circles.

The primary boundary components of games are *rules* and *goals.* Rules govern how components interact and what actions are allowed including the order, or choice of order, of these actions. Goals and subgoals define the reasons for playing the game and the favorable game states for individual players. The final component, *modes of play,* defines the sections of the game where perceivably different types of activities take place. The relationship between these components is illustrated in Figure 2.3.

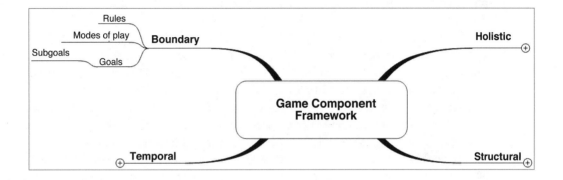

FIGURE 2.3 The boundary components.

RULES Rules limit the players' range of actions while they are playing, enforce certain actions, and describe the order in which actions should be taken. Rules also describe and lay out the boundaries of the game and govern exactly how all the other components of the framework are instantiated in the game itself. Given this ubiquity of rules one could claim, as David Parlett does when studying board games, that "every game is its rules" [Parlett99]. However, this leaves out other important aspects of games, such as the motivation for playing the game (typically found in goals or in the social interaction gained by playing). Computer games have increased the amount of rules by several orders of magnitude through the complex models and algorithms underlying any modern game. However, computer games can paradoxically be perceived as less rule-governed, because players do not need to explicitly be taught rules in computer games, they can try numerous actions and activities and learn by experience how the rules in the game work.

Rules can be divided into several different types. Salen and Zimmerman [Salen04] propose a three-part model, including operational, constitutive, and implicit rules. Operational rules define how the game is played by the players. They usually correspond to the explicitly written rules of non-digital games. Constitutive rules are the underlying formal structures that exist beneath the operational rules. The difference is, in short, that operational rules dictate a more or less physical implementation of the more abstract constitutive rules. The implicit rules govern the human and social aspects of playing a game, including etiquette, good sportsmanship, and the vast, almost innumerable, set of other rules that constitute socially acceptable behavior in general. The concept of rules in our framework corresponds almost directly to Zimmerman's and Salen's operational and constitutive rules. In our framework, rules are operational or constituative, and rules governing interface and player components are left out. The implicit rules are not part of the framework as defined here, mainly since they are outside the influence of game designers.

Rules may differ between game instances, but these rules tend to be optional and are used to either balance the game or introduce variance to the gameplay. These optional rules, often called *house rules*, are not described in game manuals and are not part of the code, but are rather rules that are agreed upon by the players before the game. However, some games are designed not to have a static rule set but to make rule modification part of the game. Games in which rules may be added, removed, or changed during gameplay have higher-order rules that govern the changes. The low-order rules can thereby be treated as other forms of components in the game, while the higher-order rules describe how they relate to the other components in the game. Making this distinction enables players to perceive two different game instances of a rule-changing game as instances of the same game nonetheless.

Computer games differ from most other games in that they can make it impossible to break the rules. Unless one hacks the code, the rules are part of the code, making illegal actions impossible or automatically penalizing such actions. As mentioned earlier, computer games also allow players to start playing the game before knowing or understanding all the rules, thereby letting the player experiment with what is allowed. This may be socially unacceptable in a game with other players, because the other players may wish to simply play the game without the burden of someone who is just learning the rules. A difference between computer games and other games is that being an expert player in a computer game can depend not only on taking advantage of all rules but also knowing all rules.

The ease of accessing files from game developers, primarily due to the Internet, has made it easier for developers to revise rules. Many games have updated rules available through downloadable patches along with bug fixes, and players can de-

cide whether these changes take place between game sessions or play sessions. This is in contrast to MMORPGs, in which the game providers choose when to update the rules but typically allow players to continue their game sessions.

> **Example:** The complex real-time strategy game *Europa Universalis II* has rules for the dependency between a country's leaders, provinces, research, international status, religion, and military forces as well as for trade, vassals, loans, and alliances between countries. Similar to other games in the genre, the model is so complex that the manual and tutorial introduce these concepts and the fundamental relationships between them, but players must learn the detailed rules unaided. Game mastery heavily depends on understanding what the rules are and how to take advantage of them.

> **Example:** In *Unreal Tournament*, players can program their own variant rules that can then be passed on to other players. These variants can be seen as encoded house rules.

> **Example:** *Nomic* is a game based on changing the rules. It starts with a collection of rules divided into two categories and has the (starting) goal of either getting 100 points or proving that gameplay cannot continue due to two contradictory rules.

MODES OF PLAY Many games have several different modes of play in which players can perform different actions. As is the case with all the other components, there can be several layers of different modes of play within the game, that is, each separate mode of play can consist of submodes of play. Further, games can be constructed so that different players have different action sets, which constitute different modes of play. For a detailed example of different modes of play, see the *Pac-Man* analysis later in this chapter.

The changes in modes of play can be made explicit by having different users interface for each mode, e.g., the inventory screen in an adventure game might be compared to the main game screen or be an implicit part of the gameplay such as the role-reversal in *Tag*. The role-reversal in *Pac-Man* does not change the interface or the low-level actions available for the player but changes the abilities of Pac-Man to be able to eat the ghosts.

> **Example:** The computer game *Space Hulk* allows a player to control a squad of space marines in a derelict monster-infected spaceship. To succeed with the missions, the player must coordinate his forces to cover each other and the possible attack routes. However, this can only be done while the player has a tactical planning value, which is continuously ticking

down. When the value reaches zero, the player is forced into a first-person view where only one marine can be controlled and the fates of the others are reported. However, being in this mode increases the tactical planning value, allowing the player to switch back to the tactical mode after some time.

Example: Team-based first-person shooters such as *Return to Castle Wolfenstein: Enemy Territory* and *Team Fortress Classic* allow players to choose different occupations with different skill sets, and all occupations are needed for a well-functioning team. *Battlefield 1942* allows different modes of play depending on whether the player is moving on foot, driving a land vehicle, steering a ship, or piloting an aircraft. The first-person shooter *Alien vs. Predator* allows not only different weapons but also different sensory input and movement possibilities, depending on whether the player controls a predator, an alien, or a marine.

Example: A separate inventory screen in a roleplaying game is a good example of a lower layer mode of play. The actions available for the player in the inventory screen are normally different from the main mode of play. The main mode of play in the early real-time first-person roleplaying game *Dungeon Master* consists of the player moving freely around the dungeon using a mouse and a keyboard. The inventory screen in the game offers the player pretty much the same actions as the equivalent mode in other roleplaying and adventure games, that is, to view, manipulate, drop, examine, and ready items. The switches between the main mode and inventory mode are similar. If the player picks up an item, it is either automatically transferred to the inventory without triggering a mode change, as in *Zelda* or *NetHack*, or the player has to explicitly move the item to the inventory mode of play by holding the item with a mouse and clicking on a character portrait, as in *Dungeon Master*. The *Ultima Underworld* series has a different approach. The inventory is part of the main interface, so there is no need to switch modes. Both *Ultima Underworld* and *Dungeon Master* maintain their real-time nature—the game world does not freeze—in inventory mode. In the *Zelda* series, the game world is frozen while the player is in the inventory mode.

GOALS AND SUBGOALS Goals give players the motivation for their actions in the game. They define the game states that the players should try to achieve by manipulating the game through their actions and those of the other players. Usually the goals have to be achieved by completing subgoals, which in turn can comprise further subgoals. Virtually all games have several layers and hierarchies of goals. Even a best-out-of-three game of *Paper-Rock-Scissors* consists of at least two layers of goals: first to win the individual matches and second to be the first to get two wins.

Many games offer players several different ways of winning, basically allowing players to choose what goals they are striving for from a collection of goals. Some games have explicit goals, while other (possibly non-winnable) games either let the players choose what they aim for or are constructed in such a way that figuring out what the goals are is a goal in itself.

Example: *Chess* has check-mating the opponent's king as the primary goal of the game. Although it does not define one particular game state, it gives players a clear goal including subgoals, such as capturing the opponent's other pieces, which make the primary goal easier to achieve.

Example: *Pac-Man* cannot be won, as all games end with "Game Over." However, the game provides many alternative primary goals: reaching a position in the high score list, beating a fellow player, or simply playing better than previously.

Example: *The Sims* is an example of a computer game that cannot be won, as it does not have explicit goals. Indeed, the creator of the game, Will Wright, has said that it is not actually a game but a toy. However, players can set their own goals, making *The Sims* at least a puzzle if not a game.

Temporal Components

The temporal components describe the flow of the game, such as when telling someone else what took place in the game after the game has been finished. The views reflected by these components are most relevant when one is interested in the individual choices a player has made or when one is describing the causality of the gameplay. This does not address why players performed the actions they did or intentionality, as these goals are addressed by the boundary components. Neither does the category include rules as they can be defined negatively, i.e., the rules may state what one cannot do rather than what one must do, and rules are also used to define the starting state of a game.

Note that although the temporal components can be seen as the basic elements for describing narrative structures of games, they do not include the essential components for storytelling such as adversary, hero, quest, and role-reversal.

The temporal components include *actions*, which describe the ways players can change the game state, *events*, which are game state changes perceivable to the players, *closures*, which are the quantifiable and meaningful game state changes related to the progress of the gameplay, and *end conditions* and *evaluation functions*, which determine the game state requirements and outcomes of closures and changes in modes of play. The relationships between these components are illustrated in Figure 2.4.

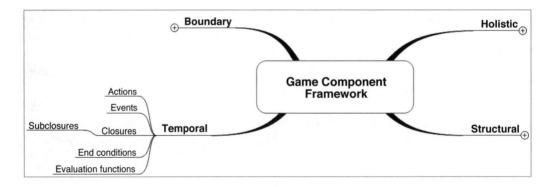

FIGURE 2.4 The temporal components.

ACTIONS Actions are the means through which the player can make changes to the game state. The actions can be either explicitly available to the player or implicit in the game. The first kind is typical in games using physical game controls where players can simply explore what happens by pressing buttons, pulling joysticks, or doing combinations. Other explicit actions are offered by buttons and menus in the graphical user interface of the game. Game actions that are implicitly available are typically found in text-based adventure games or graphical point-and-click adventures where finding out which actions are possible is an integral part of the challenge.

The action definition used in the framework is for those logical actions that cause changes in the game state. That means the physical movement of a player's finger to press a button is not considered an action but that the change in the game state that is initiated through the button press is an action. Actions are thus always associated with the interface through which the players can initiate the game state changes.

> **Examples:** *Pac-Man*, *Space Invaders*, *Asteroids*, and other early computer games typically only allow players to move their avatar, and in some cases, shoot in the direction they are moving, as seen in Figure 2.5.

EVENTS *Events* are the game state changes that are perceivable to players. If actions represent the input to the game, events are the output. They inform the players of the consequences of their actions, let them update their goals and tactics, and show the actions of other players. All events do not have to be responses to the player actions as the game can create events based on randomness, time spent playing, or algorithms, depending on the game state.

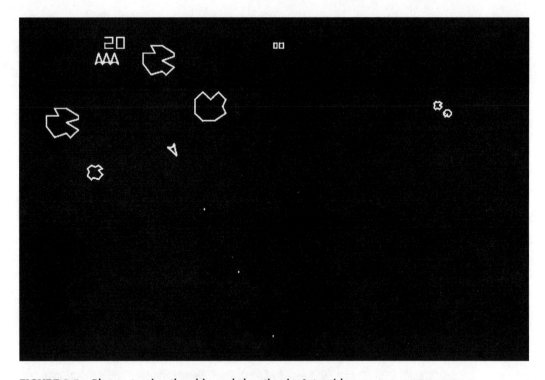

FIGURE 2.5 Player steering the ship and shooting in *Asteroids*.

Example: Events that are not initiated by player actions can be found in the historical strategy game *Europa Universalis II*, which has over 600 historical events pre-programmed, which steer the simulation toward the historical outcome and lend the player a feeling of participation in history.

CLOSURES Closures are quantifiable and meaningful player experiences usually associated with game state changes. Closures may be associated with achieving goals but do not have to be so; a closure might instead be the point when it becomes obvious that a goal cannot be reached. Another relevant difference between goals and closures is that the goals are within the game definition and do not exist at a particular point of time. The closures are always tied to a particular point of time in the gameplay. To put it another way, goals are part of the game, closures happen when playing the game.

Although they can usually be defined as particular changes in the game state, closures do not have to be dependent on the game state, as they can also be a

player's subjective experiences. Those closures that are defined by changes in the game state are usually non-reversible; once they have been achieved, the game state will not revert. Because some closures can be described as game state changes and some cannot, closures are a borderline case between first and second order game design concepts.

> **Example:** Most games include closures on many levels. *Pac-Man* can be said to have a closure for completing a level but also for eating a pill, eating a ghost, eating all the ghosts, and picking up bonus tokens.

END CONDITIONS End conditions define the requirements on the game state for a switch in mode of play, the completion of a closure, or the end of the game instance or game or play session. As such, they can be used to spawn events by the game.

> **Example:** The classic end condition for computer games is when the player has spent all lives available to him. Shooting all the aliens is the end condition for completing a level in *Space Invaders*. Losing all the cities in *Missile Command* is another example of an end condition as demonstrated in Figure 2.6.

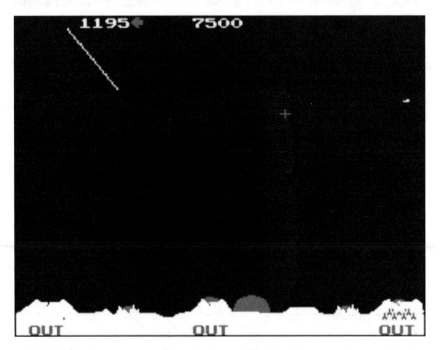

FIGURE 2.6 The player has lost all cities in *Missile Command* thus ending the game. Asteroids®, Civilization®, Missile Command®, and Pong® screenshots courtesy of Atari, Inc. All rights reserved.

The difference between the end condition of a game instance and game session is evident in almost any kind of race game. The game session ends for the player when the goal is reached, the end of the instance is (normally) when all the players have either reached the goal or have withdrawn from the game.

EVALUATION FUNCTIONS Evaluation functions are the algorithms used to determine the outcome of end conditions. Most evaluation functions are deterministic, that is, they do not depend on randomness, so they give the same result every time they are evaluated with the same game state. The commonly used terms of winning and losing are actually evaluation functions, which are associated with different end conditions. We chose not to use winning and losing conditions as components in the framework, because some game end conditions are not reliant on winning or losing. An example of such a game is soccer, where the end condition is the certain amount of time played, and the evaluation function determines the winners and losers based on the amount of goals the teams have scored.

As the pair end condition/evaluation function is associated with closures, it can be found on several different levels even in very simple games. For an example, see the analysis of *Pac-Man* at the end of this chapter.

Rewards and penalties are the results of evaluation functions that influence the game state. Rewards and penalties do not have to be mutually exclusive. A complex evaluation function can combine multiple rewards and penalties to one end condition.

Structural Components

Structural components are the basic parts of the game manipulated by the players and the system; they are probably the most concrete category in the framework. They can be physical tokens representing real-world or imaginary objects, people, or creatures, but they can also be abstract phenomena representing values or attributes. This view is most relevant when one is fine-tuning the game balance or when one is focusing on the fundamental components with which the players will interact.

The *game facilitator* is responsible for maintaining and synchronizing the game state, the *players* are entities that try to achieve their goals in the game by performing actions through an *interface*, and the *game elements* are the components, which contain the game state. *Game time* describes how the changes in the game state map to real time. The relationships between these components are illustrated in Figure 2.7.

GAME FACILITATOR Games cannot be played without some kind of a facilitating agent setting the game up and synchronizing the game state during the gameplay.

FIGURE 2.7 The structural components.

In traditional games, such as ordinary board, card, and children's games, the players themselves act as the game facilitators.

Facilitators are responsible for keeping the game state synchronized, making the necessary changes created by player actions, taking care of the game events, and providing the players the methods of playing the game. Game facilitators are also the ultimate arbitrator of disputes between the game and the players.

> **Example:** Children playing *Hide & Seek* are normally themselves facilitating the whole game from agreeing on boundaries to resolving the changes in game state.

> **Example:** Tabletop roleplaying games have a specific game master responsible for creating and maintaining the game world for the players. The game master also determines the outcome of player actions and generates and handles the game events.

PLAYERS Players are the representations of the different agencies that are competing (or cooperating) in the game to achieve their goals. In most cases, a player is simply a person playing the game but, in some cases, there might be several people playing simultaneously but acting through one focus player, such as playing *Chess* with two cooperating players on each side or several people taking turns in playing the same position in the game, as is the case in sharing a character in an MMORPG.

Computers enable humans to compete against computer-controlled entities that follow the same rules as human players. Sometimes it is useful to analyze some of the system-controlled events as computer-controlled players, even though the goals, actions, and elements available are totally different from the real player. For example, analyzing the ghosts in *Pac-Man* as players makes it possible to find the similarities between *Pac-Man* and *Tag*. In some cases, even though it is quite difficult to imagine, there may be good reasons to think of *Tetris* as a two-player game in which the computer opponent tries to fill the screen with blocks while the human player tries to keep it clean.

> **Example:** Most multiplayer computer games provide artificial intelligence functionality to provide extra players in the game if there is an insufficient number of human players to support the wished for gameplay. This is especially common in competitive games such as first-person shooters or real-time strategy games where the game must have several players—in some cases, almost two dozen—for that game to be exciting.

INTERFACES The interface of a game is extremely important since it is through the interface that the player experiences the game. The interface can perform two intertwined roles, one expressing the theme and feel of the game, the other giving players information about the state and possible actions in the game. Although the former is undoubtedly very important in determining how the game is received and for the whole game design, the audio-visual pleasure of games is beyond the scope of this framework, and interested readers are referred to other fields such as graphic design. Likewise, the usability of the interface is outside the scope of this framework, and knowledge about this issue can be found within the areas of human-computer interaction or information design. Thus, in this context, "interface" refers only to the functionality and information provided by the game on a structural level.

The interface provides players with information about the current game state and what actions they can perform. The representation of the game elements is an integral part of the interface. Again, the interface is generally a complicated and many-layered component consisting of several sub-interfaces. The interface also provides the players access to the available actions. In the game of *Chess*, the player can pick up the piece and move it to the desired board position. Non-computer game interfaces almost always allow a much wider range of actions than those that are possible according to the rules of the game. The player could take the opponent's king and throw it out the window, but that would be against the normal interpretation of the rules of *Chess*.

The interface in the framework is only concerned about how the player gets access to the actions and information governed by the rules. Misuse of the interface

is considered cheating or breaking the implicit rule of maintaining the play of the game.

> **Example:** A classic component of a computer interface is the mode where players enter their handles to the high score list. By scrolling through a list of characters and operators, they can construct three-letter handles without the use of a keyboard. In tabletop roleplaying games, the game master is the primary interface for the players with the help of maps, miniatures, and handouts. Live-action roleplaying games use costumes, equipment, and non-player characters to contain game state information and to express the theme of the game.

GAME ELEMENTS Game elements are the physical and logical components that contain the game state and are manipulated by players to achieve their goals. Players influence the game state through actions performed on the game elements, which they can control.

Game elements usually contain attributes that define their abilities and are used as input to determine the effect of actions. Typical attributes are those that define the types of game elements, signify what actions it provides, define who controls the game element, and represent numerical attributes that are used in algorithms for determining the outcome of actions.

One special category of game elements is the game world, which defines the spatial world in which the other game elements exist. Although not all games use a spatial game world, they are very common and are usually two-dimensional boards or three-dimensional virtual worlds.

Examples of types of game elements include:

- Elements that define the game space and its size and topology
- Elements that personify players
- Elements controlled by one player but that do not personify the player
- Neutral elements for which players compete
- Bookkeeping elements used to maintain and show aspects of the game state

> **Example:** The players' avatars in first-person shooters are examples of game elements that facilitate the players' possibility to interact with the game and are closely associated with the players' success in the game. The king in *Chess* is a similar example, although players can move their other pieces also.

GAME TIME As games have actions that affect the game state and thereby affect subsequent actions, the actions in a game session can be ordered sequentially on a timeline to describe what happened during the period of time the game was played, called game time. As not all games depend on the exact time an action was taken as long as it was in its position in the sequence, the time need not always be used as a measuring unit on the timeline. Thus, game time can be independent of the real time used to play the game, although in some cases it is directly linked, for example, in real-time games or races. There are some games where game time has little effect on the outcome as long as the order of events are maintained but real time can strongly influence the way the game is played. An example of this is the difference between playing chess with or without time limits for each move. Breaks and time-outs are other examples of where the effects of real time and game time differ.

USING THE FRAMEWORK

The framework we have presented here is a generic framework; that is, it can be used to describe all kinds of games and for many different points of view. This, of course, means that many aspects of the framework will not be relevant for any given purpose. For example, *Chess* may have two modes of play when viewed from one player's perspective: one where you are making a move and one when you are waiting for the other player's move. In many cases, this distinction may not be meaningful but when examining *Chess* games where each player has a limited time to think (either per turn or for the whole game), the distinction can help the analysis of time management. Being in the waiting mode as much as possible is probably tactically advantageous, as the player is then using the opponent's time to do his own planning.

Below we give a short analysis of the video game *Pac-Man* to show how the different components of an actual game fit into our framework.

Example Analysis: Pac-Man

Pac-Man has been chosen because it is well known and, although old and by today's standards simple, it illuminates quite well how most of the components work.

HOLISTIC The holistic components of the basic *Pac-Man* game are simple. In both the single- and two-player modes, the game instance and the game session are the same. *Pac-Man* is an arcade game where you have to play one game to the end. The play session also coincides with the game session in the single-player mode, but this is not necessarily the case in two-player mode, as the other player can, in principle,

do something else while the player finishes his turn. This is usual for arcade games where the main financial motive is to have the players put in as much money in as little time as possible. The setup session of *Pac-Man* consists of inserting coins and choosing the number of players. The set-down session is when "Game Over" flashes on the screen.

The extra-game activities component of *Pac-Man* is enacted if you get the high score. This feature creates a sort of a meta-game level where the outcome of a single-game instance is compared to the previous outcomes. This kind of meta-game does not necessarily require a high score, as even a competition between two friends playing for the highest score is an example of a similar meta game.

BOUNDARY As mentioned earlier, even very simple games can have several layers of goals, and *Pac-Man* is no exception. Starting from the very bottom, eating a single pill is the fundamental subgoal of the whole game. The next layer is finishing the level by eating all the pills. The top goal from the game point of view is to achieve a high score, which is made possible mainly by completing as many levels as possible. The power pills and the temporary bonus fruits bring in a set of optional goals. Eating the power pill gives Pac-Man the ability to eat ghosts. After taking a power pill, the player can decide if he wants to chase the ghosts or concentrate on completing the level. If the player chooses to hunt ghosts, there are further optional goals to choose from: eating as many of the ghosts as possible within the effect of the power pill (as the reward for catching a ghost doubles for each ghost caught) or just catching a few ghosts while staying in one part of the game area. Since *Pac-Man* cannot be won at all, and the game just continues until the player has lost all his lives, the players have to set their own high-level motivation goals. The outcome of the game—the score—can be used in several different ways depending on the context, such as beating your own high score, getting a higher score than your friend while playing the game during a party, getting the lowest score and staying alive for 10 minutes, and countless other ways, but these are not strictly parts of the framework.

Besides the setup and set-down sessions described in the boundary section, *Pac-Man* has different modes of play in the game itself, consisting of the gameplay and the end of level cut-scenes. Further, the gameplay itself has two distinct modes of play: Pac-Man trying to avoid the ghosts and, after eating the power pill, Pac-Man chasing and eating the ghosts. Losing a life changes the mode of play to another cut-scene of the Pac-Man fading away.

TEMPORAL Reaching any of the goals described previously is associated with an achievement closure. The end condition for eating the pill is that Pac-Man has

moved over it and the evaluation function adds 10 points to the player's score. The goal of eating a ghost has a similar end condition, Pac-Man moving over the ghost, and the output of the evaluation function depends on the number of ghosts eaten during the effect of the power pill. For every 10,000 points, the player is rewarded with an additional life. The other closures are associated with changes of the mode of play: a ghost catching Pac-Man results in losing a life, and when all three lives are lost, the game ends. These examples from *Pac-Man* illustrate the fact that closures in games are almost always associated with either achievement or loss.

The range of low-level actions available for the player is very limited. The player can move Pac-Man up, down, left, or right in such a way that it keeps on moving in the same direction until the direction is changed by the player or Pac-Man is stopped by a wall. Player actions in the setup session include putting in more coins to earn credits and choosing a game for one or two players. Again, the different ranges of actions and goals associated with different modes of play are worth pointing out.

The events in the game are numerous. First, every action has a direct effect perceivable to the player (which, by the way, is also a matter of good user interface design): Pac-Man moves forward or changes directions due to player action, letting Pac-Man hit a wall stops him, taking pills increase the code, etc. Also, each change of modes of play and closures is associated with an event. The rest of the events govern how the ghosts move and are regenerated.

STRUCTURAL The game facilitator in *Pac-Man* is the software and hardware running the game. The basic game offers the possibility of single- and two-player modes. The players, however, are not part of the same play session apart from watching the other player finishing his turn. The player has control over the game as described in the previous sections.

Another way of looking at the single-player mode of *Pac-Man* is to handle the ghosts as players in the game. This, of course, requires that parts of the previous analysis have to be done also from the point of view of the ghosts. The main goal for the ghosts is to catch Pac-Man and actions available are to move through the maze. The role reversal of Pac-Man (eating the pill) obviously changes the goal for the ghosts, too. The relationship between Pac-Man and the ghosts is similar, but reverse, to that of *Tag:* one of the players tries to avoid being caught by the other players. The role-reversed Pac-Man has exactly the same interaction pattern as *Tag* but without the further role reversal associated with catching the ghost.

The game elements of *Pac-Man* are demonstrated in Figure 2.8.

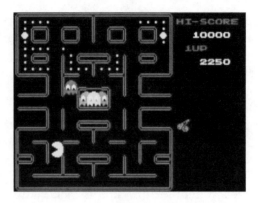

FIGURE 2.8 The game elements of *Pac-Man*. Pac-Man® ©1980 2004 Namco Ltd. All rights reserved. Courtesy of Namco Holding Corp.

The game elements are described as follows:

- The walls, side openings, and the central ghost base lay out the topology of the levels.
- Pac-Man is an avatar that personifies the player.
- The four computer-controlled ghosts with different colors and names.
- Pills, power pills, and occasional bonus fruit that Pac-Man can consume.
- Number of lives for Pac-Man.
- Levels arranged in an apparently endless sequence.
- Score representing the player's progress in the game.
- The high score of the game.
- Credits representing how many times the player can play the game.

The physical interface of the game consists of the screen, the speakers, the coin slots, the joystick, and the buttons on the panel. The screen is used to convey information about the current game element configuration: where Pac-Man, ghosts, and pills are; the current score; the level number; and so on. The graphical outlook of the displayed game elements—Pac-Man is a yellow blob with a mouth, the ghosts have different colors, and so on—are also an integral part of the interface.

The background sounds of the game represent different modes of play: the siren-like voice of the ghosts, with increasing tempo as they chase Pac-Man; the different kind of sound when Pac-Man has eaten a power pill and can chase the ghosts; the eaten ghost returning to the generator creates yet another, now higher pitched and weaker sound; and the ready sequence at the start of the game and cut-scene music after finishing a certain number of levels. The other sounds signal closures: eating a pill, be it

normal or a power pill, generates the "wakka" sound; losing a life is associated with a lowering pitch and an end splash; getting an extra life is associated with a cheerful jingling noise; and eating a bonus fruit or a ghost also have distinctive sounds.

Inputs in *Pac-Man* are coupled directly to the lower-level actions: move the joystick up and Pac-Man goes up unless blocked by a wall, and so on. Putting in more coins raises the credits available for the players and pushing either the one- or two-player button selects the number of players for the session.

Summary

This short analysis of *Pac-Man* shows the use of the framework to identify and classify components of an arcade game. Although the analysis is brief and could be expanded further, it shows how all levels of the framework are required to describe a game and shows that even what may be seen as a simple game by today's standards is complex in regard to gameplay when one explicitly describes what the gameplay in it consists of.

CONCLUSION

In this chapter, we have described a framework for discussing components in games. Divided into four main categories, the framework allows the identification of structural, temporal, boundary, and holistic components. The different subcategories in the framework provide a basis for talking about the structure of games in general from a gameplay perspective and will be used in later chapters to define gameplay concepts.

REFERENCES

[Avedon71] Avedon, Elliot M. "The Structure of Games." In *The Study of Games*, edited by E.M. Avedon & B. Sutton-Smith. John Wileys & Sons, Inc., 1971.

[Avedon&Sutton-Smith71] Avedon, Elliot M. and Brian Sutton-Smith (Eds.). *The Study of Games*. John Wileys & Sons, Inc., 1971.

[Caillois01] Caillois, Roger. *Man, Play, and Games*. University of Illinois Press, 2001.

[Costikyan94] Costikyan, Greg. "I Have No Words and I Must Design." *Interactive Fantasy 2*. Hogshead Publishing, 1994. (Also available online at *http://www.costik.com/nowords.html.*)

[Costikyan02] Costikyan, Greg. "I Have No Words and I Must Design: Toward a Critical Vocabulary for Games." In *Proceedings of Computer Game and Digital Cultures Conference*, edited by F. Mäyrä. Tampere University Press, 2002.

[Crawford84] Crawford, Chris. *The Art of Computer Game Design*. McGraw-Hill Osborne Media, 1984. (Also available online at *http://www.vancouver.wsu.edu/fac/peabody/gamebook/Coverpage.html.*)

[Fullerton04] Fullerton Tracy, Christopher Swain, and Steven Hoffman. *Game Design Workshop: Designing, Prototyping, and Playtesting Games*. CMP Books, 2004.

[Huizinga50] Huizinga, Johan. *Homo Ludens: A Study of the Play-Element in Culture*. Beacon Press, 1950.

[Juul03] Juul, Jesper. *Half-Real: Video Games Between Real Rules and Fictional Worlds* (Doctoral dissertation). IT-University of Copenhagen, 2003.

[Parlett99] Parlett, David. *Oxford History of Board Games*. Oxford University Press, 1999.

[Salen04] Salen, Katie and Eric Zimmerman. *Rules of Play: Game Design Fundamentals*. The MIT Press, 2004.

[Sutton-Smith97] Sutton-Smith, Brian. *The Ambiguity of Play*. Harvard University Press, 1997.

[Zagal99] Zagal, José Pablo, Miguel Nussbaum, and Ricardo Rosas. "A Model to Support the Design of Multiplayer Games." In *Presence: Teleoperators and Virtual Environments* (Vol 9, No. 5. pp. 448-462). MIT Press, 1999. (Also available online at *http://www.cc.gatech.edu/~jp/Papers/AModelMultiplayerGames.pdf.*)

3 Game Design Patterns

This chapter introduces the main concept in the book—game design patterns—as a way to implicitly state what a game is by providing a tool for talking about what we see as the core aspect of games: gameplay. The latter, and larger, part of the book then provides descriptions of many specific parts of gameplay in the format of game design patterns, using the terms from the component framework.

The fact that games are artificial objects rather than natural objects, and that they are designed by humans, makes the process of creating them difficult to understand. (The interested reader can see *The Sciences of the Artificial* by Herbert A. Simon [Simon96] and *Design Methods* by Jones [Jones92] for two different views on the subject of design.) The problems are further complicated by the objective of designing *interaction* in games; further, the activity of playing a game may be formalized and predictable in certain aspects but impossible to anticipate in others. So it can be argued that game design is part of the budding field of *interaction design*, although currently that field is dominated by the design of interaction between humans and computer systems with a focus on usability (see for example *Interaction Design* by Preece, et al. [Preece02]).

The work of ludologists (those who study videogames) and professional game designers mentioned in previous chapters does provide solid knowledge about game design but does not necessarily use a structured approach based on the design of interaction. For this we need to look to architecture. The focus of architects is on the intended use of a place and the experiences people should have when crossing a bridge or being in a skyscraper, while the engineers concentrate on details such as load bearing and structural fatigue. In the 1970s, Alexander, et al. introduced the concept of *design patterns* in the book *A Pattern Language: Towns, Buildings, Construction* [Alexander77] based on their experience of design within the field of architecture. These patterns described design challenges on all different levels an architect could encounter when starting from the approach of planning a city to deciding what furniture should be in a living room. The patterns are connected to each

other in such way that the choices made by following one pattern naturally move the attention to other patterns. Their focus was on creating a method for codifying design knowledge in separate but interrelated parts and they stress the practical use of the concept as can be seen from the following description:

> "Each pattern describes a problem which occurs over and over again in our environment, and then describes the core of the solution to that problem, in such a way that you can use this solution a million times over, without ever doing it the same way twice." [Alexander77]

Following the adaptation of design patterns to software engineering by Gamma et al. [Gamma95] and to interaction design by Borchers [Borchers01], Bernd Kreimeier suggested the use of patterns to support game design in his article "The Case for Game Design Patterns" [Kreimeier02]. However, design patterns are not ideally suited as design tools for games due to their initial introduction as a problem-solving tool. Thus, when we decided to develop design patterns for games, we chose not to define patterns based on the problem-solution pair templates that had previously been used. This is due to three observations we made after an initial review of the approach. First, defining patterns from problems creates a risk of viewing patterns as a method for only removing unwanted effects of a design rather than tools to support creative design work. Second, many of the patterns we identified described characteristics that more or less automatically guaranteed other characteristics in the game, in other words, the problem described in a pattern might easily be solved by applying a related and more specific pattern. Third, the effect of introducing, removing, or modifying a game design pattern in a game affected many different aspects of the gameplay, making game design patterns imprecise tools for solving problems mechanically. However, we believed that game design patterns offer a good model for how to structure knowledge about gameplay that could be used both for design and analysis of games.

Based upon these conclusions, we have chosen to define game design patterns in the following fashion: game design patterns are semiformal interdependent descriptions of commonly reoccurring parts of the design of a game that concern gameplay.

CHARACTERISTICS OF GAME DESIGN PATTERNS

In this section, we discuss some of the characteristics that are common to all game design patterns; either characteristics that are internal to the pattern or characteristics that depend on the relationships between the pattern and other patterns.

Semiformal Descriptions

Game design patterns rely on general descriptions of particular areas of gameplay without using quantitative measures. This is due to the nature of the design process; any specification of gameplay that relies on measures would be too precise to be of practical use for solving the ill-defined problems of design. Because of this, the presence or effect of game design patterns themselves cannot be measured accurately and automating their use is practically impossible. However, game design patterns do have a structure, they can be distinguished from each other, and it is possible to identify relationships between game design patterns in a game design. This makes game design patterns semiformalized concepts that have to be understood and applied differently depending on the context of their intended use.

Interrelated Descriptions

All patterns in any given game are related to each other in some form. However, some relationships are more common and can more easily be identified and constructed. We have identified three pairs of pattern relations that are both common and useful for analytic and design purposes. Two of the relationship pairs are asymmetric and one symmetric, giving rise to five relationship types:

Instantiates: When one pattern has this relation to another pattern, the presence of the first pattern causes the second pattern to be present. This is due to the fact that the design possibilities the first pattern describes limit the freedom of the designer in such a way that the design possibilities of another pattern follow automatically. A variation of this relation is when the combined effect of two or more patterns limits the gameplay space in such a way that another pattern emerges automatically. The patterns identified through this relation have the *instantiated by* relationship back to the original pattern. An example of an instantiating relationship can be found between *Dice* and *Randomness*; the effect on gameplay the pattern *Dice* has automatically introduces the effects of *Randomness*.

Modulates: The first pattern affects aspects of the second pattern in a way that influences gameplay. The modulating pattern works within a limited design space that is bounded by other restrictions regarding gameplay. Modulating relations are not instantiating relations, since they do not limit the game designer to the modulating pattern, rather the modulating pattern aids in fine tuning another pattern. This also means that the first pattern has to exist before it is possible to use the modulating pattern. If one pattern has this relationship to another pattern, that pattern has the modulated by relationship to the first pattern. An example of a modulating relationship can be found between *Privileged*

Movement and *Movement;* the use of *Privileged Movement* and the effects it has on gameplay rely on the presence of *Movement* and changes its characteristics within certain boundaries.

Instantiated by: The pattern can be instantiated by ensuring the presence of the related pattern, either because the related pattern is a more specific instance of the pattern or because the related pattern has consequences on gameplay similar to the pattern. The relation may not be binary; sometimes the presence of two patterns is required to guarantee the presence of a third pattern. Patterns with this relation to other patterns have the instantiating relation from those patterns. An example of instantiated by relationship is that of *Race* through *Traverse* and *Symmetric Goals;* a classical way of defining a race in a game is to give all players the goal of being the first to reach a certain position.

Modulated by: This relationship shows how applying additional patterns can tune a pattern's affect on gameplay. The patterns listed under this relationship can be used to modulate this pattern. An example of a modulated by relationship is *Investment* and *Diminishing Returns;* the latter can be used to influence how *Investment* affects gameplay.

Potentially conflicting with: The pattern can in certain configurations make the presence of another pattern impossible. This incompatibility affects a particular area or level of gameplay, as patterns that are potentially conflicting can often be found in the same game but on different levels. For example, *Competition* and *Cooperation* both exist in competitive team-based games. The relationship of being potentially conflicting is symmetric, so if one pattern has it toward another pattern, that pattern has the same relationship to the first pattern.

Similar to the semiformal structure of an individual pattern, the relation between two patterns is not typically quantitative. This means that although a defined relation between two patterns exists in general, its existence in a particular case cannot be guaranteed. The main exceptions are some instantiates-instantiated by relations where one pattern always creates the presence of another pattern. The relations we have noted and described in the pattern descriptions are those that are common in games, although the absence of a relation or the existence of an unnoted relation can easily be the cause of the use of other game design patterns in the specific game design.

Some patterns may have several types of relationships with each other, even within the same game. This may happen because the patterns are used in several different ways in the same game or because the game design is viewed from different perspectives, e.g., how the players perceive the game and how the internal structure of the game state is arranged. A simple example of this is a game where

defeating an opponent gives the player a sought-after game element; the internal game structure may have the goal of overcoming the opponent as a subgoal to the goal of achieving the game element, but a player may only have the goal of overcoming the opponent and getting the game element may simply be seen as a reward. Both views are correct, but the use of the views depends on what one is trying to achieve with the description.

Hierarchies of Patterns

The presence of the instantiates and instantiated by relations create hierarchies of patterns. However, these hierarchies do not contain all patterns, and several hierarchies can coexist. Further, one can differentiate between those patterns that are more concrete and those that are more abstract, although the boundary is imprecise. The more concrete design patterns are closely linked to the categories within the component framework, often describing a specific instantiation of a game component. The more abstract design patterns are those that modulate other patterns or solely appear as consequences of the presence of other, more concrete, patterns. However, the different abstraction levels in the component framework affect this distinction. Patterns directly instantiating different modes of play or game sessions, for example, are typically more abstract than patterns that are consequences of concrete patterns directly related to game elements.

When describing patterns, we will not explicitly state that patterns are more concrete or more abstract, but we will use terms of higher-level and lower-level patterns to indicate the general level of abstraction the pattern represents.

Intentional or Emergent Presence

A game design pattern may be found in gameplay either because it was an intentional decision of a game designer or because it was an unplanned consequence of the configurations of the components in the game. Unintentional, or *emergent*, game design patterns are more often higher-level patterns than lower-level patterns, as higher-level patterns are more difficult to explicitly design. For ease of reading, we describe game design patterns as intentional parts of game designs but do not assume that this is in fact the case. In many cases, it may be difficult to know if the presence was intentional or not, for example, when there is not a known designer for a game, as is the case with most traditional board and card games. However, the use of game design patterns is unaffected by the origin of the patterns.

Games of sufficient complexity, as measured by the number of potential game states, may easily contain emergent game design patterns even in games that are intentionally and explicitly designed. This is because the potential gameplay space that the game design can affect usually grows in relation to the number of potential game states and may become impossible to overview for a game designer.

The use of play testing aids in identifying emergent game design patterns. When such patterns are detected, they offer the game designer another potential way to affect gameplay. An emergent pattern can become an intentional pattern through manipulation, or it can be suppressed if it affects gameplay in a way that is in contradiction with the intentions of the game designer.

GAME DESIGN PATTERN TEMPLATE

In this section, we describe the game design pattern format we use in the book. The description is purely functional. See Part II for a description of the methods we used to create the pattern collection.

Name

The name of a game design pattern can be a single world or a short phrase describing the concept. We have deliberately not included aliases to minimize the number of names that need to be remembered; we instead provide dictionary-style references to similar concepts in other models and fields of study.

Core Definition

A brief sentence in italics follows immediately after the name. This sentence describes the core idea of the pattern. The purpose of this core description is to support browsing through a pattern collection, providing an initial overview for first-time readers and reminding returning readers of the contents of the pattern.

General Description

The pattern then continues with a short general description of the properties found in games that are the basis for the pattern, followed by the motivation for the pattern's name. General properties of the pattern are described using game examples and concepts from the component framework. Other patterns are not used in this part of the description to make it usable without reading other patterns. The first part of the pattern description ends with some explicit examples of games of various types that contain the pattern.

Using the Pattern

As patterns are general descriptions, the application of a pattern to any given situation requires a number of choices specific to the design context. This section is used to

mention the common choices a designer is faced with when trying to apply a pattern, often exemplified by specific game components. The game design patterns mentioned in this section are primarily related to the described pattern through the instantiated by and modulated by patterns.

Consequences

This section deals with the consequences of gameplay that can appear when the pattern occurs in the game. As such, the section is directed toward analyzing gameplay to help solve design problems in an already existing design or to suggest other design patterns to instantiate in the design of the game. The description makes use of other game design patterns, primarily with the instantiates and modulates relations but also with the potentially conflicting relations. However, patterns with other relations can also be present, especially when the consequences depend on the interaction between several patterns.

Relations

This section lists the relations that exist between the described pattern and other patterns. The related patterns are sorted into the five identified categories of relations: instantiates, modulates, instantiated by, modulated by, and potentially conflicting with.

References

This section lists the related previous works that have either been a direct inspiration for the pattern or contain descriptions of the main aspects of the pattern.

CONCLUSION

In this chapter, we have described integral properties of game design patterns; specifically, they are semiformal descriptions, they are strongly interrelated and often form hierarchies, and they can have either an intentional or emergent presence in games. We have also presented the template we use for describing patterns, consisting of the following parts: name, core definition, general description, using the pattern, consequences, relations, and if necessary, references. More information about the history and the current state of our approach is available at the Game Design Patterns Project Web site [GDPP].

REFERENCES

[Alexander77] Alexander, Christopher et al. *A Pattern Language: Towns, Buildings, Construction.* Oxford University Press, 1977.

[Borchers01] Borchers, Jan. *A Pattern Approach to Interaction Design.* John Wiley and Sons Ltd., 2001.

[Gamma95] Gamma, Erich et al. *Design Patterns—Elements of Reusable Object-Oriented Software.* Addison-Wesley, 1995.

[GDPP] Game Design Patterns Project. Available online at *http://www. gamedesignpatterns.org.*

[Jones92] Jones, John C. *Design Methods,* 2nd Edition. John Wiley & Sons, 1992.

[Kreimeier02] Kreimeier, Bernd. "The Case for Game Design Patterns." Available online at *http://www.gamasutra.com/features/20020313/kreimeier_03.htm* (March 2002).

[Preece02] Preece, Jenny, Helen Sharp, and Yvonne Rogers. *Interaction Design: Beyond Human-Computer Interaction.* John Wiley and Sons Ltd., 2002.

[Simon96] Simon, Herbert A. *The Sciences of the Artificial,* 3rd Edition. The MIT Press, 1996.

4 | Using Design Patterns

Game design patterns, either those in this book or patterns made by you or others, can be used in many different ways. This chapter illustrates a number of uses of patterns. Explicit methods or instructions are not included, because the methods would vary considerably between different game types, and no single method is best for all uses. All methods for examining or creating games need to be modified for their specific context. There are several books and papers that more explicitly describe game design methods (see for example [Costikyan94], [Church99], [Falstein02], [Adams03], [Fullerton04]) that can be strengthened by using game design patterns but game design patterns are not limited to these methods. However, a common set of concepts, such as game design patterns, offers valuable support for making such modifications of methods. The use of patterns described in this chapter can, and in most cases should, be combined and tailored for specific real world uses.

Target users are not specified for these uses because they can be applied in many contexts, for example, identifying patterns in a game may be used by critics writing reviews or gamers making decisions about purchases. However, we stress that game design patterns are beneficial to multidisciplinary groups as they ease communication by providing neutral definitions based on interaction in games, and they are not based on any professional jargon found in a specific research field.

The implementation of game design patterns can be roughly divided into two different categories: analysis and design. Analysis requires an existing game—or a prototype or a design document describing a game—so one can study what game design patterns exist within the game. Design can refer to the creation of an idea, concept, or description of a game by using game design patterns, or of formalizing a game idea or concept into a more structured description.

ANALYSIS: IDENTIFYING GAME DESIGN PATTERNS

Analyzing entails identifying game design patterns in games, game prototypes, or design documents. Finding game design patterns in games or game prototypes can be done by test playing the game, either doing it oneself or through observing others. With design documents, this is not possible, but by analyzing the descriptions of the games, it is possible to make a structural analysis to identify game design patterns in the game. Although not all game design patterns are easily identifiable by structural analysis, and for many, the certainty of their existence during gameplay cannot be guaranteed, it is usually quicker and more ordered than play testing. This is because play testing causes a conflict of interest between studying the game design and trying to play the game when doing it oneself, and from the vast amount of data generated when observing others.

Structural analysis cannot only be made from design documents but also from static descriptions in games and prototypes, such as instruction manuals or code. This flexibility allows for play testing and structural analysis to be combined to perform more efficient and reliable examinations. For example, one can first make a quick structural analysis of a game to determine the easily identifiable game design patterns then observe people playing the game to confirm these game design patterns and identify new game design patterns. A second round of structural analysis can then be performed to understand how the identified game design patterns relate to each other, possibly through previously unidentified game design patterns.

For categorization purposes, game design pattern analysis of collections of games can be performed to allow them to be sorted by their similarities or differences. Besides offering a multitude of dimensions for measuring how games compare to one another, collections of patterns can be used to identify or understand genres.

Identifying patterns in a game design can be beneficial from a business perspective, because it helps in analyzing the products of competitors.

Structural Analysis

The aim of structural analysis is to understand what patterns exist in a game design without actually playing the game, regardless of whether the game design is expressed through an actual game, a prototype, or a design document. Many game design patterns are formed around concepts already existing in gamer and game designer communities. Making a quick sweep through a game design to find these well-known concepts and matching them against game design patterns is an efficient way of getting an initial understanding of the game.

From an initial set of game design patterns, one can then expand the set through many different methods, but two more structured ways are based upon

using either the component framework or the relationship lists of the initial set. Using the component framework described in Chapter 2 allows the initial set of identified game design patterns to be placed on a treelike structure. By focusing on each branch of the tree in turn, the analysis will have considered holistic, boundary, temporal, and structural game components and the different subcategories of these. The relationship lists of the initial set can be used to identify additional game design patterns simply by systematically going through the patterns mentioned in the lists and by considering whether they appear in the game design.

When no further game patterns can be identified in a design, the structural analysis of the game design can be considered concluded, or the appearance of similar patterns in different parts of gameplay can be examined to try and identify potential design decisions above the game design pattern level. The robustness of the analysis can also be tried at this stage by seeing if there are any isolated groups of patterns that are not interrelated to other patterns.

> **Example:** The analysis of *Pac-Man* in Chapter 2 provides a basic understanding of the game. For a more detailed description, the analysis can be expanded by identifying game design patterns in each category and then identifying subpatterns and how all patterns in the game relate to each other. The existing analysis gives many game design patterns to start with: the holistic category gives *Lives*, *High Score List*, and *Meta Games*; the boundary category gives goals of *Collection*, *Levels*, and *Role Reversal* (through the power pill); the temporal category gives *Time Limit*, *Movement*, *Geometric Rewards for Investments* (regarding the number of captured ghosts); and the structural category gives *Enemies*, *Power-Ups*, and *Inaccessible Areas*.

Play Testing

Play testing can aid in identifying game design patterns as they appear in gameplay. The primary advantage of this type of analysis is that it can detect unintentional and emergent game design patterns that structural analysis has problems detecting. The negative aspect of play testing is that it makes focusing on particular areas of gameplay more difficult without ruining the gameplay and risks totally missing game design patterns depending on what composition of players one has. This can partially be mitigated by having the people doing the analysis also play the game, but this divides their intentions and may prevent the fully intended gameplay to take place and may lessen players' immersion in the game.

Play testing requires additional tools and material to be used while the game is being played so that the play sessions can be recorded. To create fully normal play

sessions, these have to be set up so that they do not disturb the players, and the people doing the observations need to be unobservable or ignorable by the players. Many of the methods used for understanding user behavior in human-computer interaction and interaction design can, with minor changes, be used to study people playing games (see for example [Preece02]).

Analyzing the material collected from play sessions typically takes a significantly longer time than the actual sessions. Understanding the reactions or reasoning of players, or their social interaction, can be particularly difficult and take a long time. Questioning or interviewing players after the play sessions can help but may not be completely accurate since their answers are interpretations of how they perceived their own actions.

> **Example:** Many of the more abstract design goals of games, for example player balance and emotional responses, are impossible to predict without play testing. If the results of play testing are used to identify game design patterns, for example the presence or absence of *Illusion of Influence* and *Perceived Chance to Succeed*, the knowledge contained in the pattern descriptions can be used to adjust the game design to the intended gameplay. This can become easier if the more abstract design goals have been described as game design patterns also, for example, that the game should have *Tension* in the *Social Interaction* and *Player Constructed Worlds*.

DESIGN: APPLYING GAME DESIGN PATTERNS

Implementing patterns in game design allows the designer to control what will occur in the game. Unlike previous uses of patterns in other fields, our patterns are not primarily a problem-solving method. Instead, the patterns and the component framework are generic tools. Game design patterns are useful for several potential user groups who have inherently different working methods. Not only can the patterns be used more often if more groups can use them, but communication between those groups becomes easier and thereby cross-disciplinary work.

Some may object that the use of patterns takes the creativity out of game design or renders the designers into "mere pattern cranking machines" that automatically churn out games. Another fear is that the use of patterns will lead to a situation where all games follow the same pattern and fall into stereotypes where nothing new is or can be created. Such potential objections stem from confusing the everyday meaning of patterns as something repetitive with the main idea of design patterns as introduced by Alexander et al., in which design patterns can be considered hypotheses, and collections of patterns can be considered a language that can, and should, evolve over time. In one sense, the choice of the term *pattern* might be re-

garded as a mistake, but as the term has clear and firmly established meaning in professional fields, e.g., in computer programming for example, it is unnecessary to invent new terminology, something that would indeed lessen the usefulness of the pattern concept as a tool to overcome communication difficulties in various professions. A more appropriate view on the use of patterns is to compare it to artistic endeavor in general: artists have a much better chance to create something novel when they are, though not necessarily consciously, familiar with the works of other artists. Not only can they position their own work within a community of peers, but they can also be more certain when they are innovating and creating something novel.

Game design patterns support design in four main ways: idea generation, structured development of game concepts, communication between members in design groups or projects, and solving design problems regarding gameplay.

Idea Generation

Somewhat paradoxically, the game industry has become what can be called conservative, due to the economically successful model of sequels and branding. The unwillingness to go beyond existing frames is found not only in thematic and gameplay styles but also in the limited use of mediums or hardware platforms. We believe that the use of patterns can help the exploration of new types of games, as they can provide a structured way of detecting how gameplay changes with changes in gameplay environments. This is especially likely for novel game mediums such as games on mobile phones or pervasive gaming, which are developments of computer games but need to function in social conditions similar to those in which more traditional games are played.

Game design patterns can help idea generation both in unstructured or structured ways. Simply choosing a set of patterns randomly and trying to imagine a game using them is one unstructured way of generating ideas; the use of patterns in brainstorming is a bit more structured and precise than traditional brainstorming. Patterns give descriptions of recurrent features in game design and sometimes the target for brainstorming is how to break, modify, or add to the patterns. A more structured approach is possible when one knows that some specific game design patterns, or gameplay that is related to some specific game design patterns, should be part of a game design. In these cases, game designers can study individual game design patterns to try to implement the patterns in ways that are different from the ones in the examples studied.

> **Example:** Assume generating ideas from three random patterns, for example, *Last Man Standing*, *Shared Resources*, and *Safe Havens*. The first pattern gives several associated patterns, but one, *Dynamic Alliances*, is close to the

pattern *Alliances* that is modulated by *Shared Resources*. This sparks the idea of having all players cooperate against a common enemy and although they cannot kill each other directly, they can make it more difficult for other players to survive by depleting the *Shared Resources*. Looking at the related patterns to *Resources* in general, it becomes apparent that either *Non-Renewable Resources* or *Limited Resources* should also be used. *Safe Havens* also mention *Dynamic Alliances* in the context of providing safe areas to negotiate, but if the places with *Shared Resources* are also *Safe Havens*, this would promote players to gather there when under attack and also to probably restock on *Shared Resources*. The game designer can then expand this basic game idea by defining what *Enemies* the players have, how they can fight them, and what the end and winning conditions are for the game.

Development of Game Concepts

Once an initial game concept exists, game design patterns can be used to develop and structure it. By first describing the concept as a small set of patterns, it can then gradually be fleshed out, and more specific design choices can be made as to how to instantiate those patterns through subpatterns and how the different design patterns interact. The process can be iteratively refined by examining the chosen subpatterns until the preferred level of detail is achieved. A form of stress testing can then be performed by picking random patterns not included in the game design to see if they do not provide the intended gameplay, if they make the game too complex, or if they have been overlooked.

Example: Assuming that one is to design a team-based FPS, the game design patterns *Team Play*, *Cooperation*, *Aim & Shoot*, and *First-Person View* give natural starting points to think about the gameplay in such a game: by looking at *Team Play* a game designer can see that *Shared Rewards*, *Shared Penalties*, *Asymmetric Abilities*, and other patterns can affect how team play actually occurs in the game; *Cooperation* points to the potential use of *Collaborative Actions*, *Delayed Reciprocity*, and *Social Dilemmas*; *Aim & Shoot* unsurprisingly can be used together with *Eliminate* goals but can also be used to create *Capture* or *Delivery* goals, and can be made more difficult through *Obstacles*; finally, *First-Person View* points out that this pattern gives players the limited overview known as *Fog of War* and can be modulated by *Status Indicators*. Ideas for specific game design choices may be inspired by looking at the presence of some patterns in several of the initial patterns. The presence of *Extended Actions* and *Collaborative Actions* can, for example, give the idea of splitting *Aim & Shoot* into two actions so that

one player has to aim for a certain period of time while another player does the actual shooting.

Problem Solving

Game design patterns contain information about how games have achieved certain types of interaction within gameplay. This information can be used by game designers who know they want a specific type of interaction by identifying the correct game design patterns and seeing what possibilities for instantiating them exist in the designer's current work. This can be done by inserting new patterns that have the instantiates relation to the wanted pattern, by modifying existing patterns that have instantiated by or modulated by relations to the wanted pattern, or by introducing a pattern from scratch.

The same approach can be used to remove unintended or unwanted interaction from games. Once this interaction has been identified, game designers can identify the corresponding pattern and see what typically causes it to occur. The game design can then be analyzed to see which of these causes exists, and the design can be changed to eliminate them.

> **Example:** Assume that a team-based game with strong elements of *Conflict* does not have enough *Tension*. Going through the many patterns that instantiate *Tension*, the game designer notes that *Betrayal* is not used. Examining the *Betrayal* pattern, the game designer notices that it not only increases tension but (naturally) *Conflict*, which is in line with the general gameplay. However, the game does not give any motivation to betray one's own team, so the designer introduces a possibility of one team giving *Individual Rewards* to a player on the other team if that player agrees to a *Committed Goal*. This is a form of *Negotiation*, which is difficult to perform in a game where the teams are in permanent *Conflict*, so the game designer introduces *Safe Havens* where players cannot attack each other. Based upon this addition, the original game design needs to be reexamined, especially the consequences of adding *Safe Havens*: not only are they *Strategic Locations* and points to go when conducting negotiation but also points to guard against possible betrayers.

Communication

Using patterns to describe a game offers advantages when presenting the game design to people. Besides allowing a structured description of the design, motivations for particular design choices (described as patterns) can be made in two ways: by relating the choices to other games using the same patterns or by describing how

replacing the pattern with other patterns would change the gameplay. This advantage is increased if people already have been introduced to design patterns from previous game designs as they can more easily compare the designs.

In contrast to common sense concepts, game design patterns offer a way to check a static definition whenever there is uncertainty. The definitions do not have to be those found in this book: definitions may be made more specific for particular projects or written completely from scratch.

Improved communication can help the design and creation of games on many levels: initial ideas, design concepts, and design documents can be more clearly expressed; members working on the same part of a game design have a smaller risk of misunderstanding each other; members within the same project can more easily communicate with people that have different backgrounds and professions; the agreement between developers and distributors can become more exact on what should be developed; and comparing the final game with the initial description is easier.

> **Example:** Game design patterns can allow producers to more specifically describe what game they intend to make, for example "an FPS where we increase the *Tension* by not having *Safe Havens* and only allowing saving at specific *Save Points*." This also makes it easier to verify that the game design contains agreed game features, since they are more explicitly described.

CONCLUSION

In this chapter, we have presented several ways of using game design patterns. For analytic use, we have described how game design patterns can be identified through structural analysis or play testing. For use in game design, we have described how game design patterns can support the design process by supporting idea generation, structuring the development of game concepts, providing solutions for problem solving, and aiding communication.

REFERENCES

[Adams03] Adams, Ernest and Andrew Rollings. *Andrew Rollings and Ernest Adams on Game Design*. New Riders Publishing, 2003.

[Church99] Church, Doug. "Formal Abstract Design Tools." *Game Developer Magazine* (August 1999). (Also available online at *http://www.gamasutra.com/features/19990716/design_tools_01.htm*.)

[Costikyan94] Costikyan, Greg. "I Have No Words and I Must Design." *Interactive Fantasy 2*. Hogshead Publishing, 1994. (Also available online at *http://www.costik.com/nowords.html.*)

[Falstein02] Falstein, Noah. "Better by Design: The 400 Project." *Game Developer Magazine* (March 2002).

[Fullerton04] Fullerton, Tracy, Christopher Swain, and Steven Hoffman. *Game Design Workshop: Designing, Prototyping, and Playtesting Games*. CMP Books, 2004.

[Preece02] Preece, Jenny, Helen Sharp, and Yvonne Rogers. *Interaction Design: Beyond Human-Computer Interaction*. John Wiley and Sons Ltd., 2002.

Part II

The Pattern Collection

P art II of the book contains the collection of game design patterns. The patterns have been collected in chapters that in general identify their relationship to the structural framework. The following sections provide information on how the patterns have been collected, so you may better understand the pattern collection.

DEVELOPMENT OF OUR PATTERN COLLECTION

To gather the material that is the basis for our collection, several different methods and techniques were employed. The following sections provide a short summary of the various methods used as well as the reasoning behind the choice of methods.

Theoretical Foundation

Most research to date has studied games using terms and concepts from narrative fields such as literature, theater, and film. The resulting focus on narrative has neglected the elements of interaction that is a much more defining characteristic of games than their narrative structures. This emphasis on narrative may have resulted in the limited success of such academic results being adapted by the game industry or other research disciplines interested in games. To avoid this, here is an attempt to find a basis for a game language centered on interaction rather than narratology. Interaction in this context includes both the interaction between players playing a game and the interaction between players and the game.

Transforming Game Mechanics into Game Design Patterns

Given the initial conceptual framework, the first pattern candidates were gathered by examining game mechanics and converting them to patterns. This included discarding a number of mechanics, merging some mechanics into one pattern, and identifying more abstract or more specific patterns from already identified patterns.

Harvesting Patterns by Analyzing Games

The second approach used to create an initial pattern collection was to conduct "brute force" analysis of existing games, concepts and design methods of other fields (such as architecture, software engineering, evolutionary biology, mathematics, and interaction design), and to extrapolate possible person-to-person and person-to-environment interactions from the fields of sociology, social psychology, psychology, and cognitive science. The method for harvesting patterns consists of five iterative steps: recognize, analyze, describe, test, and evaluate. The recognition phase creates a quick pattern candidate collection around a certain idea or interaction area. The next step is to analyze the collection by describing how the pattern is used in a few illustrative games and then try to remove the pattern from the games and explain how it would change gameplay. The pattern is then described using the developed pattern template. The description is tested by creating a simple prototype game using the pattern and finally the pattern is evaluated by applying the usefulness and sufficiency of the description as criteria. As the work progressed, the five-step method was transformed to a dynamic, recursive one where pattern fusion, mutation, and creation of new candidates was possible at almost every stage. The different phases, however, were still used but not in a strict sequence. The result was over 200 pattern candidates together with unexplored but promising areas of interaction.

Interviews

In order to collect information about how game development uses game concepts, nine professional game designers were interviewed that together represented designers from the full spectrum of game mediums. All used the terms genre, theme, and mechanisms casually; these were clearly concepts they were very familiar with. However, they didn't mention very many mechanics by name (perhaps because there are no standardized names and no collection). The typical exceptions (from board and card game developers) were *Bluff*, *Tension*, *Action Cards*, *Storytelling*, *Trading*, *Action Points*, and *Cooperation*. Some of the designers were themselves interested in creating structured frameworks for games, and several of them were already aware of design pattern methodologies.

Creating the Pattern Collection

One of the problems of creating a design pattern is determining exactly how much unique information is required for a concept to be a pattern in its own right and not just a variant or example mentioned in another (superior) pattern. This book favors an inclusive approach and uses an evolutionary refinement process based on use and feedback from researchers and designers to improve the collection. One result

of such a process is the choice to have a slightly weak superior pattern if it has several clear and useful subpatterns, and to have an insignificant pattern as a separate pattern if it has more than one superior pattern, in order to show the relationships more clearly.

Comments on the Pattern Collection

The pattern collection presented in this book is of course influenced by the knowledge of the authors and the knowledge of those researchers and practitioners consulted while collecting the patterns. The following sections briefly point out some basic principles that were followed when creating the collection.

OMITTED PATTERNS Some potential patterns have been omitted since their presence has been very limited in contemporary game design and is likely to remain so. For example, the methods of intervention and custodianship to capture have been used in traditional board games but do not seem to have been transferred to computer games, nor modern board games, in any greater extent.

NAMING CONVENTIONS The names of the game design patterns are intended to be evocative and easy to remember. Many are intuitive, since they have the same names as well-known concepts and terms in the gaming community, but for others, *idiomatic* names are provided, i.e., names that are easy to remember once one has read the definition of the pattern. In cases where patterns were adapted from concepts in other research fields, the field-specific terminology has been maintained to provide a link to the field.

USE OF NAMES References to patterns are set in *italic* in all pattern descriptions to signify their presence. The plural form is used in all cases except where it would be misleading, e.g., new ability instead of new abilities. However, the pattern name is sometimes used in other ways where it would otherwise make the flow of the text difficult, including varying between using the name of a game design pattern as a noun and as a verb.

Note that the use of the term *player* in the collection does not equal a human being; player as defined in the component framework is an entity in the game that can be perceived as having its own goals for playing the game. This means that a player can be a human being or a process controlled by a computer (see the *Agents* pattern). Due to the widespread use of player and avatar, the player's representation in the game world, as synonyms, there are some cases that use concepts that are inconsistent with the framework and pattern definition. For example, the commonly used term of *Player Killing* is used instead of the more correct *Avatar Killing*.

USE OF LISTED RELATIONSHIPS Nearly all patterns can in some form or another be related to every other pattern, but the indications of relationships have been limited to only those relations that are very common and that point to strong, direct consequences.

USE OF REFERENCES In order to make the text as easily readable as possible, the use of references has been reserved for cases where patterns have been based explicitly on the previous work of others, in most cases specifically related to games.

DIVISION OF THE COLLECTION INTO CHAPTERS To make searching the collection easier, the collection is divided into chapters. These chapters are based largely upon the component framework. Chapters 5, 6, and 7 focus upon structural part of games by looking at specific game elements, on the ways in which game elements are produced and consumed during gameplay, and on what information exists about them. Chapters 8, 9, and 10 look at patterns dealing with temporal aspects by focusing on actions, narrative structures, and social interaction, respectively. Chapters 11 and 12 examine patterns regarding boundaries in games by looking at goals and goal structures. Finally, Chapters 13, 14, and 15 contain patterns that relate to how games interact with other games or activities, with focus upon game sessions, game mastery, and meta games.

5 Game Design Patterns for Game Elements

These patterns relate to those components of a game that are objects players can manipulate and that have characteristics used to define the area of the game reality.

Game Worlds: *Game World, Reconfigurable Game World, Levels, Inaccessible Areas, Consistent Reality Logic, Alternative Reality, Moveable Tiles*

Objects: *Enemies, Boss Monsters, Deadly Traps, Obstacles, Avatars, Units, Tools, Controllers, Alarms, Pick-Ups, Power-Ups, Clues, Extra-Game Information, Invisible Walls, God's Finger, Mule, Buttons, Helpers, Traces, Resource Generators, Tiles, Dice, Cards, Card Hands, Drawing Stacks, Discard Piles*

Abstract Objects: *Score, High Score Lists, Lives, Parallel Lives, Cameras, Ghosts, Book-Keeping Tokens*

Locations: *Strategic Locations, Outstanding Features, Chargers, Resource Locations, Goal Points, Save Points, Spawn Points, Safe Havens*

GAME WORLDS

These patterns relate to the parts of the game that define the context of gameplay. This includes dividing the context into separate parts as well as defining specific characteristics of the game environment.

Game World

The environment in which the gameplay or parts of the gameplay takes place is determined by the spatial relationships of the game elements.

Usually games have a *Game World* in which the spatial relationships of game elements are important, for example, the actual game board in *Monopoly*. There are other elements where the spatial relationships are not important as long as categories can

55

be identified, for example, the amount of money each player has in *Monopoly*. The strict definition adopted here requires that the elements in the *Game World* have spatial relationships that define and constrain the possible movements within the *Game World*. As already stated, many games have both the spatial *Game World* and other elements that have a possible impact on the *Game World* but that do not have spatial relationships. The *Game World* is usually limited and contained, but some games, for example, *Five-in-a-Row*, have a potentially infinite *Game World*.

Game Worlds can be classified first into continuous and discrete. The movement for the player in a continuous *Game World* is at least seemingly fluid and continuous, and in discrete *Game Worlds*, the movement happens in larger steps. This classification is not clear cut, as it can be argued that every computer *Game World* is, in fact, discrete, as the positions and the environment are expressed in digital format. The second categorization concerns the main spatial relationships between the game elements. These basic categories are: linear (or 1D), reticular, 2D and 3D. These categories are orthogonal to the continuous and discrete categorization so that there are eight basic categories (even though the reticular-continuous category is slightly troublesome). Linear *Game Worlds* are those in which the movement can happen only in one or two directions. For example, *Backgammon* and *Ludo* have linear *Game Worlds*. The movement in reticular *Game Worlds* can happen only between connected nodes in a graph. The arrangement of different territories in *Diplomacy*, *Hearts of Iron*, and many other strategy games is a good example of a reticular *Game World*. The 2D *Game World* is just what it says: the movement is limited to a two-dimensional plane. *Chess's* board and *Pac-Man's* levels are good examples of 2D *Game Worlds*. The last category, 3D, is as straightforward as the previous one: the movement is more or less free in all the three dimensions. Note here that the main classification is based on how the movement, and not only player movement, is limited in the world and not on the graphical representation of the world. This means that, for example, a computer *Chess* with splendidly rendered 3D graphics still has a 2D *Game World*.

> **Example:** Even though the view to the world was in 3D, the *Game World* of *Wolfenstein 3D* still remained two-dimensional [Kent01].

USING THE PATTERN The defining features of a *Game World* are the spatial relationships between the game elements, which determine what kinds of *Movement* actions are possible in the game (see *Levels* for details on possible game elements). A designer must first determine if there is a need for the *Game World* and then decide based on the desired basic *Movement* actions which kind of game worlds would suit the gameplay the best. Another basic decision concerning *Game Worlds* is how players should experience them: concretely through *First-Person Views* and *Third-Person Views* or abstractly through *Storytelling*.

Populating the *Game World* with game elements can be continuous or can be done before gameplay begins. Players' perceptions of the *Game World* will be

strongly affected by the presence of any known *Strategic Locations* due to the placement of these types of game elements. Continuous introduction of game elements requires *Resource Generators* or *Spawn Points*, or players may create them, by *Construction* or by acting as *Producers*. Other common game elements in *Game Worlds* include *Resources*, *Obstacles*, *Inaccessible Areas*, *Enemies*, *Deadly Traps*, *Helpers*, and *Goal Points*. Besides player actions, the effects of *Producers* and *Converters* can change not only the game elements in the *Game World* but aspects of the *Game World* itself. The presence of game elements, and *Strategic Locations* due to geographical features in the *Game World*, significantly affects *Player Balance* and decides which locations are suitable for specific actions such as *Camping*.

In addition to game elements, the appearance of the *Game World* can be modulated by *Outstanding Features*. These can either point to the presence of game elements or simply give reference points to players and thereby support *Game World Navigation*. *Area Control* does not change the appearance of the *Game World* but changes how players can perform actions within the *Game World*.

The *Game World* can be constructed so that players have either a full overview through a *God View* or have a partial overview using *Fog of War*, *Game State Overview*, and varying abilities of *Avatars* and *Units*. The concrete difference here is whether players are able to view the whole game world at once. The presence of *Easter Eggs* and *Secret Resources* can encourage *Exploration* when players do not have a complete overview of the *Game World*. The spatial characteristics of a *Game World* can be further specified by designing it to be open or closed. An open game world can be expanded during gameplay, potentially infinitely or through creating spatial cycles, while a closed one has a predefined maximum size.

Game Worlds can be constructed to appear continuous or made out of *Tiles*, possibly through *Tile-Laying*. Besides this decision of how the *Game World* should be perceived on a fine level of granularity, the game world can be partitioned into different areas, *Levels*, on a higher level of granularity. The *Levels* make the rest of the *Game World* into *Inaccessible Areas*, and this can be used to guarantee different modes of play or to maintain a *Narrative Structure*. *Game Worlds* can be predetermined by the designer or constructed by the players by using a *Reconfigurable Game World*. In both cases, the designer has to first figure out the basic building blocks of the *Game World*, even when the world is continuous. The granularity or size of a *Game World* can be modulated during gameplay through *Dedicated Game Facilitators*. Especially *Game Masters*, who can provide *Storytelling*, can provide additional information such as the history of the *Game World* or facts that are not quantified in the game system. In *Player Constructed Worlds* and *Roleplaying*, players can do actions similar to *Game Masters* and provide a way to create a stable form of *Never Ending Stories*.

Game Worlds can evolve in several different ways. Besides the effect of players' actions on game elements, *Storytelling* and *Ultra-Powerful Events* such as *Shrinking Game Worlds* can change the environment during gameplay.

CONSEQUENCES *Game Worlds* give players an *Alternative Reality* in which they can experience *Immersion* through *Spatial Immersion*, especially in games with *First-Person Views*. The *Game World* limits the area on which players have to focus and also often very intuitively limits the possible movement actions, creating a basis for *Consistent Reality Logic*. Specifically, the activities outside the *Game World* related to the game should in these cases only concern administrative tasks (distributing resources, converting "money," moving score markers, etc.) and performing activities required by the mechanics of the game (e.g., rolling dice).

Not all games have a *Game World*. In *Paper-Rock-Scissors* there is no need for a *Game World* while most of the card games do not have meaningful spatial relationships between the cards that would determine possible *Movement* actions.

RELATIONS

Instantiates: *Consistent Reality Logic, Immersion, Spatial Immersion, Exploration*

Modulates: *Roleplaying, Player Balance, Camping*

Instantiated by: *Tiles, Reconfigurable Game World, Levels*

Modulated by: *Alternative Reality, God Views, Fog of War, Game State Overview, Movement, Inaccessible Areas, Tile-Laying, Game Masters, Storytelling, Never Ending Stories, Player Constructed Worlds, Dedicated Game Facilitators, Converters, Easter Eggs, Secret Resources, Obstacles, Deadly Traps, Resource Generators, Producers, Construction, Inaccessible Areas, Enemies, Converters, Resources, Goal Points, Spawn Points, Helpers, Strategic Locations, Outstanding Features, Area Control, First-Person Views, Third-Person Views, Shrinking Game World*

Potentially Conflicting with: None

REFERENCES

[Kent01] Kent, S.L. *The Ultimate History of Video Games*. Prima Publishing, 2001.
[Parlett99], Parlett, D. *The Oxford History of Board Games*. Oxford University Press, 1999.

Reconfigurable Game World

The player can reconfigure the game world itself, including the basic relationships and attributes of the game elements and the rules governing the dynamics of these relationships.

The reconfiguration may happen between game instances to create variation from instance to instance or within a game instance as part of the events and actions the players have to consider. Three main ways of reconfiguring the *Game World* are possible: changing the spatial setting, modifying basic attributes of the game elements, and modifying the rules and equations that govern the changes in game element relationships. The last one, modifying the rules of the game, usually concerns changes of the rules, which resemble the laws of nature in the *Game World*, such as making changes to the gravitational pull in flight simulators.

> **Example:** The board game *Space Hulk* contains a number of corridors and rooms that are set up in different configurations to allow a number of different scenarios.

> **Example:** The mods that can be added in different combinations to *Unreal Tournament* allow the players to select how the laws of nature function in particular game instances.

> **Example:** Games that allow the players to select different difficulty levels for each game instance.

USING THE PATTERN The first requirement is that the game have a *Game World* that can be configured. The next main design choice is whether the world will be reconfigurable between or within game instances, or in a combination of both. In some cases, the reconfigurations might be different for different players, for example, the more inexperienced players in strategy games can be given *Handicaps* by having units with better attack and defense powers than the opponents. The third design choice is if the reconfiguration is done by game rules or if the *Game World* is a *Player Constructed World*.

Reconfiguration of the *Game World* itself is often done using *Tiles* to define the *Game World* and then letting the players perform *Tile-Laying* either during the setup phase of the game or during the gameplay itself. The *Tile-Laying* can also be accompanied with the use of player controlled *Moveable Tiles*. The use of a *Reconfigurable Game World* is usually combined with flexible game element setup to speed up the initial gameplay and to provide possibilities for skillful setups.

The changes in the laws of nature within the game may be universal or applied to only certain game elements, e.g., those under the control of the players or of a particular player. This can be used as a player-decided *Balancing Effect* to create *Player Balance* or *Right Level of Difficulty*. For example, changing the difficulty level in a flight simulator can change the flight characteristics of the planes drastically. Changing the relative strengths and weaknesses of different *Units* of the game, such as modifying attack and defense strengths in strategy games, is another common way to allow *Reconfigurable Game Worlds*.

CONSEQUENCES A *Reconfigurable Game World* provides *Varied Gameplay* and *Replayability* as the *Game World* changes for each game instance but may lessen *Immersion* as players act both within and outside the *Consistent Reality Logic* of the game. Games with *Reconfigurable Game Worlds* that have *Strategic Locations* and temporarily let players observe the layout of the world support *Memorizing*, but it may prove to be difficult to have *Right Level of Difficulty* in the game.

RELATIONS

> **Instantiates:** *Game World, Varied Gameplay, Replayability, Handicaps, Memorizing*
>
> **Modulates:** *Player Balance, Right Level of Difficulty*
>
> **Instantiated by:** *Tiles, Tile-Laying, Player Constructed Worlds*
>
> **Modulated by:** *Moveable Tiles*
>
> **Potentially Conflicting with:** *Immersion, Right Level of Difficulty*

Levels

A Level is a part of the game in which all player actions take place until a certain goal has been reached or an end condition has been fulfilled.

The difference between *Levels* in a game may be in content, aesthetics, or a combination of both. Commonly used differences between levels in early arcade games, such as *Missile Command*, are different color themes and speed of enemy units, thereby creating different levels of difficulty. By contrast, most of the current first-person shooters and real-time strategy games have new environments to be explored in each level, i.e., each level presents new enemies and puzzles for the player. In some games, the levels can also have different primary activities the player has to perform repetitively.

> **Example:** In *Marble Madness*, the player has to guide a ball from the start of a level to the goal. Each level has different obstacles and routes to reach the goal and has different color themes.
>
> **Example:** Each level in *Asteroids* contains a certain number of asteroids, and the player can progress to the next level after shooting all of them. The higher levels get more difficult, as the asteroids become faster and more numerous.

USING THE PATTERN To implement levels in a game, the designer must decide how many levels the game should contain and how they differ and relate to each other.

In order to be perceived as part of the same game, the levels should adhere to the general *Consistent Reality Logic* of the game but typically with at least some local variation.

One way to differentiate levels is to change the theme from level to level. As the change from one level to another typically signifies a change from one location to another, this can be used as a means to change theme, for example, from forest to cave or from railway station to factory. The theme can then be used to set the boundaries for the *Consistent Reality Logic*, so that only game elements that fit the theme are used within the level.

Another way to differentiate between levels is by changing the end conditions and the primary activities of the players. Having different types of goals that require different fields of expertise in each level (see the patterns concerning goals and game mastery) guarantees *Varied Gameplay* and includes the possibility of having *Unknown Goals* as the player progresses from level to level.

The combination of theme, end condition, and primary activities sets the boundaries for what actual game elements should be used in a given level. The use of game elements such as *Resource Locations, Save Points, Clues, Helpers, Controllers, Resource Generators, Obstacles, Enemies, Boss Monsters*, and the spatial relationships between them, can then be used to provide additional *Varied Gameplay* and *Surprises. Spawn Points* for the player *Avatars* are especially important as they determine the players' starting conditions and can be used to create *Tension* or *Time Limit* if this is in line with the theme or the primary activities of the level.

The spatial construction of a level affects how players are made aware of the existence of possibly selectable further levels and how to reach them. Being able to directly observe the other levels through *Invisible Walls* or *Inaccessible Areas* is an obvious way to do this, but *Game State Overview* as well as *Clues* and *Helpers* can also be used. The latter option is in some cases easier to fit within the *Consistent Reality Logic* of the game.

The completion of a level in most of the currently popular genres consists of achieving a *Traverse* goal by moving through the level from the start point to the *Goal Point*. Reaching this goal is often symbolized by the activation of a *Controller*, such as opening the main door to the next level, or by defeating a *Boss Monster*.

Levels can be used to support *Smooth Learning Curves* and *Right Level of Difficulty* by making the initial levels small, or easy in other ways, to complete. Completing these initial levels, the players should get familiar with using the interface and with the primary activities of the game, making it possible at the later levels to concentrate more on achieving *Game Mastery*.

CONSEQUENCES The concept of *Levels* lets the game designer delimit the *Game World* and thereby the complexity of the game as well as giving players *Limited*

Foresight. Levels can also be used to progress the *Narrative Structure* in a controlled fashion through the use of *Closure Points* when changing *Levels* are *Irreversible Actions*. These progressions of the story in games are usually done by *Cut Scenes* between *Levels* but can also be done through the different events and game elements that occur in the new level.

The existence of a level assumes the existence of the next level or the completion of the game, providing explicit short-term *Exploration* goals for the players of finding the next level. The completion of a level thereby provides strong *Hovering Closures*, especially if *Save Points* only exist between the levels. The levels always create a *Hierarchy of Goals*, be it linear, as is the case with most shoot-'em-ups, or structured in a more elaborate way, as is done, for example, in the different worlds in *Super Mario 64*.

By being different both as to structure and gameplay, the levels can provide *Varied Gameplay* and *Surprises*. Each level also has the possibility to support *Exploration* goals, which may be extended to a larger scale if the players have a choice between the order in which to complete levels.

RELATIONS

Instantiates: *Exploration, Varied Gameplay, Game World, Consistent Reality Logic, Closure Points, Limited Foresight, Hovering Closures*

Modulates: *Surprises, Narrative Structures, Varied Gameplay, Game Mastery, Inaccessible Areas, Smooth Learning Curves, Right Level of Difficulty*

Instantiated by: None

Modulated by: *Save Points, Clues, Helpers, Resource Generators, Obstacles, Enemies, Boss Monsters, Spawn Points, Inaccessible Areas, Controllers, Irreversible Actions, Cut Scenes*

Potentially Conflicting with: None

Inaccessible Areas

Inaccessible Areas are parts of the Game World the player can perceive but cannot currently enter, such as areas behind locked doors or sufficiently high ledges.

Although the area is inaccessible for the player, it may be possible to view the area or affect it in ways other than through movement actions, for example, by shooting or throwing things at it, and the area may not be inaccessible to other types of game elements that are not under player control. It may be possible for the player to enter the area later in the game, for example, by finding the key to the locked door.

Example: The ghost generator in the middle of the *Pac-Man* level is an example of an area the player controlling Pac-Man cannot enter.

Example: Computer roleplaying games use *Inaccessible Areas* to guide the players through the *Game World* in a manner intended by the game designers.

Example: *The Legend of Zelda* series contains many areas that are initially blocked by boulders, locked doors, or other obstacles. The player can remove these obstacles after having acquired certain items or abilities, for example, by using bombs to blow away blocking boulders and special keys to open the locked doors.

USING THE PATTERN The primary design choice when creating *Inaccessible Areas* is to decide what is blocking the access. One of the most obvious uses is to place *Obstacles* in the *Game World* in such way that they block access to an area. Depending on the nature of the *Obstacles* actions other than movement can be blocked, such as vision. For example, deep chasms and great height differences can block the vision but still allow the player to shoot or throw other kinds of game elements at the obstacle. Windows and *Invisible Walls* do not block vision but can block all the access from other game elements. Locked or blocked doors block both vision and other types of game elements. The *Inaccessible Area* may also be inaccessible due to its own nature. For example, an area containing lava, water, or poisonous atmospheres can make it impossible or difficult for *Avatars* and *Units* to enter the area and can even make the whole area one big *Deadly Trap*. *Inaccessible Areas* can be used to create *Leaps of Faith* in which players have no perception of what part of an area is inaccessible because of a *Deadly Trap* and which part of an area is safe to enter.

The *Inaccessible Area* can in some cases be accessible for certain types of game elements, and the nature of these elements should comply with the *Consistent Reality Logic* of the game. For example, if water is used to block an area in a strategy game, it might follow that boat *Units* can enter the water area but other *Units* cannot. This is also an example how *Inaccessible Areas* together with *Privileged Movements* for certain game elements can have *Orthogonal Unit Differentiation*. This kind of unit design may also be used to create *Safe Havens*.

The *Inaccessible Area* may be the initial location of the game elements but may be inaccessible during the actual gameplay, making it a form of a *Safe Haven*. This is typically used in team-based first-person shooters where *Spawn Points* are placed so that players *Spawning* cannot be attacked directly at that location. By using *Privileged Movement*, these *Safe Havens* and *Resource Locations* may be accessible to only one team in the game, ensuring a minimal area of control to each team. Making initially *Inaccessible Areas* possible to enter after players have completed goals or

demonstrated competences in performing necessary actions is one way to create *Smooth Learning Curves*. This can promote *Replayability* of *Levels* during gameplay or *Replayability* on whole games if the *Inaccessible Areas* are part of *Optional Goals* or *Easter Eggs*.

The players' perception of an *Inaccessible Area* depends on the exact position of the players and their knowledge about current goals and dangers. For example, an area may be perceived as an *Inaccessible Area* when there is an *Enemy* guarding the route through the area or a player *Camping* in the area.

Consequences The main use of *Inaccessible Areas* is to make *Game Worlds* and *Levels* that are limited in size appear larger, thereby maintaining a *Consistent Reality Logic*. They restrict players' *Freedom of Choice* by imposing *Movement Limitations* on players and affect how players can conduct *Movement* to enact *Game World Navigation*.

Inaccessible Areas do not have to be areas in the actual *Game World* but simply provide players with an illusion that the *Game World* or *Level* is larger than it is. However, some *Inaccessible Areas* are true areas and can come into play. *Inaccessible Areas* that can be reached through solving subgoals may be used as *Traverse* goals. Used in this fashion, gaining access to these areas can be used to maintain the *Narrative Structure* of the game, especially in cases where the obstacle blocking the access clearly indicates the possibility for later gaining access to the area motivates the player. *Inaccessible Areas* can, however, also cause player frustration, especially in cases where it seems like a player can later access an area even though that's not the case. For example, having a locked door in an adventure game where there is no possibility for getting the right key will frustrate most players.

Relations

 Instantiates: *Consistent Reality Logic, Traverse*

 Modulates: *Game World, Levels, Spawn Points, Game World Navigation, Spawning, Camping, Leaps of Faith, Smooth Learning Curves, Movement*

 Instantiated by: *Obstacles, Invisible Walls, Movement Limitations*

 Modulated by: *Orthogonal Unit Differentiation, Privileged Movement, Safe Havens, Deadly Traps, Resource Locations, Levels, Replayability*

 Potentially Conflicting with: *Freedom of Choice*

Consistent Reality Logic

Consistent Reality Logic governs that the game elements, the player actions and their consequences, and the game events are consistent.

For a game to be consistent means, first, that there are no contradictions or irregularities in the functioning of the game. For example, if the player can blow up a crate, the player should also be able to blow up all other similar crates. Another, more fundamental, layer of consistency concerns the degree to which our intuitive and natural ways of being in the real world are transformed into the metaphors used in the game itself. This means that all games have an internal logic that mimics reality or at least relates to how we understand reality through categories and relations.

> **Example:** *The Sims*, one of the most popular computer games ever, takes some of the features of suburban life and blends them into a consistent totality. The play experience is intuitive, seamless, and fluid. This is partly because of a great user interface but also because the *Consistent Reality Logic* of *The Sims* is extremely well constructed. Even though the player actions do not always have a direct counterpart in the real world, the consequences are lifelike and consistent.

USING THE PATTERN The primary design challenge with creating *Consistent Reality Logic* is how to limit the *Game World*. The most common ways are to partition the *Game World* into *Levels*, to use *Inaccessible Areas*, and to make the world appear infinite in size by making movement off an "edge" of the *Game World* cause game elements to enter from the "other edge." *Invisible Walls* can serve the same purpose but are harder to explain within an *Alternative Reality*. The choice of how to limit the *Game World* through *Consistent Reality Logic* can be used to modulate how easy or difficult *Game World Navigation* is.

When dealing with the *Consistent Reality Logic* of the game, two levels of consistency have to be considered: the level of logical contradictions and irregularities between the game elements in the game and the level of how the *Game World* reflects the real world. The second layer is defined by carefully making the actions and their consequences and the game events consistent with both the internal logic of the game and, to some extent, with the fundamental features of the real world. As previously mentioned, this does not necessarily mean that they should simulate their real-word counterparts, but there should be some resemblance to how we as human beings act and perceive the world. For example, even though *Tetris* is an abstract game, the basic actions and events have their counterparts in real life. Moving and rotating objects—in this case, the falling blocks—are very fundamental actions in the real world. Changes in the game can nearly always be explained by real world equivalents: introduction of new game elements can be explained by *Construction*, and *New Abilities* can be explained through *Tools* or *Character Development*. Other changes such as *Ultra-Powerful Events* can be explained through *Storytelling* or unfolding of the *Narrative Structure* without breaking the reality logic, but such changes may require *Downtime* for players during the explanation.

The first layer of consistency, not having logical contradictions or irregularities in the game, is somewhat easier to deal with. When the basic actions, events, and game elements have been designed for a game, it is just a matter of going through these and checking that there are no outright contradictions in their behavior. For example, if some of the items can be picked up, it makes sense to make all items portable or to otherwise indicate clearly the difference between static and moveable items. *Alternative Reality* can also be used to mold the elements and actions according to the theme of the game.

The choice of *Focus Loci* easily affects the *Consistent Reality Logic*: *Avatars* and *Units* may maintain it while a controllable *Camera* or a *God's Finger* likely damages it.

CONSEQUENCES A *Consistent Reality Logic* in a game almost always creates a stronger sense of *Immersion* even without having realistic audiovisual representations of the game elements. Concentrating on *Consistent Reality Logic* at the expense of the graphical outlook of the *Game World* may promote *Cognitive Immersion* instead of *Emotional Immersion*, and may be more suitable for a particular game design. For example, it is doubtful that the experience of playing computer *Chess* would benefit from photorealistic and animated movement of the pieces; the outcome would probably be negative regarding gameplay. A sign of *Consistent Reality Logic* that is combined with *Emotional Immersion* in games is when players can have *Identification* with their *Enemies*.

Consistent Reality Logic also helps players get started. If the actions, events, rules, and especially the *Penalties* of the game are intuitive and have *Predictable Consequences*, i.e., they resemble the basic notions of how the reality works, it is much easier to learn the controls and the rules of the game, thus supporting *Smooth Learning Curves* and *Predictable Consequences*. This, of course, does not mean that the game should simulate the reality as accurately as possible; on the contrary, games are caricatures of reality, and as such, it is in most cases detrimental to the whole gameplay to make the simulation too real.

Common ways *Consistent Reality Logic* is challenged include: any kind of *Extra-Game Information*; the use of *Lives*, *Rewards*, or *Ability Losses* not motivated by what caused them within the *Game World*; *Spawning*, as this has few plausible real world explanations; and *Easter Eggs*, which provide *Extra-Game Consequences* or *Games within Games*. *Clues*, *Indirect Information*, and *Game Pauses* that are not designed in such a way that they function within the *Alternative Reality* of the game also negatively affect *Consistent Reality Logic*.

RELATIONS

Instantiates: *Smooth Learning Curves, Immersion, Emotional Immersion, Cognitive Immersion, Predictable Consequences*

Modulates: *Game World Navigation, Penalties, Game Pauses, Indirect Information*

Instantiated by: *Game World, Inaccessible Areas, Levels, Symmetry, Alternative Reality, Construction*

Modulated by: *Focus Loci, Avatars, Units, Games within Games, Improved Abilities, Character Development, Tools, Ultra-Powerful Events, Narrative Structures, Storytelling, Identification, Downtime*

Potentially Conflicting with: *Invisible Walls, God's Finger, Cameras, Clues, Rewards, Ability Losses, Spawning, Easter Eggs, Extra-Game Information, Lives, New Abilities*

Alternative Reality

The game is described as taking place in an alternative reality in order to justify and motivate game elements, possible actions, and rules that contradict the ordinary laws of nature or the usual rules of social conduct.

All games taking place in fantasy and science fiction settings make use of this pattern, but the pattern is also used in games taking place in alternative histories. Some forms of live-action roleplaying games take place in a historical setting and, although it is an alternative reality, the participants try to make the *Game World* as similar as possible to the known facts about that historical period. Even though it can be argued that every game takes place in an alternative reality, which is defined and bound by the rules of the game, this pattern is mainly concerned with making the theme and the function of the *Game World* seem lifelike.

> **Example:** *Medieval: Total War* is a strategy game set in the power struggles of medieval Europe and as such can be classified as an alternative history game. The game contains huge amounts of references to historical facts, such as political events and real people. The tactical part of the game allows the player to control seemingly realistic troops in a fluid three-dimensional environment.

USING THE PATTERN Using the *Alternative Reality* pattern mainly concerns describing and explaining to the players the theme and setting of the game. When properly done, this makes non-intuitive parts of a game, for example explaining *Construction* in most games or *New Abilities* through *Rewards*, easy to understand and remember. If the actions and events in games are to be tied to the *Alternative Reality* description to strengthen it, *Game Worlds* and *Narrative Structures* must be designed with fitting objects and *Characters* so that the games have *Predictable Consequences* and are also socially and emotionally believable. This may be done through the audio-visuals of the *Game World*, *Clues*, *Extra-Game Information*, and typically part of

the *Narrative Structure* is described using *Cut Scenes*. *Clues* and *Helpers* are ways to introduce *Indirect Information* without breaking the illusion of an *Alternative Reality*.

CONSEQUENCES *Alternative Realities* provide other realms in which players can experience *Emotional Immersion*. This *Immersion* is typically promoted by *Storytelling* and *Cut Scenes* but also by providing players the opportunity to control *Storytelling* and *Roleplaying* of Characters so they may experience *Identification*.

An *Alternative Reality* can be used to explain components in the game that are included to improve the gameplay but do not have a counterpart in the real world. By doing so, an *Alternative Reality* can provide a *Consistent Reality Logic* even though the logic is different from that of the real world. The archetypical examples that are explained by *Alternative Realities* are players' *Focus Loci*, since few games let players play themselves as part of the gameplay.

The degree of difference between the *Alternative Reality* and the real world can affect the ability to relax and forget the real world. The more unlike reality, the easier it may be for players to take chances, play aggressively, or try something unusual, since consequences of the actions are less realistic and remind less of the full consequences of corresponding real-world actions, but games taking place in unrealistic settings may also limit the number of potential players. The *Alternative Reality*, however, has to be consistent with the game itself to ensure *Consistent Reality Logic*.

RELATIONS

Instantiates: *Consistent Reality Logic, Predictable Consequences, Emotional Immersion*

Modulates: *Game World, New Abilities, Indirect Information*

Instantiated by: *Roleplaying*

Modulated by: *Ephemeral Goals, Narrative Structures, Clues, Extra-Game Information, Characters, Storytelling, Cut Scenes, Identification, Rewards, Construction, Focus Loci*

Potentially Conflicting with: None

Moveable Tiles

These are Tiles that can move during gameplay either as the effect of player actions or game events.

Moveable Tiles are very common in platform games from *Super Mario Bros.* to *Crash Bandicoot* to *Super Monkey Ball*. In these games, the *Moveable Tiles* mainly

consist of constantly moving platforms the player has to use to reach certain places in the game. The main challenge for the player in such cases is to time and coordinate his movements according to the movement of the tiles. Another common use of *Moveable Tiles* is to allow the player to push, pull, or otherwise move the tiles around the *Game World*, usually to block enemies or to reach otherwise inaccessible areas.

> **Example:** One of the levels in *Super Monkey Ball* consists almost exclusively of moving tiles, where each tile contains bananas for bonus scores. The tiles move in a very predictable pattern by first contracting to the center of the level and then again spreading out.

USING THE PATTERN Besides the considerations that need to be made for other *Tiles*, the design of *Moveable Tiles* requires decisions regarding the movement patterns, such as how the movement is activated and how the movement can be stopped, if necessary. Movement patterns can either be predetermined, decided on the fly using *Randomness*, or determined by the actions made either by game elements on the tile or through *Controllers*. The activation of the movement may be due to certain events or actions (maybe requiring some form of *Resources*), or the movement may be constant so that activation is not required, and the movement may continue only for a limited amount of time. The movement of the tile may also end or change direction when blocked by an *Obstacle*. When the movement is caused by player actions, this provides a form of *Reconfigurable Game World*.

Another decision to be made when using *Moveable Tiles* is whether the game elements on the *Moveable Tiles* need to move in order to stay on the tile or if they are automatically carried by the tile when it is moving. For example, in almost all cases of lifts in platform games, the player's character is automatically carried on the lift tile. On the other hand, to stay on the *Moveable Tiles* in *Super Monkey Ball*, the player has to explicitly move the ball.

CONSEQUENCES *Moveable Tiles* are a typical use of *The Show Must Go On*, as the players usually cannot affect the movement of the tiles once set in motion. These types of *Moveable Tiles* are also examples of such *Ultra-Powerful Events* that do not make the players lose control over their game elements; rather, the *Moveable Tiles* in this case bring in more complexity and variation to the game system. *Moveable Tiles* that are not under players' control can be used to create *Timing* challenges that require *Rhythm-Based Actions* as well as *Strategic Knowledge* when the player actions have to be coordinated according to the movement of several *Moveable Tiles: Moveable Tiles* also make *Aim & Shoot* actions more difficult, as the movement of the tiles needs to be considered.

RELATIONS

Instantiates: *Ultra-Powerful Events, The Show Must Go On, Timing, Strategic Knowledge, Rhythm-Based Actions*

Modulates: *Tiles, Aim & Shoot, Reconfigurable Game World*

Instantiated by: None

Modulated by: *Controllers*

Potentially Conflicting with: None

OBJECTS

These patterns describe different types of game elements that can be manipulated by players or are game elements through which players manipulate the game state.

Enemies

Enemies are Avatars and Units that hinder the players trying to complete the goals.

Many games have game elements that portray people or monsters that try and hinder players' goals. These *Enemies* can actively resist players' intentions through actions or they can be an explanation for challenges or obstacles in the *Game World*.

> **Example:** With the exception of puzzles, most games include enemies. A typical example of an enemy, albeit initially unknown, is Ganon in *The Legend of Zelda*, whose defeat is the plot of the game.

> **Example:** In *Soul Calibur II*, the combat opponents are straightforward *Enemies*, which try to hinder the players' progress in the game as illustrated in Figure 5.1.

USING THE PATTERN The primary design choice when defining *Enemies* is how players can *Overcome* or *Evade* them. There may be many ways to do this, which may change during gameplay, and players may have to complete several subgoals before having the chance to challenge the *Enemies* at all. Typical ways of overcoming *Enemies* are by *Elimination* (most often in the form of *Aim & Shoot*), by permanently making *Interferable Goals* impossible or by converting through succeeding with *Gain Ownership* goals. Games that provide many *Enemies* can give them different abilities to support *Orthogonal Unit Differentiation*, and thereby *Varied Gameplay*, or vary the environment in which these *Enemies* are encountered.

FIGURE 5.1 The *Enemy* attacking the player in Soul Calibur II. © Namco.

Another design choice is where in a *Level* the *Enemies* are met. They may block paths to *Traverse* goal, which makes their appearance likely or guaranteed, they may be the objectives of *Reconnaissance* goals, or may be *Surprises* in *Exploration* goals. In games requiring *Maneuvering* they can provide additional hazards that have to be actively avoided.

Having the *Enemies* appear separated allows players to decide what *Enemies* to challenge first (which can be useful to counter *Orthogonal Unit Differentiation*), while having the *Enemies* appear together can modulate the *Right Level of Difficulty* between different areas of the *Level*.

The most challenging *Enemies* are other humans. Computer controlled *Agents* can be made very challenging by using information or ultra-powerful abilities impossible for players to have, in principle, using *Ultra-Powerful Events*, but this easily conflicts with players' *Perceived Chance to Succeed*. *Game Masters* can more precisely modulate players' *Perceived Chance to Succeed* not only on their actual chance to succeed but also what the players believe.

The cause for enmity between the player and the *Enemies* can usually be described through a goal and a *Preventing Goal* pair. By using high-level goal pairs, the *Enemies* can be used as the main driving force for the *Narrative Structure* of the game. Such an overarching goal can then be used to create numerous subgoals within a *Hierarchy of Goals*: a *Collection* of goals that consist of several duels, *Gain Information* goals to gain the identity of the *Enemies* or their *Achilles' Heel*, *Overcome* to defeat the henchmen of the *Enemy*, *Supporting Goals* to find the *Tools* for defeating the *Enemy*, and so on. However, causes compatible with the *Consistent Reality Logic* need to be found to explain why these *Enemies* cannot be encountered early in the game.

The difficulty of *Enemies* can be modulated by changing their *Skills*, giving them *Privileged Movement*, or changing their numbers. *Alarms* can be used to support *Enemies* and can motivate the introduction of move *Enemies* if the *Alarms* are tripped. If players can have *Identification* with the *Enemies*, it can create a form of *Social Dilemma* as can having to perform certain actions to *Overcome* the *Enemies*. A special type of an *Enemy* is the *Boss Monster*, who is used to signify the final goal that has to be fulfilled to complete a *Level*.

CONSEQUENCES *Enemies* are the *Characters* or *Avatars* of players that have *Preventing Goals* or *Agents* or *Units* controlled by *Dedicated Game Facilitators* or *Game Masters*. The presence of *Enemies* in *Game Worlds* causes *Tension* and gives players motivation for *Overcome* goals, often through *Combat*. As such, they naturally cause *Conflict* or *Competition* as they threaten to make the players lose *Lives* or *Resources* (working as a form of *Consumer*), or otherwise block the players' progress in the game.

The appearance of *Enemies* are nearly always *Disruption of Focused Attention* events and can require *Attention Swapping* when several different groups of *Enemies* exist. *Enemies* are often used to give the motivation for the unfolding of *Narrative Structures* in games. When players can identify common *Enemies*, this is usually a motivation for creating *Alliances*.

RELATIONS

Instantiates: *Overcome, Conflict, Competition, Preventing Goals, Tension, Aim & Shoot, Alliances, Disruption of Focused Attention, Social Dilemmas, Reconnaissance, Combat, Attention Swapping*

Modulates: *Lives, Evade, Exploration, Traverse, Levels, Narrative Structures, Right Level of Difficulty, Perceived Chance to Succeed, Maneuvering, Game World*

Instantiated by: *Boss Monsters, Agents, Dedicated Game Facilitators, Game Masters, Characters, Avatars, Units, Eliminate*

Modulated by: *Privileged Movement, Orthogonal Unit Differentiation, Gain Ownership, Skills, Identification, Alarms, Consumers*

Potentially Conflicting with: None

Boss Monsters

A more powerful enemy the players have to overcome to reach certain goals in the game.

Sometimes defeating the *Boss Monster* can be a goal in itself, but usually *Boss Monsters* are used as subgoals in the game and the high-level goal is of another type of goal. *Boss Monsters* are almost always used to structure the progress of the game.

> **Example:** The games in *The Legend of Zelda* series are almost totally structured around defeating *Boss Monsters* in order to progress in the game and to reach the high-level goals of the game.

USING THE PATTERN Defeating the *Boss Monster* typically uses *Eliminate* modulated with some version of *Overcome* goal patterns. For example, in a tabletop roleplaying game, defeating the evil dragon guarding the princess consists of several rounds of tests of skills and attributes of the players until the dragon is dead. As previously mentioned, the *Boss Monster* is used as a subgoal to signify reaching a high-level goal, as is the case in the previous roleplaying example: *Eliminating* the dragon is a subgoal for *Rescuing* the princess. It is common for *Boss Monsters* to have some form of *Achilles' Heel* that allows players to have an easier way to defeat them.

Boss Monsters are usually an integral part of *Narrative Structures* and sometimes they are the main motivation for the player to progress in the game. That is why there is a need to carefully consider how to fit the nature, history, abilities, and even the audiovisual representation of the *Boss Monsters* to the *Alternative Reality* of the game.

CONSEQUENCES *Boss Monsters* are used to structure the progress in the *Hierarchy of Goals* so that *Higher-Level Closures as Gameplay Progresses* occur, and they typically signify the end of *Levels*. Defeating the *Boss Monster* creates a more significant closure associated with the progress in the game. The *Boss Monster* can be used to modulate the *Tension* in the overall game and is a natural part in the *Narrative Structure* of the game, as it can be seen as an end climax for a narrative section.

Relations

Instantiates: *Enemies, Tension, Overcome, Higher-Level Closures as Gameplay Progresses*

Modulates: *Rescue, Levels, Narrative Structures*

Instantiated by: *Eliminate*

Modulated by: *Achilles' Heels*

Potentially Conflicting with: None

Deadly Traps

Deadly Traps are game events that kill Avatars and Units if they are within the area of effect of the trap.

Typical examples of deadly traps include pits, falling blocks, lava, fire, acid, steam, machinery, crushing presses, fast-moving vehicles, and collapsing bridges, but many more are possible.

> **Example:** Platform games such as *Super Mario Sunshine* and *The Legend of Zelda: Wind Waker* are filled with a wide variety of *Deadly Traps*.
>
> **Example:** The tracks in *Super Monkey Ball* are hovering high above the ground, effectively surrounding the tracks with a *Deadly Trap*.

Using the Pattern *Deadly Traps* can be divided into three categories: those that are visible and whose effects are clear, those that can be found by noticing differences from the surrounding environment of the trap, and those that cannot be noticed before they are activated. The first type, exemplified by game elements such as crushers, flame dischargers, and so on that follow a certain pattern in activation, allows the players to choose to try to bypass or deactivate the trap, typically requiring *Timing* or *Rhythm-Based Actions*. The second type, exemplified by (badly) camouflaged pits, may instantly kill the player character and thus require the player to be observant of *Outstanding Features* in the environment. The last type, exemplified by traps activated by counterweights when picking up objects, creates *Surprises* but also promotes *Memorizing* to remember the location of the trap. The last two categories do not have to instantly kill the player character, but can give the player a *Time Limit* within which to react, thus increasing *Tension*.

Deadly Traps can be used to limit the players' accessible area, either by acting as a barrier to an area or by setting the entire *Inaccessible Area* as a *Deadly Trap*, for example, a lake of acid. When accessible routes are hidden among *Deadly Traps* and players cannot distinguish between the two, they force players into making *Leap of*

Faith actions. *Shrinking Game Worlds* can take the form of *Deadly Traps*, which seal off game areas, e.g., collapsing bridges or cave-ins. Less commonly, *Deadly Traps* can be used to open up game areas, e.g., a fallen rock exposes a tunnel. This can be used to enforce the *Narrative Structure* of the game and to create or open up *Inaccessible Areas*.

Deadly Traps can be used to help *Guard* goals and can make it possible to achieve *Eliminate* goals without directly attacking opponents.

CONSEQUENCES *Deadly Traps* introduce *Consumer* game elements into the *Game World* that threaten players with *Penalties* of *Damage* or loss of *Lives* or *Units* if the players activate them. Common objects of *Evade* goals, *Deadly Traps* give players restricted *Movement* within their immediate surrounding and can force players into *Maneuvering*. *Deadly Traps* are typically *Ultra-Powerful Events*.

Depending on whether the trap is known to the player, *Deadly Traps* can cause *Tension* or *Surprises*, especially in *Exploration* or *Reconnaissance* goals. *Deadly Traps* can also be used to limit the *Game World* in an intuitive way. *Deadly Traps* are examples of *Ultra-Powerful Events* when they are impossible to *Evade* by the players who have activated them.

Safe Havens cannot be combined with *Deadly Traps*, since the presence of the trap would make the location unsafe.

RELATIONS

Instantiates: *Timing, Rhythm-Based Actions, Time Limits, Surprises, Movement Limitations, Tension, Leaps of Faith, Memorizing, Ultra-Powerful Events, Damage*

Modulates: *Rescue, Evade, Exploration, Reconnaissance, Inaccessible Areas, Lives, Units, Maneuvering, Game World, Movement, Eliminate, Guard*

Instantiated by: *Shrinking Game World*

Modulated by: *Damage, Outstanding Features, Penalties, Consumers*

Potentially Conflicting with: *Safe Havens*

Obstacles

Obstacles are game elements that hinder the players from taking the shortest route between two places.

Often the *Obstacles* can be moved, destroyed, or avoided by specific actions but until this has been done (and it has become possible to do so), the *Obstacles* slow or block the players' progress in the game.

Example: The typical *Obstacles* in adventure games are locked doors, which can only be opened with a correct key, for example, the locked doors of *The Legend of Zelda: Wind Waker* require keys.

USING THE PATTERN The choice of an *Obstacle* determines how players can bypass it, if at all. *Obstacles* that block the way to *Inaccessible Areas* are often also *Controllers*, which support an action to remove the *Obstacle* but also require a specific *Resource* or *Tool*. *Obstacles* can be *Outstanding Features* when placed alone or given different visual appearance than other *Obstacles*.

Typically, *Obstacles* that do not act as boundaries for *Inaccessible Areas* can be avoided by taking a longer route, even if it is simply walking around a boulder or tree. The *Obstacle* may not necessarily block the passage through it, but can make the movement slower or cause damage or deplete *Resources*. Note that an *Obstacle* can also be a larger area, for example, a chasm or a pit.

Skillful players can often bypass more than one *Obstacle* at the same time, and without requiring more *Resources* than needed for an *Obstacle*-free course. This expression of *Game Mastery* can be made possible by *Timing*, e.g., moving between moving objects, or *Dexterity-Based Actions*, e.g., avoiding stationary objects and other vehicles when driving, depending on the nature of the *Obstacle*.

Obstacles are usually not deadly to *Units* or *Avatars*, at least not immediately. However, they can cause *Leaps of Faith* and can hinder *Aim & Shoot* actions against threats. See *Deadly Traps* for these types of game elements.

CONSEQUENCES *Obstacles* create *Movement Limitations* in how players can perform *Movement* or *Maneuvering* in *Game Worlds*. Depending on the size of the *Obstacles*, they can also make *Game World Navigation* difficult. By using these features and purposely placing them in special locations in *Game Worlds* it is possible to use *Obstacles* to modulate the *Right Level of Difficulty* of *Traverse* or *Exploration* goals in *Levels*.

The combination of several *Obstacles* can create natural boundaries to an *Inaccessible Area*, and when used in this fashion, they can support the *Narrative Structure* of the game. To be able to bypass *Obstacles* more easily can be the effect of a *Privileged Ability* or an expression of *Game Mastery*.

RELATIONS

Instantiates: *Timing, Dexterity-Based Actions, Inaccessible Areas, Movement Limitations, Outstanding Features*

Modulates: *Rescue, Traverse, Exploration, Levels, Right Level of Difficulty, Maneuvering, Game World Navigation, Leaps of Faith, Game World, Movement*

Instantiated by: *Controllers*

Modulated by: *Privileged Abilities*, *Privileged Movement*

Potentially Conflicting with: *Aim & Shoot*

Avatars

Avatar is a game element, which is tightly connected to the player's success and failure in the game. In many cases, the Avatar is the only means through which a player can affect the game world.

Example: The computer game *Paradroid* used an extended variant of the *Avatar* pattern. The player controlled a defenseless robot, which could control one other robot, and the gameplay consisted of switching between these second-order *Avatars* to defeat all robots on a spaceship.

Example: The players are represented as personalized *Avatars* in Massively Multiplayer Online Roleplaying Games, as illustrated in Figure 5.2.

FIGURE 5.2 Players represented by their *Avatars* meet in *Anarchy Online*. © Funcom, Inc. Reprinted with permission.

USING THE PATTERN When used, an *Avatar* is typically the only way in which a player can affect the game world. Thus, of primary importance in the design of an *Avatar* regarding gameplay is what actions it can perform. By limiting the actions that can be performed early in the game (for example, *Super Mario* and *The Legend of Zelda* series), the game can provide a *Right Level of Difficulty* in the beginning and *Smooth Learning Curves* as the game commences. Further, the game design can support the *Narrative Structure* by limiting access to game areas until various *Privileged Abilities* have been acquired, either by *Tools* or *Character Development*. The possibility to improve the *Avatar's* abilities and attributes through *Character Development* can thereby be used to merge the development of the *Narrative Structure* with goals the player has. This can strengthen the player's empathic link with the *Avatar* as an effect of the *Investments* made while developing the *Avatar*.

New Abilities or *Improved Abilities* given to players can either be given to *Avatars* or *Characters*; the abilities are linked to *Avatars* when the abilities are only observable through actions in the *Game World* or there is no abstract representation of a *Character* behind the *Avatar*.

Avatars may be used in a layered fashion where the player's *Avatar* controls another game element directly. This is presented to the player by replacing the *Avatar* with the other game element and providing the actions of the game element to the player. Examples of this are the possessing of other droids in *Paradroid* and the possibility to enter the driving position in vehicles in *Battlefield 1942*.

The death or destruction of the *Avatar* typically signifies the end of the game or the loss of one of the *Lives* available for the *Avatar*. This makes the *Survive* goal an integral part of games using *Avatars* in *Player Killing*. Other possible options include the loss of *Privileged Abilities*, *Score*, or *Tools*.

Many *Avatars* are designed to let the players feel a positive empathic link toward the *Avatar* to achieve *Emotional Immersion*. This can be achieved either through a design so that the *Avatars* have a sympathetic personality or appearance, have abilities the players would like to have, or have been mistreated. However, they do not usually have strongly developed personalities, as this can prevent the players from interpreting what they want into the *Avatar's* actions. Further, if the *Avatar* can initiate actions on its own, this lessens the players' *Freedom of Choice* and may destroy an *Illusion of Influence* as well as *Emotional Immersion* directed toward other objects or players in the *Game World*. The use of *Avatars* in *Persistent Game Worlds* is common to create stronger *Emotional Immersion* and a sense of *Ownership*.

CONSEQUENCES *Avatars* are the representations of players' *Characters* or are players' *Focus Loci* and are therefore an expression of player *Ownership*. They are what are created by *Producers* when players are *Spawning*. They allow *Improved Abilities* to be

presented to other players within a *Consistent Reality Logic* by changing the *Avatar's* appearance to reflect the current abilities the player has.

The use of an *Avatar* gives players a focus for *Immersion*—particularly *Spatial Immersion* when used with *First-Person Views*—and a focus for *Roleplaying* without affecting *Consistent Reality Logic* negatively; players can pretend that they are the *Avatars* on a physical level. The *Spatial Immersion* is further increased by the use of a *Camera* for *Third-Person Views* at the expense of *Consistent Reality Logic*. *God Views*, on the contrary, are not necessarily suitable for use with *Avatars*. Being a *Focus Loci* for players, *Avatars* can have strong emotional links to the players: what is good for the *Avatars* is good for the players and what is bad for the *Avatars* is bad for the players. *Avatars* can provide *Enemies* for other players, and their abilities usually modulate *Combat* and can provide the basis for *Orthogonal Unit Differentiation*.

RELATIONS

> **Instantiates:** *Focus Loci, Immersion, Spatial Immersion, Ownership, Enemies, Third-Person Views, First-Person Views*
>
> **Modulates:** *Survive, Combat, Persistent Game Worlds, Player Killing, Roleplaying, Consistent Reality Logic*
>
> **Instantiated by:** *Mule*
>
> **Modulated by:** *Lives, Privileged Abilities, Tools, Character Development, Investments, Cameras, Characters, Improved Abilities, Producers*
>
> **Potentially Conflicting with:** *Emotional Immersion, Units, Parallel Lives, God Views*

Units

Units are groups of game elements under the player's control that let the player perform actions to influence the Game World.

The *Units* can have different actions and attributes associated with them. As a single player controls several *Units*, the loss of a single *Unit* may not determine the final outcome of a game.

> **Example:** Real-time strategy games make heavy use of *Units*, where the choice and use of the different available types of units is one of the strategic skills of the games as illustrated in Figure 5.3.
>
> **Example:** *Pik-Min*, a more or less real-time puzzle game, and *Lemmings* are examples of games that make heavy use of *Units*, which in these cases are only partly under the player's direct control.

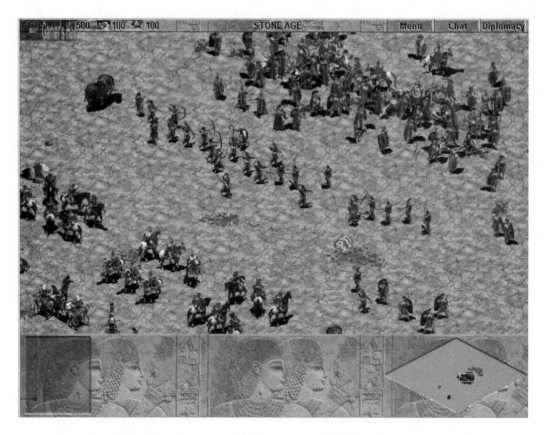

FIGURE 5.3 *Age of Empires II* has several different units, which the players can control. Copyright Microsoft Corporation. Reprinted with permission.

Example: All the pieces in *Chess* except the king are *Units*.

Example: In the board game *Space Hulk*, one of the players controls an essentially unlimited amount of *Units*, called genestealers, which are replenished endlessly. The opposing player has a preset number of *Units*, called space marines, which are not replenished once lost.

USING THE PATTERN Several design choices have to be made when using *Units*. The amount of *Units* available to the players is one of the most fundamental choices. The number of the *Units* may be preset so that the players have *Limited Resources* or it may be determined by *Randomness*, or depending on the player actions, during the setup phase. When the players can affect the number of *Units* they may have

during the gameplay, these *Units* are *Renewable Resources* and can be rewards for completing subgoals or be produced from *Resource Generators* or *Converters* that are under the player's control. The *Units* themselves may be part of a neutral pool of *Resources*, which the player can take control over. In most cases, the lifetime of *Units* is governed by a *Producer-Consumer* pattern. For example in *Civilization*, the production of *Units* is done in cities, and the *Units* can be consumed in battle. Control of the *Producers* may allow players to gain *New Abilities* for their *Units*, as may *Transfer of Control* and *Ownership* of enemy *Units*.

Beyond how many *Units* are available to players is the decision of when the players can start to use them. Making all possible *Units* available at the start makes them a *Non-Renewable Resource* and typically speeds up the game if they can be eliminated during gameplay. Portioning the available *Units* over time or giving them out as rewards for goals can be used to maintain the *Right Level of Complexity* and avoid *Analysis Paralysis*.

The abilities of the *Units* can either be identical—in order to stress the use of them as a group—or *Asymmetric Abilities* offering *Orthogonal Unit Differentiation* can be used to provide different *Privileged Abilities* for different *Units*. In the latter case, this can increase the value of each *Unit* as it may not be replaced by another and may promote *Stimulated Planning* on when and where to use uncommon *Units*. *Orthogonal Unit Differentiation* between *Units* under the control of different players may set up *Paper-Rock-Scissors* power relations. If the players can control the production of *Units*, the existence of several different types can promote *Varied Gameplay* and *Tradeoffs*, as the players have to decide what types of *Units* they want to acquire.

Naturally, game elements that are *Units* cannot also be *Avatars*. However, *Units* can be used as companions to the *Avatars*; in this case, they can be given various degrees of autonomy or be directly controlled by the *Avatar*.

Providing players with sufficient information about the current state of the *Units* can require the use of a *Game State Overview* or a *Game World* that they can view in its entirety. Many games using *Units*, and especially those where the number of the *Units* can change over time, make use of a *Camera* for *Third-Person View* and a *God's Finger* to allow the players to navigate the *Game World* in order to locate and select which *Units* to use.

CONSEQUENCES *Units* are a form of *Resource* in games, and often acquiring them represents a form of *Investment*. *Units* allow the players to have multiple *Focus Loci* where they can affect the *Game World* without affecting *Consistent Reality Logic*. However, this may make it difficult to attain the *Right Level of Complexity* due to *Attention Swapping*. This is especially likely if the game does not support a *Game*

State Overview, which shows relevant information about each player's *Units*. *Units* are often targets of the *Damages* from *Deadly Traps* and *Combat* motivated by other players' *Eliminate* goals, resulting either in the destruction of the *Units* or in *Decreased Abilities* of those *Units*. The *Penalties* of losing the *Units* are often *Ability Losses*, and the player controlling the *Units* may have *Evade* and *Survive* goals.

Various *Units* can have different *Limited Set of Actions* by making use of *Orthogonal Unit Differentiation*, so using them can require the players to make *Trade-offs* between different types of *Units*. Performing the *Attention Swapping* between *Units* is most commonly enabled by another *Focus Loci*, a *God's Finger*. Different stages of the gameplay can further require different types of *Units*, allowing *Varied Gameplay*. The different abilities of the *Units* do not have to be inherent; the use of *Tools* can explain various *Privileged Abilities*.

Units let the players simulate *Team Play* so they can set up complex actions as well as *Extended Actions* by coordinating the individual actions of several *Units*. This allows *Stimulated Planning* and allows the players to do *Resource Management* on a higher level than using *Avatars*, as the destruction or death of the *Units* may in some cases even be advantageous and necessary. Thus *Units* can be seen as a use of *Parallel Lives* which in contrast to *Avatars* are more or less dispensable.

RELATIONS

Instantiates: *Focus Loci, Stimulated Planning, Varied Gameplay, Attention Swapping, Orthogonal Unit Differentiation, Enemies, Paper-Rock-Scissors, Resource Management, Third-Person Views, Team Play, Investments, Resources*

Modulates: *Evade, Survive, Consistent Reality Logic, Extended Actions, Ability Losses, Asymmetrical Abilities, Combat*

Instantiated by: None

Modulated by: *Producer-Consumer, Game State Overview, Non-Renewable Resources, Privileged Abilities, Eliminate, Deadly Traps, Tools, God's Finger, Parallel Lives, Cameras, Producers, Limited Set of Actions, Penalties, Damage, New Abilities, Transfer of Control, Decreased Abilities, Ownership, Renewable Resources*

Potentially Conflicting with: *Avatars*

Tools

Tools are game elements that enable the players' Avatars and Units to perform actions otherwise unavailable to them.

Tools and the game elements that use them are separate entities and can exist independently of each other, allowing *Tools* to be designed in such way that they can be

picked up, dropped, destroyed, traded, and so on; that is, they do not have a fixed position in the *Game World*.

> **Example:** Roleplaying games make most intense use of *Tools*, often in the form of weapons and armors to affect combat outcomes and gadgets (e.g., keys, ladders, mirrors) to overcome problems. Massively Multiplayer Online Roleplaying Games have expanded this further by requiring the use of various *Tools* in the item production chains such games sometimes support.

USING THE PATTERN The fundamental characteristics of *Tools* are the actions they support. They may be *Improved Abilities* through increases in *Skills*, *New Abilities*, and possibly *Privileged Abilities* that players do not have otherwise, or they may have *Extra-Game Consequences*.

Several questions regarding the nature of the actions to provide are possible: Do they allow *Achilles' Heels* of *Enemies* to be exploited? Do the *Tools* allow *Controllers* to be used that otherwise would not be usable? Do they modify *Aim & Shoot* actions?

Depending on how actions of the *Tools* have been set up, several other design choices need to be made: which *Units* or *Avatars* can use the *Tool*? Does the use of the *Tool* require specific skills or does it consume *Resources*? Is there a limit on how long a time or how many times a *Tool* can be used? Can *Tools* be combined? Is there a limit on the amount of *Tools* that can be carried? Are the *Tools* available to a player when creating a *Character* and giving it abilities? Can some *Tools* be acquired directly after *Spawning*?

Typically *Tools* are *Pick-Ups*, i.e., they exist as game elements in the *Game World* before being acquired. It is also possible to combine *Tools* with other kinds of game elements such as *Helpers*. If the *Tools* are useful to several players, they promote *Competitions* and *Races* if the players know the location of the *Tools*. However, it may or may not be possible to drop or trade a *Tool* after it has been taken. If a *Tool* is dropped when an *Avatar* or *Unit* carrying it is killed or destroyed, or if *Gain Ownership* over other players' *Tools* is supported in the game design, the presence of *Tools* promotes *Competition* even after the *Tool* has been acquired.

Tools can be used as goal objects in *Gain Ownership* goals, especially if there is only one instance of the *Tool* available and it is in a predetermined place. If the players can construct the *Tools* themselves, which is common in games using *Converters* in *Producer-Consumer* chains, the knowledge of what *Tools* to construct can be *Strategic Knowledge*. However, the production of the *Tool* can require *Resources* or knowledge, and gaining these may be used as goals in themselves using *Gain Ownership* or *Gain Information* goal patterns.

CONSEQUENCES *Tools* are game elements that provide actions within a *Consistent Reality Logic* and allow players means of having *Ownership* and performing *Transfer of Control* actions regarding these actions. They provide players with *Collecting* goals that directly give players *Illusion of Influence* or a *Perceived Chance to Succeed*.

As *Tools* can give *Privileged Abilities*, they allow the fulfillment of *Gain Competence* goals but are also often *Rewards* of other goals. Further, as physical game elements, they can function as explicit goal objects and can be affected by the various actions and events in the *Game World*. *Tools* give the players the ability to affect what actions are available to them and in some cases to other players, for example, by giving the *Tool* to another player.

RELATIONS

Instantiates: *Gain Competence, Perceived Chance to Succeed, Illusion of Influence, Extra-Game Consequences, Collecting, Improved Abilities, New Abilities, Rewards*

Modulates: *Gain Ownership, Avatars, Units, Controllers, Consistent Reality Logic, Spawning, Characters, Skills, Achilles' Heels, Ownership*

Instantiated by: *Pick-Ups*

Modulated by: *Privileged Abilities, Converters, Transfer of Control, Aim & Shoot, Helpers*

Potentially Conflicting with: None

Controllers

Controllers are game elements fixed in particular locations in the Game World that allow players to perform actions that would not be possible otherwise.

Example: First-person shooters, such as *Quake*, often have doors that have to be opened through activating *Controllers*.

Example: The cannons in *Super Mario 64* are *Controllers* that allow Mario to reach areas otherwise inaccessible by shooting himself from a cannon.

Example: Abstract *Controllers* can be found in *Return to Castle Wolfenstein: Enemy Territory* as players can construct bridges, command centers, and towers in certain places.

USING THE PATTERN *Controllers* share many design possibilities with *Tools*. After choosing what *Privileged Abilities* the *Controllers* support, a game designer has to decide which *Units* or *Avatars* can use the *Controller*, any specific skills that are needed, and any *Resources* the *Controller* might consume. However, *Controllers*

differ in some respects from *Tools*. First, they are public in the sense that they are stationary, and whoever is near it can activate it (unless specific skills or resources are needed). This means that any *Gain Ownership* goals related to the *Controllers* are linked to controlling the game area. Second, they may need *Tools* to be activated besides any requirements on skills and *Resources*. Third, as they often are presented as part of a large machine or system, they often can affect something outside the usual reach of *Units'* or *Avatars'* actions without breaking the *Consistent Reality Logic* of the game. The activation of *Controllers* can often be the completion of a goal or a *Level*. Further, the actions can be both *Extended Actions* (requiring the constant activation of a player) and *Ultra-Powerful Events* (for example when activating *Moveable Tiles*).

The archetypical type of *Controller* is a *Button*. However, *Controllers* do not have to be tangible game elements, but they can be areas where the construction or destruction of game elements is possible. Examples of this are boxes of construction material, which can be assembled to specific game elements, such as bridges or bases in *Return to Castle Wolfenstein: Enemy Territory*.

CONSEQUENCES *Controllers* are natural *Strategic Locations* since *Area Control* over the location gives players or teams access to actions that otherwise may not be performed. In addition, as they are an integral part of the *Game World* and thus linked to its structure, the actions they provide, including *Ultra-Powerful Events*, usually have greater effects than mere *Tools*.

Controllers that are *Resource Generators* provide a way to have *Renewable Resources* in games and create *Resource Locations* in *Game Worlds*. Other *Controllers* are simply *Obstacles* that allow players to perform actions to remove them.

RELATIONS

> **Instantiates:** *Obstacles, Strategic Locations, Ultra-Powerful Events, Resource Locations*
>
> **Modulates:** *Levels, Gain Ownership, Moveable Tiles, Renewable Resources, Area Control*
>
> **Instantiated by:** *Buttons*
>
> **Modulated by:** *Extended Actions, Tools, Resource Generators, Helpers*
>
> **Potentially Conflicting with:** None

Alarms

Alarms are abstract game elements that provide information about particular game state changes.

Alarms are turned on and off either by manipulating explicit game elements or by inherent actions of the game elements. *Alarms* can, for instance, show if a forbidden area has been entered or if certain game elements have been manipulated.

> **Example:** Some team-based first-person shooters, such as *Return to Castle Wolfenstein: Enemy Territory*, include *Alarms* to inform the players about events that are relevant on a team level, e.g., that a particular goal has been completed or that a certain activity has been initiated by the other team.

USING THE PATTERN The main design choices for *Alarms* are how they are tripped and what *Outstanding Features* they set off. Further when designing *Alarms*, the designer may choose either explicit *Tools* or *Controllers* to manipulate the *Alarms* or to have the manipulation of the *Alarms* as *Privileged Abilities* for certain types of *Avatars* or *Units*. Using *Tools* or *Controllers* increases the complexity of the game by allowing such possibilities as deactivating the *Alarm* when it should not be deactivated, *Bluffing* by raising erroneous *Alarms*, and preventing the raising of *Alarms* by destroying the means to activate them. All these actions increase the player's *Freedom of Choice* but may make it more difficult to guarantee the coherent *Narrative Structure* of the game. Having *Avatars* or *Units* with *Privileged Abilities* to raise *Alarms* may avoid this problem but may break the *Consistent Reality Logic*.

The activation of the *Alarm* can signify the failure of a *Stealth* or *Reconnaissance* goal but can also make the completion of it more difficult by imposing a *Penalty*. This *Penalty* is often a *Time Limit*, the introduction of new *Enemies*, or directing existing *Enemies* to the area where the *Alarm* was raised.

CONSEQUENCES *Alarms* are ways to pass information about activities and states within a game, and as such provide a *Game State Overview*. When activated by players, an *Alarm* notifies the players that they have been detected, and this can explain changes in the behavior of *Enemies* or the introduction of new *Enemies* within the *Consistent Reality Logic* of the game. When activated by others, *Alarms* can notify players of *Enemies* activities. In both cases, raised *Alarms* cause *Disruption of Focused Attention*.

RELATIONS

 Instantiates: *Disruption of Focused Attention*

 Modulates: *Game State Overview, Stealth, Rescue, Reconnaissance, Enemies*

 Instantiated by: None

 Modulated by: *Bluffing, Outstanding Features*

 Potentially Conflicting with: None

Pick-Ups

Pick-Ups are game elements that exist in the game world and can be collected by players, usually by moving an avatar or Units in contact with the Pick-Up.

Common examples of *Pick-Ups* include weapons, ammunition, and health packs in first-person shooters; money and energy in platform games; and food, wood, money, and metals in real-time strategy games.

> **Example:** The ammunition packs in *Quake 3* are *Pick-Ups* that replenish the players' ammunition.

USING THE PATTERN *Pick-Ups* are in essence *Resources*, and as such, the fundamental game design choice regarding a *Pick-Up* is to decide what the resource is to be used for: is it to gain advantages in possible actions against opponents, to fulfill goals such as *Delivery*, to directly increase winning possibilities or is the resource usable for several different purposes and thus requiring *Tradeoffs*? The nature of the *Pick-Up* may not be completely revealed to the player who collects it until it is collected, allowing the game to change the nature of the *Pick-Up* depending on players' positioning, thereby providing *Balancing Effects*. These kinds of *Pick-Ups* can also cause disadvantages to the players.

As *Resources* that exist in the game world, the design of *Pick-Ups* is linked to the design of *Resource Locations*, and the design choices available for the locations have to be considered in parallel with those of the *Pick-Ups*. The production of the *Pick-Ups* is another design choice that has to be considered. Is the *Pick-Up* only produced once (maybe at the beginning of the game) thus providing *Limited Resources* on a global level, or is this type of *Pick-Up* a *Renewable Resource* that is produced during gameplay? In the latter case, is the location of the production a known place (and thereby a *Strategic Location*) or is it random? The production may be tied to a *Resource Generator,* which may be influenced or destroyed by player actions. The production of the *Pick-Ups* may also require actions by the players, for example, providing *Resources* to a *Converter*. In any case, the production of *Pick-Ups* also follows the methods outlined in the more abstract *Producers* pattern.

Most *Pick-Ups* affect numerical characteristics of the *Avatar* or *Unit* that collected the *Pick-Up*, e.g., by increasing the player's *Score* or an *Avatar's* hit points. The simplest way of implementing these is having a specific increase or decrease of one attribute of the game element each time a *Pick-Up* is taken. However, one can also have cut-off limits to promote *Player Balance* (e.g., not letting health packs or ammunition replenish past a certain level) or having *Diminishing Returns*.

A less common type of *Pick-Up*, which may also affect numerical characteristics, is a *Tool*. *Tools* provide players with *Privileged Abilities* but may require resources when used.

A special type of *Pick-Up* is a *Power-Up*, which gives players a time-limited advantage often consisting of increased efficiency at an action or by providing a *Privileged Ability*. Other special *Pick-Ups* are those whose only function is to increase a player's *Score*.

CONSEQUENCES *Pick-Ups* are a very common way to provide *Renewable Resources* to players, and as such, they provide *Supporting Goals* requiring *Collecting* and possibly *Maneuvering*. More formalized, *Collection* goals can be constructed by requiring players to get all *Pick-Ups* before being able to advance in the game, e.g., eating all the pills in *Pac-Man* before completing the level.

Since the successful collection of *Pick-Ups* has a clear effect in the *Game World*, and it is usually easy to distinguish *Pick-Ups* in the game environment, they make easy goal objectives for *Gain Ownership* goals. The absence of a *Pick-Up* from a location is a form of *Trace* that players can use to infer activities in the game.

RELATIONS

> **Instantiates:** *Tools, Resource Locations, Strategic Locations, Collecting, Supporting Goals*
>
> **Modulates:** *Gain Ownership, Score, Collection, Producers, Renewable Resources, Maneuvering*
>
> **Instantiated by:** *Power-Ups, Delivery*
>
> **Modulated by:** *Balancing Effects, Resource Generators, Renewable Resources, Limited Resources, Traces*
>
> **Potentially Conflicting with:** None

Power-Ups

Power-Ups are game elements that give time-limited advantages to the player that picks them up.

> **Example:** The power pill in *Pac-Man* allows Pac-Man to hunt ghosts for a limited amount of time, as illustrated in Figure 5.4.
>
> **Example:** Quad damage *Power-Up* in *Quake* quadruples the damage caused by the player's weapons for a limited amount of time.

USING THE PATTERN The possibilities regarding where the *Producers* of the *Power-Ups* are and when *Power-Ups* appear are similar to those of *Pick-Ups*. The main differences are that *Power-Ups* often give the player *New Abilities* or *Privileged Abilities*, and one has to determine how long the effect of the *Power-Up* lasts and if players

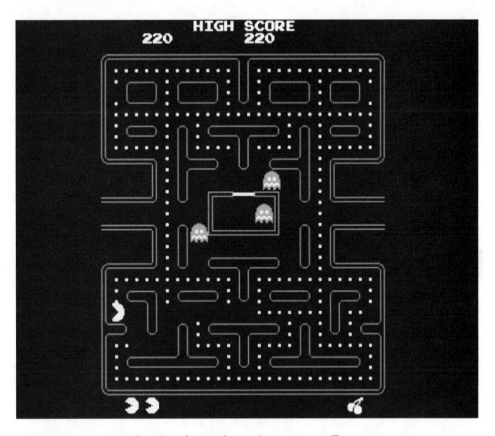

FIGURE 5.4 Pac-Man hunting ghosts after eating a power pill. Pac-Man® © 1980 2004 Namco Ltd. All rights reserved. Courtesy of Namco Holding Corp.

can *Trade* them. However, *Power-Ups* can also provide *Improved Abilities* such as temporarily raising *Skills*.

Since the *Power-Up* typically gives the player an advantage without a matching disadvantage, the use of *Power-Ups* may cause problems with *Player Balance* more easily than using plain *Pick-Ups*.

CONSEQUENCES *Power-Ups* share many of the consequences of *Pick-Ups* but typically have a more transient effect. Since the effect has a *Time Limit*, picking up a *Power-Up* can actually increase *Tension* if the usefulness of the *Power-Up* depends on the success of other goals, for example, using the quad damage *Power-Up* properly in *Quake* games efficiently depends on locating and hitting enemies first. *Power-Ups* can be used as target objects for *Gain Competence* goals.

Power-Ups give players *Ephemeral Goals* of *Collecting* when they appear; knowing their location and when they are produced allows players to locate *Strategic Locations* and have *Strategic Knowledge.*

RELATIONS

Instantiates: *Pick-Ups, Gain Competence, Ephemeral Goals, Time Limits, Strategic Locations, Strategic Knowledge, Privileged Abilities, Collecting, New Abilities, Improved Abilities*

Modulates: *Skills*

Instantiated by: None

Modulated by: *Producers, Trading*

Potentially Conflicting with: *Player Balance*

Clues

Clues are game elements that give the players information about how the goals of the game can be reached.

The clues may be explicit, describing exactly how to reach the goal, or implicit, describing facts and events in the game world which need to be interpreted by the player. Of course, this categorization is not clear-cut, as the vagueness of the clues can vary between these two poles.

> **Example:** Arrows and signs in *The Legend of Zelda* series are direct clues, which can guide the player through the game.

> **Example:** Many racing games contain warnings for the next turns as signs on the side of the road.

USING THE PATTERN *Clues* may take the form of advice, encouragement, or warning. Advice tells players what to do before they have started performing a set of actions; encouragement provides feedback that a given action is correct although the goal or the closure is not completed yet; and warning gives players advice on what not to do. Encouragement is typically used to indicate completion of low-level subgoals or to promote further *Exploration* of a given area or object. A more specific encouragement is to use a *Near Miss Indicator* to indicate that the player started performing the right actions but failed to do them correctly.

A *Clue* can either be an object in the game, which has to be taken or manipulated to change the game state, or plain information. In the latter case, the *Clue* is an *Outstanding Feature* and can also be *Extra-Game Information* if it is about some-

thing outside the *Game World*. Of course, the *Clue* may be about how to use the game controls or the game mechanics, which automatically makes it *Extra-Game Information*. These forms of *Clues*, however, may break the *Consistent Reality Logic* and *Emotional Immersion* in the game, with one example being arrows that show the way to the exit of a *Level*. If the clues are set within the *Consistent Reality Logic* of the game or support the *Alternative Reality* of the game, they can also be used to support the *Narrative Structure*.

Two typical forms of *Clues* are *Helpers* and *Traces*. *Helpers* can provide *Indirect Information* to the players on how to reach the goals, and *Traces* allow the players to indirectly deduce how to locate *Deadly Traps* and *Enemies*, for example. Other *Clues* provide more *Direct Information*, for example, arrow signs to indicate directions where the player should go or explicit warning signs about dangers ahead.

Clues, especially warnings and *Helpers*, may be used to indirectly guide players who have gone astray toward the goals and the main areas of the *Game World* thus enacting *Game World Navigation*. An excellent example of such a *Helper* is the owl in *The Legend of Zelda: The Ocarina of Time*, who sometimes flies in to steer the player to the correct places.

The direct use of *Clues* is as goal objects in either a *Gain Information* or *Gain Ownership* goal, for example to learn about *Achilles' Heels*. The player knows about the existence of the *Clue* and strives to retrieve the additional information by going to a specific location in the *Game World*.

A *Clue* may not necessarily lead the players toward actions they perceive as beneficial for the progress in the game. When this is the case, the *Clue* is used to promote actions, which the players would probably not otherwise initiate, in order to support the *Narrative Structure* or to promote *Player Balance* and *Cooperation*. This may be construed as a *Red Herring* pattern, used to trick players into actions that are against their low-level goals but that may be required to complete the game narrative or to put the players in positions so that they can reach the higher-level goals of the game. *Clues* to finding *Easter Eggs* are examples of luring players to perform actions that are not necessarily required to complete or win games but can rather be seen as *Clues* to *Unknown Goals*.

CONSEQUENCES *Clues* can be used to provide the *Right Level of Difficulty* and *Smooth Learning Curves*, especially in the case where the game provides more *Clues* to the player if the progress is too slow. The *Clues* are often used to guide the player through the *Narrative Structure* of the game and create *Tension* by signaling the existence of dangers before they actually occur. This is especially the case in adventure games, which use *Clues* as the basic *Resources* of the player.

Clues are a form of *Illusionary Reward*, since they do not have to help players nor do they actually have to change the game state in a beneficial way for the players.

RELATIONS

Instantiates: *Near Miss Indicators, Outstanding Features, Resources, Smooth Learning Curves, Illusionary Rewards, Indirect Information*

Modulates: *Red Herrings, Unknown Goals, Right Level of Difficulty, Levels, Gain Ownership, Exploration, Alternative Reality, Narrative Structures, Imperfect Information, Game World Navigation, Easter Eggs, Achilles' Heels, Tension*

Instantiated by: *Extra-Game Information, Traces, Helpers*

Modulated by: *Gain Information, Direct Information*

Potentially Conflicting with: *Consistent Reality Logic, Red Herrings, Emotional Immersion*

Extra-Game Information

Information provided within the game that concerns subjects outside the Game World.

> **Example:** *The Legend of Zelda: The Wind Waker*, like other games in the series, includes a significant amount of *Extra-Game Information* about how to perform the actions in the game. This information is portioned out over the game so that the complexity of the gameplay is simple in the beginning and grows as the player becomes more experienced.

USING THE PATTERN The primary use of *Extra-Game Information* is to provide instructions of the game or to show how the interface works, especially the mapping between the game controller and the player actions, but *Extra-Game Information* can also provide *Strategic Knowledge*. When not contained within *Clues*, it typically consists of *Outstanding Features*.

CONSEQUENCES *Extra-Game Information* affects *Immersion* negatively, as it directs the players' attention outside the *Game World*. However, it allows instructions to be introduced when needed in the game, making it possible for the players to begin the game quickly as the more complex actions are gradually described later, thereby maintaining *Right Level of Complexity* of the interface for the player.

When provided through *Storytelling*, the delivery of *Extra-Game Information* can be used to explain aspects of an *Alternative Reality* or gameplay that may be difficult to explain otherwise inside a *Consistent Reality Logic*.

Extra-Game Information is often *Clues* on how to perform gameplay (for example, *Combos*), and as such can provide *Smooth Learning Curves* and the *Right Level of Difficulty* but also promote *Memorizing*. As any *Clues*, they are *Illusionary*

Rewards, but since they can provide concrete information about how to perform actions within the game, they can give players an *Illusion of Influence*.

RELATIONS

Instantiates: *Clues, Memorizing, Smooth Learning Curves, Illusionary Rewards, Strategic Knowledge*

Modulates: *Alternative Reality, Right Level of Complexity, Illusion of Influence, Right Level of Difficulty*

Instantiated by: *Outstanding Features, Combos*

Modulated by: *Storytelling*

Potentially Conflicting with: *Immersion, Consistent Reality Logic*

Additional Patterns

Descriptions of these additional patterns can be found in the Chapter 5 folder on the companion CD-ROM.

ON THE CD

Invisible Walls	**Tiles**
God's Finger	**Dice**
Mule	**Cards**
Buttons	**Card Hands**
Helpers	**Drawing Stacks**
Traces	**Discard Piles**
Resource Generators	

ABSTRACT OBJECTS

These patterns describe game elements that do not necessarily have concrete manifestations in the *Game World* but represent abstract values associated with game states.

Score

Score is the numerical representation of the player's success in the game, often not only representing the success but also defining it.

Having a *Score* value for each player allows the players to easily determine the leader or the winner of the game; the *Score* value also allows players to compare *Scores* between different games and to calculate outcomes of tournaments. Many games give players several different ways to gain *Score* points to promote different tactics.

Example: *Pac-Man* gives players three different possibilities to gain points: eating pills, capturing ghosts while under the effect of a power pill, or collecting the bonus object when it appears. The player's *Score* is shown in the upper part of the screen next to the current high *Score*, as illustrated in Figure 5.5.

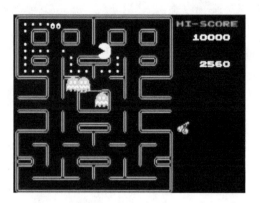

FIGURE 5.5 Players' *Score* and the high *Score* are shown in *Pac-Man.* Pac-Man® © 1980 2004 Namco Ltd. All rights reserved. Courtesy of Namco Holding Corp.

USING THE PATTERN The two fundamental choices to be made when creating a *Score* system is first to determine which actions or goals give points and then to decide how large these amounts are. Examples of simple scoring goals include reaching a *Pick-Up* first (thus modulating a *Collecting* activity or a *Gain Ownership* goal) or successfully completing a *Dexterity-Based Action* or an action requiring *Timing*. More complex scoring goals can depend on the distribution of *Resources* between the players or completed *Collections*. In games with *Role Reversal*, different possibilities to *Score* may exist for different roles, but the use of *Score* can provide players with means to continue striving toward goals independent of their current role. The possibility of using *Tiebreakers*, commonly another form of *Score* systems, should also be considered when designing a *Score* system, as *Score* systems usually allow for *Tied Results* unless explicitly designed to make them impossible.

Besides affecting *Player Balance*, the choice of actions and goals that give points can be used to control the overall flow of the gameplay during a game session. This

can be done by giving different points for the same achievements depending on when in the game it is achieved, which will encourage the players either to haste or wait; to reward certain types of actions and goals, e.g., *Eliminate* goals and *Player Elimination*; or to reward the use of actions requiring *Non-Renewable Resources* to limit the players' *Freedom of Choice* as the game progresses.

Allowing the players to gain *Score* points for different kinds of goals expands the players' *Freedom of Choice* and promotes *Varied Gameplay* and *Replayability*.

Another important consideration is to determine whether the *Scores* of the players are *Symmetric Information* that should, or should not, be available to all players. If the *Score* values themselves are known, they provide a *Game State Overview* and can give rise to *Dynamic Alliances* where the players actively work together against the leader, thereby achieving a *Balancing Effect*. However, this can cause *Analysis Paralysis* and prevents the *Tension* of not knowing who the leader is and the possible *Surprise* of an unpredicted winner.

One simple way of letting players of *Single-Player Games* compete against themselves or each other is to let them compare *Scores*. The typical way to explicitly support this in games is to use *High Score Lists*. As this requires that the game is played several times, such designs promote *Replayability*.

CONSEQUENCES Having *Scores* in games can be seen as an instantiation of an abstract *Race*. When outcomes are determined by who first reaches a certain *Score*, this creates a normal *Race*, but when outcomes are based on having the highest *Score*, the goal of achieving this becomes a *Continuous Goal*. The *Score* is used this way as both *Progress Indicator* and *Status Indicator*.

The use of a *Score* system promotes *Stimulated Planning* as players, given sufficient information, can calculate numerically optimal tactics not only for themselves, but also for the other players. *Score* is typically the information from a game state that can be used as *Trans-Game Information* or provide *Extra-Game Consequences* in *Meta Games* such as *Tournaments* and *High Score Lists*. It can also be used to give *Handicaps* by giving some players a bonus to their *Scores*. Some games use the *Score* as a *Resource* to perform actions, for example, to determine order in *Turn Taking*, while others base *Scores* on *Resources*, and completely linking *Score* to *Resources* is possible. This requires the players to see these kinds of actions as *Investments* and make *Risk/Reward* calculations, especially in games, which are parts of *Meta Games*.

The use of *Save-Load Cycles* and *Save Points* make the use of *Score* irrelevant to some degree, as players can repeat parts of the game until they reach a *Score* they are satisfied with.

RELATIONS

Instantiates: *Race, Continuous Goals, Resources, Investments, Stimulated Planning, Game State Overview, Dynamic Alliances, Balancing Effects, Trans-Game Information, Extra-Game Consequences, Meta Games, Replayability, Collecting, Progress Indicators, Status Indicators, Tied Results*

Modulates: *Gain Ownership, King of the Hill, Tournaments, Role Reversal, Turn Taking, Player Elimination, Single-Player Games*

Instantiated by: *High Score Lists, Resources*

Modulated by: *Pick-Ups, Tiebreakers, Handicaps*

Potentially Conflicting with: *Save Points, Save-Load Cycles*

High Score Lists

High Score Lists give players the chance to rank themselves against other players who have previously played the game.

Example: The first arcade game to have *High Score Lists* was *Asteroids*. The player who achieves a high enough score compared to the other players of the same machine is allowed to enter his initials to be displayed in the *High Score List* as illustrated in Figure 5.6.

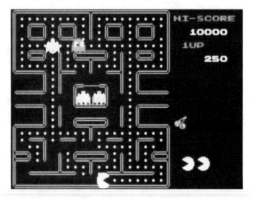

FIGURE 5.6 The player is allowed to enter three letter initials to the *High Score List* in *Asteroids*. Asteroids®, Civilization®, Missile Command®, and Pong® screenshots courtesy of Atari, Inc. All rights reserved.

USING THE PATTERN The use of *High Score Lists* is fairly standardized, with the main design choices being the number of *Scores* saved in the *High Score List* and how *Handles* are supported. Most *High Score Lists* make use of *Handles* so that the players can identify their own scores and know that other players can recognize them. Since *High Score Lists* typically are ordered, they need *Tiebreakers* or have to be explicitly designed to allow several players with *Tied Results* to be displayed as completely equal.

The use of *Ghosts* can be seen as a form of *High Score List* that allows players to judge their progress against other performances, as well as their own individual performances, in previous game sessions while playing the game.

CONSEQUENCES *High Score Lists* create a *Meta Game* out of the game by using *Trans-Game Information*, allowing players to have *Player Defined Goals* such as to rank themselves against previous achievements, and thereby encouraging *Game Mastery*. Doing so adds *Replayability* to the game, as the players have the additional goal of simply performing slightly better than in the previous game sessions. *High Score Lists* are also a simple way to introduce *Competition* to otherwise *Single-Player Games* and are also a way for players to compare and display their *Social Statuses*.

RELATIONS

Instantiates: *Score, Player Defined Goals, Meta Games, Replayability, Trans-Game Information, Social Statuses, Tied Results*

Modulates: *Game Mastery*

Instantiated by: *Ghosts*

Modulated by: *Handles, Tiebreakers, Single-Player Games*

Potentially Conflicting with: None

Lives

Lives can be defined as the number of chances a player has within a game session before it is terminated.

The loss of an individual *Life* is usually also associated with at least some negative effects in the game.

> **Example:** *Counter-Strike* is sometimes regarded as the first multiplayer first-person shooter that made explicit use of *Lives*. The player's *Avatar* that was killed did not respawn, and the player had to wait until the next level started, in principle, giving each player one *Life*.

Example: Platform games such as *Super Mario* and *The Legend of Zelda* series make use of *Lives* but in such way that the only consequence of losing all *Lives* is that the player will have to restart from the latest saved location.

Example: In *Asteroids*, the player initially has three *Lives*, and they are lost either when the *Avatar* is shot by the UFO or collides with an asteroid. When all *Lives* have been lost, it is the end of the game session, as illustrated in Figure 5.7.

FIGURE 5.7 Game Over as the player loses his last *Life* in *Asteroids*. Asteroids®, Civilization®, Missile Command®, and Pong® screenshots courtesy of Atari, Inc. All rights reserved.

USING THE PATTERN *Lives* are typically associated with *Avatars*, but games using *Units* can also be regarded as using *Lives* through the use of *Parallel Lives*. The main considerations when introducing *Lives* in a game are: what can cause the loss of a *Life*, what are the consequences of losing a *Life*, and how many *Lives* are available. The loss of a *Life* is always a *Penalty*, but the effect can vary. The loss of all *Lives* typ-

ically signifies the end of the game session for that player, but in games that allow players to join the game instance later, the player may simply start a new game session. The loss of a *Life* usually means that *Tools* are lost or that the player's *Score* is reduced but may also signify the loss of *New Abilities* and *Privileged Abilities* or require players to have a certain amount of *Downtime* before the gameplay can resume.

The number of *Lives* a player has can be set to a static number to limit the time of the game session. Alternatively, the *Lives* can be replenished during gameplay, for example, by reaching a certain *Score* or collecting *Pick-Ups*. The possibility to replenish *Lives* gives the players clear short-term goals and makes *Lives* into *Renewable Resources*. The use of *Lives* can be modulated by *Damage* to allow *Status Indicators* and partial *Penalties* before more significant penalties occur.

Losses of *Lives* are typically the effects of *Deadly Traps*, failing to *Evade* actions by *Enemies* or players in *Conflict* with the player, or failing to replenish *Resources* within a certain *Time Limit*. Typically, only one *Life* is at stake at a time (although some games may refer to *Lives* when they are actually using something similar to hit points), but games using *Parallel Lives* are an exception.

Once the player has suffered the consequences of losing one but not all *Lives*, gameplay continues as the *Avatar* respawns somewhere in the *Game World*. The location where the *Avatar* respawns can be the point of death, which provides continuation but may have *Player Balance* problems since the cause of death may still be present. The *Avatar* may also spawn in a random location in the *Game World* or a pre-determined *Spawn Point*. If the game design uses *Spawn Points*, the specific point may be determined randomly, according to an algorithm to provide *Player Balance*, or the player may be allowed to select from a set of *Spawn Points*.

Common goals closely related to the use of *Lives* are *Last Man Standing* and *King of the Hill*.

CONSEQUENCES *Lives* are a form of *Resources* that allow players to participate in the game as long as players have at least one life left. *Lives* give the players a clear *Continuous Goal*: to *Survive* against *Damage* from *Deadly Traps* or *Combat* against *Enemies* or other players, in the case of games with *Player Killing* and *Player Elimination*.

As *Lives* are typically linked to *Avatars* or *Characters*, they are a way to link the players' successes and failures in the game to those of their *Avatar* or *Character*. If players have emotional links to the *Avatars* or *Characters*, the risk of losing *Lives* increases the *Emotional Immersion*. Regardless of this, the presence of *Lives* can increase *Tension*, as players have something easy to relate to that can be lost in the game.

As multiple *Lives* do not exist in reality, the use of them in games can break a *Consistent Reality Logic*, not only by players having several lives but also through the process of *Spawning*.

RELATIONS

Instantiates: *Continuous Goals, Tension, Emotional Immersion, Resources, Player Killing, Spawning*

Modulates: *Avatars, Conflict, Evade, Survive, King of the Hill, New Abilities, Combat, Characters, Player Elimination, Last Man Standing*

Instantiated by: *Parallel Lives*

Modulated by: *Enemies, Deadly Traps, Spawn Points, Penalties, Damage, Renewable Resources*

Potentially Conflicting with: *Consistent Reality Logic*

Additional Patterns

Descriptions of these additional patterns can be found in the Chapter 5 folder on the companion CD-ROM.

ON THE CD

Parallel Lives **Ghosts**

Cameras **Book-Keeping Tokens**

LOCATIONS

These are patterns that modify locations within the *Game World* regarding what game elements exist there, what actions are possible there, and how they affect the completion of goals.

Strategic Locations

Strategic Locations are areas in the Game World that give an advantage to the players controlling them.

Their value can be that they contain game elements that allow certain actions or resources unavailable elsewhere, or that they control the access to other areas of the *Game World*.

Example: The player who controls the center of the game board in *Chess*, especially with officers, has a significant strategic advantage.

Example: Controlling locations that produce valuable resources, such as the cities in *Civilization* illustrated in Figure 5.8, provide the player a long-term strategic advantage.

FIGURE 5.8 Controlling cities in *Civilization* gives the player the ability to build more units. Civilization II and Civilization III screenshots courtesy of Atari, Inc. © 2004 Atari, Inc. All rights reserved.

USING THE PATTERN *Strategic Locations* may be either explicit by the presence of game elements or implicit deriving from the relationship between the location and other locations in the game. Explicit *Strategic Locations* can easily be created by the placement of *Resource Generators*, *Resource Locations*, *Chargers*, *Tiles*, *Pick-Ups*, *Power-Ups*, *Controllers*, *Safe Havens*, *Spawn Points*, and *Goal Points*. To ensure players' awareness of *Strategic Locations*, they can be set to stand out in the visual design of the *Game World* as *Outstanding Features*. Implicit *Strategic Locations* may be intentionally created by the arrangement of explicit *Strategic Locations* nearby, or they may be emergent features due to *Randomness* of *Resource* allocation or due to the combinations of player strategies. In either case, *Strategic Locations* can affect *Player Balance*, typically by giving advantages in *Combat*.

Games using player constructed boards from *Tiles* allow the players to modify the value of explicit *Strategic Locations* by placing them in positions where their relationship to other *Tiles* increase or decrease their usability. Similarly, *Tiles* with no inherent value can be made *Strategic Locations* by connecting them to other *Tiles* in a certain way.

A player might *Gain Information* about *Strategic Locations* as a *Supporting Goal* with *Traverse*, *Guard*, or *Reconnaissance*. It can be the primary subgoal in goals of *Exploration*. Knowing *Strategic Locations* can also influence *Spawning*, if players have control over which *Spawn Points* to use.

CONSEQUENCES Knowing and *Memorizing* the proper value and use of *Strategic Locations* is one way for the players to gain *Strategic Knowledge* in a game, for example, in *Traverse* goals. This is especially true for *Strategic Locations* that depend mainly on the topology of the surrounding *Game World* for their values, rather than on the explicit presence of valuable game elements. An example of how topology dictates that value of a location is the value of the central area of the board in *Chess*. If the locations can be owned in the game, *Strategic Locations* make excellent *Gain Ownership* goals that can be achieved through *Area Control* or other actions that provide *Ownership* of parts of the *Game World*.

RELATIONS

Instantiates: *Strategic Knowledge, Gain Ownership, Gain Information, Memorizing, Area Control*

Modulates: *Player Constructed Worlds, Guard, Gain Ownership, Reconnaissance, Traverse, Exploration, Combat, Spawning, Player Balance, Game World*

Instantiated by: *Power-Ups, Controllers, Tiles, Resource Generators, Pick-Ups, Goal Points, Spawn Points, Resource Locations, Safe Havens*

Modulated by: *Outstanding Features, Safe Havens, Ownership*

Potentially Conflicting with: None

Outstanding Features

Outstanding Features are parts of the Game World that cannot be manipulated but by their shape, color, or texture convey information to players.

For players to be able to position themselves in *Game Worlds*, there needs to be distinguishing features, those that more strongly attract players' attention to *Outstanding Features* and can make players aware of where game elements exist or how to navigate the *Game World*.

Example: The rivers in *Civilization* indicate that cities that are located near them have better production rates, as illustrated in Figure 5.9.

FIGURE 5.9 Rivers are *Outstanding Features* that indicate better production rates in *Civilization*. Civilization II and Civilization III screenshots courtesy of Atari, Inc. © 2004 Atari, Inc. All rights reserved.

USING THE PATTERN *Outstanding Features* can be achieved in many forms, from the barely noticeable to that of explicit *Extra-Game Information* describing to the players the game effects of game elements. When not using explicit *Outstanding Features*, the two main design choices can be categorized into first whether the feature should lure or dissuade, and second if the feature should be understandable before any consequences of nearby game elements are noticeable, or after those game elements (e.g., *Deadly Traps*) have taken effect. The former may make *Surprises* more difficult, while the second allows for *Strategic Knowledge* if the same *Outstanding Features* are used again in the game. *Traces* and *Clues* that cannot be manipulated are other examples of *Outstanding Features*.

The actual design of *Outstanding Features* can range from simple variations in the appearance of the *Game World* to *Obstacles* that give players' *Movement Limitations* due to their placement. An easy way to create *Outstanding Features* is to

introduce local *Symmetry* in an otherwise unsymmetrical environment. If the *Outstanding Features* have dynamic appearance or can change between different appearances, they can be used as *Status Indicators*, for example, to show the status of *Alarms*.

CONSEQUENCES *Outstanding Features* give players landmarks to support *Game World Navigation* in *Game Worlds*, thereby making *Exploration* goals easier to complete. Another typical use of *Outstanding Features* is to provide information where abstract game elements, such as *Chargers*, *Resource Locations*, and *Resource Generators*, are located within the *Game World*. *Strategic Locations* that do not depend on physical game elements are usually also marked by *Outstanding Features* in the immediate environment. In a similar fashion, *Outstanding Features* can be used to let players know or guess the presence of *Deadly Traps* but might then limit the chances of *Surprises* working.

In all these cases, *Outstanding Features* work as *Clues* and noticing them is an *Illusionary Reward*, since they may not necessarily aid the players.

RELATIONS

> **Instantiates:** *Extra-Game Information, Illusionary Rewards, Status Indicators*

> **Modulates:** *Game World Navigation, Resource Generators, Chargers, Resource Locations, Exploration, Deadly Traps, Strategic Locations, Game World, Alarms*

> **Instantiated by:** *Movement Limitations, Clues, Traces, Obstacles, Symmetry*

> **Modulated by:** None

> **Potentially Conflicting with:** *Surprises*

Chargers

Chargers are locations in the Game World that affect the players' resources when they are in the location.

Example: Speed boosters in *Super Monkey Ball II: Monkey Race* give, as their names imply, more speed to the player driving on top of the charger.

Example: *Battlefield 1942* and *Battlefield Vietnam* have two categories of chargers: medicine cabinets and ammunition caches that replenish the health and ammunition of the players' *Avatars* and repair facilities that fix damages to vehicles.

Example: The board game *Robo-Rally* contains repair areas, which remove damage from the player's robot if it spends time there.

USING THE PATTERN Selecting the *Improved Abilities*, the *New Abilities*, and possibly *Privileged Abilities*, or *Resources* gained defines the use of the *Charger*. The way it produces *Resources* is similar to *Resource Generators* except that players usually do not have any choice if they should be affected by the *Charger* (besides not entering its affect area), and any *Privileged Ability* granted by the *Charger* may be activated at once, for example, as in the case of speed boosters in most racing games. *Improved Abilities* can be handled by simply increasing *Skills* or increasing the effect of player actions.

CONSEQUENCES *Chargers* provide means for players to get *New Abilities* or *Improved Abilities* as well as providing *Renewable Resources*.

They function as both *Resource Locations* and *Resource Generators* but do not produce any *Resources* unless a player is within the area, which may require *Maneuvering* to get to. They are typically used to give the player *Renewable Resources*, which can be used as goals or to set the *Right Level of Complexity*. Their presence in a *Game World* creates natural *Gain Competence* and *Traverse* goals.

If the *Charger* provides a bonus beyond the normal limits, i.e., letting players move faster than otherwise possible, it can be seen as a form of *Power-Up* that gives *Privileged Abilities*. For *Chargers* that give a certain effect per time unit spent in its effect area, staying on it is a *Risk/Reward Tradeoff* for players as their *Freedom of Choice* is limited. If the area that contains the *Charger* can be controlled so other players cannot access the *Charger*, this can give rise to *Gain Ownership* goals.

RELATIONS

 Instantiates: *Resource Locations, Privileged Abilities, Renewable Resources, Gain Competence, Resource Generators, New Abilities, Improved Abilities*

 Modulates: *Gain Ownership, Traverse, Renewable Resources, Maneuvering, Skills, Resources*

 Instantiated by: None

 Modulated by: *Risk/Reward, Outstanding Features*

 Potentially Conflicting with: None

Additional Patterns

Descriptions of these additional patterns can be found in the Chapter 5 folder on ON THE CD the companion CD-ROM.

Resource Locations	**Safe Havens**
Goal Points	**Spawn Points**
Save Points	

6 Game Design Patterns for Resource and Resource Management

The patterns in this chapter focus on what different types of resources there are and how players and the game system can control the flow of these resources within and outside the game itself.

Types of Resources: *Resources, Secret Resources, Limited Resources, Non-Renewable Resources, Renewable Resources, Closed Economies*

Resource Control: *Producer-Consumer, Ownership, Resource Management, Producers, Consumers, Converters, Container, Shared Resources, Symmetric Resource Distribution, Asymmetric Resource Distribution*

Progress: *Investments, Diminishing Returns, Arithmetic Rewards for Investments, Geometric Rewards for Investments*

TYPES OF RESOURCES

These patterns govern what *Resources* are in the first place and what different main types of *Resources* can be used in games.

Resources

Game elements that are used by players to enable actions in a game.

Resources are the representation of a commodity that is used in the game to fund actions or is depleted by other players' actions. The commodity may exist as a physical game element or as a purely virtual one, or change between both. Common *Resources* in computer games include health and ammunition in first-person shooters, money and units in real-time strategy games, hit points and mana points in roleplaying games, action points in turn-based games, and players and money in sport management games.

Example: The board game *Space Hulk* gives each unit a number of action points at the beginning of a turn. These points are a form of *Resources* that pay for the actions of the units.

Example: *Victoria* is an example of a computer game with complex use of resource refinement, for example producing a Tank unit in the game requires the production of the Tank commodity. This commodity, in turn, requires *Resources* that are refined from other *Resources*, et cetera.

USING THE PATTERN The primary question regarding a *Resource* is what it is used for. Generalizing, a *Resource* is used to win a comparison with other players in an evaluation function or can sometimes be converted into actions (possibly providing *Privileged Abilities*) or other more valuable *Resources*. *Resources* are typically used or consumed by paying for actions through *Budgeted Action Points*, becoming part of objects built through *Construction* actions, or being destroyed due to *Damage*. Other actions that require the use of *Resources* are *Aim & Shoot* and *Betting*.

When *Resources* can be used for several different purposes, for example, as *Budgeted Action Points*, they can be used to modulate the *Right Level of Complexity* and force players to make *Tradeoffs*. Examples of games using one *Resource* for multiple purposes include the board game *Carolus Magnus*, where markers can be used to strengthen a faction's control over an area or the player's control over the faction, and the card game *San Juan* where each card represents a good, a colonist, money, and a building.

After determining the use of a *Resource*, the next question is how players gain access to the *Resources*. Players may start with *Non-Renewable Resources* to promote *Stimulated Planning* for the whole game session, actions may be required to collect the *Resources* from the *Game World*, *Resource Generators*, or *Chargers*, or the *Resources* may be rewards for completing certain goals. Regardless of how players achieve the *Resources*, the game may be set up to promote either *Symmetric Resource Distribution* or *Asymmetric Resource Distribution* to enforce different strategies and *Varied Gameplay*. However, *Asymmetric Resource Distribution* may negatively affect *Player Balance*, unless used in a controlled fashion to provide *Handicaps*. Goals that give *Resources* as *Rewards* are in most cases *Supporting Goals*. In addition to completing goals and *Collecting* them, players may be able to redistribute *Resources* among them through actions such as *Trading* and *Bidding*.

The *Resources* available at the beginning of game play may be the only resources that exist, or they may be *Renewable Resources*. In the latter case, they may be produced from *Resource Generators*, handed out at regular time intervals, or be *Rewards* for completing goals. All these options are examples of how *Producers* can create *Resources*, and together with how the *Resources* are consumed, they form *Producer-Consumer* patterns. When the resources are collected from the *Game*

World, several additional design choices are required, including the location of the *Resources*, who can see them, and whether there are *Clues* to where they can be found. Are they *Secret Resources* that are hidden by *Fog of War* or can they only be detected by *Privileged Abilities*? Are they *Rewards* for finding *Easter Eggs*? Do they appear in different amounts or concentrations? What time is required to collect them? What game elements can collect them? Does the possession of them affect game element characteristics? Are they physical entities in the game and, if so, can they be converted to virtual ones? Do players have influence over how they are divided between players through *Player-Decided Distribution of Rewards & Penalties*?

Once possession of a *Resource* is achieved, does it need to be stored in a *Container*, and is there a maximum of how much of a resource can be stored? Does the *Resource* need to be used before a certain *Time Limit* has expired? Can the *Resources* be lost as an effect of *Penalties*?

The next question is how control of resources is decided. Is it a *Shared Resource* whose use several players need to agree upon through *Negotiation*, or is it manipulated by all players through *Indirect Control*? Is the ownership changeable, i.e., can other players steal *Resources* by various actions that have *Transfer of Control* effects, or can the players change *Resources* through *Trading*? When *Resources* are contested but also used to produce *Units*, the struggle for *Resources* can become a *Red Queen Dilemma* where gaining control over larger amounts of *Resources* can only be achieved by consuming larger amounts of *Resources*.

In games where several different types of resources are used, knowing how and when to convert one form of resource to another may be part of the *Strategic Knowledge* of the game. The conversion may have inefficient exchange rates (by use of *Diminishing Returns*), may require access to a *Converter*, or may only be possible through *Trading* with other players.

Resources usually have to fit within the *Consistent Reality Logic* of the game, the main exception being *Time Limits* to prevent *Analysis Paralysis* and *Resources* that are primarily used to determine winning conditions. In this light, the concept of *Score* can be seen as a *Resource*, which is used to determine the winner of a game.

Units are common *Resources* in god games. The games *Lemmings* and *Pikmin* both make use of different types of *Units* that players have to direct to achieve goals while making *Tradeoffs* between various actions and what *Units* to use. The equivalent to these *Resources* in games using *Avatars* is *Lives*.

The introduction of *Time Limits* or *The Show Must Go On* in games makes time a *Resource* that has to be used efficiently. The computer game *Space Hulk* uses two modes of play: a strategic mode, where nothing happens but which is time limited, and a real-time mode, where the *Time Limit* is replenished but commands cannot be given to *Units*, to force players to promote *Tension* together with *Stimulated Planning*.

CONSEQUENCES *Resources* provide players with quantifiable measures to judge their progress and plan possible future actions, and thereby provide one way for players to have *Emotional Immersion* in games. The *Resources* can either exist from the beginning of gameplay or be created through *Producers*, and are either destroyed by *Consumers*, transformed through *Converters*, or part of *Closed Economies*. Games where the goal consists of *Collecting* various types of *Resources* can use the number of owned *Resources* as a *Score*, and in games that have a separate *Score* system, *Resources* are often used as a second order *Score* system to function as *Tiebreakers*. The presence of *Resources* in *Game Worlds* can motivate *Area Control* goals and *Exploration* goals in the case of *Secret Resources*. *Resources* are often also used to give *Characters* acting as *Consumers* or *Converters* the ability to perform actions. In some games, the distribution of *Resources* between players decides the order of *Turn Taking*.

RELATIONS

> **Instantiates:** *Collecting, Score, Stimulated Planning, Varied Gameplay, Strategic Knowledge, Tradeoffs, Easter Eggs, Rewards, Penalties, Red Queen Dilemmas*
>
> **Modulates:** *Player-Decided Distribution of Rewards & Penalties, Player Balance, Tiebreakers, Construction, Area Control, Turn Taking, Characters, Emotional Immersion, Exploration, Game World, Supporting Goals*
>
> **Instantiated by:** *Score, Units, Clues, The Show Must Go On, Time Limits, Lives, Budgeted Action Points, Indirect Control*
>
> **Modulated by:** *Symmetric Resource Distribution, Asymmetric Resource Distribution, Converters, Container, Secret Resources, Non-Renewable Resources, Shared Resources, Renewable Resources, Limited Resources, Ownership, Transfer of Control, Resource Generators, Handicaps, Secret Resources, Time Limits, Trading, Diminishing Returns, Damage, Aim & Shoot, Betting, Producers, Consumers, Closed Economies, Chargers, Trading, Bidding, Producer-Consumer, Investments*
>
> **Potentially Conflicting with:** None

Additional Patterns

Descriptions of these additional patterns can be found in the Chapter 6 folder on the companion CD-ROM.

Secret Resources	**Renewable Resources**
Limited Resources	**Closed Economies**
Non-Renewable Resources	

RESOURCE CONTROL

The following patterns are used to govern the *Resource* flows within the game from the basic patterns for *Resource* production and consumption to the patterns that dictate how players can have access to the *Resources*.

Producer-Consumer

Producer-Consumer determines the lifetime of game elements, usually Resources, and thus governs the flow of gameplay.

Games usually have several overlapping and interconnected *Producer-Consumers* governing the flow of available game elements, especially resources. As resources are used to determine the possible player actions, these *Producer-Consumer* networks also determine the actual flow of the gameplay. *Producer-Consumers* can operate recursively, i.e., one *Producer-Consumer* might determine the lifetime of another *Producer-Consumer*. *Producer-Consumers* are often chained together to form more complex networks of *Resource* flows.

> **Example:** In *Civilization*, the units are produced in cities and consumed in battles against enemy units and cities. This kind of a *Producer-Consumer* is also used in almost all real-time strategy games.

> **Example:** In *Asteroids*, the rocks are produced at the start of each level and are consumed by the player shooting at them. The same principle applies to many other games where the level progression is based on eliminating, i.e., consuming, other game elements: the pills in *Pac-Man*, free space in *Qix*, and the aliens in *Space Invaders*.

USING THE PATTERN As the name implies, *Producer-Consumer* is a compound pattern of *Producer* and *Consumer* and as such, this pattern governs how both are instantiated. The effect of producing and consuming *Resources* or *Units* often turns out to be several different pairs of *Producer-Consumers*, as the produced game element can be consumed in many different ways. For example, the *Units* in a real-time strategy game such as the *Age of Empires* series can be eliminated in direct combat with enemy *Units*, when bombarded by indirect fire, and finally when their supply points are exhausted. The *Producer-Consumer* in this case consists of the *Producer* of the *Units* with three different *Consumers*.

Producer-Consumers are often, especially in *Resource Management* games, chained together with *Converters* and sometimes *Containers*. These chains can in turn be used to create more complex networks. The *Converter* is used as the *Consumer* in the first *Producer-Consumer* and as the *Producer* in the second. In other words, the *Converter*

takes the *Resources* produced by the first *Producer* and converts them to the *Resources* produced by the second *Producer*.

This kind of *Producer-Consumer* chain sometimes has a *Container* attached to the *Converter* to stockpile produced *Resources*. For example, in the real-time strategy game *StarCraft*, something is produced and taken to the converter and then converted to something else and stockpiled somewhere. *Investments* can be seen as *Converters* that are used to convert *Resources* into other forms of *Resources*, possibly abstract ones.

CONSEQUENCES As is the case with the main subpatterns *Producer* and *Consumer* of *Producer-Consumer*, the pattern is quite abstract but the effects on the flow of the game are very concrete. The *Producer-Consumers* simply govern the whole flow of the game from games with a single *Producer-Consumer* to games with complex and many layered networks of *Producer-Consumers*.

The feeling of player control is increased if players are able to manipulate either the *Producer* or *Consumer* part or both. However, in more complex *Producer-Consumer* chains, this can lead to situations where players lose *Illusion of Influence* as the effects of individual actions can become almost impossible to track down and the process no longer has *Predictable Consequences*. Also, adding new *Producer-Consumers* that the players have control over gives them opportunities for more *Varied Gameplay*. *Producer-Consumer* networks with *Converters* and *Containers* are used in *Resource Management* games to accomplish the *Right Level of Complexity*. The game usually starts with simple *Producer-Consumers* and, as the game progresses, new *Producer-Consumers* are added to the network to increase the complexity.

RELATIONS

Instantiates: *Varied Gameplay, Resource Management*

Modulates: *Resources, Right Level of Complexity, Investments, Units*

Instantiated by: *Producers, Consumers, Converters*

Modulated by: *Container*

Potentially Conflicting with: *Illusion of Influence, Predictable Consequences*

Ownership

Ownership dictates which of the players have access to the Resources and other game components and how.

Often the *Ownership* in games is tied to specific game elements used as *Resources*, but the same principles can also be applied to goals, information, and even player-to-player relationships. The most intuitive one, of course, is the *Ownership* of concrete game elements such as pieces in a board game or cards in card games. The *Ownership* can also vary between being persistent even between game instances, as in *Magic: The Gathering* and other collectable card games, to being permanent within the game instance, as with the pieces in *Chess*, to being variable within the game instance, as with the basic resources in *Settlers of Catan*.

> **Example:** In *Chess*, the players have 16 pieces each, the *Ownership* is indicated by the color of these pieces, and the *Ownership* governs that only the player that owns the piece can move it on his turn, and that only pieces owned by the opposing player can be captured. The pieces are used to claim *Ownership* of the grids of the chessboard.

> **Example:** In *Diplomacy*, the players can claim *Ownership* of the areas by occupying them with armies. The areas owned by a player are used to calculate the amount of armies and fleets the player can control. Also, only the owner of the army or the fleet can command it.

> **Example:** In collectable card games such as *Magic: The Gathering*, the player may own hundreds or even thousands of different cards, and one of the main reasons for playing the game is the sense of *Ownership* of such a collection. The collection is used to create the decks used in single game instances and, naturally, the more cards the player owns the better possibilities there are for creating the decks used in play.

> **Example:** *Settlers of Catan* incorporates several layers of *Ownership*. The most basic one is the *Ownership* of basic *Resources*, which are used to build roads, settlements, and cities, and to buy special development cards. The player, naturally, has *Ownership* of these elements as well. The player building the longest continuous road claims the *Ownership* of the longest road card and the player having most armies claims the *Ownership* of the largest army card. The *Ownership* of these cards is used to calculate victory points.

USING THE PATTERN *Ownership* is mainly used in games to provide goals for players, provide *Resources* needed to continue performing actions, or give *Privileged Abilities* for owning specific *Tools* or *Producers*. In some games, the players can also share the *Ownership* of other game components such as *Mutual Goals* or information. The game can have several different *Resources* with several different *Ownership* structures. Some of these *Ownership* structures require that the design of both the game itself and the *Meta Game* level take them into account. For example, most

collectable card games in which the *Ownership* of the cards is persistent between game instances have *Trading* on the *Meta Game* level or have *Extra-Game Consequences* in a form of *Betting*.

Ownership can either be permanent in game instances or change due to *Transfer of Control* events. Having permanent *Ownership* within one game instance is often used in games with *Non-Renewable Resources*, such as *Chess*, where the *Ownership* of the game pieces is fixed at the start of the game and remains fixed until the end of the game or until the pieces are captured and removed from play. Card games almost invariably use *Card Hands* where the *Ownership* usually dictates that only the player owning the *Card Hand* has *Perfect Information* of the cards and can use the cards in play. The composition of the *Card Hand*, however, can change radically during the game. *Investments* are an interesting use of *Ownership* where *Ownership* of a *Resource* is renounced for a while in order to later claim *Ownership* of the *Rewards* of the *Investments*. It can be said that *Investments* are speculative *Ownership* structures.

Ownership can be used to motivate many types of goals in games. The most obvious goal related to *Ownership* is naturally *Gain Ownership*, where the objective is to achieve *Transfer of Control* of the goal object to the player. *Capture*, *Guard*, and *Rescue* are also goals that usually involve either the *Transfer of Control* of the goal object or prevention of the *Transfer of Control*. These goals are likely to cause *Conflict*, especially if they cause *Player Killing*. *Collection* as a goal naturally involves the use of *Ownership* for both the parts of the *Collection* and for completing the *Collection* itself. This is evident especially in cases where the *Ownership* is persistent from game instance to game instance as in Collectable Card Games. *Pokémon* is also an excellent example of using the completion of a *Collection* as an overarching goal of the game.

As for goals, *Ownership*—or the possibility of *Ownership*—can motivate players to perform many forms of actions. *Trading*, both between the players and with the game system, is based on *Ownership* as *Trading* involves *Transfer of Control*. Actions to gain *Area Control*, even in its simplest forms, are also dependent on *Ownership*. For example, the piece can be said to own the grid it is standing on. More complex forms of *Ownership* in *Area Control* involve explicit *Transfer of Control* of the areas as is done in many strategy games, such as *Diplomacy* and *Europa Universalis*. In some of the strategy games, the *Ownership* structures of the areas are complex, where the players can also give partial *Ownership* of the areas, for example, rights to move armies through the areas or even to make the areas *Shared Resources*, where the other players have the same *Ownership* rights to the area as well.

Asymmetric Resource Distribution and *Symmetric Resource Distribution* can be used to create different *Ownership* structures for different players and motivate both *Gain Ownership* goals and *Trading* actions. *Ownership* can also be shared between many players, as is done in games based on *Shared Resources*.

CONSEQUENCES Sense of *Ownership* is a strong basic human emotion, and *Ownership* can be used to create *Tension* in the game as is evident in games involving loss of *Ownership* as a threat. *Ownership* is also one of the cornerstones for deepening the *Emotional Immersion* in the game and achieving *Identification* through, for example, using *Avatars* in *Persistent Game Worlds*. The *Tension* and *Emotional Immersion* caused by *Ownership* is however reduced for *Renewable Resources* compared to *Non-Renewable Resources*.

Besides *Ownership* that games explicitly have given to players, feelings of *Ownership* are likely to occur for game elements produced by *Producers* under the players' control, or even stronger, when players have had *Creative Control* of game elements or other aspects of the *Game World*.

RELATIONS

Instantiates: *Identification, Emotional Immersion, Tension, Mutual Goals, Rewards, Betting, Privileged Abilities*

Modulates: *Resources, Strategic Locations, Investments, Characters, Capture, Collection, Guard, Rescue, Units, Resource Management, Meta Games, Conflict, Persistent Game Worlds, Non-Renewable Resources, Renewable Resources*

Instantiated by: *Transfer of Control, Card Hands, Avatars, Area Control, Creative Control*

Modulated by: *Shared Resources, Asymmetric Resource Distribution, Symmetric Resource Distribution, Shared Rewards, Producers, Tools, Gain Ownership, Trading, Player Killing*

Potentially Conflicting with: None

Resource Management

The players have to plan, manage, and control resource flows within the game in order to reach the goals of the game.

All games where the use of *Resources* is not simply used for bookkeeping require players to perform *Resource Management*. This includes deciding how to use *Resources* to perform different actions and strive toward different goals as well as planning on how to acquire new *Resources* and judging which *Resources* will be most valuable in the future.

Example: Almost all strategy games, including real-time ones, have a strong *Resource Management* component. The final goal is usually just to overcome the opponents by maximizing the use of the *Resources* available.

Example: *Magic: The Gathering*, as well as other collectable card games, has *Resource Management* in at least three layers. First, when playing a single game instance the cards in the deck selected for the game are the *Resources* that have to be managed to overcome the opponents; second, the cards for that deck usually have to be selected from a much larger collection of cards available; and third, managing the whole collection consists of buying new cards, trading cards with other people, and other methods of obtaining the cards. The last layer of *Resource Management* often involves the use of extra-game *Resources*, usually real money.

Example: Professional team sports such as *Soccer* and *Ice Hockey* have a high level *Resource Management* layer for managing the composition of the teams.

USING THE PATTERN The basic building block for instantiating *Resource Management* in the game is to have some sort of *Limited Resources*, which have a direct impact on the possibilities of reaching the goals of the game through the use of *Producers* and *Consumers*. In *Chess*, for example, the players have 16 pieces each at the start, and these are *Non-Renewable Resources*. The use of *Renewable Resources* as *Limited Resources* often creates more complex games, especially when there are *Producer-Consumer* chains with *Converters* for creating the final *Resources* from the basic *Renewable Resources*. For example, in *Age of Empires*, the basic *Resources*, such as wood and food, first have to be gathered from *Resource Locations* back to the stock-piles, the *Containers*, and then these *Resources* can be refined in *Converters* to *Units*. In some games, the renewal rate of the *Renewable Resources* can also be one of the *Resources* to be managed.

Interesting variations of *Resource Management* are *Player-Decided Distribution of Rewards & Penalties* where the *Resources* to be managed are, as the name implies, *Rewards* or *Penalties* of the game and *Attention Swapping*, where the players' attention is the basic *Resource* to be managed. In many cases of team-oriented *Multiplayer Games*, the players themselves are also *Resources*, which have to be managed as part of *Team Development*. This management level can lead to *Social Organizations* where there is a hierarchy of control similar to the hierarchy of military operations.

In any case, *Resource Management* can become uninteresting if there are no *Tradeoffs* with associated *Risk/Reward* structures. This can happen especially in cases where the availability of the *Resources* is out of balance or where there is a dominant strategy for maximizing the utility of the *Resources*.

Book-Keeping Tokens are not used for *Resource Management* since they do not require any active decisions, investments, or risks on any players' behalf.

CONSEQUENCES *Resource Management* gives players a *Freedom of Choice* of how to use *Producers* and *Consumers* in a game and often causes *Gain Ownership* goals. Games with *Resource Management* usually involve long-term *Stimulated Planning*, and this kind of strategic thinking can lead to *Cognitive Immersion*. Games involving management of complex *Producer-Consumer* chains can make *Resource Management* a means through which players can develop *Game Mastery*. The *Resource Management* involved in these games ranges from controlling the immediate *Resources*, for example *Units* in a strategy game, to making long-term *Investments*, such as research in *Civilization* to increase the number of different *Unit* types available.

If it is possible to quantify how well the players have performed *Resource Management*, this can be used as a *Tiebreaker*.

RELATIONS

Instantiates: *Tradeoffs, Cognitive Immersion, Stimulated Planning, Risk/Reward, Freedom of Choice, Game Mastery*

Modulates: *Tiebreakers, Right Level of Complexity, Social Organizations, Team Development*

Instantiated by: *Limited Resources, Renewable Resources, Attention Swapping, Player-Decided Distribution of Rewards & Penalties, Combat, Betting, Producer-Consumer, Investments, Units*

Modulated by: *Converters, Ownership, Container, Consumers, Producers, Gain Ownership*

Potentially Conflicting with: *Right Level of Complexity, Book-Keeping Tokens*

Additional Patterns

Descriptions of these additional patterns can be found in the Chapter 6 folder on the companion CD-ROM.

ON THE CD

Producers	**Shared Resources**
Consumers	**Symmetric Resource Distribution**
Converters	**Asymmetric Resource Distribution**
Container	

PROGRESS

These patterns describe how players, and the game system, can control the transforming of resources to higher-order resources or to use the resources to progress the game.

Investments

Committing Resources for a certain amount of time to something in order to reap the rewards later.

Games where players have to use *Resources* without immediate results give players the opportunity to make *Investments*. This requires players to make difficult decisions based upon uncertain futures, and some games, especially strategy games, contain many different layers of *Investments* to create complex gameplay experiences. Games from other genres often also contain *Investments*, but these *Investments* are usually not as directly perceivable.

> **Example:** *Tetris* has an incentive mechanism for taking risks in form of *Investments* in order to reap greater rewards as the simultaneous removal of several rows brings in more points than removing them one by one. Players, in effect, make *Investments* by creating situations where, for example, the four block stick would fit and remove four rows at the same time.

> **Example:** The research ladders in the *Civilization* series as illustrated in Figure 6.1 bind valuable *Resources* for a long time without direct rewards. The progress in research, however, will give a significant advantage in military power later in the game. A lower layer of *Investments* is the building of the combat and settlement units. They take time and *Resources* to build and they are not necessarily useful right away.

> **Example:** Developing the character's skills and attributes in roleplaying games is a direct form of *Investments*. Raising the skills and attributes is costly and there are no direct rewards or benefits from the game system point of view for doing so. These skills and attributes, however, are often useful in the long run.

USING THE PATTERN *Investments* require that players voluntarily let a form of *Consumers* destroy *Resources* in order to gain the *Rewards* later in the game. However, the *Investments* must have some form of *Predictable Consequences* for players in order for them to be willing to invest *Resources* or time into the *Investments*. There are three main design choices when designing *Investments*: choosing the *Resources*

FIGURE 6.1 The complex research ladders in *Civilization III* are a form of *Investments*. Civilization II and Civilization III screenshots courtesy of Atari, Inc. © 2004 Atari, Inc. All rights reserved.

that can be used in the *Investments*, deciding on the relationship between the kinds of *Rewards* given and the different kinds of *Resources* used, and determining the relationships between different amounts of *Investments* and how this affects *Rewards*. *Budgeted Action Points* are always a form of *Investment* as they are the players' basic *Resources* for performing actions in the game.

The simplest case of *Investments* is when the *Resources* and the *Rewards* are of the same kind, such as putting money in a bank account to get a certain interest rate back or *Betting* on the outcome of an action. The *Resources* and *Rewards* in these cases are usually fungible currencies of some kind within the economy of the game system. The next category is to use chains of *Producer-Consumers* with *Converters* to create a "ladder" of refinements of *Resources* from basic *Resources* to *Construction* of *Units* and new *Producers* and *Converters*. Treadmilling, having to perform repetitive actions in order to get basic *Resources* such as experience points and new items, exist

in many MMORPGs and belongs to this category. In this case, the raw *Resource* is basically the players' time. In *Self-Facilitated Games*, the *Investment* of time, as well as other *Extra-Game Consequences* into maintaining game sessions, can have *Social Status* as the primary, possibly intended, *Reward*. The last category of direct *Investments* is to use the more basic *Resources* to obtain *New Abilities*, *Privileged Abilities*, and *Skill* improvements for the *Units* and *Characters* under the players' control. In the case of *Multiplayer Games*, the improvement of individual players' abilities takes the role of improvement of *Units* and forms the basis for *Team Development*.

The game system *Rewards* can be roughly classified into *Arithmetic Rewards for Investments* and *Geometric Rewards for Investment* regardless of the type of *Reward* compared to the *Investment*. *Randomness* of the exact specification of the *Rewards* lessens the *Predictable Consequences* of *Investments*, while *Rewards* whose usefulness or value are in *Paper-Rock-Scissors* relationships with *Investments* of other players increase both the risk and potential reward of the *Investment*. *Diminishing Returns* together with either of the previous types can be used to encourage more *Varied Gameplay* and to maintain *Player Balance*. All these affect players' *Risk/Reward* choices to do *Investments*.

The *Rewards* associated with the *Investments* can be different from the *Resources* used in the *Investment* itself. For example, investing experience points in raising weapon *Skills* in a fantasy-oriented roleplaying game is associated with the game system *Reward* of performing better in combat. This kind of *Character Development* is, of course, also associated with non-game system *Rewards* of achievement and recognition.

Games can allow players to make *Investments* through *Extra-Game Actions* to achieve *Game Mastery* or make artistic use of in-game actions that they have *Creative Control* over. Further, *Social Organizations* and *Self-Facilitated Games* require or encourage players to make *Investments* that have *Extra-Game Consequences* in the form of invested time and effort.

CONSEQUENCES *Investments* are a form of *Resource Management*, and usually a *Committed Goal*, as *Resources* are typically bound in the *Investments*. Bringing *Investments* of any form into game designs promotes *Stimulated Planning*, as the player has to plan ahead the use of *Resources* and weight this with the possible later *Rewards*. This is the case even in the *Tetris* example: the player has to plan how to use the blocks to get more points by removing several rows at the same time. In this case, as in most *Investments*, there are also risks involved, and the players have to make decisions by assessing the involved *Risk/Reward* relations.

Investments are a direct form of *Extended Actions* with *Delayed Effects*: there is a time delay between the action of investing the *Resources* and having the effect of that action. The difference between *Investments* and other forms of *Delayed Effect* is

that the *Resources* used in the *Investment* are tied up between the action and the effect. The main incentives for the players to make *Investments* are, of course, the possible *Rewards* associated with the outcome of the *Investment*. This kind of longer-term planning is a common feature in everyday life, and games just make these decision points more explicit.

RELATIONS

Instantiates: *Predictable Consequences, Rewards, Budgeted Action Points, Delayed Effects, Stimulated Planning, Social Statuses, Social Organizations, Resource Management, Committed Goals, Team Development*

Modulates: *Skills, Character Development, Resources, Extra-Game Consequences*

Instantiated by: *Predictable Consequences, Score, Units, Construction, Betting, Ultra-Powerful Events, Extended Actions, New Abilities, Privileged Abilities, Characters, Consumers, Self-Facilitated Games, Game Mastery, Creative Control, Extra-Game Actions*

Modulated by: *Ownership, Arithmetic Rewards for Investments, Geometric Rewards for Investments, Diminishing Returns, Producer-Consumer, Paper-Rock-Scissors, Extra-Game Consequences, Risk/Reward*

Potentially Conflicting with: None

Diminishing Returns

The returns for similar investments decrease as the player progresses in the game.

To encourage variation in gameplay, many games make player effort have less and less effect after a certain point. This reduction of usefulness in invested actions, *Resources*, or even display of high skill levels are all indications of *Diminishing Returns* in the game design.

Example: The potential gains of winning bidding sessions in games have diminishing returns that become more and more apparent the further the bidding session goes on.

Example: In many roleplaying games, raising skills and abilities require more experience points, or other types of investments, for the higher skill and ability levels.

USING THE PATTERN *Diminishing Returns* offer a way to modulate *Rewards* for *Investments* in addition to *Geometric Rewards for Investments* and *Arithmetic Rewards for Investments*, and can be used to modulate these *Reward* schemes to achieve *Player Balance*. Implementing *Diminishing Returns* is simple by just making

the *Rewards* associated with similar *Investments* smaller as the player progresses in the game. *Diminishing Returns* can also be used to limit the effectiveness of different means of *Renewable Resources* in games.

CONSEQUENCES *Diminishing Returns* naturally modify *Player Balance* where there is a possibility to advance *Skills* and receive *Improved Abilities* of the player controlled *Units* and *Characters*, especially in games in which *Mules* are possible. The advantages for making *Investments* diminish as the players' progress in the game. At the same time, this creates a practical limit for the progress while keeping the feeling, or in many cases an illusion, of player progress and *Character Development*. In this case, the *Diminishing Returns* are a form of *Balancing Effect*. *Diminishing Returns* can also be used as a incentive for more *Varied Gameplay* as the players gain less and less *Rewards* by performing the same kind of actions and may encourage *Transfer of Control* of *Resources* between players.

RELATIONS

> **Instantiates:** *Player Balance, Balancing Effects*
>
> **Modulates:** *Investments, Rewards, Varied Gameplay, Skills, Character Development, Improved Abilities, Renewable Resources, Transfer of Control, Geometric Rewards for Investments, Mule, Resources, Arithmetic Rewards for Investments*
>
> **Instantiated by:** None
>
> **Modulated by:** None
>
> **Potentially Conflicting with:** *Arithmetic Rewards for Investments, Geometric Rewards for Investments*

Additional Patterns

Descriptions of these additional patterns can be found in the Chapter 6 folder on
ON THE CD the companion CD-ROM.

> **Arithmetic Rewards for Investments**
>
> **Geometric Rewards for Investments**

7 Game Design Patterns for Information, Communication, and Presentation

The patterns in this chapter focus on how information about the game state is made available to the players or is kept hidden from them. These patterns are most often used to govern the player's access to information about the game elements. The information patterns, however, can also be used for any other component of the framework, for example, to hide from players actions other players have performed or make a player's subgoals unknown at the beginning of the game and reward the discovery of them. Similarly, it is possible to use these patterns for end conditions, evaluation functions, and the knowledge of other players' existence to modify gameplay.

Information Quality: *Imperfect Information, Perfect Information, Uncertainty of Information, Fog of War, Red Herrings*

Information Distribution: *Symmetric Information, Asymmetric Information, Public Information*

Information Access: *Communication Channels, Indirect Information, Direct Information*

Indicators: *Outcome Indicators, Progress Indicators, Near Miss Indicators, Goal Indicators, Status Indicators*

Information Presentation: *Game State Overview, First-Person Views, Third-Person Views, God Views*

INFORMATION QUALITY

These patterns address what information is available to a single player and, to a certain extent, the quality and reliability of that information.

Imperfect Information

One aspect of information about the total game situation is not fully known to a player, either the information known is totally wrong or the accuracy of the information is limited.

There are several ways of withholding knowledge about the current or previous states of the game from a player. The player may have access only to a limited set of attributes of the game components or the player may not even know about the existence of certain components or their attributes. In multiplayer games, the players can very rarely be completely convinced that they have *Perfect Information* about the strategies and goals of the other players.

Games of chance are not necessarily games using *Imperfect Information*, as players can, as in *Yahtzee*, have *Perfect Information* about what has occurred previously in the game.

> **Example:** Games of exploration and discovery, such as many adventure and role-playing games, use *Imperfect Information* to gradually reveal the world and the story to the players.

> **Example:** The removal of *Imperfect Information* can be system controlled, such as when players reveal their cards at the end of a *Poker* round to settle who has the winning hand.

> **Example:** *Doom* provides statistics of how many secrets exist on a level after the players have completed it. It does not, however, reveal their location, meaning the players can replay the level simply to try to find all the secrets.

> **Example:** Both *Zendo*, a matching game, and *Eleusis*, a card game, have rules that are decided by an umpire before gameplay begins, and winning the game consists mainly of being able to guess the rules.

USING THE PATTERN Obviously, the designer has to choose what parts of the game state will not to be revealed to the players when using *Imperfect Information*. The dynamics of *Imperfect Information* are another aspect to consider. How can the missing information be revealed to the player? What are the incentives for the player to gain the missing information? Is the information embedded in game elements under players' control (such as *Cards*) or provided by, for example, *Book-Keeping Tokens* or *Dedicated Game Facilitators*? How much does the use of *Imperfect Information* rely on players *Memorizing*? If all players do not have the same level of information available to them, *Imperfect Information* gives rise to *Asymmetric Information*. This can also be achieved by not revealing the information to the players

simultaneously, so that some players have more information available to them than others, at least for a certain time.

There are two main ways in which players can have *Imperfect Information*: either they lack information or they have faulty information. Lack of information is typically combined with access to information on a higher level; players may not know what *Units* are used by the other players, but they know what kinds of *Units* exist in a strategy game, for example, they know what *Cards* exist in a deck of cards, but they may not know the exact *Cards* the other players have. These two examples are also typical uses of *Secret Resources*. Faulty information means that a player has received information that is not correct, either due to intentional actions by the other players or *Indirect Information* that has caused misinterpretation. *Uncertainty of Information* can be used to modulate both instances, in the first case by providing partial information on the basic or the higher level, and in the second case by providing *Clues* that the information may not be correct.

The use of faulty information is primarily to set up *Red Herrings*, provide system support for player *Bluffing*, or to allow the system to fake *Near Miss Indicators*. By contrast, lack of information is used primarily to set up *Gain Information* goals. Games with a strong presence of *Exploration* are good examples of this kind of use of *Imperfect Information*, often using *Tile-Laying* or combining *Fog of War* with *Game State Overview*. The latter pattern is in itself an instance of *Imperfect Information*, since it is not a complete view of the game state but an overview, and in some cases, only updated information about the environment in which the players' *Focus Loci* can be found.

The use of *Imperfect Information* usually assumes that the missing information is revealed to the player at some point, but this does not necessarily have to be the case. Games with systemized information control—especially computer games— can leave parts of the information concealed for the duration of the game. There are two main reasons not to clarify the *Imperfect Information* even after the game has been played. The first reason, typically linked with *Optional Goals*, is that players can replay the game, or part of the game, to complete the goals overlooked in the earlier game sessions. This can lead to some amount of *Replayability*, as players have an incentive to find out the missing information, but it can also end up in player frustration. This form of *Imperfect Information* also allows for *Trans-Game Information* to be shared between players and between game instances. The second reason may be to avoid revealing secret tactics or building up *Strategic Knowledge*, for example in *Tournaments* where the information from one game instance can be used in later game instances.

Imperfect Information is often applied to game elements, to support *Gain Information* or *Gain Ownership* goals, and to goals in general, to support *Unknown Goals*. A goal can easily be made into a *Hierarchy of Goals* by providing *Imperfect*

Information about it and using *Gain Information* as a subgoal to the main goal, for example, having a *Configuration* as the main goal but not providing full information about what game elements are to be part of the *Configuration*. A further use of the application of the pattern to goals in this sense is to hide parts of the *Narrative Structure* of the game. Games with *Dedicated Game Facilitators* can have *Imperfect Information* about rules and actions, which can later be revealed as *Rewards* or reached by *Experimenting*. Having rules with *Imperfect Information* without *Dedicated Game Facilitators*, as for example in some forms of roleplaying games and children's games, may allow *Creative Control* but can easily ruin *Immersion* due to rule arguments.

A simple case of a lower level of accuracy of information is the use of overview maps, a form of *Game State Overviews*, in games of a spatial nature. The overview map is a diagram of the whole game area concealing the details of the spatial arrangement and illuminating certain higher level aspects of that area. It can, of course, be said that the map itself is a more accurate description of the significant features of the area, such as the room configuration in an adventure game, but the point is that these are on a different representation level, concerned with different aspects of the spatial configuration and thereby providing different levels of accuracy.

In some games, players have control over how to create *Imperfect Information*. This is common in games where one player is trying to spread disinformation to the other players, typically by *Bluffing*. However, games that present large amounts of information to players, e.g., reconfigurable forms of *Game State Overview*, can let the players modify these presentations with *Imperfect Information* to avoid *Analysis Paralysis* from information overload.

CONSEQUENCES *Imperfect Information* and *Uncertainty of Information* are tightly connected, and the presence of one usually indicates the presence of another. While *Uncertainty of Information* deals with transfer of information, *Imperfect Information* deals with the information the players possess and how they can use that information. Depending on the discourse and what is considered information transfer, *Uncertainty of Information* can be achieved through *Imperfect Information*. An explicit example of this is when game elements are used to transfer information between a few players, and the other players have *Imperfect Information* about which game elements are actually transferred.

Imperfect Information is often the basis for *Gain Information* goals since these goals can be easily defined as finding or confirming information about specific game elements. The completion of these goals can then be used to help *Predictable Consequences* for the players in the game, to give players *Strategic Knowledge*, to describe how a *Configuration* should be achieved, or to unfold the *Narrative Structure*. In the last case, *Imperfect Information* also offers the possibility for having *Surprises*. However, for the *Gain Information* goal to be present, players must at least have the

knowledge that they have *Imperfect Information* about something. For example, to have the goal of finding the princess, the players must first know that there is a princess and that players do not currently know where the princess is.

The dynamics of *Imperfect Information* are a natural part of creating different kinds of *Anticipation*. *Imperfect Information* has an effect on the capability of the players to analyze the situation in order to determine their next actions. This kind of *Limited Foresight* gives *Limited Planning Ability* regarding either the level of detail or the length of the planning and may lead to *Risk/Reward* situations where the players can or have to resort to *Leaps of Faiths*. In cases where *Imperfect Information* is about the other players' game elements, it may be difficult for these players to succeed with *Interferable Goals* or even to be in *Conflict* with each other. However, *Imperfect Information* about neutral or other players' game elements can be necessary for certain actions—for example, *Betting*—and can prolong the players' opinion that they have a *Perceived Chance to Succeed*. *Imperfect Information* about players' abilities and *Resources* can also heavily influence how players perceive and act in *Combat* or *Player-Decided Distribution of Rewards & Penalties*.

Depending on the nature of the information, *Imperfect Information* can have either negative or positive effects on *Analysis Paralysis*. An example where *Imperfect Information* can cause *Analysis Paralysis* can be found in *Stratego* and trick-taking card games. In these cases, the players can try to deduce the missing information from the available information while forcing other players to have *Downtime*. An example where *Imperfect Information* is used to avoid *Analysis Paralysis* can be found in some real-time strategy games. The locations of the enemy bases are hidden from the players at the beginning of the game, letting the players focus upon building their own bases and exploring the nearby environment.

Games relying on *Imperfect Information* require that the information must change between game instances for the game to have *Replayability* (or that players can succeed in different ways that can be quantifiably compared to each other). By using *Dynamic Goal Characteristics*, the overall structure can be maintained between game instances, including having *Predefined Goals*, while the exact configuration can be *Imperfect Information* to the players. This can be done using *Randomness*, but in games with *Dedicated Game Facilitators*, these can also modify the information. However, *Imperfect Information* that does not change between game instances in *Single-Player Games* can be a source of *Social Interaction*, as players can compare notes between their different gameplay experiences.

RELATIONS

Instantiates: *Asymmetric Information, Gain Information, Conceal, Surprises, Unknown Goals, Uncertainty of Information, Limited Foresight, Experimenting, Exploration, Indirect Information, Red Herrings, Secret Resources, Leaps of Faith, Risk/Reward*

Modulates: *Limited Planning Ability, Predictable Consequences, Perceived Chance to Succeed, Narrative Structures, Memorizing, Replayability, Trans-Game Information, Near Miss Indicators, Anticipation, Player-Decided Distribution of Rewards & Penalties, Betting, Configuration, Single-Player Games, Predefined Goals*

Instantiated by: *Dedicated Game Facilitators, Book-Keeping Tokens, Randomness, Combat, Cards, Dynamic Goal Characteristics*

Modulated by: *Fog of War, Tile-Laying, Clues*

Potentially Conflicting with: *Perfect Information, Direct Information, Interferable Goals, Conflict*

Perfect Information

The player has full and reliable access to current or past information about a game component, or that total current or past game state is known to the player.

Perfect Information can either be applied to a subset of the game state, typically to the attributes of some game elements, or the game state as a whole. Well-known examples of games where the whole game state is known are traditional board games such as *Chess* and *Go*. Examples of how *Perfect Information* can be applied to several different subsets of the game state can be found in *Poker*. In *Poker*, players have *Perfect Information* about the number of cards in the deck, the number of cards the other players have, how many they have changed during the round, and what cards are in their hands. Further, the amount of the bet is normally fully known to the players as well. The only exception to the *Perfect Information* in the game is the knowledge about the other players' hands, but depending on the outcome of the betting, some of the other players' hands may be revealed as they have to show their cards to determine the winner, thus applying *Perfect Information* on those cards as part of the evaluation function for the end condition of the round.

Example: A player in the dice game *Yahtzee* has *Perfect Information* about all game elements since the results of all dice rolls are public and recorded on a common score track.

Example: Programming games such as *JRobots*, *CRobots*, and *PRobots* (where J, C, and P stand for the Java, C, and Pascal programming languages, respectively) let the players code their own robots that then fight the other robots in a simulation, which the players cannot affect. Unless specified, the code controlling the other robots is available to the players after the game instances, letting them have *Perfect Information* about the other players' strategies for future games if the player can interpret the strategies from the code.

USING THE PATTERN Supporting *Perfect Information* naturally depends on presenting information in such way that the risk of misunderstanding is minimal. For this reason, *Direct Information* is easier to use with *Perfect Information* than *Indirect Information* since there is no risk of information loss due to the translation. Classical board games, such as *Chess* and *Go,* do this by having the game state stored as physical game elements that are visible to all players. *Perfect Information* is also difficult to use with *Red Herrings.*

Providing *Perfect Information* in a game is tied to the *Right Level of Complexity* of the game. Games with a large possible game state and few *Closure Points,* e.g., *Chess* and *Go,* can provide *Perfect Information* without having too much predictability. This is not the case for games with smaller possible game states such as *Poker,* which may become too predictable when using the pattern.

Games of complete *Perfect Information* and *Symmetric Information* automatically create a perfect *Game State Overview* and typically support *Public Information* easily, if not automatically.

Perfect Information may be applied during the determination of evaluation functions. This can allow players to gain information about the strategies and tactics of the other players, offering an opportunity to gain *Strategic Knowledge* about the game. However, this may limit otherwise potential *Tension,* e.g., not knowing the card hand of *Poker* players who folded or successfully completed *Bluffing.*

Games can be constructed so that *Perfect Information* about game elements is temporarily presented explicitly to players then hidden again. These games, where the archetypical example is *Memory,* make use of *Memorizing* and may allow players to have *Perfect Information* about the whole game state without showing any information after the game has been played for some time. Trick-based games and games using *Discard Piles* can allow the same possibilities by making players show information for a while and then remove it. This can further be strengthened by imposing limitations on actions, e.g., requiring players to follow suit or take if they can in card games.

Games of *Cooperation* and *Negotiation* can have *Perfect Information* among the players but have the information distributed among the players, i.e., all players start with *Imperfect Information* but can gain *Perfect Information* through actions or negotiation. *Bridge* and *Cluedo* are examples.

CONSEQUENCES *Perfect Information* about game elements, rules, evaluation functions, and other components makes it easier to have *Predictable Consequences* for the players. If players have *Perfect Information* about the entire game state—especially about *Predefined Goals*—this can promote *Stimulated Planning* but may also result in *Analysis Paralysis,* especially if the game does not include *Randomness, Negotiation,* or the possibility of *Dynamic Alliances. Perfect Information* about the game state

may also make it obvious to the players what the possible outcomes are, making an illusion of a *Perceived Chance to Succeed* impossible.

When *Perfect Information* is used to give the players a good overview of the game state, it is easier to deduce or guess the other players' goals and tactics. *Outcome Indicators* are sometimes used to give the players *Perfect Information* about changes in the game state. If players in this situation have *Interferable Goals*, it is easier for the other players to try to ruin the chances of succeeding with the goal by completing *Preventing Goals*, thereby increasing the possibility of *Conflict* in the game.

RELATIONS

Instantiates: *Predictable Consequences, Stimulated Planning, Direct Information, Symmetric Information, Preventing Goals*

Modulates: *Memorizing, Symmetric Information, Asymmetric Information, Gain Information, Analysis Paralysis, Public Information, Strategic Knowledge, Game State Overview, Right Level of Complexity, Outcome Indicators, Predefined Goals*

Instantiated by: None

Modulated by: None

Potentially Conflicting with: *Imperfect Information, Uncertainty of Information, Asymmetric Information, Gain Information, Randomness, Tension, Perceived Chance to Succeed, Indirect Information, Red Herrings*

Uncertainty of Information

The information available to the player may have different levels of reliability.

Many games give players information but of a kind, or through a medium, that makes their correctness uncertain. This is not the same as not knowing the specific details of a part of the game state or even knowing that a part of the game state exists. It is rather that the player cannot trust the information completely due to the manner in which he or she received the information.

Example: In *Diplomacy*, the current game state is known to all players, but as the player actions are revealed simultaneously, there is a level of uncertainty as to what the other players are going to do during the game round and ultimately what is going to be the outcome. This seems to be in conflict with the previous statement that information patterns only govern the current game state, but as the players in *Diplomacy* have to write down their orders before the resolution phase, they then become part of the whole game state.

USING THE PATTERN The prime design requirement for *Uncertainty of Information* about game elements is to de-couple the spreading of information from the game element that carries the information. As soon as information about a specific part of the game state can be spread without simultaneously revealing that part of the game state, *Uncertainty of Information* is possible. This is especially unavoidable when sending *Indirect Information*, which loses accuracy when translated, but uncertainty can also be achieved by sending *Direct Information* that has been tampered with or has been sent through a distorting medium. An illustrating example of *Indirect Information* in this sense is the use of white and black pegs in *Mastermind* to show the level of correctness of guesses without relying on the actual pegs to show the correct answer.

Actions and goals that can be chosen without requiring the consumption of game elements naturally have an *Uncertainty of Information* about them, allowing for *Unknown Goals* and secret tactics. However, by designing game elements that control what actions or goals players may or may not use, the *Uncertainty of Information* may be limited. An action or event with *Delayed Effect* can be a source for *Uncertainty of Information* in itself.

Uncertainty of Information can be either based on unmediated *Social Interaction* or be supported by the mechanics of the game. The first case is more difficult for the game designer to modulate but offers players the chance of gaining *Extra-Game Information* by reading the body language of the other players. Examples include *Poker* and *Diplomacy*. The second case can be achieved in several ways: through *Communication Channels* that are not limited by the correctness of the information sent, through the design of the game elements used to pass information so that *Imperfect Information* is achieved (e.g., the markers in *Space Hulk* that indicate one, two, or three genestealers), or through unreliability in the game elements used by a player to collect information, e.g., having game elements with actions that collect information but have an evaluation function that contains *Randomness*.

Patterns that provide players with information about the consequences of players' actions, e.g., *Status Indicators*, *Outcome Indicators*, *Progress Indicators*, and *Goal Indicators*, naturally limit *Uncertainty of Information*. However, one way to combine an indicator with the pattern is to show players the accuracy of information as part of an indicator. Possible examples of this use of explicit accuracy levels include indicating only the presence of enemy units but not their type or statements along the line of "The enemy unit is in this position with a certainty of 80%."

Uncertainty of Information can be applied on *Perfect Information* and even *Direct Information*. By falsely indicating that information may be wrong or by introducing *Red Herrings*, the player may be tricked into not relying on correct information.

CONSEQUENCES *Uncertainty of Information* is tightly connected to *Imperfect Information*; one of them is required for *Secret Alliances* to be able to exist, and both can be the basis for *Gain Information* and *Exploration* goals. While *Uncertainty of Information* concerns how reliable the medium and representation of the information are, *Imperfect Information* deals with information possessed by the players. When information exchange is performed in such way that the players can have information about the exchange itself, *Uncertainty of Information* can be the effect of *Imperfect Information*. An example of this is when information is exchanged through the explicit exchange of game elements and players have *Imperfect Information* about which game element has been passed.

Basically all games with *Asymmetric Information* between players that allow some form of *Negotiation* support *Uncertainty of Information*, as the players themselves can be an unreliable medium. However, any *Communication Channel* that similarly supports transferal of *Indirect Information* can be a source of uncertainty. The presence of the pattern forces players to make decisions without being sure about the conditions that influence the decision, something that can heighten *Tension* if the decisions are important. To some players, the *Uncertainty of Information* is also perceivable as *Randomness*.

Different levels of reliability of information give rise to another level of uncertainty players have to take into account when deciding further actions. Depending on the level of *Predictable Consequences*, this can either promote *Analysis Paralysis* or give *Limited Planning Ability*. When the *Uncertainty of Information* is mainly about the game state values connected to other players, this may limit the potential of succeeding with *Interferable Goals* or even *Conflict*.

RELATIONS

Instantiates: *Secret Alliances, Secret Resources, Tension, Limited Planning Ability*

Modulates: *Predictable Consequences, Delayed Effects, Unknown Goals, Outcome Indicators*

Instantiated by: *Communication Channels, Imperfect Information, Indirect Information, Gain Information, Exploration*

Modulated by: *Randomness*

Potentially Conflicting with: *Perfect Information, Interferable Goals, Conflict, Direct Information, Status Indicators, Outcome Indicators, Progress Indicators, Goal Indicators*

Additional Patterns

Descriptions of these additional patterns can be found in the Chapter 7 folder on the companion CD-ROM.

ON THE CD

Fog of War

Red Herrings

INFORMATION DISTRIBUTION

These patterns describe the relationships between how different players, and even non-players, access information. The patterns rely on the use of the previous patterns to create different information distributions between the players.

Symmetric Information

All players have the same information about the game state, or part of the game state, available to them.

In some games, all players have the same information, so the mastery of the game does not rely on having specific information. The simplest and most often used case is having the whole game state known to the players, as in many traditional board games.

> **Example:** Trick-taking card games have *Symmetric Information* about the cards that have been played. Typically, this means that players start with no shared information about who has which cards, but this knowledge grows until the last trick has been played and all players know the exact distribution of cards.

> **Example:** *Chess* and *Go*, as well as nearly all other traditional board games, have all information public, making the distribution symmetric by default. In most cases, the information is simply where all pieces are and what strengths they have.

> **Example:** In the tile-laying game *Carcassonne*, all players have the same amount of information: the configuration of placed tiles and where players have placed their tiles. No players know the order in which the remaining tiles will come into play.

USING THE PATTERN Game designers can implement enforced or potential *Symmetric Information*. Enforced *Symmetric Information* means that the action and events in the game are designed so that all players are presented with the same information openly. Potential *Symmetric Information* occurs when several players have some information, not necessarily the same, but can deduce the same additional information from the information that is known. The use of enforced *Symmetric Information* on players' information makes it less risky to have that information as *Public Information*, as the possibility of passing sensitive information is avoided.

Enforced *Symmetric Information* can be present at the start of a game due to the nature of the setup phase, but in order to maintain *Symmetric Information*, actions and events of a game need to be public. An example of how to enforce *Symmetric Information* in a card game can be to only allow players to take cards through drafting and not to take cards upside down from a *Drawing Stack*.

One way of creating potential *Symmetric Information* is to let all players know what individual elements of a certain game element type exist but not to know their distribution. If actions and events during play reveal information about the distribution so that all players get this information, they can start to figure out which distributions are impossible or unlikely, typically combining the pattern with *Uncertainty of Information*. As all players have received the same information, they can all potentially reach the same conclusions. The *Right Level of Difficulty* for achieving information can be modulated by limiting how long the players have access to the information of public actions and events. Games that support *Memorizing* only let the players have the information for a short while, for example, only letting the players look at the cards played in a trick until the next trick is started in the trick-taking card games. Games that support *Puzzle Solving*, such as *Cluedo*, have special game elements to allow players to record what information has been revealed by actions and events. The game *Mastermind* is a further example of the latter, and shows how achieving *Symmetric Information* with the other player can be used as a winning condition for a player, while maintaining *Asymmetric Information* distribution is the goal for the other player.

CONSEQUENCES *Symmetric Information* gives all players the same amount of information to decide their actions and strategies. Thus, even if the information is imperfect, games using *Symmetric Information* lead to more strategically oriented game play, removing the direct possibilities for *Bluffing* in *Negotiation* situations such as *Bidding* or *Trading*, limiting secret tactics, and limiting deceit based on the information about the game state. This typically leads to *Stimulated Planning*, especially when *Predefined Goals* are used and known to all. However, since players are aware that other players have the same information that they do, they need to take this into consideration when planning. As this requires trying to guess what the other players

are planning and what, in their turn, they are guessing the player is planning, this can significantly affect the *Right Level of Complexity* and cause *Analysis Paralysis*.

Games with *Social Interaction* and *Conflict* may become somewhat self-balancing if *Symmetric Information* is present. In these cases, players may form *Alliances* and perform actions such as blockades in order to counter any lead an individual player has.

Symmetry of information and the quality of the information are loosely connected. Games with total *Perfect Information* automatically have *Symmetric Information*, but in all other cases, *Symmetric Information* can be available irrespective of *Perfect Information*.

RELATIONS

Instantiates: *Stimulated Planning*

Modulates: *Public Information, Conflict, Analysis Paralysis, Negotiation, Bluffing, Bidding, Trading, Predefined Goals*

Instantiated by: *Perfect Information*

Modulated by: *Interferable Goals, Perfect Information*

Potentially Conflicting with: *Asymmetric Information, Bluffing, Secret Tactics*

Asymmetric Information

Players have different information available to them, i.e., some players know more than other players.

Asymmetries of information are very widespread in all kinds of multiplayer games. The most common situation is that every player has private information that is hidden from the other players. This kind of private information is often related to ownership, for example, the player "owns" his card hand in *Poker*. This kind of private information, however, can also be used on game components where there is no sense of ownership, such as game events and specific locations.

Asymmetric Information does not have to be balanced between the players as in Poker and other card games with private information. One of the simplest examples of this kind of asymmetry is *Mastermind*, the classic family game by Pressman Toy Corp., where one of the players, the codemaker, sets up a secret code, which the other player tries to break. The codemaker has *Perfect Information* of the game state while the player trying to break the code has only access to the codemaker's clues given during gameplay. The same principle is used in popular quiz and guessing games, such as *Alias*, where one of the players knows the answer and the other players try to guess it from the clues provided by the player. These games are often

based also on *Indirect Information* in such a way that the player cannot reveal the information directly but has to apply some other means of communication.

Asymmetric Information can, like other information patterns, govern not only information available about game elements but also about other players' goals, abilities, and even end conditions and evaluation functions of the game.

> **Example:** In *Pictionary*, players take turns drawing pictures and the other player tries to guess the word or concept correctly without verbal communication from the player drawing. *Alias* uses the same principle, but the player tries to explain the word in other words and is forbidden to use the word itself or direct synonyms in the explanation.

> **Example:** In *Illuminati*, it is possible that one player has hidden goals that the other players do not know. This forces the other players to try to guess the hidden goals from the player's actions.

USING THE PATTERN *Asymmetric Information* requires that at least one of the players has *Imperfect Information* about the game state. Common examples of this are *Card Hands* in card games. Another typical example of this can be when goals in the game are known to some of the players but are *Unknown Goals* to others. This is possible even for *Predefined Goals*, if the goals are randomly or secretly distributed to the individual players. *Asymmetric Information* can make *Resources* into *Secret Resources*, and as *Card Hands* show, this does not have to depend on information about where the *Resource* is physically but can also be about the information contained in the *Resource*.

Asymmetric Information can be combined with *Symmetric Information* in team-based games so that one whole team has the same information but the other team does not. This is, for example, found in online multiplayer first-person shooters where not only the positions of one's team may be shown but also the location of the traps the team has placed. Another way of using *Asymmetric Information* in team-based games is to provide the player chosen as team leader or strategist the overview of the whole situation, typically by some form of *Game State Overview*. The other team members have more specific information about their situation but not about the larger game state. These types of games require some kind communication at least between the team members and the team leader, be it normal conversation or by direct game actions.

The kinds of asymmetries where one player has access to more information than the others can lead to the use of *Asymmetric Abilities* to balance the gameplay. In these cases, information—or the means of gaining information other players cannot get themselves—is often designed as one of the *Asymmetric Abilities* available. Unless this is the case, players who have more information can make more in-

formed choices during gameplay and can disrupt *Player Balance*. *Asymmetric Information* can be used for game components other than game elements, for example, using *Asymmetric Information* for player composition of *Alliances* leads to *Secret Alliances*.

CONSEQUENCES *Asymmetric Information* often leads to gameplay based on *Bluffing*, *Betrayal*, and guessing, features that quite well describe many of the card games based on unequal information distribution, such as *Poker*, as well as other games with *Bidding* and *Negotiation*. As it offers players advantages to know the tactics of other players, or know if they are trustworthy, the presence of *Asymmetric Information* gives natural rise to *Gain Information* goals.

RELATIONS

> **Instantiates:** *Conceal, Gain Information, Betrayal, Secret Alliances, Bluffing, Secret Resources*
>
> **Modulates:** *Asymmetric Abilities, Unknown Goals, Bidding, Negotiation, Predefined Goals*
>
> **Instantiated by:** *Imperfect Information, Card Hands*
>
> **Modulated by:** *Perfect Information*
>
> **Potentially Conflicting with:** *Symmetric Information, Perfect Information*

Public Information

All or part of the information of the game state is available during the game to people other than the players.

Many games either by explicit design or by their medium allow people not playing the game themselves to have access to the game state. Sports and board games are the most typical examples of games that provide *Public Information* because of their medium; non-players can simply observe the positions of the players and game elements and follow the actions performed. Other games, for example, card and computer games, require technological support that has to be either embedded in the game or set up specifically for a certain game instance to provide information to non-players in an easily accessible format.

> Note that information available to people not playing the game may not be available to all the players.

> **Example:** The spectators of a soccer game have information about the changes in the game state during the match, and the results are normally available to an even wider audience. Public high score lists, such as those in

most arcade games, are also an example of using public information about the results of game instances.

Example: Players who have been killed in *Counter-Strike* can in the normal setups follow other players while they are waiting for their next turn to begin.

USING THE PATTERN What information can or should be *Public Information* naturally depends on the type of game, but the most important factor is how *Spectators* can influence the players based on *Public Information*. This can be avoided by either forbidding the *Spectators* to influence the players' actions directly or it can be made part of the game through *Extra-Game Actions*, for example, by asking the audience for advice in *Who Wants to be a Millionaire?* In *Real-Time Games* or games with *Limited Planning Ability*, the possibility of *Spectators* unbalancing gameplay through advice may be insignificant due to the problem of giving advice in time, especially in games based on *Rhythm-Based Actions* or *Dexterity-Based Actions*.

The availability of information is the prime factor affecting how players can make use of *Public Information*. *Symmetric Information* and *Perfect Information* between all players are already available to the players and therefore harmless to make public. *Trans-Game Information*, including statistics of earlier performances can affect *Strategic Knowledge*, but this is typically not a problem since such information is commonly available between games also for the players.

The *Public Information* made available can be aimed at providing an overview or detailed information about certain players or game elements. In the first case, *Game State Overview* and *God Views* are commonly used but also explicit *Goal Indicators*, *Status Indicators*, *Progress Indicators*, and *Outcome Indicators*. Detailed information is typically kept by *Book-Keeping Tokens* or in the form of *Trans-Game Information*, but it can also be represented in *First-Person Views* or *Third-Person Views*, as these allow focusing on particular parts of gameplay. *Public Information* is often broadcast or otherwise transmitted through dedicated *Communication Channels*, such as newspapers and television. *Public Information* for *Spectators* has an effect on the perceived *Social Status* of the players.

CONSEQUENCES *Public Information* is a requirement for *Spectators* and is especially common in *Tournaments*. However, letting *Spectators* have access to the information about the game state can cause problems, since they can potentially send this information back to the players, either unmodified or after processing it. This potential problem can be solved in *Self-Facilitated Games* or those that have *Game Masters*, but it is a more difficult problem in games having other forms of *Dedicated Game Facilitators* or in *Asynchronous Games*.

Public Information allows people to collect their own *Trans-Game Information*, i.e., statistics and observations about players' tactics, in order to gain *Strategic Knowledge* and promote *Stimulated Planning*. When provided during gameplay and concerning *Paper-Rock-Scissors* relations or *Achilles' Heels*, the availability of *Public Information* heavily influences players' plans and actions.

RELATIONS

Instantiates: *Spectators*

Modulates: *Extra-Game Actions, Trans-Game Information, Stimulated Planning, Strategic Knowledge, Social Statuses, Status Indicators, Paper-Rock-Scissors, Achilles' Heels*

Instantiated by: *Book-Keeping Tokens*

Modulated by: *Game State Overview, Trans-Game Information, First-Person Views, Third-Person Views, God Views, Symmetric Information, Outcome Indicators, Goal Indicators, Communication Channels, Perfect Information*

Potentially Conflicting with: *Asynchronous Games, Dedicated Game Facilitators*

INFORMATION ACCESS

These patterns govern the different ways the players can obtain or have access to information about the game state.

Communication Channels

Communication Channels are the medium and the methods players can use to send messages to other players.

The game itself can be a *Communication Channel*: players can send "messages" to other players by making changes to the game state. This lowest level of communication does not necessarily have interesting social interaction between the players. More interesting situations happen when there is a possibility for verbal and especially non-verbal communication in addition to just sharing the game state.

Example: In *Pictionary*, teams score points when members of the team guess correctly the words that one of the members tries to draw within a time limit. The player doing the drawing is not allowed to use any verbal communication. Drawing and non-verbal signs, such as gestures, are the

only allowed methods of communication for that player. The players trying to guess the word are, of course, allowed to use verbal communication.

Example: Current MMORPGs usually provide many different kinds of *Communication Channels* for the players, from chat channels to predefined gestures for the players' *Avatars*. Players can, of course, use *Communication Channels*, such as IRC and even telephones, which are not part of the game system itself.

USING THE PATTERN For the sake of this brief discussion, the communication methods and channels and social situations are classified in terms of three rather crude and slightly interdependent dichotomies: face-to-face versus mediated, synchronous versus asynchronous, and verbal versus non-verbal. All these also use a simple model of communication based on the sender sending a message through a channel to the (potential) receiver.

Face-to-face situations occur when players share the same physical location. This is the case for almost all traditional and more current games from *Hide & Seek* to *Chess* to *Pictionary*. In face-to-face situations, players use natural non-verbal cues, such as gestures and facial expressions—in many cases unconsciously—as *Indirect Information* to determine the current situation. *Poker* is perhaps the best example of a game where these natural social cues present only in face-to-face situations have an extremely strong impact on the game play experience. Mediated communication is the opposite: the players are not (necessarily) sharing the same physical location, and the communication between the players is mediated by, for example, semaphores, telephone lines, or computer networks, which all can be considered part of a *Dedicated Game Facilitator*.

The communication between players can be either synchronous or asynchronous. In synchronous communication players share the situation as there is no significant delay in communication, and the situation usually requires attention from all the participants. Asynchronous communication can have time delays of hours, days, or in extreme cases, millennia between sending the message and receiving it. Asynchronous communication always has to be mediated, in contrast to face-to-face communication where there cannot be time delays between sending and receiving the message. It is possible, however, to devise a situation where there is an enforced time delay in responding to the message in face-to-face situations using, for example, one-directional mirrors, but this area might remain marginal in commercial games.

Verbal communication is based on using a shared language for messages. The simplest case, of course, is physically talking to other players. Forms of non-verbal communication range from gestures and facial expressions in face-to-face situations to visual messages such as drawings, diagrams, and animations. As the *Pictionary* example demonstrated, it is possible to base a whole game on requiring

players to communicate by using *Asymmetric Abilities*. Game systems, as *Dedicated Game Facilitators*, often provide and control the *Communication Channels* available to the players as in most current MMORPGs. In these cases, the game system can even manipulate the characteristics of the *Communication Channels* to cause, for example, even more *Uncertainty of Information* by garbling the messages. The nature of *Communication Channels* used in *Real-Time Games* and *Synchronous Games* depends on the pace of the game time.

CONSEQUENCES Existence and use of *Communication Channels* is a prerequisite for any *Social Interaction* between players and can heavily influence how *Social Organizations* emerge or are maintained. As *Indirect Information* requires that information is first translated and then transmitted to players, it also naturally requires that there are *Communication Channels* available to transmit the information. *Communication Channels* can also cause *Uncertainty of Information* for the receiver, if they have disturbances (called *noise* in technical contexts) or if the sender can intentionally send false messages. However, *Communication Channels* can also be used to ensure that players only get *Direct Information* about the game state, without any chance of information being hidden or changed.

Many cases of *Public Information* also require that the game state is compressed and translated and then broadcast or otherwise transmitted to the *Spectators*. Free use of *Communication Channels* can also cause social problems within the game in situations where communication is mediated. In order to alleviate this problem, many games that provide chat systems allow players to ban, mute, or otherwise ignore players who use the *Communication Channels* inappropriately.

RELATIONS

> **Instantiates:** *Social Interaction, Indirect Information, Uncertainty of Information, Direct Information*

> **Modulates:** *Public Information, Social Organizations, Real-Time Games, Asynchronous Games, Synchronous Games*

> **Instantiated by:** *Dedicated Game Facilitators*

> **Modulated by:** *Asymmetric Abilities*

> **Potentially Conflicting with:** None

Additional Patterns

Descriptions of these additional patterns can be found in the Chapter 7 folder on the companion CD-ROM.

ON THE CD

Indirect Information **Direct Information**

INDICATORS

This category contains patterns that govern information about components other than game elements, and also gameplay processes, that might be available to the players. The other patterns in this chapter can be used to modulate these indicator patterns. For example, *Asymmetric Information* together with *Goal Indicators* creates situations where the players do not know the other players' goals.

Additional Patterns

Descriptions of these additional patterns can be found in the Chapter 7 folder on the companion CD-ROM.

<div></div>

ON THE CD

Outcome Indicators Goal Indicators

Progress Indicators Status Indicators

Near Miss Indicators

INFORMATION PRESENTATION

These patters define how information is presented, mainly visualized, to the players. As with the indicators, the other patterns in this chapter can be used to modulate these patterns.

Game State Overview

Players are provided with information that extends beyond the observational abilities provided by game elements.

Many games require players to have more information than can easily be acquired by using the game elements under the players' control. In order to provide information, the game design can include various forms of overviews of the kind of information most relevant to support the intended gameplay. This *Game State Overview* can then let players plan their tactics better and judge their positions more accurately.

Example: Most racing games, e.g., *Mario Kart Double Dash!!* and the *Monkey Race* party games in the *Super Monkey Ball* series, provide a small overhead map that shows the location of other players on the track.

USING THE PATTERN *Game State Overviews* can be achieved both in the primary view of the *Game World* and in smaller secondary views, typically overhead maps. In the primary view, this requires that the game has *Third-Person View* or a *God View*, unless done through a *Cut Scene*, in which case any type of view can be used, but several other views are possible as secondary views. Information not connected directly to game elements or connected to abstract game elements can be provided by indicators such as *Book-Keeping Tokens*, *Progress Indicators*, *Goal Indicators*, *Outcome Indicators*, *Status Indicators*, and *Near Miss Indicators*. Low-resolution *Third-Person Views*, *God Views*, and even *First-Person Views* can provide alternative viewpoints for secondary views that can use the same format as the primary view and thereby allow quick syntheses of information. Navigation or exploration of *Game State Overviews* requires players to enact *Extra-Game Actions* since using the overviews does not affect the game state.

The information provided by *Game State Overviews* is always *Imperfect Information* of the whole game state but may be *Perfect Information* of parts of it. Providing *Direct Information*, or at least *Indirect Information* that loses little information in the translation, is common in *Game State Overviews* since their prime function is to provide quick presentations of the game state and this is often represented as *Public Information*. This makes the information safe to show to *Spectators* as long as passing the information back to players in the game does not reveal sensitive information.

If the *Game State Overview* shows values related to other players, this can lead to *Identification* with other players in teams or to *Balancing Effects* as players can through *Negotiation* agree to collaborate against perceived leaders.

Special forms of *Game State Overviews* are log books and other parts of the user interface that allow players to access information about previous events in the *Game World*. These *Game State Overviews* allow players to explore the part of the *Narrative Structure* that has already unfolded.

CONSEQUENCES *Game State Overviews* provide players with more information than they would otherwise have, typically about the current *Score*, the current state of the *Game World*, or the status and positions of their own *Units*. They thereby give *Strategic Knowledge* but also potentially create *Analysis Paralysis*. They can support *Player Defined Goals*, *Game World Navigation*, and *Puzzle Solving*, create *Cognitive Immersion*, and encourage *Stimulated Planning*. As they can present the vital information for evaluation functions, *Game State Overviews* can show *Perceivable Margins* to players that otherwise would have been unknown.

The presence of a *Game State Overview* can cause *Disruption of Focused Attention* for players due to events in the *Game World* that require players to do *Attention Swapping*, for example, changes in *Area Control* or when having *Preventing*

Goals. In this case, the *Game State Overview* can function as a presentation of the statuses of various *Alarms*, or can be considered the *Alarm* system itself. *Game State Overviews* can also make *Attention Swapping* easier or even unnecessary. Games with complete *Perfect Information* can either be seen as not needing a *Game State Overview* or as automatically providing one.

The use of *Game State Overview* in games can remove *Limited Foresight* from players and make *Surprises* impossible, thereby eliminating *Leaps of Faith* actions and making *Reconnaissance* goals unnecessary. However, if modulated by *Fog of War,* a *Game State Overview* can support players with *Exploration* or *Reconnaissance* goals.

In order to make use of *Game State Overviews* players have to spend time observing the overviews. *Turn Taking* in games allows this without making players lose valuable game time.

RELATIONS

Instantiates: *Strategic Knowledge, Stimulated Planning, Cognitive Immersion, Analysis Paralysis, Disruption of Focused Attention*

Modulates: *Progress Indicators, Goal Indicators, Outcome Indicators, Near Miss Indicators, Public Information, Exploration, Attention Swapping, Game World Navigation, Identification, Balancing Effects, Puzzle Solving, Negotiation, Reconnaissance, Units, Game World, Preventing Goals, Perceivable Margins, Player Defined Goals, Narrative Structures*

Instantiated by: *God Views, Disruption of Focused Attention, Turn Taking, Cut Scenes, Book-Keeping Tokens, Score*

Modulated by: *Fog of War, First-Person Views, Status Indicators, Third-Person Views, Perfect Information, Area Control, Spectators, Extra-Game Actions, Alarms*

Potentially Conflicting with: *First-Person Views, Attention Swapping, Leaps of Faith, Surprises, Limited Foresight, Reconnaissance*

Additional Patterns

Descriptions of these additional patterns can be found in the Chapter 7 folder on the companion CD-ROM.

First-Person Views

Third-Person Views

God Views

8 | Actions and Events Patterns

The main patterns in this chapter govern what kinds of actions are available to players, how they relate to changes in the game state, and how they relate to the goals of the players. Some of the patterns are not necessarily related to the outcomes of player actions but rather how the game system-initiated events affect gameplay.

Actions: *Combat, Movement, Maneuvering, Aim & Shoot, Construction, Tile-Laying, No-Ops, Camping, Collecting, Movement Limitations, Game World Navigation, Spawning, Betting, Leaps of Faith*

Action Control: *Privileged Abilities, Asymmetric Abilities, Limited Set of Actions, Downtime, Experimenting, Transfer of Control, Interruptible Actions, Focus Loci, New Abilities, Improved Abilities, Ability Losses, Decreased Abilities, Extended Actions, Irreversible Actions, Save-Load Cycles, Attention Swapping, Damage, Privileged Movement, Indirect Control, Area Control, Budgeted Action Points, Turn Taking*

Rewards and Penalties: *Rewards, Penalties, Illusionary Rewards, Player-Decided Distribution of Rewards & Penalties*

Events: *Ultra-Powerful Events, Role Reversal, Shrinking Game World, Disruption of Focused Attention*

ACTIONS

These patterns cover the major basic actions available to the players. The list is by no means complete, but gives an overview of the more common action types.

Combat

Actions where the intent is to kill or otherwise overcome opponents.

Symbolizing the actions between game elements in games as *Combat* is one of the oldest and most common ways to give games themes. By doing so, the theme of the game contains a link with the real-world competition between players as well as alludes to the tension, uncertainty, and importance of the real-world equivalent. *Combat* in games gives players clear goals and opponents and gives clear indication of what players have succeeded and what players have failed.

> **Example:** First-person shooters' main challenge is to kill or otherwise overcome the enemies found in the game.

> **Example:** Fighting games such as the *Dead or Alive*, *Tekken*, or *Mortal Kombat* focus purely on *Combat*, with meta goals of unlocking new characters or new costumes.

USING THE PATTERN The main influence on designing *Combat* in games is whether the games are *Real-Time Games* or *Turn-Based Games*. In both cases, *Combat* usually includes *Randomness* and *Imperfect Information* in the process to determine the outcome but how these are achieved depend on the type of game. Both types of games also typically provide *Privileged Abilities* specifically affecting *Combat* and can have *Enemies* with *Achilles' Heels* that provide specific targets to aim for.

In *Turn-Based Games* the results of *Combat* are usually based on an evaluation function, as players' skills lie in trying to make the game state have as many modifiers in their favor as possible. Common influences on the evaluation function include *Skills*, *Privileged Abilities*, and *Collaborative Actions*. *Budgeted Action Points* can be used to allow several *Combat* actions to be performed in one turn and increase the *Tradeoffs* between different possible actions in these forms of *Combat*. *Imperfect Information* exists mainly due to not knowing the opponents' strengths, weaknesses, and configuration, while *Randomness* is usually instantiated through *Dice* or the equivalent.

In *Real-Time Games*, the main difference between design choices for *Combat* lies in whether players control *Avatars* or *Units*. *Imperfect Information* is often the cause of bad *Game State Overview* or the problem of perceiving enemy actions as they occur while *Randomness* occurs due to opponents' guesses to the *Imperfect Information* they have.

Control of *Avatars* in *Combat* requires *Timing* and *Dexterity-Based Actions*, typically *Aim & Shoot* or *Combos* of close combat maneuvers. *Damage* in this case is often abstracted to forced retreats, stuns simulated by forced *No-Ops*, and health values shown by *Progress Indicators*. If *Combat* is the only activity in the game, as is the case in fighting games, the *Combat* is often structured in *Tournaments* to allow *Perceivable Margins* and *Higher-Level Closures as Gameplay Progresses* by having more difficult opponents appear later in the *Tournament*. Fighting games also often

combine loss of *Combat* with *Player Elimination*. Games where players engage in activities other than *Combat* usually make use of *Lives* and penalize loss of *Lives* by *Ability Losses* and *Spawning* at earlier locations. *Real-Time Games* with *Avatars* and *Team Play* often have special *Penalties* for team killing or make those events impossible through *Privileged Abilities*.

Controlling *Units* require skills in coordinating *Collaborative Actions* and employing *Attention Swapping*. Often knowledge of *Strategic Locations* is important as well as efficient *Resource Management*. The loss of *Units* due to *Combat* in these games do not usually have any specific *Penalties* connected to them except for the possible *Ability Losses* if no other still existing *Units* have the same abilities.

Consequences *Combat* is the means to achieving *Capture*, *Overcome*, or *Eliminate* goals against *Enemies* and gives rise to *Conflict* against either other players or *Dedicated Game Facilitators*. When these goals deal with *Area Control*, the presence of *Combat* is especially common since the opposing goals typically are also achieved by *Combat*. The actual actions required to successfully win *Combat* depend heavily on the definitions of how to successfully complete the goals.

Participating in *Combat* is a *Risk/Reward* choice as are the *Tradeoffs* that have to be considered between different possible actions within the *Combat*.

Relations

 Instantiates: *Tension, Conflict, Randomness, Imperfect Information, Timing, Player Elimination, Perceivable Margins, Higher-Level Closures as Gameplay Progresses, Collaborative Actions, Attention Swapping, Resource Management, Aim & Shoot, Dexterity-Based Actions, Budgeted Action Points, Risk/Reward, Tradeoffs*

 Modulates: None

 Instantiated by: *Overcome, Eliminate, Capture, Area Control, Enemies*

 Modulated by: *Real-Time Games, Turn-Based Games, Damage, Dice, Avatars, Units, Lives, Tournaments, Privileged Abilities, Combos, Strategic Locations, Achilles' Heels, Dedicated Game Facilitators*

 Potentially Conflicting with: None

Movement

The action of moving game elements in the Game World.

Movement of game elements is a common action in games that have a *Game World* or board. *Movement* allows players to try and move game elements into favorable positions as well as control or explore the game area.

Example: Racing games such as *F-Zero GX* and *Mario Kart: Double Dash!!* have movement as the primary activity in the game.

Example: With the exception of the value of kings and the ability of pawns to become queens, different *Movement* abilities are what distinguish different types of pieces in *Chess*.

Example: *Spacewar* and *Asteroids* both allow players to move spaceships by rotation and thrust in the spaceships' direction. However, they also allow players to escape dangerous situations by providing a limited number of hyperjumps that place the spaceship in a random location.

USING THE PATTERN Deciding how game elements can move depends on the *Game World* and the intended differences between game elements. *Obstacles*, *Inaccessible Areas*, and *Deadly Traps* in the *Game World* can all be used as basics for *Privileged Movement* or *Movement Limitations*. The easiest form of *Privileged Movement* for one game element compared to other game elements is the ability to move faster (or longer in *Turn-Based Games*). This can be used to modulate the *Right Level of Difficulty* in *Capture* and *Evade* goals.

The difficulty of *Movement* is connected to the complexity of the movement and the *Freedom of Choice* the player has. The more degrees of freedom of movement a player has, up to the maximum of six (three absolute and three rotational) for a single *Focus Loci*, the more the complexity of the *Movement* is increased. So, finding the *Right Level of Difficulty* for *Movement* lies in finding a balance between the *Right Level of Complexity* for the *Movement* and the intended *Freedom of Choice* the players should have when moving. Further complications to *Movement* occur through the introduction of acceleration, deceleration, momentum, dislocated centers of gravity, jointed vehicles, and vehicles with complex forms of locomotion.

Movement can be used to create *Orthogonal Unit Differentiation* by either giving *Units* some form of *Privileged Movement* or imposing some form of *Movement Limitation* on the units.

In *Turn-Based Games*, the typical way of instantiating *Movement* is through randomizing how far players can move, giving players *Budgeted Action Points* that can be spent (possible not only) on *Movement*, or a combination of both.

CONSEQUENCES *Movement* actions are prerequisites for completing *Race*, *Capture*, *Stealth*, *Exploration*, *Herd*, *Delivery*, and *Traverse* goals as well as for performing the actions of *Aim & Shoot* or the *Collecting* of *Pick-Ups*. The *Movement* done to reach the *Goal Points* of these goals makes the game elements used act as *Progress Indicators* against the *Game World*. *Evade* also requires *Movement* but does not use a location as a goal but rather avoiding a specific location. All intentional *Movement* in a *Game World* requires *Game World Navigation*.

Movement does not always offer *Spatial Immersion* but does so in *Real-Time Games*, especially when *First-Person Views* are used. In these cases, *Movement* becomes actions of *Maneuvering* and requires skills in *Dexterity-Based Actions*. *Turn-Based Games* with *Movement* give rise to *Puzzle Solving* rather than *Dexterity-Based Actions*, for example, games that require players to move between many interconnected places give rise to Traveling Salesman's problems.

Movement of game elements that are not under the control of any players, usually *Obstacles*, can be *Ultra-Powerful Events* that require *Movement* or *Maneuvering* from the players in response, for example completing *Aim & Shoot* actions.

RELATIONS

Instantiates: *Dexterity-Based Actions, Puzzle Solving, Game World Navigation, Spatial Immersion, Orthogonal Unit Differentiation, Progress Indicators, Ultra-Powerful Events, Game World Navigation, Budgeted Action Points*

Modulates: *Game World, Aim & Shoot*

Instantiated by: *Delivery, Collecting, Stealth, Herd, Traverse, Evade, Capture, Race, Exploration, Maneuvering, Aim & Shoot*

Modulated by: *Privileged Movement, Movement Limitations, Obstacles, Inaccessible Areas, Deadly Traps*

Potentially Conflicting with: None

Maneuvering

Controlling the movement of game elements in real-time games.

Games in which players control vehicles or characters that move in real time often have *Obstacles* or *Enemies* that have to be avoided. Doing this in real time requires *Maneuvering* of the game elements under the players' control.

Example: Much of the skill in playing first-person shooters consists in being able to maneuver one's *Avatar* so one avoids enemy gunfire and has good opportunities to attack enemies.

Example: The racing game *F-Zero GX* requires players to maneuver to avoid obstacles and other vehicles while traveling at high speeds on a 3D racing track.

USING THE PATTERN *Maneuvering* can be necessary either due to the *Movement* of a game element controlled by a player or by the movement of other game elements.

In the first case, *Obstacles* and *Deadly Traps* in the environment may cause emergent *Evade* goals, or *Chargers* and *Pick-Ups* may require *Collecting* actions, both of which can be completed by *Maneuvering*. *Movement* of other game elements can be *Enemies*, or shots from them, that aim directly for the players' game elements or can be *Ultra-Powerful Events*, e.g., raising bridges or rock falls, that have to be avoided. *Maneuvering* due to the *Movement* of other game elements does not only have to aid in *Evading* them but can also include *Aim & Shoot* actions with the intention of fulfilling *Capture* or *Eliminate* goals.

Maneuvering requires that players at least have a weak *Spatial Immersion* in the game and thereby requires either a *First-Person View* or a *Third-Person View*. Setting the *Right Level of Difficulty* for *Maneuvering* actions can be done either by controlling the speed game elements move in or controlling the *Right Level of Complexity* by the number of game elements that have to be taken into consideration at any given point. The first raises the requirements on skills in *Dexterity-Based Actions* while the second requires *Attention Swapping*.

CONSEQUENCES The need for *Maneuvering* comes either from a lack of *Game State Overview* that causes the current situation to be suboptimal or because the *Game World* is sufficiently complex to make corrections necessary regardless of chosen path. Both these causes may be due to the *Movement* of other game elements, which can either be intentional movement by *Enemies* or instantiations of *The Show Must Go On*.

Maneuvering, like other forms of *Movement* in *Real-Time Games*, can give *Spatial Immersion* and cannot be done in *Turn-Based Games*.

RELATIONS

> **Instantiates:** *Movement, Dexterity-Based Actions, Attention Swapping, Spatial Immersion*
>
> **Modulates:** *Evade, Race, Capture*
>
> **Instantiated by:** *The Show Must Go On, Collecting, Real-Time Games, Aim & Shoot*
>
> **Modulated by:** *Chargers, Pick-Ups, Obstacles, Enemies, Deadly Traps, Right Level of Difficulty, Ultra-Powerful Events, First-Person Views, Third-Person Views*
>
> **Potentially Conflicting with:** *Turn-Based Games*

Aim & Shoot

The act of taking aim at something and then shooting at it.

One of the most natural ways of showing attention to something is to look or point at it. Real-time games usually provide some action that can be done to the game element pointed at. Generalized, this action can be described as *Aim & Shoot* regardless of if anything is aimed or actually shot.

> **Example:** Shooting in all first-person shooters consists of taking aim on the opponents, with possible compensations for their movement, and shooting as illustrated in Figure 8.1.
>
> **Example:** In *Zelda: Ocarina of Time*, the player must aim and shoot a grappling hook to be able to swing Link between chasms.
>
> **Example:** *Pokemon Snap!* gives players a camera and lets them move along a track trying to take as good pictures as possible of Pokemons.

FIGURE 8.1 The targeting cursor helps the players to *Aim & Shoot* in *Battlefield 1942*. Copyright Digital Illusions CE AB. Reprinted with permission.

USING THE PATTERN Making *Aim & Shoot* actions possible primarily depends on enabling players to complete *Alignment* goals of two points by a straight line. For *First-Person Views* this is trivial, as one point is the player's view point unless either of the two points is moving. Somewhat more difficult are *Third-Person Views*, as

more movement of the player's *Focus Loci* is usually necessary. *God Views* are in most cases too difficult, as it is too hard to get the *Spatial Immersion* required in order to line up the two points accurately.

The difficulty of *Aim & Shoot* actions can be due to the *Movement* either of the game elements aimed at or the game element aiming. For *Units* or *Avatars*, the intentional *Movement* due to *Traverse* or *Evade* goals can make aiming at them more difficult. For *Moveable Tiles* or other game elements, the mechanical *Movement* due to *The Show Must Go On* can likewise make aiming more difficult. The aiming can be further complicated by the players' own *Movement* of their *Focus Loci* or by a swaying of the aim to simulate the difficulty of real-world aiming.

Design of the *Game World* that makes players have a bad overview of the game state, for example, the inclusions of *Obstacles*, makes it difficult to prepare for shooting. This means that potential targets likely are *Surprises*, and any shots will not be well aimed. Similarly, other forms of *Surprises* likely cause *Disruption of Focused Attention* events and make players lose their aim. Aiming can also be made more difficult by introducing *Tension*, for example through *Competition* or *Time Limits*.

The possibility of *Aim & Shoot* actions can be restricted by requiring *Tools* or the use of *Resources*. The latter can introduce *Tension* to the activity and require *Risk/Reward* choices between shooting now or waiting for a possible better situation to shoot.

Although *Combat* with the goals of *Capture* or *Eliminate* is the activity that most often creates *Aim & Shoot* actions, other goals and reasons are possible. *Delivery* of game elements can be done by throwing or shooting the game elements to the receiver and *Capture* can be the capturing of information rather than game elements. Shooting spider webs, throwing grappling hooks, or even firing cannons with oneself inside it can give explanations for how *Privileged Movement* can be performed by *Aim & Shoot*.

CONSEQUENCES *Aim & Shoot* is a *Dexterity-Based Action* that is possible in *Real-Time Games*. Often requiring *Extended Actions* and *Timing* from a game element's point of view, *Aim & Shoot* promotes *Spatial Immersion*.

Interestingly enough, most sports games do not make use of *Aim & Shoot* even though this is one of the primary activities in sports they simulate. The cause for this is probably the lack of overview of the game state that players would have if they had perspectives that allowed *Aim & Shoot*.

Aim & Shoot actions from other players or *Enemies* naturally increase and present *Evade* goals.

RELATIONS

> **Instantiates:** *Evade, Spatial Immersion, Tension, Movement, Dexterity-Based Actions, Extended Actions, Timing*

Modulates: *Delivery, Tools, Resources, Capture*

Instantiated by: *Alignment, Combat, Real-Time Games, Eliminate, Privileged Movement, Enemies*

Modulated by: *Evade, First-Person Views, Third-Person Views, Traverse, Movement, Moveable Tiles, The Show Must Go On*

Potentially Conflicting with: *Surprises, Obstacles, Disruption of Focused Attention, God Views*

Construction

The action of introducing new game elements that are presented as intentional constructions into the Game World.

The introduction of game elements in the game can be the cause of players' actions. When the game elements introduced are perceived as something requiring organizing the environment (in technical terms, countering entropy) this can be framed as *Construction*.

Example: *Pontifex* by ChronicLogic allows players to build bridges that are tested by a physics engine that sends a train over the bridges.

Example: *The Sims* allows players to construct homes for their Sims, redecorating and rebuilding the houses as the needs and living conditions of the Sims change.

Example: The board game *The Settlers of Catan* allows players to build villages and towns at the intersections of hexes in the game, and roads between them.

Example: Massively Multiplayer Online Roleplaying Games usually allow players to construct houses by buying them and construct items through actions. Text-based multiplayer dungeons take this further by letting high-level players create new areas in the *Game World* and program the functionality of areas and game elements.

USING THE PATTERN The main design choices for supporting *Construction* include the design of the new game elements that are the product of the action, what *Resources* are needed, the possibility of succeeding, and the variations in designs that the players can create. Requiring scarce *Resources* for construction to occur can give rise to *Exploration* or *Gain Ownership* as well as *Trading*. Linking the chance of success to a *Skill* encourages *Construction* as a *Competence Area*. Allowing a large variation in the possible *Constructions* give players a *Freedom of Choice* and the

Creative Control to *Experiment* and select *Player Defined Goals*. The possibility of failed *Constructions* leading to alternative *Constructions* also encourages *Experimenting*.

The amount of *Construction* in a game can easily be limited by making it a *Privileged Ability*.

CONSEQUENCES *Construction* allows the introduction of new game elements as the effect of *Producers*, instead of having to rely on *Spawning*. As such, it can be used to explain within the *Consistent Reality Logic* of an *Alternative Reality* the appearance of artificial objects by non-automatic processes.

Construction is typically a form of *Investment* but is often perceived as *Constructive Play* since the *Investment* is toward creating something. When the *Construction* gives players sufficient *Creative Control* the results can be *Surprises*. When the players can create game elements that affect the *Game World*, especially in *Persistent Game Worlds*, *Construction* can enable *Player Constructed Worlds*. An obvious way to affect the *Game World* in this fashion is through *Tile-Laying*.

Goals to *Eliminate* are typically the antithesis of the intentions of *Construction* as may be used to create *Preventing Goals* and *Conflict*.

RELATIONS

> **Instantiates:** *Consistent Reality Logic, Constructive Play, Player Constructed Worlds, Surprises, Preventing Goals, Investments, Exploration, Player Defined Goals, Competence Areas, Freedom of Choice, Creative Control, Trading, Gain Ownership, Experimenting,*
>
> **Modulates:** *Alternative Reality, Persistent Game Worlds, Game World*
>
> **Instantiated by:** *Tile-Laying, Producers*
>
> **Modulated by:** *Privileged Abilities, Resources, Producers*
>
> **Potentially Conflicting with:** *Eliminate*

Additional Patterns

Descriptions of these additional patterns can be found in the Chapter 8 folder on the companion CD-ROM.

ON THE CD

Tile-Laying	**Betting**
No-Ops	**Movement Limitations**
Camping	**Game World Navigation**
Collecting	**Leaps of Faith**
Spawning	

ACTION CONTROL

These patterns govern both how the more basic actions can be used in sequences or otherwise combined and special internal characteristics of the actions, for example, how the players can access different kinds of actions.

Privileged Abilities

Privileged Abilities are those that let players perform actions that are not readily available to all other players.

Many games have different sets of actions possible for different players. The actions one player has, or possibly a few players have, are *Privileged Abilities* in that they allow different tactics and often different forms of goals to be sought.

> **Example:** Computer roleplaying games, such as *Neverwinter Nights* and *Diablo*, make use of *Privileged Abilities* by making certain actions only available to specific classes, for example, only allowing wizards to cast spells.

> **Example:** Online multiplayer first-person shooters such as *Return to Castle Wolfenstein: Enemy Territory* or *Battlefield 1942* use the same method of dividing special abilities, such as repairing vehicles or providing air strikes, to specific classes. *Return to Castle Wolfenstein: Enemy Territory* further provides new actions as players gain experience in various activities.

> **Example:** The board game *History of the World* uses cards with special abilities that can be played only on certain turns in order to loosely follow the historical development of civilizations.

USING THE PATTERN The design choices regarding *Privileged Abilities* can be divided into three main categories: the actual nature of the action, how the action is made available, and which player has access to the action.

Privileged Abilities can take many different forms, but common ones allow players to move differently than other players, avoid the effects of *Penalties*, allow special actions in *Combat*, create *Resources*, manipulate the *Resource Management* system in the game, create *Asymmetric Information* states by providing additional access to information, or affect the outcome of other actions. Examples are numerous: ordinary attacks and *Combos* for use in *Combat*; movement enhancement such as speed of movement or ability to jump longer, or in other ways making it easier to ignore or avoid *Obstacles*; *Privileged Movement* in the form of flying, swimming, or diving; activation of armor or invulnerability that make the effect of *Damage* little or none to avoiding *Penalties*, perhaps automatic when *Spawning*; being a

Producer of *Renewable Resources*, for example to create health packs that remove *Damage*, or being able to employ *Construction*; for *Resource Management*, actions that affect *Resource Collecting*, for example, enabling card pick-up from the *Discard Pile* instead of the *Drawing Stack*; for information, having *Units* with less *Fog of War* than other *Units* or being allowed to look at another player's *Card Hand*; for outcomes, control of *Player-Decided Distribution of Rewards & Penalties* or possession of replay and cancellation cards that force a new evaluation of the action or that a new action is taken instead of the one that has just taken place. In some cases, even the option of performing a *No-Op* action can be a *Privileged Ability*.

Privileged Abilities that are present from the beginning of the game allow players to perform extra-game activities in planning strategies if these actions are known or can be chosen. Those *Privileged Abilities* that are gained during gameplay can provide *Stimulated Planning*, including *Planned Character Development* and *Team Development*, and gaining the abilities is often done through some form of *Investment*. *Privileged Abilities* that only can be used or are useful during certain parts of the game put players under a *Time Limit* and strengthen the importance of *Timing* the actions.

Area Control, *Chargers*, and *Power-Ups* can be used to activate *Privileged Abilities*. In this case, gaining the *Privileged Ability* can become a question of knowing *Strategic Locations*, and the activation of *Privileged Ability* is tied to a specific location in the game. As the effects of *Chargers* and *Power-Ups* usually are under a *Time Limit* or otherwise bounded, the effects on *Player Balance* can more easily be controlled than for other types of *Privileged Abilities*.

Privileged Abilities may also appear due to *Penalties* inflicted on other players; the effect of losing your knights in *Chess* while your opponent still has them can be seen as if your opponent has the *Privileged Ability* of making knights move.

The question of who has access to the *Privileged Ability* can be split into the questions of what *Focus Loci* provides the action and which players have access to the action. When using *Avatars* representing *Characters* as the *Focus Loci*, the *Privileged Abilities* can be represented by *Skills* to allow further modulation of the abilities.

The choice of *Focus Loci* affects how player's can experience *Ability Loss*. If the *Privileged Abilities* are provided by *Avatars* or *Characters*, the loss is typically either due to the end of a *Time Limit* in the case of *Power-Ups* or a *Penalty* for losing a *Life* or losing *Ownership* of *Tools*. Besides allowing for *Orthogonal Unit Differentiation*, *Tools* and *Units* allow the *Privileged Abilities* to shift between players by different forms of *Transfer of Control*, e.g., stealing.

The affect of which player has the *Privileged Abilities* depends heavily upon whether the game involves *Team Play*. In *Team Play*, the *Privileged Ability* of a

player can be matched by the same *Privileged Ability* in the other teams to create *Player Balance*. This makes the teams have symmetric abilities while providing *Asymmetric Abilities* within the team and allows individual players to have game-controlled *Competence Areas*. In games without teams but with *Cooperation*, the pattern can also support *Competence Areas*, while in games with *Conflict*, it is more likely to affect *Player Balance*.

Possible affects on *Player Balance* by *Privileged Abilities* can be mitigated somewhat if they are part of the set of actions selectable by *Budgeted Action Points*.

CONSEQUENCES *Privileged Abilities* give players *Empowerment* in games since they have abilities that others do not. This is especially apparent in *Self-Facilitated Games* that make use of *Game Masters*, since the entire game state is controlled by them and all events in the game must be approved by them.

By their very nature, *Privileged Abilities* create a state of *Asymmetric Abilities* between players and thereby easily affect *Player Balance* and *Team Balance*. When unsupervised by the game system, this can create greater and greater differences in *Player Balance* as gameplay progresses, but by actively modifying what *Privileged Abilities* players have and when, e.g., by deciding the nature of a *Power-Up* due to the positions of players in a racing game, the pattern can instead be used to support *Player Balance*.

When combined with *New Abilities*, *Privileged Abilities* can be used as the goal for *Gain Competence* goals. When tied to *Avatars* or *Characters*, they can be used to explicitly indicate *Character Development*. In games with *Team Play*, this naturally can also affect *Team Development* and can strengthen the *Competence Area* of players and give them *Social Statuses*. Further, it can support stimulated *Social Interaction*, as players usually need to coordinate their activities to take full advantage of the set of actions they have. If the *Privileged Abilities* are matched between the teams, *Team Balance* can be achieved even though *Player Balance* may not be.

If competing players can gain access to the same or balancing *Privileged Abilities* through completions of similar goals in games using *Competition*, a *Red Queen Dilemma* situation can occur. In this case, and other cases where players can gain or have had *Privileged Abilities* but currently do not, not having the abilities can be a form of *Penalty*.

RELATIONS

Instantiates: *Red Queen Dilemmas, Stimulated Planning, Competence Areas, Asymmetric Abilities, Orthogonal Unit Differentiation, Gain Competence, Interruptible Actions, Empowerment, Social Statuses, Penalties, Investments*

Modulates: *Self-Facilitated Games, Timing, Team Play, Social Interaction, Character Development, Team Development, Planned Character Development, Avatars, Tools, Discard Piles, Penalties, Combat, Spawning, Player-Decided Distribution of Rewards & Penalties, Characters, Fog of War, Construction, Units, Obstacles*

Instantiated by: *New Abilities, Privileged Movement, Power-Ups, Chargers, No-Ops, Combos, Transfer of Control, Area Control, Skills, Game Masters, Renewable Resources, Ownership, Producers*

Modulated by: *Time Limits, Budgeted Action Points, Team Balance, Planned Character Development*

Potentially Conflicting with: *Player Balance, Team Balance*

Asymmetric Abilities

Players, or game elements, do not all have the same actions available.

When not all players have the same actions available, they have *Asymmetric Abilities*. This makes the game more complex in one sense, as more types of actions need to be considered when visualizing future game states, but also makes the experiences of playing the game depend on what role a player has.

Asymmetric Abilities can also exist between the game elements under a player's control. In this case, the variety of actions available gives players more opportunities to create different tactics and increases the value of each game element as losing all elements that have an ability means that the ability is lost to the player.

Example: The pieces of one type in *Chess* have asymmetrical movement abilities compared to all other types.

Example: *Fox & Geese* gives the two players different abilities but one player has a single piece that can capture the opponent's pieces while the other player has many pieces that can only move.

Example: Roleplaying games and class-based multiplayer first-person shooters encourage co-operation between players by giving them *Asymmetric Abilities* that can be put to most efficient use by coordinating actions.

Example: The card game *Citadels* lets players have different roles every turn where each role has different special abilities.

Example: The board game *Space Hulk* has one player controlling a few space marines with guns under time pressure that do not get reinforcement in conflict with a player controlling many genestealers that can only fight

in close combat but continuously get reinforcements and whose numbers are not exactly known to the other player.

USING THE PATTERN The primary reasons for using *Asymmetric Abilities* are usually to provide *Varied Gameplay* or to support *Asymmetric Goals*. In *Multiplayer Games*, this is expanded with the reasons of promoting *Team Play* and *Social Organizations* (as the division of labor is one characteristic of civilizations). *Asymmetric Abilities* can either be explicit or implicit in games.

The creation of explicit *Asymmetric Abilities* is done by designing *Privileged Abilities*, for example, how *Fog of War* affects vision or what *Communication Channels* are available, but the primary design choices lie in whether to create the asymmetry on a *Unit* or player level and how to achieve *Player Balance*. Choosing asymmetry on the *Unit* level makes symmetry possible on the player level and thereby aids in avoiding potential balancing problems. Asymmetry on the player level gives different gameplay experiences for the players but may require rules for determining who plays what role.

Implicit *Asymmetric Abilities* are not enforced by the game system but depend on either *Asymmetric Information* or different levels of *Game Mastery* between players. The former can be intentionally made part of a game design while the latter is more difficult, at least requiring *Trans-Game Information* as a source of how good players are.

Ways of balancing *Asymmetric Abilities* include having *Paper-Rock-Scissors* relations between the abilities, shifting the abilities every turn in *Turn-Based Games*, or playing *Tournaments* where every combination of players and abilities are played. When a game has been play tested extensively, *Handicaps* can be given as a *Balancing Effect*.

CONSEQUENCES *Asymmetric Abilities* are a consequence of *Privileged Abilities*. The presence of *Asymmetric Abilities* modulates the *Right Level of Complexity* by increasing it unless the asymmetry is temporary. When the asymmetry can be alleviated by the completion of *Gain Competence* goals, this gives rise to *Red Queen Dilemmas*.

Games may contain *Asymmetric Abilities* on a *Unit* level without having it between players by having the same setup of *Units* between players. This is the typical case in games combining *Symmetry* and *Orthogonal Unit Differentiation* such as *Chess* or *Stratego*.

In the same fashion as with *Units*, games may have *Asymmetric Abilities* between players within a team. This encourages *Team Play* to make the most efficient use of possible actions and often requires *Constructive Play* in the form of *Negotiation* to perform *Collaborative Actions*. However, the development of *Asymmetric Abilities* of one team compared to another team may be a more relevant way of measuring *Team Development* in games with *Team Play*.

Games with roles that have permanent *Asymmetric Abilities* and do not have *Team Play* can easily have problems with *Player Balance* unless they form *Paper-Rock-Scissors* power relations. However, they do give players a *Freedom of Choice* between the roles and varying between these roles gives *Varied Gameplay* between game sessions and promotes *Replayability*.

RELATIONS

Instantiates: *Handicaps, Red Queen Dilemmas, Constructive Play, Negotiation, Collaborative Actions, Team Play, Freedom of Choice, Orthogonal Unit Differentiation, Gain Competence, Varied Gameplay, Replayability, Paper-Rock-Scissors, Social Organizations*

Modulates: *Team Development, Game Mastery, Fog of War, Communication Channels, Asymmetric Goals*

Instantiated by: *Privileged Abilities*

Modulated by: *Paper-Rock-Scissors, Balancing Effects, Turn-Based Games, Tournaments, Units, Asymmetric Information*

Potentially Conflicting with: *Symmetry, Player Balance*

Limited Set of Actions

Players can only have a few actions to choose from.

The actions that players can perform in a game are usually restricted, either because the focus of the game is centered on a limited topic or to make the game easy to play (although not necessarily to master).

Example: Bidding in *Poker* only lets players choose from folding, matching, or raising a bet.

Example: *Russian Roulette* has only one possible action for a player, to pull the trigger.

Example: Players in real-time strategy games typically have very *Limited Sets of Actions* for each *Unit*, and if the number of *Units* decreases, they have few actions overall to choose from.

USING THE PATTERN Limiting the possible actions available to players can be done either on an overall level or on a *Focus Loci* level. When done on a *Focus Loci* level by having limited amounts of actions available to *Avatars* or *Units*, the player may have many actions available in total but only have a few available at a time, which can create different play modes. Connecting actions to *Units* makes it easy to

further restrict the *Limited Set of Actions* as a *Penalty* for losing the *Unit*, not only because the total number of possible actions shrinks but potentially because the loss of *Privileged Abilities* of the *Unit* leads to *Ability Losses* for the player. An example of this can be seen in *Chess*, where the loss of each piece reduces the total amount of actions players can choose from but may also cause the loss of specific types of actions such as diagonal moves or the knight's move.

Although *Limited Set of Actions* promotes *Stimulated Planning*, this can be restricted in different ways. If the actions do not have *Predictable Consequences*, this promotes *Limited Planning Ability*. If the actions do have *Predictable Consequences* but few *Closure Points*, this may also cause *Limited Planning Ability* due to the size of possible game states but can maintain the risk of *Analysis Paralysis* as players try to overview all possible game states.

Limited Set of Actions can be used to restrict the possible game states so that *Narrative Structures* can be maintained and *Higher-Level Closures as Gameplay Progresses* are guaranteed, although this often clearly limits players' *Freedom of Choice*.

CONSEQUENCES Not having many choices can negatively affect *Freedom of Choice* at any given time in the game. However, this may only be on a local level if the game has few *Closure Points*, such as in *Chess* or death matches in first-person shooters, the *Freedom of Choice* to what long-term goals or where to move are considerably freer.

Limited Set of Actions typically promotes *Stimulated Planning* as the possible series of future actions is bounded, but this can in turn cause *Analysis Paralysis*. If the possible actions are very limited and the outcome is associated with high *Penalties* or *Investments*, the choice of action can cause anxiety and thereby heighten the *Tension*.

Games where the *Limited Set of Actions* can be expanded by gaining *New Abilities* offer *Gain Competence* goals, which can among other things enhance players' *Freedom of Choice*, make previously *Inaccessible Areas* accessible through *Privileged Movement*, or progress the *Narrative Structure* as they indicate a form of *Character Development*. Conversely, reduction to an already *Limited Set of Actions* during gameplay is nearly always a *Penalty*.

Games using a *Game Master* let game designers have little influence on when players have *Limited Sets of Actions* to choose from, as the *Game Master* can in most cases decide what actions are possible on the spur of the moment. However, *Game Masters* and other *Dedicated Game Facilitators* make it unnecessary for players to *Memorize* all rules and effects of a game.

RELATIONS

Instantiates: *Stimulated Planning, Analysis Paralysis, Tension, Penalties*

Modulates: *Character Development, Limited Planning Ability, Gain Competence, Units, Higher-Level Closures as Gameplay Progresses*

Instantiated by: *Ability Losses, Narrative Structures*

Modulated by: None

Potentially Conflicting with: *Game Masters, Freedom of Choice, Memorizing*

Downtime

The player cannot directly affect the outcome of the game for a period of time.

Whenever players cannot actively work toward achieving a goal, they experience *Downtime*. This does not mean they cannot do anything in the game; one may be able to move within a limited area without being able to affect the outcome. Neither does it have to automatically occur because players cannot affect the game state; as long as one is planning future actions, one is not having *Downtime*.

> **Example:** Waiting for one's opponent to move a piece in *Chess* when one has finished one's own planning.

> **Example:** Players that have *Avatars* killed in a *Counter-Strike* game do not have them respawned and have to wait as spectators until the next match begins.

> **Example:** Many team-based multiplayer first-person shooters, for example, *Team Fortress Classic* or *Return to Castle Wolfenstein: Enemy Territories*, have a certain amount of time where players can move their *Avatar* in the game environment before the game begins. This time, which allows more players to be logged on at the beginning of the actual game, cannot be used to affect the outcome of the game with the exception of minor differences in starting position.

USING THE PATTERN *Downtime* is a difficult pattern to explicitly design for since the cause of *Downtime* depends heavily on the players doing action in the game, the current game state, and the subjective opinion of the players experiencing the *Downtime*. However, the amount of *Downtime* in a game can usually be restricted by achieving the *Right Level of Difficulty* or giving players *Limited Planning Ability*, for example, limiting *Analysis Paralysis* through *Limited Resources*. *Dedicated Game Facilitators*, especially *Game Masters*, can observe *Downtime* among players and stop it by giving players opportunities—or forcing them—to act. However, these game facilitators can also force *Downtime* upon players. When the right level of *Downtime* is achieved, the pattern can support several other patterns, for example, *Anticipation* or *Penalties*.

There are a number of ways to cause intentional *Downtime* for players. Both *Turn-Based Games* and *Real-Time Games* use the pattern to create *Penalties*—more specifically, *Individual Penalties*—often as an effect of *Damage*. In the first case, this usually consists of having to skip a turn, while in the second case, it can consist of having to wait a certain time, possibly as a *Spectator*, until *Spawning* occurs or having to wait until the game is finished. In games where all actions are of the same type, any limitations of actions or *Ability Losses* can cause *Downtime*, for example, *Movement Limitations* in racing games. *Cut Scenes* cause *Downtime*, which allows for directed parts of the *Narrative Structure* to be unfolded, and may be combined to release *Tension* after *Closure Points*. *Ultra-Powerful Events* can cause *Downtime*, but only when they completely hinder players from making any form of actions.

Downtime can also be caused by the game system. Examples include the time caused by the saving and loading in *Save-Load Cycles* and other system-initiated *Game Pauses*. *Tick-Based Games* with long tick times can also have *Downtime*, and sometimes this is also intentionally designed into the game.

Downtime does not necessarily mean that players cannot affect the game state but that the changes are not perceived as meaningful for the players. *Downtime* can be lessened by promoting *Negotiation* or *Stimulated Planning* for all players, but if the *Downtime* is caused by a player, this can negatively affect *Player Balance*. This is because the player has an advantage since his planning is done from the current game state and does not have to take several possible game states as the starting point for the planning.

CONSEQUENCES *Downtime* occurs primarily in *Multiplayer Games*: either *Asynchronous Games* or *Synchronous Games* that are *Turn-Based Games* and where the *Turn Taking* takes time due to *Cognitive Immersion* and *Analysis Paralysis* of other players. However, any type of game with *Player Elimination* or *Player Killing* can have *Downtime* if they allow players to return to the game after a period of time. *Downtime* can be especially problematic in games with the possibility of *Early Elimination*. *Downtime* can also exist in *Single-Player Games*, but in those cases is mainly due to having to wait for *Extended Actions* to complete or the effect of *Penalties*.

Since players experiencing *Downtime* cannot choose what they do, it causes loss of *Freedom of Choice*, and experiencing *Downtime* can be perceived as an *Individual Penalty*. The pattern can also occur in *Real-Time Games*, typically because of players being in a section where no meaningful changes in game state occur, for example, in a moving elevator. When combined with views of *Inaccessible Areas*, these periods of *Downtime* can cause *Tension*, for example, if one can see that the elevator is moving toward a place filled with monsters. *Downtime* is usually enforced on the player after a *Closure Point*, either for technical reasons or for maintaining the *Consistent Reality Logic* through a *Cut Scene*.

Too large periods of *Downtime* make reasonable waiting times impossible and can ruin *Immersion*. However, acceptable levels of *Downtime* not only allow reasonable waiting times but may be required to build *Anticipation* for one's next action. Further, *Downtime* can be used to try and figure out *Unknown Goals* of other players by observing their actions.

No-Ops do not create *Downtime* since they are choices made by players to not affect the game state, which affects the outcome of the game.

RELATIONS

Instantiates: *Tension, Anticipation, Individual Penalties, Penalties*

Modulates: *Stimulated Planning, Closure Points, Consistent Reality Logic, Damage, Unknown Goals, Multiplayer Games, Single-Player Games*

Instantiated by: *Closure Points, Multiplayer Games, Turn-Based Games, Synchronous Games, Asynchronous Games, Analysis Paralysis, Spectators, Ultra-Powerful Events, Save-Load Cycles, Cut Scenes, Extended Actions, Movement Limitations, Ability Losses, Spawning, Turn Taking, Cognitive Immersion, Player Killing, Player Elimination, Early Elimination, Game Pauses*

Modulated by: *Game Masters, Dedicated Game Facilitators, Right Level of Complexity, Limited Resources, Tick-Based Games*

Potentially Conflicting with: *Ephemeral Goals, Real-Time Games, Time Limits, Negotiation, Tension, Freedom of Choice, Game Masters, Dedicated Game Facilitators, Limited Planning Ability, Immersion*

Experimenting

Performing actions to learn how the rules of cause and effect work in a game.

In all but the most simple of games, the complete consequences from actions performed are difficult to understand, but *Experimenting* can aid in understanding them. Actions may be tested for this reason simply because they have not been tested before if a player is willing to see a game session primarily as a learning period. Some games explicitly build experimenting into gameplay as puzzles. In these cases, the actions used to test possible solutions are usually reversible.

Example: Gameplay in *Mastermind* consists of one player guessing the correct combination of colored pegs. As the chance for guessing correctly based only on luck is very small, successful gameplay requires that the player combines the results from different guesses to draw conclusions and uses the guesses as experiments.

Example: In *Pontifex*, players' goals are to build bridges and to learn how the physics model works. The players' have to experiment with how cable, joints, and metal beams interact.

Example: The computer game *The Incredible Machine* lets players use a limited set of objects such as pipes, bowling balls, cats, candles, ropes, and balloons to try and reach goal states by making the objects interact with each other in certain ways.

Example: The abstract game *Zendo* requires players to set up arrangements of different colored pyramids to extrapolate the correct arrangement rules that a game master has decided to use for that particular game instance.

Example: Creating potions in *Morrowind* can be an experiment if the player is not an alchemist master, as not all effects of ingredients are known until one reaches that level.

USING THE PATTERN *Experimenting* is a form of *Gain Information* goal and as such requires *Imperfect Information*. The *Imperfect Information* can be about the fundamental rules of cause and effect in computer games, about the long-term consequences of actions, or about the game state. In the first two cases, gaining the *Imperfect Information* gives *Strategic Knowledge* about the *Predictable Consequences* in the game, while the last case can provide information about other players' game elements and tactics. The actual actions used in the *Experimenting* can be any; with *Experimenting*, players learn about the actions by performing them. However, it is especially common with *Experimenting* when doing *Puzzle Solving*, to find possible *Combos*, or try to find *Achilles' Heels* of *Enemies*.

In order to encourage *Experimenting*, the actions should not have severe consequences. In *Quick Games*, this may not be a problem if the outcome of the game has no *Extra-Game Consequences*, as a new game session can be started again. In other forms of games, *Experimenting* is encouraged by having *Reversability* of actions, either by allowing *Save-Load Cycles* or avoiding *Irreversible Actions*. This is typically easier to do in games with *Dedicated Game Facilitators*, as they can easily restore game states and not require players to do so. Actions that are closely related to *Constructive Play*, for example *Construction*, are better suited for *Experimenting*, because these actions are less likely to result in *Competition*. Providing *Reversability* in certain locations, which can be seen as a form of *Safe Havens*, allows for *Smooth Learning Curves*, as players can train and gain a certain level of *Game Mastery* before having to risk failure.

When *Experimenting* can have severe consequences, they create *Tension* and can require *Leaps of Faith* but also encourage *Stimulated Planning*. *Competition* puts players in situations where the effect of every action can have the potential of

affecting the overall outcome of the *Competition*, and due to this act of *Experimenting*, these situations force players to make *Risk/Reward* choices between the potential benefits of the experiment against the possible loss of not performing the most optimal action.

CONSEQUENCES *Experimenting* relies on the presence of a *Gain Information* goal, which players try to complete by performing different variations of actions in a game. The act of planning and *Experimenting* promotes *Cognitive Immersion* and can modulate the *Right Level of Difficulty* of a game. As the actions performed when *Experimenting* do not usually fulfill a goal in the game, the activity gives *Illusionary Rewards*, but these can be valuable for gameplay since they may provide *Strategic Knowledge*.

The possibility of *Experimenting* in a game can aid in avoiding the emergence of *Analysis Paralysis*, as players can try the effects and consequences of their ideas and plans rather than try to deduce the effects and consequences. This can provide *Smooth Learning Curves*.

Using *Non-Renewable Resources* when *Experimenting* can be costly but encourage *Stimulated Planning*, unless the game allows players to use *Save-Load Cycles*.

RELATIONS

Instantiates: *Tension, Smooth Learning Curves, Game Mastery, Risk/ Reward, Leaps of Faith, Strategic Knowledge, Cognitive Immersion, Stimulated Planning*

Modulates: *Right Level of Difficulty*

Instantiated by: *Illusionary Rewards, Save-Load Cycles, Reversability, Imperfect Information, Gain Information, Predictable Consequences, Construction, Puzzle Solving, Combos, Achilles' Heels, Right Level of Complexity*

Modulated by: *Safe Havens, Constructive Play, Dedicated Game Facilitators, Quick Games*

Potentially Conflicting with: *Analysis Paralysis, Competition, Irreversible Actions, Non-Renewable Resources*

Transfer of Control

When the influence over a game element is passed from one player to another.

Many games let game elements, or the control over the actions they allow, shift between players. This *Transfer of Control* makes the ownership of game elements less sure in the game and provides players with goals of trying to change the ownership status of game elements.

Example: Trading in the board game *Civilization* allows players to collect series of a commodities, which can then be used to purchase advances.

Example: The special ability of *Priests* in *Age of Empires* is to transfer the control of enemy units to the player controlling the *Priests*.

USING THE PATTERN *Resources* are the most common type of game element that may shift between different players' control, followed by *Tools* and *Units*. *Transfer of Control* also addressed which player has *Area Control* over various parts of the game board or world. *Gain Ownership* and *Collection* goals require *Transfer of Control* events to occur, but the *Transfer of Control* does not have to be between players; the control can go from being uncontrolled, or controlled by the game system, to a player or vice versa. *Collecting* is an activity that gives a player control over game elements that in most cases are not under any other player's control. *Penalties* of losing *Resources* or *Tools*, and the *Ability Losses* these cause, are examples of *Transfer of Control* from players to an uncontrolled state.

If the *Transfer of Controls* are *Irreversible Actions* and the *Resources* involved are *Limited Resources* or *Non-Renewable Resources*, the action of transferring control defines a sort of *Closure Point*. If *Reversability* of the control transversal is possible, either between players or between players and the game system, this makes the *Resources* used *Renewable Resources*, as a *Closed Economy* exists.

Transfer of Control can be modulated to encourage players to specialize in a few game element types or spread control over many types. *Geometric Rewards for Investments* encourage players to focus upon one or a few game elements, while *Privileged Abilities*, *Diminishing Returns*, and explicit heterogeneous *Collections* all favor wider spreads of control.

The actions leading to *Transfer of Control* can either be based on *Collaborative Actions* or *Conflict* although the former can lead to the latter. *Negotiation* is an example that enables *Collaborative Actions* regarding control transfer through such actions as *Trading* or *Bidding*. *Betting* is similar but lies closer to *Conflict*. *Overcome* and *Capture* goals are pure examples of *Conflict* and are most often conducted through *Combat*.

Transfer of Control does not have to be total. By giving other players some control, the control can become shared and require *Collaborative Actions* such as *Bidding*. Another form of making *Transfer of Control* less total is by introducing some form of reversed transfer. Examples of this occur naturally in *Trading* but may be enforced in *Bidding* by distributing the *Resources* used for the *Betting* to the players who do not win the bet. This form of reciprocal transfer usually has *Balancing Effects* but also allows players to have *Strategic Knowledge* about the difference in values between the transferred game elements or actions.

CONSEQUENCES *Transfer of Control* provides means of changing *Ownership* of game elements during gameplay. This can provide *Varied Gameplay* for players, as it means that *New Abilities* or *Privileged Abilities* that are unavailable other times can be available for players. Depending on how the *Transfer of Control* can be done, the presence of the possibility of it gives rise to *Negotiation* or *Conflict*. Both gaining control and losing control of game elements easily causes *Emotional Immersion*.

RELATIONS

Instantiates: *Closed Economies, Varied Gameplay, Collaborative Actions, Conflict, Closure Points, Strategic Knowledge, Collecting, Privileged Abilities, New Abilities, Area Control, Emotional Immersion, Ownership*

Modulates: *Tools, Resources, Units, Non-Renewable Resources*

Instantiated by: *Trading, Bidding, Betting, Negotiation, Gain Ownership, Overcome, Capture, Collection*

Modulated by: *Renewable Resources, Non-Renewable Resources, Diminishing Returns, Geometric Rewards for Investments, Balancing Effects, Irreversible Actions*

Potentially Conflicting with: None

Interruptible Actions

Actions that can be interrupted before they affect the game state.

Just because players have performed, or started to perform, actions does not mean that they will affect the game state. Games that allow actions to be interrupted before they affect the game state, either partially or fully, have *Interruptible Actions*.

Example: Most fighting games allow players to block opponent's attacks, effectively making the attacks interruptible.

Example: In *RoboRally*, players choose how their robots should move by deciding a sequence of programming cards. These are the actions the robot will perform, but since other robots' movement may push the robot around, the intended actions are interruptible.

USING THE PATTERN In *Real-Time Games, Interruptible Actions* are either *Extended Actions* with *Delayed Effects*, so that other actions can be performed before the effect of the *Interruptible Actions* takes place, or that the interrupting actions can be started before the *Interruptible Actions*. In *Turn-Based Games*, special *Turn Taking* sequences may be necessary to describe in rules for how actions can be interrupted, even though these sequences are skipped in many turns.

Interruptible Actions can be used to modulate *Irreversible Actions* so that permanent effects on the game state cannot be initiated by one player without other players having a chance to affect this, thus providing *Balancing Effects* in games. This is common in fighting games where players can block attacks or interrupt *Combos*.

In games with *Negotiation*, for example *Trading*, having the *Negotiation* be an *Interruptible Action* allows several parts to simultaneously engage in *Negotiation* and lets them immediately respond to the proposals of other players.

Being able to interrupt an action can be a *Privileged Ability*. This is most common in card games but can also be found in situations where judges are used to modulate *Negotiation*. Depending on the game, it may be allowed to interrupt *Storytelling* and this can be used to make the story into a collaborative action.

CONSEQUENCES As completing an *Interruptible Action* can be a goal in itself, all *Interruptible Actions* spawn *Interferable Goals*. In a case where players have multiple *Focus Loci*, *Interruptible Actions* that are also *Extended Actions* may require players to perform *Risk/Reward* choices on how much *Attention Swapping* is necessary to ensure completion of the actions.

RELATIONS

Instantiates: *Attention Swapping, Interferable Goals, Risk/Reward, Balancing Effects*

Modulates: *Irreversible Actions, Extended Actions, Storytelling, Combos, Trading, Negotiation*

Instantiated by: *Privileged Abilities, Turn Taking*

Modulated by: *Delayed Effects*

Potentially Conflicting with: None

Focus Loci

The game elements through which a player's actions are taken.

Focus Loci, the locations of the focus, are the game elements through which players can affect the game state. The most obvious *Focus Loci* are the game elements that can be moved by the player, and the actions they provide are the possibility of moving them.

Example: Each piece in *Chess* acts as a *Focus Loci* for the players by providing a number of potential actions.

Example: The stones used in *Go* are only *Focus Loci* when they are being placed on the board, since players cannot perform any other actions through them later.

Example: The *Avatar* that a player controls in a first-person shooter is the *Focus Loci* they have in the game.

Example: Various types of mouse cursors used in real-time strategy games and *Sims* games are *Focus Loci* that allow players to move between units and characters, which in their turn are also *Focus Loci* as illustrated in Figure 8.2.

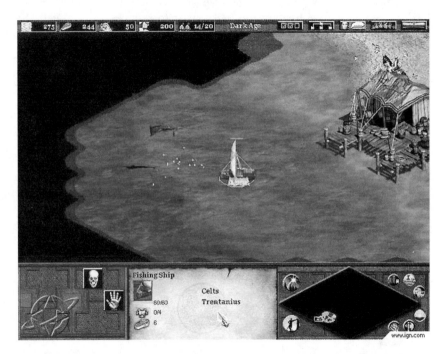

FIGURE 8.2 The player has used the mouse cursor to select the ship in the middle of the screen to be the current focus in *Age of Empires 2*. Copyright Microsoft Corporation. Reprinted with permission.

USING THE PATTERN The four main options for *Focus Loci* are *Avatar*, *Units*, *Characters*, and *God's Fingers*. The first three can maintain a *Consistent Reality Logic*, but the actions they provide are then restricted by the *Alternative Reality* of the game. They also allow points within the game for players to have *Identification* with. The use of *Characters* allows players to have *Focus Loci* without the need for *Game*

Worlds. The use of several *Focus Loci* through *Units* allows single players to simulate *Team Play* but requires *Attention Swapping* and *Status Indicators* to show where the *Focus Loci* are in the *Game World.* As the swapping between *Units* is often done by explicit actions performed from a *Third-Person View,* this *Third-Person View* can actually be seen as a form of *Focus Loci. God's Fingers* are most often used to allow players to have *Game State Overview* and to let them do *Attention Swapping* between other *Focus Loci* but can be used to provide the god-like actions found in god games.

Although not as common as the three main options, *Cards* can, especially in collectable card games, be *Focus Loci* either when being played or by being in play and giving a player *New Abilities. Book-Keeping Tokens* whose presences indicate that a player has *New Abilities* are another form of more unusual *Focus Loci. Dice* are seldom *Focus Loci* except in pure dice games, since using them is not usually an activity affecting the game directly but rather determining how actions are to be performed.

The choice of *Focus Loci* and the actions they support dictate which game elements players have *Indirect Control* over.

CONSEQUENCES *Focus Loci* are game elements within *Game Worlds* that provide methods for players to affect the *Game Worlds. Focus Loci* can affect the *Game World* usually by affecting themselves, other game elements, or the environment in their immediate vicinity, for example, to gain *Area Control* in the latter case. These *Focus Loci* support *Cognitive Immersion,* and in some cases, *Spatial Immersion.* The *Focus Loci* that are not defined as part of the *Game World* primarily support *Cognitive Immersion* but can also support *Sensory-Motoric Immersion.*

Providing multiple *Focus Loci* affects the *Risk/Reward* tradeoffs that have to be made when initiating *Extended Actions.*

RELATIONS

> **Instantiates:** *Cognitive Immersion, Spatial Immersion, Sensory-Motoric Immersion, Indirect Control, Identification*
>
> **Modulates:** *Consistent Reality Logic, Alternative Reality, Attention Swapping, Extended Actions, Area Control*
>
> **Instantiated by:** *Avatars, Units, God's Finger, Characters, Cards, Dice, Book-Keeping Tokens, Third-Person Views*
>
> **Modulated by:** *New Abilities, Status Indicators*
>
> **Potentially Conflicting with:** None

New Abilities

Gaining new abilities during gameplay.

Many games provide players with additional actions that they can perform after they have started playing. These *New Abilities* give players more freedom in the game and allow them to be more empowered as gameplay continues.

> **Example:** Roleplaying games that use character levels often, especially to wizard or cleric character classes, award players with new spell-casting abilities. Other examples of new abilities include new forms of attack for fighters and new stealth possibilities for thieves.

> **Example:** *Return to Castle Wolfenstein: Enemy Territory* allows players to gain experience in several different skills during game play. When players "level up" in a skill, they gain new abilities connected to that skill, e.g., being able to call air strikes based on observation with binoculars, fully reviving team mates with health injections, or having more ammunition in supply packs.

> **Example:** Becoming a zombie in *Zombiepox* does not automatically mean game over, since players can cure their *Avatars* by finding brains. However, the players' *Avatars* have the ability to spread the zombie disease just like other zombies, which does not aid in player success.

USING THE PATTERN Besides what abilities should be given, the primary design choices for *New Ability* are if the ability gains are temporary, if the ability is linked to a certain *Focus Loci* or to the player, and if players can affect what ability is gained. Further, the *New Ability* may be the cause of a *Reward* or the result of an *Investment*.

When *New Abilities* are linked to *Units* or *Characters*, they may be in the form of *Chargers* or *Power-Ups* that give temporary effects with *Time Limits*, or they may be in the more permanent form of *Tools*. *Tools* may allow a *Transfer of Control* of the *New Ability* and may have limited numbers of uses due to *Limited Resources*.

Linking *New Abilities* to *Characters* is not much different than linking them to players, unless the ability can be lost with the loss of *Lives*. Giving the *New Abilities* to *Units* increases the value of individual *Units* of the type that received the ability and can create *Orthogonal Unit Differentiation*.

When players can influence what *New Abilities* they gain, this gives *Freedom of Choice* to the players and makes *Planned Character Development* possible. In games with *Team Play*, this also allows *Team Development* and player-directed *Orthogonal Unit Differentiation*.

Like *Privileged Abilities,* any *New Ability* can affect *Player Balance* negatively. This may be countered by the *Balancing Effect* of linking the *New Ability* to an *Ability Loss* of another type, forcing players to perform *Risk/Reward* choices. Another way to provide a *Balancing Effect* is to have the *New Ability* as part of a set of *Budgeted Action Points,* which means that use of the *New Ability* is done instead of using an existing one.

CONSEQUENCES *New Abilities* are the objectives for *Gain Competence* goals, *Gain Ownership* goals of *Tools,* and give new possibilities for new *Competence Areas.* As they give players increased *Freedom of Choice* and the *New Abilities* often are *Privileged Abilities,* receiving them is almost always considered a *Reward.* This may affect players' *Perceived Chance to Succeed* and creates *Illusion of Influence* even if no actual influence needs to exist. The ability to have more influence over the game state makes goals of acquiring *New Abilities* into implicit if not explicit *Supporting Goals* and gives players *Empowerment.* Having diseases and the ability to spread them is an example of how a *New Ability* can be a *Penalty. Role Reversal* events often give players *New Abilities* while at the same time imposing *Ability Losses* of existing ones.

New Abilities given to *Characters* are a form of *Character Development* and as such can move the development of the *Narrative Structure* forward. In games with *Team Play, New Abilities* also foster *Team Development.* Giving *New Abilities* as the gameplay unfolds lets players have *Smooth Learning Curves* and provides a means to support *Varied Gameplay* over a game session. *New Abilities* give rise to *Red Queen Dilemmas* when a game allows a series of *New Abilities* to be acquired by competing players.

The difference between *New Abilities* and *Improved Abilities* can be defined in several different ways: if the new action is activated in the same way as the old, if the consequences of the action affect different parts of the game state, or if the explanation given by the *Alternative Reality* differentiates them. *New Abilities,* unless present in other game elements or part of *Predefined Goals,* fits less well with a *Consistent Reality Logic* than *Improved Abilities.*

RELATIONS

> **Instantiates:** *Gain Competence, Privileged Abilities, Rewards, Varied Gameplay, Supporting Goals, Character Development, Orthogonal Unit Differentiation, Planned Character Development, Team Development, Freedom of Choice, Empowerment, Competence Areas, Illusion of Influence, Perceived Chance to Succeed, Red Queen Dilemmas, Investments*
>
> **Modulates:** *Team Play, Gain Ownership, Focus Loci, Risk/Reward, Smooth Learning Curves, Characters, Units, Narrative Structures, Ability Losses*

Instantiated by: *Role Reversal, Power-Ups, Chargers, Tools, Transfer of Control*

Modulated by: *Balancing Effects, Alternative Reality, Ability Losses, Lives, Freedom of Choice, Time Limits, Budgeted Action Points*

Potentially Conflicting with: *Player Balance, Consistent Reality Logic*

Improved Abilities

Players' chance of succeeding with an action as a function within the game is increased, or the calculated effect the action has increased in the game.

Players can progress in games by having their action's effect on the *Game World* increase and by having greater chances of succeeding. When these chances or effects have improved, the players have received *Improved Abilities* and have greater chances of completing goals or otherwise influencing the game state.

Improved Abilities are not the physical or mental abilities of players; they are the effects of the game state upon the evaluation functions of actions.

Example: Tabletop roleplaying games often describe players' skill in an area with a value, and succeeding with the skill requires players to roll below the value with a die. Improvement of these skills is done simply by increasing the associated value.

Example: *Chargers* and *Power-Ups* in racing games often give vehicles a speed boost or raise the maximum speed possible without further affecting players' possible actions.

USING THE PATTERN *Improved Abilities* most often raise players' chance to succeed with actions or make the effects of their actions more powerful. *Improved Abilities* are often easier to explain within a *Consistent Reality Logic* than *New Abilities*, as the pattern can use increases of *Skills* of *Characters* or *Avatars*. *Power-Ups* and *Chargers* are common game elements used to provide temporary *Improved Abilities* with *Time Limits*, while *Tools* give improvements as long as they are carried. Another way to give players *Improved Abilities* is to make their actions require fewer *Resources*, thereby letting players make more efficient use of *Limited Resources*.

As a *Balancing Effect*, *Diminishing Returns* can be used to avoid letting players with powerful abilities more easily get *Improved Abilities* than other players. In the same way, *New Abilities* can be balanced by *Ability Losses* in other *Competence Areas*; game design can have *Balancing Effects* by linking *Decreased Abilities* in some areas to *Improved Abilities* in others.

CONSEQUENCES *Improved Abilities* are *Rewards* that give players *Empowerment* and promote *Competence Areas*. The improvement is typically a consequence of *Gain Competence* goals or the acquisition of *Tools* as part of *Gain Ownership* goals. Gaining *Improved Abilities* creates *Supporting Goals*, as they empower players to influence the game state and thereby can raise players' *Perceived Chance to Succeed* as well as create *Illusion of Influences*.

Like *New Abilities*, the improvement of abilities is a form of *Character Development* and when players are given a *Freedom of Choice* to affect what abilities are improved, it gives rise to *Planned Character Development*. In games with *Team Play*, this provides *Team Development*, with the additional effect of *Orthogonal Unit Differentiation*. *Improved Abilities* can also, like *New Abilities*, give rise to *Red Queen Dilemmas* when competing players can have *Improved Abilities* several times during gameplay.

The difference between *New Abilities* and *Improved Abilities* is often one of scale or perspective: are the abilities activated in the same fashion as before, do they affect the same parts of the game state, and are does the *Alternative Reality* explain them as being different or the same?

RELATIONS

> **Instantiates:** *Gain Competence, Rewards, Empowerment, Supporting Goals, Illusion of Influence, Perceived Chance to Succeed, Red Queen Dilemmas, Team Development, Planned Character Development*
>
> **Modulates:** *Gain Ownership, Consistent Reality Logic, Competence Areas, Decreased Abilities, Orthogonal Unit Differentiation, Characters, Avatars, Skills, Limited Resources*
>
> **Instantiated by:** *Tools, Power-Ups, Chargers, Character Development*
>
> **Modulated by:** *Freedom of Choice, Time Limits, Balancing Effects, Decreased Abilities, Diminishing Returns*
>
> **Potentially Conflicting with:** None

Ability Losses

The loss of ability to perform an action in the game.

Games do not have to let players have the same possibility of actions the whole game. Such *Ability Losses* may be the cause of *Penalties* for failing goals or the effect of opponents' actions, but may also simply be due to different play modes.

> **Example:** Respawning in multiplayer first-person shooters is typically done without any weapons, and the special abilities they provided, gained in earlier gameplay.

Example: Game masters in roleplaying games can sometimes be forced to invent events that are unavoidable to the players to strip them of equipment that gives the abilities that disrupt the game balance.

USING THE PATTERN The design of *Ability Losses* consists of deciding what action is lost, for example a severe form of *Movement Limitation,* and the reason for the loss, typically a *Penalty* for failing a goal. A loss of ability can be used to create *Gain Competence* goals in order to regain it, or *Gain Ownership* if the ability was the effect of a *Tool.*

A loss of ability affects *Player Balance.* If the lost ability was possessed by most or all players, it is a *Penalty,* but if the ability was a *Privileged Ability* and other players did not have other forms of actions that equaled the lost ability in value, the loss can affirm *Player Balance* and is a *Balancing Effect* if explicitly designed. The *Penalty* of *Ability Loss* can also be mitigated by having a *Time Limit* on the loss or by giving the same player *New Abilities* within other areas.

CONSEQUENCES *Ability Loss* is a common *Penalty,* for example, by the effects of *Damage.* Losing an ability naturally restricts the *Limited Set of Actions* available and thereby players' *Freedom of Choice,* either on a *Unit* level or for the player overall, and may cause *Competence Areas* to be lost as well. In extreme cases, *Ability Loss* may cause players to have *Downtime,* and if the loss is temporary, this is equal to *Player Killing* and, if permanent, to *Player Elimination.* An *Ability Loss* may reduce the complexity of a game while increasing the difficulty, modulating *Right Level of Complexity* and *Right Level of Difficulty* in different directions.

Besides *Penalties, Ability Losses* may be the natural affect of *New Abilities* that had *Time Limits.* Other causes for *Ability Losses* can be *Spawning* after losing a *Life* or *Role Reversals* where the losses of some abilities are usually countered by *New Abilities* in other *Competence Areas.* If the *Ability Losses* severely affect how players can complete goals, they hinder them to have a *Perceived Chance to Succeed* and any *Illusion of Influence.*

The presence of *Units* in a game with *Privileged Abilities* regarding other *Units* controlled by the same player gives that player the *Continuous Goals* to make the *Units Survive* (or not be *Captured*) in order to not have *Ability Loss.* If the *Units* are under *Indirect Control,* the loss may not be so severe, as control can be regained.

Ability Losses are not commonly used to advance *Narrative Structures* unless they are *Ultra-Powerful Events,* since players may see goals in resisting the loss, especially in games that support *Save-Load Cycles.* One reason for enforcing these types of *Ability Losses* in *Narrative Structures* is as part of *Character Development.* When the losses are part of the game story, they do provide a form of *Varied Gameplay,* as players have to adjust to a *Limited Set of Actions,* which may be used to modulate the

Right Level of Difficulty. However, *Ability Losses* may be enforced by a game design to ensure a *Narrative Structure*, although this may be in conflict with a *Consistent Reality Logic*, for example, making it impossible to attack shopkeepers in computer-based roleplaying games when it is possible to attack monsters.

In games with *Game Masters*, *Ability Losses* may be the outcome of *Negotiation* with the players in order to restore *Player Balance* and provide the *Right Level of Difficulty*.

RELATIONS

Instantiates: *Penalties, Limited Set of Actions, Continuous Goals, Varied Gameplay, Downtime, Player Elimination, Gain Competence, Gain Ownership, Character Development*

Modulates: *Damage, New Abilities, Narrative Structures, Right Level of Difficulty, Right Level of Complexity, Player Balance, Spawning, Player Killing*

Instantiated by: *Role Reversal, Movement Limitations, Ultra-Powerful Events*

Modulated by: *Balancing Effects, Indirect Control, Units, Game Masters, Negotiation, Time Limits, New Abilities*

Potentially Conflicting with: *Narrative Structures, Save-Load Cycles, Competence Areas, Consistent Reality Logic, Illusion of Influence, Perceived Chance to Succeed, Freedom of Choice*

Decreased Abilities

Players' chance of succeeding with an action as a function within the game is decreased, or the calculated effect the action has in the game decreased.

Many games have events that make players' future actions have less effect, or less chance of succeeding, than they originally had. These *Decreased Abilities* can be the consequences of running out of *Resources* or being affected by hostile actions but require players to use the abilities more efficiently to reach the same level of effect as previously.

> **Example:** Each point of damage received in *RoboRally* gives the player one card less at the beginning of each turn. As these cards are used to program a robot's movement, the reduction in number of cards effectively reduces the player's ability to control the robot.

> **Example:** Being hit by an ice cube or polygon ball weapon in the *Monkey Race 2* party game in *Super Monkey Ball 2* significantly reduces players' top speed and ability to steer.

USING THE PATTERN Instantiating *Decreased Abilities* can easily be done by changing the values in the game state that are part of the evaluation functions of an action. Typically, this is motivated by changes in *Skills* of *Characters* or *Units*. An indirect way of achieving *Decreased Abilities* is to require use of *Limited Resources*, and maybe *Non-Renewable Resources*, so that players have to make *Risk/Reward* choices of whether to use the action. This limits the *Freedom of Choice* when the players can use the actions. Reducing the amount of *Resources* a player can access or store is another way to combine *Decreased Abilities* with *Limited Resources*.

Decreased Abilities are often used as *Penalties* to affect *Player Balance*. When the effect of this needs to be modulated, *Time Limits* of the decrease or complementing *Improved Abilities* in other areas can be used to achieve a *Balancing Effect*.

A common place for *Decreased Abilities* to occur in gameplay is as the consequences of *Player Killing*, either represented through the loss of *Tools* or experience.

CONSEQUENCES *Decreased Abilities* are *Penalties* that affect players' *Perceived Chance to Succeed*. If an ability is decreased so much that the perceive chance of success to achieve a goal by using it becomes nothing, any *Illusion of Influence* due to the action is lost. If the chance actually is nil, the *Decreased Ability* can be seen as an *Ability Loss* and is in conflict with providing players with a *Perceived Chance to Succeed*. Unlike *Ability Loss*, *Decreased Abilities* can be used to affect the *Right Level of Difficulty* by raising it while retaining the *Right Level of Complexity*.

Decreased Abilities can be used to negatively define *Orthogonal Unit Differentiation*. This kind of differentiation typically is an emergent feature due to different levels of *Damage* or depletion of *Resources* between *Units* or players in a team.

RELATIONS

Instantiates: *Ability Losses, Penalties*

Modulates: *Improved Abilities, Risk/Reward, Right Level of Difficulty, Perceived Chance to Succeed, Player Balance, Characters, Skills, Orthogonal Unit Differentiation, Units, Player Killing, Limited Resources, Right Level of Complexity*

Instantiated by: *Limited Resources, Non-Renewable Resources*

Modulated by: *Balancing Effects, Time Limits, Improved Abilities*

Potentially Conflicting with: *Freedom of Choice, Illusion of Influence, Perceived Chance to Succeed*

Extended Actions

Actions that take so long to complete that they require players to miss opportunities to perform other actions in order to complete them.

Not all actions in games take place immediately, and some require that players continue to perform them for a period of time before taking effect. Such actions are *Extended Actions* and require players to make choices between completing them and abandoning them in order to start other actions. If they cannot be interrupted, they do not even let players abandon them in favor of other actions, and the player must commit fully to them.

> **Example:** Taking photographs to complete certain mission goals in *America's Army* requires that the player performs an action continuously for a certain period of time, is not able to check the surroundings freely, and risks being killed.

> **Example:** Buildings in the *Age of Empires* series let players build *Units*, but the production of these *Units* takes time, and while they are being produced, no new production of units can start.

USING THE PATTERN There are three main reasons for using *Extended Actions* instead of normal actions: requiring a certain commitment of players to start using the action but make continued use easy; encouraging players to use the actions continuously to achieve additional effects; or requiring commitment from players for a continuous period of time. The first reason gives *Stimulated Planning* and may have *Balancing Effects* if more powerful actions require more preparation and *Resources*. The second reason gives players increased *Freedom of Choice*, as it provides players with additional ways of using actions but can also limit players by making the continuation of the action very valuable, as for example when using *Geometric Rewards for Investments*. The third reason can, like the first reason, cause *Stimulated Planning* and have *Balancing Effects* but can also increase *Tension* if the actions are *Interruptible Actions*. Gaining *Area Control* is an example of an action often using *Extended Actions* for the third reason.

Once the action is started, the *Extended Actions* may either be possible to stop or be unstoppable by the players who initiated the action. The first case makes completing the actions into *Continuous Goals* as the player may be tempted to perform other actions instead, and the completions may be affected by other players' actions if the actions are *Interruptible Actions*. The latter case makes the *Extended Actions* a form of *Ultra-Powerful Events* and starting to use them becomes *Irreversible Actions*. This makes the initiation of such actions *Risk/Reward* choices against other possible future needs of the actions and may cause *Tension*.

CONSEQUENCES *Extended Actions* can be seen as a form of *Investments* as they tie up the possible actions available to players besides any possible uses of *Resources*. They may either start taking effect immediately, having increased consequences the

longer they are performed, or may require an initial threshold to be reached before starting to have effect. In the latter case, the completion of them entails *Hovering Closures* and has *Perceivable Margins*, especially if they are also *Collaborative Actions*, since they then show the willingness of several players to perform the actions. A *Progress Indicator*, which may be an *Illusionary Reward* to provide feedback within a *Game World*, usually shows how close to the threshold the player is in this case.

When *Extended Actions* do not produce effects until they are finished, the actions leading up to the completion can be regarded as *No-Ops* and the initial action can be seen as having a *Delayed Effect*. When players only have one *Focus Loci*, these *No-Ops* can equal *Downtime* for the player and limit their *Freedom of Choice*. In contrast, when *Extended Actions* are used in combination with multiple *Focus Loci*, typically *Units*, gaining maximal benefit of all the possible actions through *Attention Swapping* can become a part of *Game Mastery*.

Producers and *Controllers* are typically game elements to provide *Extended Actions* that are not provided by players' *Focus Loci*. *Combos* and *Dexterity-Based Actions* such as *Aim & Shoot* are examples of *Extended Actions* provided by players' *Focus Loci*. *Rhythm-Based Actions* are a form of *Dexterity-Based Action* that can support *Extended Actions* using or not using *Focus Loci*.

Relations

Instantiates: *Attention Swapping, Investments, Continuous Goals, Ultra-Powerful Events, Balancing Effects, Stimulated Planning, Hovering Closures, Tension, Risk/Reward, Downtime, Irreversible Actions, Delayed Effects, Freedom of Choice, Perceivable Margins, Area Control, Rhythm-Based Actions, Dexterity-Based Actions*

Modulates: *Controllers, Game Mastery, Producers, Collaborative Actions*

Instantiated by: *No-Ops, Combos, Aim & Shoot*

Modulated by: *Units, Progress Indicators, Focus Loci, Interruptible Actions, Geometric Rewards for Investments, Illusionary Rewards*

Potentially Conflicting with: *Freedom of Choice*

Irreversible Actions

Actions whose effect on the game state cannot be undone.

All actions in a game affect the game state but many may be countered by another action, for example, moving in one direction and then moving the same distance in the opposite direction. The actions that do not have other actions that can revert the game state back to its original state are *Irreversible Actions*.

Example: The Ko (and meta Ko) rule in *Go* is used to make it impossible for the game to run into infinite loops.

Example: Pushing a box into a corner in *Sokoban* means that the box cannot be moved from there, as the boxes can only be pushed and not pulled.

USING THE PATTERN Making actions into *Irreversible Actions* can be done by simply making sure that all other actions in the whole game design do not affect a specific part of the game state. Other actions may affect that part of the game state as long as all actions affect it in the same way or direction. Other ways of making *Irreversible Actions* are to make the actions use *Non-Renewable Resources* or those that give players information. Designed *Surprises* are thus a form of *Irreversible Actions*, and since they are a form of *Trans-Game Information*, they are even *Irreversible Actions* across game sessions. Actions whose events provide *Strategic Knowledge* are likewise *Irreversible Actions* since these also generate *Trans-Game Information*.

The possibility of saving makes it impossible to have totally *Irreversible Actions* in a game but forces players to use *Save-Load Cycles*. This can be countered to a certain extent by causing actions to have *Delayed Effects* at the cost of *Predictable Consequences*.

Buttons and *Alarms* are game elements that can be used to enforce *Irreversible Actions*, in the first case by not being able to be activated more than once and in the second case by not being able to be deactivated once activated. A typical example of a class of *Irreversible Actions* is *Leaps of Faith*. Making the *Transfer of Control* of *Resources* into *Irreversible Actions* is part of creating *Non-Renewable Resources*.

CONSEQUENCES Every *Irreversible Action* performed is a closure, and since there is no *Reversability* to their effect, they do not promote *Experimenting* and make *Puzzle Solving* more difficult. Rather, they promote *Stimulated Planning* and may cause *Analysis Paralysis*.

Irreversible Actions are required to progress *Narrative Structures* and can be used to provide a condensed history of gameplay in a game session without losing any events that affected the final outcome. Leaving a *Level* and not being able to come back to it is an example of a *Narrative Structure* maintained by an *Irreversible Action*. An example of how *Irreversible Actions* can advance the *Narrative Structure* in *Real-Time Games* without relying on *Levels* is to move the places where *Spawning* occurs.

Not all *Irreversible Actions* are *Ultra-Powerful Events*, as players may hinder the effect of the actions from taking place if the actions are *Extended Actions* and *Interruptible Actions*. Likewise, the actions that caused the *Ultra-Powerful Events* do not have to be *Irreversible Actions* since another action can counter the event after it is completed. An example of this is *Shrinking Game Worlds*: these are usually *Ultra-Powerful*

Events that cannot be affected while they are occurring but after the *Game World* has become smaller it may at a later stage expand again.

RELATIONS

> **Instantiates:** *Stimulated Planning, Analysis Paralysis, Narrative Structures*
>
> **Modulates:** *Buttons, Ultra-Powerful Events, Shrinking Game World, Spawning, Levels, Transfer of Control, Puzzle Solving*
>
> **Instantiated by:** *Extended Actions, Trans-Game Information, Non-Renewable Resources, Surprises, Leaps of Faith*
>
> **Modulated by:** *Delayed Effects, Interruptible Actions*
>
> **Potentially Conflicting with:** *Experimenting, Predictable Consequences, Save-Load Cycles*

Save-Load Cycles

> *The actions of saving and loading game states.*

Some games allow players to save the game state at points in the gameplay to later return to them. This allows players to replay challenges in the game as many times as they wish in order to successfully complete actions or to maximize how well the actions are performed.

> **Example:** The single-player campaigns *Return to Castle Wolfenstein* and most other first-person shooters allow players to save the game state whenever they wish. A recent exception is *Far Cry* where the game state is automatically saved as soon as players reach certain locations.

USING THE PATTERN *Save-Load Cycles* may be instantiated in games either by letting players initiate saving and loading whenever they wish or only at specific *Save Points*. The former increases players' *Freedom of Choice* and encourages *Experimenting*. The latter creates goals of reaching the *Save Points* and makes *Risk/Reward* choices have more *Tension*.

Considerations that should be made when creating *Save-Load Cycles* are how this affects *Surprises* and *Leaps of Faiths* in the game. Further, *Save-Load Cycles* are difficult to include in *Multiplayer Games* since they require *Negotiation* to coordinate these actions and thereby easily ruin *Immersion*. Although no *Negotiation* is required in *Single-Player Games*, the presence of *Save-Load Cycles* during gameplay may in this case also work against *Immersion*.

CONSEQUENCES *Save-Load Cycles* are *Extra-Game Actions* that allow players to save and load entire game states, typically made possible by *Dedicated Game Facilitators*. The possibility of *Save-Load Cycles* in a game means that play sessions do not have to be part of the complete game session as parts of the gameplay can be abandoned to return to previous game states. This gives players the possibility of *Replayability* within a game instance, although the players can use *Trans-Game Information* from previous play sessions. Being able to learn from experience and try to practice this new knowledge can provide players with *Smooth Learning Curves* and form a sort of *Near Miss Indicator* since players can compare how well they have succeeded when playing from a saved point several times.

Since *Save-Load Cycles* make *Irreversible Actions* impossible in the perspective of the overall game session, players are free to do *Experimenting*. Further, *Save-Load Cycles* make *Penalties* and *Ability Losses* have less influence on the overall game session as in other cases of *Reversability*. The act of loading a game state creates a form of *Spawning* action for players, and since they can know the game state from earlier experiences, they have the opportunity of *Stimulated Planning*.

Although *Save-Load Cycles* provide the possibility of *Replayability*, they do not necessarily make replay meaningful. *Puzzle Solving* especially becomes pointless to do repeatedly, unless the puzzle can be solved in many different ways that can be quantifiably measured against each other.

Save-Load Cycles cause *Downtime* and *Game Pauses* from actual gameplay in *Real-Time Games*, since the actions to perform saving and loading take time away from actions in the game.

Although not intentionally constructed so, *Save-Load Cycles* may give players *Direct Information* to the game state by analyzing the files in which the saved game state is stored.

RELATIONS

> **Instantiates:** *Downtime, Experimenting, Freedom of Choice, Spawning, Stimulated Planning, Replayability, Smooth Learning Curves, Extra-Game Actions, Trans-Game Information, Game Pauses, Reversability*
>
> **Modulates:** *Tension, Real-Time Games, Direct Information,* *Near Miss Indicators, Single-Player Games*
>
> **Instantiated by:** *Dedicated Game Facilitators*
>
> **Modulated by:** *Save Points*
>
> **Potentially Conflicting with:** *Irreversible Actions, Immersion, Multiplayer Games, Ability Losses, Penalties, Leaps of Faith, Surprises, Puzzle Solving*

Additional Patterns

ON THE CD Descriptions of these additional patterns can be found in the Chapter 8 folder on the companion CD-ROM.

Attention Swapping	**Area Control**
Damage	**Budgeted Action Points**
Privileged Movement	**Turn Taking**
Indirect Control	

REWARDS AND PENALTIES

Games do not work without incentives for the players to perform actions and to strive toward their goals. The following patterns describe these incentives, both the positives, as rewards, and the negatives, as penalties, and how they can be used to modify the possible gameplay.

Rewards

The player receives something perceived as positive, or is relieved of a negative effect, for completing goals in the game.

Rewards are the positive effects that players hope to get by completing goals. The *Rewards* may be changes to the game state or other game-related effects that make other goals easier to complete, or may be effects outside the game.

> **Example:** Managing to pick a box in *Mario Kart Double Dash!!* or *Monkey Race 2* in *Super Monkey Ball 2* give the players the reward of a special power they can activate later.

> **Example:** *Betting* in games is a common form of providing *Rewards* outside the game due to what happens in the game. *Betting* can be added to all games to add this form of *Reward*, but some games such as playing on horses consist only of choosing what to bet on.

> **Example:** All games that can be won have the main reward of winning the game.

USING THE PATTERN *Rewards* are one of the main ways game designers have to encourage players to do certain actions in a game. However, the players must be aware of the *Rewards* for the *Rewards* to be able to influence them, and players must feel that the *Reward* is purposeful either to advance their chances in the game or

give enjoyable *Extra-Game Consequences*. For example, it makes little sense to let players know what a *Reward* is for an *Unknown Goal*, or have *Rewards* that only support the completion of *Excluding Goals*.

Mutual Goals allow for a number of additional design opportunities for *Rewards*, as these goals support *Individual Rewards*, *Shared Rewards*, and *Player-Decided Distribution of Rewards & Penalties*. The first option can promote *Conflict* or lessen predictability depending on whether the choice of who receives the *Reward* is based upon who completes the goal or *Randomness*. The second option supports *Team Play* and can support *Investment* if the proportion of the *Reward* depends upon some quantifiable measure of effort to reach the goal. Examples of different design approaches for how *Investments* should affect *Rewards* are *Geometric Rewards for Investments*, *Arithmetic Rewards for Investments*, and *Diminishing Returns*. *Player-Decided Distribution of Rewards & Penalties* can require *Negotiation* and have *Balancing Effects*, since the player controlling the distribution can make choices depending on the current situation in the game at the time when the *Reward* is distributed. In all cases, the motivation for trying to get *Rewards* can depend upon how much *Identification* players have with what is trying to get the *Reward* in the game.

Rewards are an easy way to create *Tension* and *Competition* between players. A typical example of this is the *Competition* in *Bidding* and *Trading* where the possible *Rewards* direct much of the struggle or the *Tension* in games where *Player Killing* is possible and can be seen as a *Reward* for the players doing the action. More abstract collections of *Rewards* can be designed to put players in positions where they have *Red Queen Dilemmas* and must strive to improve simply to maintain their relative position compared to other players. *Rewards* can also be designed so that they give rise to *Social Dilemmas*, for example when *Betrayal* is possible.

Rewards can be divided into rewards that affect gameplay and those that are *Extra-Game Consequences*, typically winning the game or winning a bet based on the game. Common in-game rewards are *Improved Abilities* and *New Abilities*, the latter of which have greater value if they also are *Privileged Abilities* such as gaining access to new *Combos*. By tying these effects to *Characters*, for example, through *Skills*, the *Rewards* can become permanent and create *Character Development*, which can drive *Narrative Structures*. By tying them to *Tools*, players can instead have *Ownership* but may risk losing the *Rewards*. Examples of *Extra-Game Consequences* are *Illusionary Rewards* and social rewards. These are the usual results of *Player Defined Goals*, but *Illusionary Rewards* can be designed as formal results of completing goals to provide *Extra-Game Information*. Both *Extra-Game Consequences* and in-game *Rewards* can give *Social Status*, although in the second case it is usually tied to *Privileged Abilities*.

Rewards may allow players to decide the exact configuration of the *Reward* to support *Freedom of Choice*. How this affects gameplay depends primarily on when

players can affect the configuration: before starting the goal, during the completion of the goal, or after the goal is completed.

The possibility of configuring *Rewards* tied to goals before trying to complete the goals is only meaningful if these goals are *Committed Goals*. The commitments may be as simple as not being able to change the configuration later or may be tied to *Penalties*, but the commitments do represent *Risk/Reward* choices as players cannot change them later. This causes *Stimulated Planning* but requires that players have a *Game State Overview* and that the game supports predictability. Otherwise, the commitment is simply one to *Luck*, as would be the case with *Betting* (in contrast to the fixed ante) in *Poker* before looking at any cards.

Being able to affect *Rewards* while trying to reach them is usually done through *Investments*, where the *Investment* represents the commitment and well as part of the *Penalty* if it is lost if the goal is failed. *Betting* is a typical example of such an *Investment* where the *Reward* is in direct proportion to the *Investment*. The function between the *Investments* and the *Rewards* can be used to modulate player interest in *Investment*: *Geometric Rewards for Investments* encourage specialization, increase the *Risk/Reward* of the *Investment*, and may disrupt *Player Balance*; *Arithmetic Rewards for Investments* have the most *Predictable Consequences* but may negatively affect *Perceived Chance to Succeed*; while *Diminishing Returns* encourage diversification between different goals if possible and may have *Balancing Effects*.

Freedom of Choice to personalized *Rewards* affecting *Character* is common in roleplaying games and supports *Planned Character Development*. In games with *Conflict*, choosing what *Resource* to replenish or what *New Ability* to receive can have *Balancing Effects*. Giving *Penalties* to other players is another form of player controlled *Reward* that can be used in games with *Conflict*.

Another way of making it possible to affect how *Rewards* are distributed after a goal has been achieved is to embed the *Reward* in a game element. For example, gaining *Area Control* may give *Resources* or *New Abilities* but it is impossible or at least difficult to steal the actual area. If instead the *Rewards* are given through *Resources*, *Pick-Ups*, or *Tools*, these resources may be moved, given away, or be stolen by *Enemies*. However in both cases, change of *Ownership* can change which player has the *Rewards*.

CONSEQUENCES The presence of *Rewards* in games makes goals desirable, and the value of the *Rewards* raises the *Anticipation* and *Tension* for players trying to complete the goals and usually provide short moments of *Emotional Immersion* when they are received. Knowing the long-term value, rather than the immediate value, of *Rewards* is *Strategic Knowledge* for a game and is often required for *Game Mastery*. *Rewards* advance gameplay by offering new goals or making existing goals easier to complete, for example, by giving players *Improved Abilities* or *New Abilities*. For this reason, they often introduce new concepts to the game, requiring the

expansion of the *Alternative Reality* to maintain the *Consistent Reality Logic*. *Rewards* that allow players to choose the exact effects on the game state from a couple of opinions promote *Freedom of Choice*. When these choices affect players' *Characters*, this allows for *Planned Character Development*.

What type of goals the *Rewards* are linked to affects the value of the *Reward*. The *Rewards* of *Player Defined Goals* are, unless the game allows formalization of such goals, social rewards or *Illusionary Rewards*, without impact on the game state. *Rewards* for *Unknown Goals* are *Surprises* but once received, the knowledge of the existence of such goals and their rewards is *Strategic Knowledge*. Goals and actions linked in *Player-Decided Distribution of Rewards & Penalties* create *Risk/Reward* situations as effort put into reaching the goal may not be rewarded but may also create *Balancing Effects*.

A *Penalty* can modulate a *Reward* and vice versa to affect the overall value and *Risk/Reward* of a goal. This can make a goal less attractive by combining the *Reward* for completing the goal with a *Penalty* affecting another aspect of the game state. Likewise, the *Penalty* for failing to fulfill a goal can be partly mitigated by having an effect similar to a *Reward*. *Continuous Goals* provide a special relationship between *Penalties* and *Rewards*: the *Penalties* occur as soon the requirement for the goal fails, while *Rewards* either do not exist or are only given after the requirement has been kept until a certain amount of time has passed or another event in the game has occurred.

The actions of receiving *Rewards* can be seen as a form of *Collecting*, especially when the *Rewards* are from goals that are part of *Hierarchies of Goals*. This can be strengthened by using *Outcome Indicators* that show statistics of the currently collected *Rewards*.

RELATIONS

Instantiates: *Anticipation, Tension, Planned Character Development, Balancing Effects, Stimulated Planning, Surprises, Strategic Knowledge, Collecting, Emotional Immersion, Social Statuses, Competition*

Modulates: *Ephemeral Goals, Player Defined Goals, Attention Swapping, Character Development, Narrative Structures, Penalties, Game Mastery, Alternative Reality, Area Control, Skills, Risk/Reward, Combos, Characters, Bidding, Trading, Betrayal, Player Killing, Red Queen Dilemma, Social Dilemmas*

Instantiated by: *Improved Abilities, New Abilities, Investments, Betting, Individual Rewards, Shared Rewards, Resources, Ownership, Tools*

> **Modulated by:** *Extra-Game Consequences, Unknown Goals, Player Defined Goals, Committed Goals, Mutual Goals, Freedom of Choice, Penalties, Player-Decided Distribution of Rewards & Penalties, Identification, Balancing Effects, Continuous Goals, Outcome Indicators, Geometric Rewards for Investments, Arithmetic Rewards for Investments, Diminishing Returns*
>
> **Potentially Conflicting with:** *Consistent Reality Logic*

Penalties

Players are inflicted with something perceived as negative or stripped of an advantage, due to failure to meet a requirement in the game.

Very few games allow all players to reach all the goals they have when playing a game. While failing to meet a goal that one has strived for is often experienced as unpleasant, games may make the failure of completing goals even more unpleasant by punishing those who fail them. These *Penalties* increase the importance of the goals they are connected to in comparison with other goals and can thereby influence player actions and tactics. In games, especially sports, where it can be difficult to judge if the actions performed by a player follow the rules, there are often meta rules for how to penalize rule-breaking.

Players can receive *Penalties* as consequences of actions and events they have not initiated, for example, being hit by an opponent. Although this can be described as failing to avoid the goal of being hit, it is more common to describe such *Penalties* as consequences of events; in many cases, what one player perceives as a *Penalty* is perceived as a good outcome for another player.

> **Example:** *Soccer* and *Ice Hockey* have several types of *Penalties*, including giving control of the ball or puck to the other team or banning players from the game, for failing to follow the rules of the game.
>
> **Example:** The loss of the money bet in a deal is the *Penalty* in *Poker* for folding or not having the best hand.
>
> **Example:** The *Penalty* for losing a piece to an opponent in *Chess* is the loss of that game piece for the remainder of the game.

USING THE PATTERN Compared to *Rewards*, *Penalties* are less common in games. This is because playing a game is a voluntary activity; if players did not over time perceive it as having more advantages than disadvantages, playing a particular game would cease in preference to other games that people overall perceived as more rewarding. Further, *Penalties* tend to be defined so that they are more often *Predictable Consequence* than *Rewards*; players perceive it as being more important to know what the most negative consequences can be compared to what the positive

outcomes are when making *Risk/Reward* judgments. Due to this, *Penalties* are more bound by the *Consistent Reality Logic* of the game and do not introduce new aspect of an *Alternative Reality* in the same way *Rewards* do. For this reason, few games advance the *Narrative Structure* through *Penalties*. *Penalties* to *Characters* with players can further modulate *Risk/Reward* choices due to *Emotional Immersion*.

These restrictions on the use of *Penalties* are especially true in games supporting saving, as *Save-Load Cycles* can return the player to a game state before the *Penalty* is given. However, *Penalties* can be used to lessen players' wishes for *Reversability* of the game state to occur by exposing additional explicit *Penalties* for allowing *Continuous Goals* to be interrupted, for example, losing *Area Control* after gaining it.

That *Penalties* tend to have *Predictable Consequences* does not mean that their effect has to be fixed. This can either be due to the definition of the *Penalty* depending on the game state or that the consequences create chain reactions; in both cases, this may require players to perform *Attention Swapping* between different activities while playing to judge the effect of *Penalties* given the current game state.

The choices available when designing *Penalties* are affected by the nature of the goals that the *Penalties* are linked to. For *Mutual Goals*, the difference between *Individual Penalties* and *Shared Penalties* greatly affects how players cooperate. For *Continuous Goals*, the *Penalties* are continuous threats while the *Rewards* may be distant. *Penalties* are required components of *Committed Goals*; without them, any commitment would be purely symbolic or based on *Extra-Game Consequences*. This does not mean that players have to fulfill them, e.g., *Ephemeral Goals* can appear during gameplay, and players have to decide whether to try and complete them to avoid their *Penalties* or accept the *Penalties* and focus upon the main goals of the game. In contrast, *Player Defined Goals* that are not modeled within the game state of a game are always without in-game *Penalties*.

Common forms of *Penalties* include loss of *Resources*, *Skills*, *Combos*, *Lives* (which may be modulated by *Spawning*), *Parallel Lives,* or *Units* but other forms are also common: limiting players' *Freedom of Choice* by giving them a *Limited Set of Actions* through *Ability Loss*; forcing players to have *Downtime* by doing *No-Op* actions for a certain amount of time or turns, often but not always as *Spectators*; imposing *Movement Limitations*; or performing a *Role Reversal* so that the player receiving the *Penalty* gets an unfavorable role. Less common is the *Penalty* of giving other players *Privileged Abilities*. *Player Killing* is a *Penalty* that gives the killed player *Downtime* but may also affect the player that did the killing, especially if they were on the same team in a game with *Team Play*.

In some cases, the *Reward* for one player is to select *Penalties* for other players, for example, in *Player-Decided Distribution of Rewards & Penalties* where one player decides with absolute power. However, in *Multiplayer Games* the value of such *Rewards* lessens compared to positive *Rewards*, with the number of players. This is

because, unless the *Penalty* is given to all other players, the relative change in position for the player receiving the *Reward* is nothing to all but one player while a positive *Reward* gives a relative change in position toward all other players. The forms of *Penalties* encourage *Negotiation*, as does *Player-Decided Distribution of Rewards & Penalties* in general.

Penalties can be used to negatively create *Social Statuses*; for example, by showing the amount of *Player Killing* each player has done. When they exist, the ability to assign *Penalties* within a social group without prompting from the game system is a form of *Player-Decided Distribution of Rewards & Penalties* that is usually assigned to those with higher *Social Status*.

Penalties can be used to encourage *Team Play* by using *Shared Penalties*, for example, by losses of *Shared Resources*. These can also be used to force players into *Alliances* where no *Rewards* exist. Random *Individual Penalties* can have the same effect; for example, the practice of decimating a Roman unit (i.e., killing one randomly chosen soldier out of every 10) after soldiers deserted made soldiers watch each other to ensure that nobody deserted the unit. *Penalties* can also be to ensure continued cooperation by penalizing *Betrayal*. When *Penalties* do not exist, most *Alliances* are actually *Uncommitted Alliances*, and one of the major considerations for the cooperation is the risk of *Betrayal*.

CONSEQUENCES *Penalties* are the effects of *Damage, Deadly Traps,* or failing to complete goals and usually give *Emotional Immersion* in games. *Penalties* indicate to players what actions and strategies should be avoided in a game but do not make the action or strategies impossible. Indeed, knowing what short-term *Penalties* to take in order to gain long-term *Rewards* is often *Strategic Knowledge* and a sign of *Game Mastery*. The presence of *Penalties* increases *Tension* in a game and can be forced upon players in a way that the *Tension* of trying to reach a *Reward* cannot.

Imbalances in *Freedom of Choices* between players or, more generally, imbalances in *Player Balance* can be perceived as *Penalties*. For example, not having a *Privileged Ability* (including one that protects from a *Penalty*) can be seen as a *Penalty*. *Penalties* can be used to correct these imbalances; giving *Penalties* to players leading a game has a *Balancing Effect*, something that can be used by the other players in games where players can hand out *Penalties* and there exists a sufficient *Game State Overview*.

A *Penalty* can be modulated by a *Reward* and vice versa. This can mitigate the effects of a *Penalty* or make a *Reward* less attractive. Another way of modulating *Rewards* with *Penalties* is to define the *Reward* of a goal as the *Penalty* for another player, as for example, the *Reward* of *Eliminate* goals often can be seen.

RELATIONS

 Instantiates: *Strategic Knowledge, Tension, Dynamic Alliances, Spawning, Predictable Consequences, Emotional Immersion, Social Statuses*

 Modulates: *Player Defined Goals, Game Mastery, Rewards, Deadly Traps, Damage, Lives, Parallel Lives, Units, Ephemeral Goals, Attention Swapping, Team Play, Area Control, Skills, Risk/Reward, Combos, Characters, Betrayal, Player Killing, Uncommitted Alliances*

 Instantiated by: *Downtime, Limited Set of Actions, Ability Losses, Decreased Abilities, No-Ops, Privileged Abilities, Committed Goals, Eliminate, Individual Penalties, Role Reversal, Movement Limitations, Spectators, Shared Penalties, Resources*

 Modulated by: *Extra-Game Consequences, Consistent Reality Logic, Rewards, Privileged Abilities, Player-Decided Distribution of Rewards & Penalties, Identification, Balancing Effects, Mutual Goals, Continuous Goals, Shared Resources*

 Potentially Conflicting with: *Narrative Structures, Freedom of Choice, Save-Load Cycles*

Illusionary Rewards

The player receives something that is perceived as a reward but does not quantifiably help in completing a formalized goal in the game as expressed by the game state.

Some *Rewards* gained in games do not actually provide players with any substantial gameplay advantages, but when they still are perceived by the players as a reward, these types of *Rewards* can be called *Illusionary Rewards*. Examples include becoming invincible to a type of monster that doesn't exist, getting mines in a racing game when one is last and no one will pass that part of the track again, and finding game objects that cannot be used for anything in the game except for carrying around.

 Example: All effect of character actions in *The Sims* can be *Illusionary Rewards*, since there is no formalized goal in the game. However, these *Rewards* are the very essence of gameplay: players have either set their own goals based on the *Rewards* or the *Rewards* provide entertainment when they occur unplanned.

 Example: Some games allow players to unlock new outfits for the *Avatars* they control. This does not change the gameplay itself but is still perceived as a *Reward* since it offers some novelty and can be shown to other people.

Example: Collecting all stars in *Super Mario Sunshine* is not required to complete the game but doing so, even after completing the goal of the game, can give players satisfaction and be used to compare one's skill and dedication to the game with other players.

USING THE PATTERN *Illusionary Rewards* can either be intentionally created or be the effect of games where not all actions are tightly linked to the completion of a goal.

Intentionally created *Illusionary Rewards* can be misguiding, e.g., *Red Herring* to complicate a goal or *Narrative Structure*, or provide extra game *Rewards*, for example, visual effects such as gaining new outfits or being shown additional *Cut Scenes* or other forms of *Extra-Game Information*. One form of *Illusionary Reward* is to continue providing players with *Rewards* that normally affect an evaluation function but that evaluation has already been decided or cannot be affected enough to change the outcome.

The most common form of *Illusionary Rewards* is providing feedback to players that *Extended Actions*, such as *Rhythm-Based Actions* or *Combos*, are being properly executed, and in this form, *Illusionary Rewards* function as *Progress Indicators* but within a *Consistent Reality Logic*. Intentionally created *Illusionary Rewards* can also be used to help players complete their goals without affecting the game state. Reaching *Helpers*, *Traces*, and *Clues* that do not affect the game state are forms of *Illusionary Rewards*, as they do not explicitly increase the chance of succeeding but can still be *Balancing Effects*. Rather, they work as a form of *Progress Indicator* for players as they can be used to have one measure of how close players are to completing goals. Another way *Illusionary Rewards* can support players is to provide feedback in *Real-Time Games* that the player has succeeded in an action, e.g., providing feedback that a *Combo* has been performed correctly in a fighting game even though it missed the enemy. These forms of *Illusionary Rewards* give players *Perceivable Margins* and allow players to learn *Predictable Consequences* of their actions by *Experimenting*, and thereby achieve *Game Mastery*.

Games that require a large number of actions to be performed before completing a goal and provide no explicit subgoals in between easily create *Illusionary Rewards*. In these cases, players often create *Player Defined Goals* in order to divide the main goal into smaller pieces, for example, finding a high place—an *Outstanding Feature* in the *Game World*—in order to gain an overview of one's surroundings so that one can position oneself in relation to where one wants to go. If players have *Unknown Goals*, the chances of players using *Player Defined Goals* to create *Illusionary Rewards* increase, as they are likely to perform *Experimenting* of how they can use actions or *Exploration* of the *Game World*. Avoiding these forms of *Illusionary Rewards*, e.g., to couple the gameplay closely with the *Narrative Structure*, can be done by inserting explicit subgoals or by using *Helpers*, *Traces*, and *Clues* that affect the game state (and can be subgoals in themselves).

Consequences The presence of *Illusionary Rewards* increases the number of closures in the game. Further, *Illusionary Rewards* can be extra game rewards as they may be shown to other people as indications of *Game Mastery* and thereby become social rewards.

Illusionary Rewards that the players are aware of, independently if they know that the *Reward* is an illusion or not, work as potential *Player Defined Goals*. This allows for *Stimulated Planning* as well as provides goals in game that otherwise would not have any. When used by players as goals, *Illusionary Rewards* give players a *Perceived Chance to Succeed*.

Illusionary Rewards can occur in *Tournaments* where one meets several opponents in each round. When the outcome of other previous games make the outcome of the round given, the winning or losing of a game can become pointless from the perspective of winning the *Tournament*.

RELATIONS

Instantiates: *Perceived Chance to Succeed, Extra-Game Consequences, Social Statuses, Predictable Consequences, Experimenting, Player Defined Goals, Progress Indicators, Exploration, Narrative Structures, Balancing Effects, Perceivable Margins*

Modulates: *Rhythm-Based Actions, Combos, Extended Actions, Game Mastery*

Instantiated by: *Extra-Game Information, Helpers, Traces, Clues, Outstanding Features, Tournaments*

Modulated by: None

Potentially Conflicting with: None

Additional Pattern

A description of the additional pattern can be found in the Chapter 8 folder on the companion CD-ROM.

ON THE CD

Player-Decided Distribution of Rewards & Penalties

EVENTS

These are patterns describing more or less game system-governed events, which have a major effect on the current game state and game situations for the players. They can, however, also be outcomes of the basic player actions.

Ultra-Powerful Events

Events that cannot be affected by player actions.

Some events in games cannot be affected by players. Some of these events are parts of the game environment, for example the rising and setting of the sun, and can be well-known to the players and occur whether or not players try to cause them to occur. Others can be started by players, for example, by tripping alarms, but once they have been started, players cannot influence how they develop. These events may be used to unfold the game's story or simply represent greater forces of, for example, machinery.

> **Example:** Some of the platforms in *Super Mario Sunshine* start to dissolve after Mario has stood on them for a certain time. Although Mario can be moved from the platform to save him, the player cannot affect the disappearance of the platform.

> **Example:** Games that have cut-scenes between levels or after completing goals are examples of games with *Ultra-Powerful Events*, since players cannot affect the game while the cut-scenes are being shown.

USING THE PATTERN *Ultra-Powerful Events* can be impossible for players to affect in two ways. The first way, which is optional, is that players cannot affect why and when the events start. The second way, which is required, is that players cannot affect the events when they have begun to unfold nor the way in which they unfold.

Knowledge of why *Ultra-Powerful Events* start can be *Strategic Knowledge*, especially if players can start the events. Likewise, knowing how *Ultra-Powerful Events* unfold can be *Strategic Knowledge* and promote *Stimulated Planning*, as players can prepare for actions in the game state that will be after the events has taken place.

Game elements that can cause *Ultra-Powerful Events* that can be explained within a *Consistent Reality Logic* during gameplay include *Moveable Tiles*, *Deadly Traps*, and *Controllers*. *Shrinking Game World* is an example of an *Ultra-Powerful Event* that affects the *Game World* rather than game elements. *Movement* of *Obstacles* in the *Game World* is another example of an *Ultra-Powerful Event* that affects the *Game World* and may require *Maneuvering* or *Rhythm-Based Actions* by the players. *Storytelling* and *Cut Scenes* are common forms of *Ultra-Powerful Events* that can be used to move *Narrative Structures* forward, or explain *Ability Losses*, and make players into *Spectators*.

In games with *Turn Taking*, *Ultra-Powerful Events* are common after the completion of a cycle of turns to ensure a level of *Player Balance* and prepare the game state for the next round of *Turn Taking*.

CONSEQUENCES *Ultra-Powerful Events* cannot be affected by players. To guarantee this, they must be enforced by *Dedicated Game Facilitators* such as *Game Masters* or computer programs. They can make actions into *Irreversible Actions*, for example, to unfold *Narrative Structures*. In contrast, *Reversability* of *Ultra-Powerful Events* cannot unfold *Narrative Structures* but represents a form of *Investment* or play mode, as the game state is restricted to a certain subgroup of the possible game states until the *Ultra-Powerful Event* is completed. Since the enforcement of events cannot be guaranteed in *Self-Facilitated Games* (with no *Game Masters)*, these types of games cannot guarantee *Ultra-Powerful Events* unless players agree upon them.

Ultra-Powerful Events that also are *Extended Actions* usually have *Predictable Consequences*, as players cannot affect them, although they may be difficult to predict if their outcome is dependent on the game state. As these *Predictable Consequences* are caused by *Delayed Effects*, these types of *Ultra-Powerful Events* provide *Hovering Closures* and *Anticipation* for players and are examples of *The Show Must Go On*.

Ultra-Powerful Events can easily remove players' *Freedom of Choice*. Further, they can cause players to have *Downtime* or lose a *Perceived Chance to Succeed* if they remove players' possibilities to perform any actions or make all action only have negative consequences. *Extended Actions* are an example of such *Ultra-Powerful Events* that have been initiated by the players themselves. Depending on if the player is left with any actions and how well the events can be explained within a *Consistent Reality Logic*, *Ultra-Powerful Events* can support or break an *Illusion of Influence*.

RELATIONS

> **Instantiates:** *Downtime, Predictable Consequences, Strategic Knowledge, Stimulated Planning, Narrative Structures, Spectators, Investments, The Show Must Go On, Ability Losses, Delayed Effects, Anticipation, Hovering Closures, Rhythm-Based Actions*

> **Modulates:** *Maneuvering, Consistent Reality Logic, Illusion of Influence, Turn Taking, Storytelling*

> **Instantiated by:** *Moveable Tiles, Deadly Traps, Controllers, Cut Scenes, Extended Actions, Shrinking Game World, Movement, Game Masters, Dedicated Game Facilitators*

> **Modulated by:** *Irreversible Actions, Reversability*

> **Potentially Conflicting with:** *Self-Facilitated Games, Freedom of Choice, Perceived Chance to Succeed*

Additional Patterns

ON THE CD Descriptions of these additional patterns can be found in the Chapter 8 folder on the companion CD-ROM.

Role Reversal

Shrinking Game World

Disruption of Focused Attention

9 Game Design Patterns for Narrative Structures, Predictability, and Immersion Patterns

This chapter has patterns that deal with how the game design can support *Immersion* and commitment to the game by the players. The patterns range from quite low-level patterns governing the unfolding of the outcome of a single action to high level patterns, such as *Tension*, which describe the whole gameplay experience.

> **Evaluation:** *Delayed Effects, Hovering Closures, Illusion of Influence, Perceived Chance to Succeed, Tiebreakers, Tied Results*

> **Immersion:** *Immersion, Anticipation, Spatial Immersion, Emotional Immersion, Cognitive Immersion, Sensory-Motoric Immersion*

> **Creative Control:** *Freedom of Choice, Creative Control, Storytelling, Player Constructed Worlds, Dedicated Game Facilitators, Self-Facilitated Games, Game Masters, Skills*

> **Narrative Structures:** *Narrative Structures, Tension, Characters, Character Development, Planned Character Development, Identification, Higher-Level Closures as Gameplay Progresses, Surprises, Cut Scenes, Easter Eggs, Never Ending Stories*

EVALUATION

These patterns describe some common and, at least somewhat, interesting cases of evaluation functions for different kinds of end conditions within the game, from one single action to the whole game instance. The patterns also deal with how the players perceive or can influence the evaluation functions, not only strictly about the effects on the game state.

197

Delayed Effects

The effects of actions and events in games do not occur directly after the actions or events have started.

Delayed Effects are those effects of actions and events that are explicitly dictated by the rules in the game; effects that are the results of combined actions or are unexpected or unplanned do not qualify as *Delayed Effects*, even if the effects take place after some actions or events have taken place.

> **Example:** The effect of placing bets in *Poker* does not become apparent until a player folds or players show their card hands.

> **Example:** The activation of the most powerful weapons in first-person shooters usually takes some time from activation to the time it fires, usually to balance them somewhat against the other weapons in the game.

USING THE PATTERN The primary design choices for *Delayed Effects* are if players should be aware of when the effects will occur and how the period of delay is determined. Showing when the effects will take place is usually done through *Progress Indicators* and allows players to perform actions requiring *Timing*. Not providing information about when *Delayed Effects* are about to occur increases the sense of *Randomness* in a game, even if the period of delay is not random. *Delayed Effects* that are unknown to players lessen the functionality of saving as they may make it difficult to know when to save to be able to avoid *Irreversible Actions*.

Fixed periods of delay give players the chance to use *Memorizing* to have a form of *Strategic Knowledge*. If the periods of delay are random, or if players do not have knowledge of the periods of delay, this can turn the use of other actions into *Risk/Reward* choices, if their success depends on the *Delayed Effects*.

Making some actions have *Delayed Effects* is a way of creating *Balancing Effects* between different actions when the more powerful actions take a longer time to perform.

CONSEQUENCES *Delayed Effects* impose a *Time Limit* on actions so that players must wait until the effects occur and can therefore affect *Tradeoffs* between different effects. When the *Delayed Effects* of an action are known, it gives *Predictable Consequences* to the game, which provides *Stimulated Planning*. When combined with the absence of *Predictable Consequences*, it instead provides players the possibility to start feeling *Luck* before the outcome is shown, regardless of if they feel *Luck* after the outcome is presented. This is used often in *Quick Games* with single actions to heighten the *Anticipation*.

The wait for the effects to take place is a form of *Hovering Closures* once the events or actions that cause the *Delayed Effects* have been done, and waiting for them can create *Anticipation* or *Tension*, especially when combined with *Uncertainty of Information*. When the *Delayed Effects* are also the cause of *Extended Actions*, it allows players to detect and try to stop them if they are *Interruptible Actions*.

Examples of *Delayed Effects* are *Delayed Reciprocity, Betting, Ultra-Powerful Events*, and *Investments*. The first two are caused by other players and can cause friction between them and those experiencing the *Delayed Effects*, while the last two are determined by the game system and can have more *Predictable Consequences*. *Delayed Effects* cause increased *Tension* in the two first cases when they can result in *Betrayals*.

RELATIONS

Instantiates: *Tradeoffs, Hovering Closures, Anticipation, Tension, Stimulated Planning, Time Limits, Timing, Strategic Knowledge, Balancing Effects, Memorizing*

Modulates: *Irreversible Actions, Interruptible Actions, Luck, Quick Games, Betrayal*

Instantiated by: *Delayed Reciprocity, Extended Actions, Betting, Ultra-Powerful Events, Investments*

Modulated by: *Randomness, Progress Indicators, Uncertainty of Information*

Potentially Conflicting with: None

Hovering Closures

Events that are about to occur and can clearly be observed by players.

Many events that may but have not yet occurred in games can be foreseen by players and give them experiences of *Hovering Closures*. These closures may be used by the players to plan their actions: players may intentionally try to increase the chances of *Hovering Closures* that are perceived as positive or simply allowed to occur, while closures with negative consequences may be acted against.

Example: Auctions in games are examples of *Hovering Closures* where one outcome is clearly perceived by the players, but this outcome can be changed by additional bids.

Example: Races nearing the finishing lines give strong *Hovering Closures* as the outcome is often predictable but still requires players to continue moving.

Example: Leaving an opening for specific blocks in *Tetris* usually create strong *Hovering Closures*.

USING THE PATTERN Designed *Hovering Closures* can either be *Ultra-Powerful Events* or *Interruptible Actions* depending on whether players are supposed to have *Illusion of Influence* and a *Perceived Chance to Succeed*. The most common ways to create *Hovering Closures* are *Delayed Reciprocity*, various goals based upon *Symmetry* or *Configuration*, or *Extended Actions* with *Time Limits*. *Progress Indicators* are explicit *Hovering Closures*, which are part of the game design.

Hovering Closures can either be created through the *Narrative Structure* or through the game state. When part of the *Narrative Structure*, the *Hovering Closure* is usually not affected by players but can give *Anticipation*, for example, nearing the end of a *Level*. Regarding game state, *Hovering Closures* can either be due to players observing *Predictable Consequences* from *The Show Must Go On* such as *Alignment* or due to players soon completing actions. These actions can either be those that fulfill *Continuous Goals* or planned actions that cannot have been done earlier due to *Turn Taking*.

CONSEQUENCES *Hovering Closures* are caused by *Extended Actions* and events with *Delayed Effects* that have *Predictable Consequences*. The consequences do not have to be certain, but at least one outcome must be clearly perceivable, as, for example, is the case of perceiving the chance to win when *Betting* and also in *Quick Games* with single actions. *Hovering Closures* can create *Emotional Immersion* and *Anticipation* when the closures are related to players' success in the game or parts of the *Narrative Structure*. *Uncommitted Alliances* may be the result of the *Hovering Closure* of one player being close to completing a goal or action that can be perceived by other players.

Surprises, being neither *Extended Actions* nor predictable, cannot be *Hovering Closures* and may destroy existing ones.

RELATIONS

Instantiates: *Emotional Immersion, Anticipation, Uncommitted Alliances*

Modulates: *Quick Games*

Instantiated by: *Alignment, Continuous Goals, Extended Actions, Turn Taking, Betting, Delayed Effects, The Show Must Go On, Ultra-Powerful Events, Predictable Consequences, Narrative Structures, Delayed Reciprocity, Symmetry, Levels, Progress Indicators, Configuration*

Modulated by: *Time Limits*

Potentially Conflicting with: *Surprises*

Illusion of Influence

Players believe that they can influence the outcome of the game, regardless of whether this is correct.

Some games allow actions that do not actually make players come closer to achieving goals, or even changing the game state. When these actions appear meaningful, including being meaningful to the player but not within a game state perspective, the players have an *Illusion of Influence* within the game.

> **Example:** Games with well-developed stories, such as the *Final Fantasy* or *Zelda* series, do not let players experience the stories unless they complete the goals. If this is an *Illusion of Influence*, as the stories are fully planned before gameplay begins, or real influence, as the stories are not told unless the players do actions, is a matter of perspective.

> **Example:** Adventure games consisting of multiple branch stories provide the players with choices of what story to read and, thereby, a feeling of affecting the story. However, this is an illusion, as all the possible stories have already been scripted.

USING THE PATTERN Having a *Perceived Chance to Succeed* is a requirement for players to be able to experience an *Illusion of Influence*. This can be achieved through providing the *Right Level of Difficulty* for the players or by basing outcomes on *Randomness*, which gives players a potential *Illusion of Influence* through *Luck*. In *Multiplayer Games*, it is important to consider *Player Balance*, as this strongly affects players' *Illusion of Influence*, and in games with *Team Play*, this is both regarding differences between players within the same team and between players of different teams. *Smooth Learning Curves* can be used to give *Illusion of Influence* throughout the game, even if the game becomes more and more difficult or complex. If the *Right Level of Complexity* is not achieved, this can ruin *Illusion of Influence* since players then get *Limited Planning Abilities*, for example, when too many *Producer-Consumer* relationships exist for players to have an overview of how they interact.

Influence can be either to choose between what should happen or exist in the game or to be able to create objects or events in the game. Choosing between what events should occur in the game depends on players' *Freedom of Choice* as well as the chance of success. Influence, or the *Illusion of Influence*, can thereby be created through *New Abilities* and *Improved Abilities*, and removed by *Ability Losses* and *Decreased Abilities*. Affecting abilities in this fashion is most easily done with *Tools*. Creating objects and events provides a more tangible form of influence and can be done by *Creative Control*; for example, by creating *Characters* and allowing *Planned Character Development*.

Game Masters can provide a strong *Illusion of Influence*, as anything players may want to influence can be discussed as part of *Social Interaction*. *Randomness* can create an *Illusion of Influence* in two different ways: first, players may feel that they do have influence through *Luck*; and second, the results can be faked by *Game Masters* or computers. However, the first form of illusion is brittle, as players do not have any real influence over random results, and players with this form of *Strategic Knowledge* are unlikely to have any such *Illusion of Influence*.

CONSEQUENCES *Illusion of Influence* can affect *Emotional Immersion*, as it makes players feel that their actions are important in the game, and when they feel this, they often experience *Freedom of Choice*. The possibility to influence encourages *Stimulated Planning* but this, and the perception of influence, is restricted by *Limited Foresight* and *Limited Planning Abilities* in the games.

Narrative Structures due to limitations on possible actions and what order events need to occur naturally limit players' *Illusion of Influence*, and this is most strongly affected by the presence of *Cut Scenes*. Indeed, beginning to play a game that one knows has a strong story is done with the *Extra-Game Information* that one has a limited impact on the possible stories that can develop.

Although players can influence the initiation of *Ultra-Powerful Events*, they cannot affect their development, and this is one way *Illusion of Influences* can be destroyed in games. *Surprises*, since they cannot be anticipated, are likewise events that can destroy *Illusion of Influences*, as are *Shared Penalties*, which players have no control over avoiding.

RELATIONS

Instantiates: *Emotional Immersion, Stimulated Planning*

Modulates: *Freedom of Choice, Team Play, Multiplayer Games*

Instantiated by: *New Abilities, Improved Abilities, Game Masters, Perceived Chance to Succeed, Planned Character Development, Creative Control, Characters, Luck, Social Interaction, Player Balance, Tools, Right Level of Difficulty*

Modulated by: *Randomness, Ultra-Powerful Events, Strategic Knowledge, Extra-Game Information, Limited Foresight, Smooth Learning Curves, Right Level of Complexity*

Potentially Conflicting with: *Surprises, Narrative Structures, Ability Losses, Decreased Abilities, Cut Scenes, Limited Planning Ability, Shared Penalties, Producer-Consumer*

Perceived Chance to Succeed

Players believe, whether correctly or not, that they have a chance to succeed with actions in a game.

For games to be interesting to play, players must feel that they can influence the outcome of the game. Being able to affect the outcome means that players can also choose what sort of outcome they wish the game to have, and that they have a *Perceived Chance to Succeed* with their intentions. Players do not actually have to have a chance to succeed for a game to be interesting; the important part is that they believe that they have.

> **Example:** Simple betting games such as *Roulette* or various dice games always give players a chance to win, and players usually can know the exact percentage that they will win. In contrast, players can have hands in most forms of *Poker* that appear to be able to win when they in fact may not be, due to the cards that have already been dealt.

> **Example:** Most computer games can either not be won at all or guarantee that there are ways to win. In the latter case, players know that there exists a chance to succeed in completing the game, but the perception of that possibility for them is mainly due to their perception of their own skills compared to the difficulty of the game.

USING THE PATTERN Players' basic perception of their chance to succeed is usually based on *Strategic Knowledge*, the *Skills* of their *Characters*, and if they feel games have *Player Balance* and the *Right Level of Difficulty*. *Player Balance* can be made more likely through ensuring *Team Balance* and introducing *Balancing Effects* such as *Handicaps*. *Smooth Learning Curves* can make players continuously feel that they have a *Perceived Chance to Succeed* throughout a game. One simple way of modifying the *Right Level of Difficulty* without redesigning the core of challenges in games is to modify the number or abilities of *Enemies*.

Player perceptions of the chances to succeed with specific abilities can easily be modulated negatively during gameplay with *Ability Losses* and *Decreased Abilities*, and positively by *New Abilities* and *Improved Abilities*. This is most easily done while maintaining a *Consistent Reality Logic* by using *Tools* but may also be due to *Character Development*. *Player Decided Results* always guarantee that at least some players have an influence on the results and thereby a *Perceived Chance to Succeed* in gaining the results they wish, although the results typically become compromises.

If players have several ways of succeeding, which can be modulated through *Ability Losses* and *New Abilities*, the *Perceived Chance to Succeed* may be under the

players' control. This increases players' *Freedom of Choice* but may require players to make *Tradeoffs*, *Risk/Reward* choices, or experience *Social Dilemmas*. *Cut Scenes* can give players information on how they should act and thereby increase their perceived chance. The actual performance of actions in the game can provide players with the *Perceived Chance to Succeed* with the following actions through *Illusionary Rewards*, *Near Miss Indicators*, and *Progress Indicators*.

Although *Perfect Information* naturally gives players a *Perceived Chance to Succeed* that is equal to the actual chance to succeed, this may dissuade players from trying if the chance is small or nonexistent. In these cases, *Imperfect Information* can instead be used to show, or give the illusion, that players have a chance to succeed and thereby encourage players to try.

Surprises and *Ultra-Powerful Events* are examples of events that may ruin players *Perceived Chance to Succeed* while *Leaps of Faith* are actions that players have to perform without having a strong *Perceived Chance to Succeed*.

CONSEQUENCES Having a *Perceived Chance to Succeed* gives players influence, or at least the *Illusion of Influence*, in games and may be required for players to have *Emotional Immersion* or experience *Tension* while playing. Giving players a *Perceived Chance to Succeed* requires that games offer them *Freedom of Choice* between actions or goals and that their actions in the game have *Predictable Consequences*. However, having the *Perceived Chance to Succeed* with several different actions gives a *Freedom of Choice*, so the patterns affect each other on different levels, for example, regarding choices between the ways actions can be tried and why actions should be performed. *Player Decided Results* are an example of how players can be guaranteed to influence the game, although not necessarily all players get to do so.

Game Masters have a strong impact on players' *Perceived Chance to Succeed*: they can either make attempted actions automatic successes, automatic failures, or let the success depend on *Randomness* with the possible influence of *Skill*. Automatic successes instantiate *Player Decided Results* and possibly *Creative Control*, although players may not be aware of this to maintain *Tension* and maintain other players' *Illusion of Influence* or *Perceived Chance to Succeed*. Automatic failures may be necessary to maintain *Narrative Structures* but can be done without breaking players' *Illusion of Influence* if the way of determining the evaluation function is hidden from the players, for example, by rolling *Dice* behind a *Game Master's* screen.

RELATIONS

Instantiates: *Tension, Emotional Immersion, Illusion of Influence*

Modulates: *Freedom of Choice*

Instantiated by: *Freedom of Choice, Predictable Consequences, New Abilities, Improved Abilities, Player Decided Results, Balancing Effects, Right Level of*

Difficulty, Player Balance, Team Balance, Game Masters, Handicaps, Tools, Character Development, Player Decided Results, Progress Indicators, Illusionary Rewards

Modulated by: *Tradeoffs, Risk/Reward, Social Dilemmas, Skills, Randomness, Enemies, Smooth Learning Curves, Near Miss Indicators, Imperfect Information, Decreased Abilities, Smooth Learning Curves, Cut Scenes*

Potentially Conflicting with: *Leaps of Faith, Surprises, Narrative Structures, Ability Losses, Decreased Abilities, Ultra-Powerful Events, Game Masters, Perfect Information*

Additional Patterns

Descriptions of these additional patterns can be found in the Chapter 9 folder on the companion CD-ROM.

ON THE CD

Tiebreakers

Tied Results

IMMERSION

The following patterns are mainly categorizations of immersion or what are the different ways to let the players be engaged in the game.

Immersion

Immersion in the Game World or immersion in the activity of play.

Games require players' attention and as such can make players focus on gameplay to the extent that they feel immersed in the games. This *Immersion* can take many forms, depending on what type of activity the players are performing in a game and what is required to become an expert player. Regardless of the type of immersion, achieving it can be satisfying to the players and can be one of the goals for playing the game. However, the immersion does not mean that players are unaware of their surroundings or that they are playing a game, but rather that they are deeply focused on the interaction they are having within the game.

> **Example:** First-person shooters require players to focus intensely on the spatial movement of their *Avatar* and react instantaneously to events that occur in the *Game World*. This is more efficiently achieved when players perform their actions with the *Avatar* as their reference point for movement rather than their own body.

Example: Many simple puzzled-based games such as *Bejeweled* or *Minesweeper* can, even though they have very little graphics and no virtual environment compared to advanced 3D games, capture players' attention through their cognitive demands so that the players become unaware of how much time is spent playing them.

USING THE PATTERN Four main types of gameplay *Immersion* can be found in games: *Spatial Immersion*, *Emotional Immersion*, *Cognitive Immersion*, and *Sensory-Motoric Immersion*. *Spatial Immersion* is the result of extensive *Maneuvering* in the *Game World* in *Real-Time Games* and can sometimes be felt in movies. *Emotional Immersion* is obtained by responding to the events that *Characters* are part of during the unfolding of a *Narrative Structure* and is similar to the *Immersion* that books, theater, or movies provide. *Cognitive Immersion* is based upon the focus on abstract reasoning and is usually achieved by complex problem solving. *Sensory-Motoric Immersion* is the result of feedback loops between repetitive movements players make to perform actions in the game and the sensory output of the game. Although claimed as one of the greatest dangers with playing games, psychological immersion, or the confusion of the *Game World* and the real world, has not been verifiable under rigorous examination (see [Dear91] or [ESA]).

Although *Immersion* is one of the most difficult patterns to instantiate in game design, common ways of trying to achieve it are through *Narrative Structures, Characters, Avatars, Game Worlds, Overcome* goals, and the presence of *Freedom of Choice. Smooth Learning Curves* can maintain *Immersion* in games by not making challenges too easy or hard, which can make the game boring or frustrating and make players move their focus away from gameplay.

CONSEQUENCES *Immersion* is not the cause of *Game Mastery* but can often be found in those that possess *Game Mastery* and is often sought by players. However, once the *Immersion* gained in gameplay has been achieved, it can easily be lost. The most common causes for this loss are *Disruption of Focused Attention* events, *Extra-Game Actions* such as handling *Book-Keeping Tokens* or performing *Save-Load Cycles*, presentation of *Extra-Game Information* such as *Status Indicators*, the breakdown of a *Consistent Reality Logic*, and forced *Downtime*. Examples of more specific causes are *Reconfigurable Game Worlds* and *Invisible Walls*, which can ruin *Spatial Immersion*; *Games within Games* breaking the *Consistent Reality Logic*; *Surprises*, which can ruin *Cognitive Immersion*; and players' own *Avatars*, which can ruin *Emotional Immersion* if they do not portray the emotions players expect them to.

RELATIONS

 Instantiates: None

 Modulates: *Overcome, Game Mastery*

Instantiated by: *Consistent Reality Logic, Avatars, Surprises, Characters, Narrative Structures, Game World, Freedom of Choice, Spatial Immersion, Emotional Immersion, Cognitive Immersion, Sensory-Motoric Immersion, Smooth Learning Curves*

Modulated by: *None*

Potentially Conflicting with: *Reconfigurable Game World, Invisible Walls, Extra-Game Information, Save-Load Cycles, Surprises, Downtime, Disruption of Focused Attention, Extra-Game Actions, Games within Games, Book-Keeping Tokens, Status Indicators*

REFERENCES

[Dear91] Dear, William. *The Dungeonmaster: The Disappearance of James Dallas Egbert III*. Bloomsbury, 1991.

[ESA] Entertainment Software Association. Information about games and youth violence, available online at *www.theesa.com*.

Anticipation

The feeling of being able to predict future game events in the games to which one has emotional attachments.

Many games allow players to anticipate possible future game events. However, players only feel *Anticipation* about these future events if they have some emotional investment, either that the future events are something that they planned and strived for or that the future events concern characters in a narrative structure that the players care for.

> **Example:** The presence of traces in the environment of enemies in first-person shooters gives players a strong anticipation that combat will occur soon.

> **Example:** *Anticipation* is common in roleplaying games when players have planned the development of their characters and they near points where the characters will advance.

USING THE PATTERN *Anticipation* can occur through *Narrative Structures* or the developing game state but both cases require *Predictable Consequences* and some form of specific *Immersion*, most commonly *Emotional Immersion*. However, *Anticipation* can negatively affect *Immersion* in general as players have to abstractly predict the possible future events. One example where *Anticipation* can be created through *Spatial Immersion* is *Game World Navigation*. *Cognitive Immersion* can likewise give *Anticipation* when linked to foreseeing the completion of goals.

As players easily have *Emotional Immersion* in future *Rewards*, *Delayed Effects* and *Hovering Closures* easily create *Anticipation*, for example, through *Betting*. Rewards linked to *Player Defined Goals* and *Planned Character Development* are especially suitable for creating *Anticipation*, as they are chosen by players themselves and the players choose them for their emotional values. The *Anticipation* can be further modulated by limiting the affect that the players can have through *Turn Taking* and *Downtime* in general. Setting *Time Limits* for player actions and effects also increases *Anticipation* when the limit is clearly indicated to the players.

When *Anticipation* is misguided, i.e., the expected result does not occur, the resulting feeling of frustration or disappointment can be modulated by *Near Miss Indicators*.

CONSEQUENCES *Anticipation* creates *Emotional Immersion* but requires some specific form of *Immersion* to be already present. *Anticipation* is closely linked to *Tension*, but where *Tension* is primarily concerned with the negative aspects of uncertainty, *Anticipation* instead deals with the sense of being able to predict game events. A typical case when both coincide is *Delayed Reciprocity*, where the *Anticipation* may be both that of fulfillment of agreements and that of *Betrayal*. Examples where *Anticipation* can exist without *Tension* include *Ultra-Powerful Events* such as those that occur in games where *The Show Must Go On*.

Surprises are naturally difficult to closely link to *Anticipation*, except when modulated by *Red Herrings* or *Imperfect Information*. *Analysis Paralysis* is often caused by players being able to notice too many possible future game states, and thereby makes *Anticipation* of any of them difficult.

RELATIONS

Instantiates: *Emotional Immersion*

Modulates: *Tension*

Instantiated by: *The Show Must Go On, Downtime, Rewards, Turn Taking, Betting, Delayed Effects, Predictable Consequences, Emotional Immersion, Spatial Immersion, Cognitive Immersion, Player Defined Goals, Planned Character Development, Delayed Reciprocity, Hovering Closures, Ultra-Powerful Events, Narrative Structures*

Modulated by: *Red Herrings, Betrayal, Time Limits, Imperfect Information, Near Miss Indicators*

Potentially Conflicting with: *Immersion, Surprises, Analysis Paralysis*

Additional Patterns

ON THE CD Descriptions of these additional patterns can be found in the Chapter 9 folder on the companion CD-ROM.

Sensory-Motoric Immersion	**Emotional Immersion**
Spatial Immersion	**Cognitive Immersion**

CREATIVE CONTROL

Games are voluntary activities where the players have the freedom to play or not to play the game. This can also manifest itself within the game by allowing the players the freedom to perform actions of their own will and even to express themselves by playing the game. These patterns highlight some of the common ways to enhance that freedom.

Freedom of Choice

Players have the ability to make choices in the game.

For a game to be a game at all, the players have to be able to make what they feel are interesting choices. This means that the choices must have seemingly different effects and have effects that are meaningful. If these conditions are met, players can feel that they have the *Freedom of Choice* within the game system and they can affect the outcome of the game.

> **Example:** Open-ended games like *The Sims* provide players with a multi-tude of game elements to interact with and many types of actions for each game element. In addition, they give players the freedom to define their own goals within the game.

> **Example:** Menu-based adventure games limit players to only a few choices throughout the entire game.

USING THE PATTERN The most important thing with *Freedom of Choice* is not that players can affect game states, it is that they have the *Illusion of Influence* and a *Perceived Chance to Succeed*. *Freedom of Choice* can be achieved in several ways: affecting the actions possible for the players, what can be done with the actions, letting players choose goals, or letting players affect the results in the game.

Freedom of Choice can be increased by expanding players' possible range of actions. This can be done by *Improved Abilities* and *New Abilities* and is often represented as *Rewards* or *Character Development*. Even allowing players to do *No-Ops*

is a form of expanding the range of possible actions for players and thereby increasing their freedom. Ways of letting players have increased *Freedom of Choice* of what to do when performing actions include *Trading, Conceal, Construction, Character* creation, *Planned Character Development*, deciding how to do *Game World Navigation*, choosing where *Spawning* occurs, and giving them *Creative Control* through the actions. *Extended Actions*, which players can choose how long to continue doing, are another way of giving players more freedom in how to use actions.

Although motivated by *Limited Resources, Resource Management* gives players opportunities of how to use *Resources*, including *No-Ops*, by saving them in *Containers* and creating other types of *Resources* through *Converters*. The type of *Investments* that give players the greatest *Freedom of Choice* are *Arithmetic Rewards for Investments*, since they do not give any *Penalties* or disadvantages between making one large *Investment* or several smaller ones.

Players' goals can be chosen by the players through *Selectable Sets of Goals*, which still let the game designer control the goals, or *Player Defined Goals*, which can either be implemented in the game state or be completely under the players' will. *Optional Goals* can further give players choices of objectives in the game without forcing them. *Asymmetric Goals* are the effect of allowing players to choose goals in *Multiplayer Games*.

The most powerful *Freedom of Choice* players can have is that which affects the results in games. This can range from the relatively limited *Budgeted Action Points* and *Player-Decided Distribution of Rewards & Penalties* to allowing full *Reversability* through *Save-Load Cycles* and initially letting the players freely choose when they want to play the game in *Asynchronous Games*.

CONSEQUENCES *Freedom of Choice* gives players *Empowerment* within the game and can thereby give *Emotional Immersion*. Being able to choose between different actions or goals supports *Varied Gameplay* in a concrete way, and when this causes players to have *Asymmetric Abilities*, it can promote *Replayability* of the game. *Freedom of Choice* can either be due to the ability of affecting the game states or through the possibility of performing *Extra-Game Actions*, for example, *Storytelling* or *Social Interaction*. The presence of *Freedom of Choice* can also have negative effects: it can cause *Social Dilemmas* and force players to make *Tradeoffs* and *Risk/Reward* choices.

Freedom of Choice lets players plan their actions and thereby promotes *Stimulated Planning* and *Immersion*, especially *Cognitive Immersion*. Too much *Freedom of Choice* is however a source of *Analysis Paralysis*, and there are many ways to limit players' *Freedom of Choice*: *Limited Planning Ability* lessens players' freedom to make long-term plans in a game; *Predefined Goals* may force players to have certain goals and tactics in a game; *Ultra-Powerful Events* may enforce *Narrative Structures*

and *Downtime* and cause *Shrinking Game Worlds*; *Inaccessible Areas* and *Movement Limitations* can hinder players from moving within the whole *Game World*; what players can do in the game may be defined as a *Limited Set of Actions* or require commitment to *Extended Actions* or *Collaborative Actions*; and actions may further be restricted by *Decreased Abilities* and *Ability Losses* during gameplay.

Players' *Freedom of Choice* can affect their *Perceived Chance to Succeed* with actions, but having a *Perceived Chance to Succeed* with several different types of actions gives *Freedom of Choice*.

RELATIONS

Instantiates: *Empowerment, Replayability, Varied Gameplay, Analysis Paralysis, Reversability, Cognitive Immersion, Stimulated Planning, Immersion, Social Dilemmas, Tradeoffs, Risk/Reward, Perceived Chance to Succeed, Emotional Immersion, Game World Navigation*

Modulates: *Conceal, Rewards, Improved Abilities, New Abilities, Character Development, Multiplayer Games, Characters*

Instantiated by: *Optional Goals, Player Defined Goals, Selectable Sets of Goals, No-Ops, Extended Actions, Save-Load Cycles, New Abilities, Asymmetric Abilities, Player-Decided Distribution of Rewards & Penalties, Budgeted Action Points, Construction, Planned Character Development, Creative Control, Storytelling, Social Interaction, Extra-Game Actions, Trading, Converters, Container, Arithmetic Rewards for Investments, Resource Management*

Modulated by: *Asymmetric Goals, Spawning, Illusion of Influence, Perceived Chance to Succeed, Limited Resources, Asynchronous Games*

Potentially Conflicting with: *Predefined Goals, Limited Set of Actions, Downtime, Extended Actions, Shrinking Game World, Collaborative Actions, Movement Limitations, Decreased Abilities, Ability Losses, Penalties, Narrative Structures, Inaccessible Areas, Ultra-Powerful Events, Limited Planning Ability*

Creative Control

Players have the ability to be creative within the Game World.

Some games allow players to perform actions in the *Game World* that qualify as expressions of creativity. This form of *Creative Control* makes it possible for players to define their own goals within the game environment as well as making it possible for them to show their creations to other players.

Example: MUDs are the games that probably provide the strongest form of *Creative Control* of all computer games. In these games, players who have achieved wizard status are allowed to add code to the program running the game, in essence, being able to change nearly any aspect of the game.

Example: Many roleplaying games allow players to have *Creative Control* over the creation of their characters, as well as how the character develops over time. Even the somewhat limited *Creative Control* of choosing the *Avatar's* appearance in *Anarchy Online*, as illustrated in Figure 9.1, allows the players to express themselves.

FIGURE 9.1 Changing the *Avatar's* appearance in *Anarchy Online.* © Funcom, Inc. Reprinted with permission.

USING THE PATTERN *Creative Control* can either be provided within the game state or through *Extra-Game Consequences*. For players to have *Creative Control* within the game state requires a *Right Level of Complexity* in the game state for unexpected combinations to exist or a *Game Master* that can manipulate the game state space to allow creativity for players.

Letting players have *Creative Control* over the *Narrative Structures* in games can be done through *Storytelling* or *Roleplaying*. In games with *Persistent Game Worlds* that are also *Player Constructed Worlds*, this allows *Never Ending Stories* to emerge.

Common ways to allow players to have *Creative Control* are through the creation of *Characters* and providing possibilities for *Planned Character Development*.

Other less common ways that are more restricted include *Construction* or even *Conceal*. Games with *Game Masters* can provide the greatest levels of *Creative Control*, not only for the *Game Masters* but for the players, as the *Game Masters* can help players make player ideas possible.

CONSEQUENCES *Creative Control* allows players the opportunity to have *Constructive Play* with the aim of creating game elements, information, or even sequels of actions. Since these require *Investments* from the players, both within the game and outside the game, they rightly give players the sense of *Ownership* or *Identification*.

Games with *Creative Control* allow players the *Freedom of Choice* to choose *Player Defined Goals* of creating game content. Choosing these goals and how to use the *Creative Control* promotes *Stimulated Planning*. These goals often motivate *Extra-Game Actions* and provide *Extra-Game Consequences* of accomplishment for players such as social rewards in the form of *Social Status* in *Multiplayer Games*. Being skillful within one area of creativity can also become a *Competence Area* in these games.

Players who make use of their *Creative Control* in a game are likely to have *Emotional Immersion* in the game as they make use of their *Empowerment*. *Creative Control* can give the *Illusion of Influence*, as it allows players to perform actions that have perceivable effects although it may not change the game state that affects evaluation functions.

RELATIONS

> **Instantiates:** *Social Statuses, Emotional Immersion, Freedom of Choice, Extra-Game Consequences, Empowerment, Stimulated Planning, Ownership, Investments, Constructive Play, Competence Areas, Illusion of Influence, Identification*

> **Modulates:** *Conceal, Narrative Structures, Never Ending Stories, Multiplayer Games, Persistent Game Worlds, Player Constructed Worlds*

> **Instantiated by:** *Construction, Player Defined Goals, Characters, Game Masters, Planned Character Development, Roleplaying, Storytelling, Extra-Game Actions, Right Level of Complexity*

> **Modulated by:** None

> **Potentially Conflicting with:** None

Storytelling

The act of telling stories within the game.

Some games promote players to tell stories within games. This may be retelling of actions and events that players have done, the history of the *Game World*, or part of creating the *Game World*.

> **Example:** *Once upon a Time* is a card game based around storytelling. Players play cards with story concepts to be allowed to continue the story based upon the narrative started by other players.

> **Example:** The role of game masters in roleplaying games is partly that of storyteller, merging the preplanned events with the actions the players have performed within the *Game World*. The gameplay in these games is based on *Storytelling* assisted with background material such as maps and rulebooks, as illustrated in Figure 9.2.

FIGURE 9.2 Game master advancing the story in a tabletop roleplaying game.

USING THE PATTERN *Storytelling* in games can be done both by *Dedicated Game Facilitators* and by players. The stories told do not have to be part of the *Narrative Structure* of the *Game World* but can be in several different ways. First, they can be explanations of the history and current state of the *Alternative Reality* of the *Game*

World and this is the typical way *Storytelling* is done by *Dedicated Game Facilitators* to advance the *Narrative Structure*. Second, the stories can be part of *Roleplaying*, the retelling of previous gameplay within *Consistent Reality Logic*. Third, the stories can be part of creating and expanding the *Narrative Structure* rather than unfolding an existing structure, although this requires *Game Masters* or *Self-Facilitated Games*. Providing back stories for *Characters* is an area where players usually are allowed *Creative Control* for *Storytelling*, even in games with tightly restricted *Narrative Structures*.

Storytelling gives both players and *Dedicated Game Facilitators* the possibility to explain *Extra-Game Information* in a context so that it does not disturb a *Consistent Reality Logic*.

Storytelling by players or *Game Masters* may be controlled through *Turn Taking* or be *Interruptible Actions*. In contrast, the *Storytelling* done in computer games, for example by *Cut Scenes*, is a form of *Ultra-Powerful Event* that cannot be interrupted although they may be skipped.

CONSEQUENCES *Storytelling* can be used to frame all actions and events in a *Game World* within the *Consistent Reality Logic* of the *Alternative Reality* and can visualize the *Game World* and its history. When the *Storytelling* is performed by enacting *Characters*, the activity gives rise to *Roleplaying*.

When *Storytelling* is performed by humans, it is a form of *Social Interaction* that often gives *Emotional Immersion*, and being able to tell stories well can give *Social Status* and can even be considered part of *Game Mastery* in some games. *Storytelling* can give players *Creative Control* and *Freedom of Choice*, and in games with *Game Masters*, these stories can become part *Player Constructed Worlds* by being *Player Decided Results*. In *Persistent Game Worlds*, the stories can have further influence by being part of the development of *Never Ending Stories*.

Games can of course also cause *Storytelling* as *Extra-Game Actions*, for example, bragging about results. In this case, *Storytelling* passes *Trans-Game Information* between players including possible *Strategic Knowledge*.

RELATIONS

 Instantiates: *Extra-Game Actions, Social Status, Game Mastery, Never Ending Stories, Player Constructed Worlds, Narrative Structures, Social Interaction, Player Decided Results, Creative Control, Freedom of Choice, Emotional Immersion, Roleplaying*

 Modulates: *Trans-Game Information, Self-Facilitated Games, Game World, Persistent Game Worlds, Characters, Strategic Knowledge, Extra-Game Information, Alternative Reality, Game World, Consistent Reality Logic*

Instantiated by: *Dedicated Game Facilitators, Game Masters, Cut Scenes, Roleplaying*

Modulated by: *Ultra-Powerful Events, Turn Taking, Interruptible Actions*

Potentially Conflicting with: None

Additional Patterns

Descriptions of these additional patterns can be found in the Chapter 9 folder on
ON THE CD the companion CD-ROM.

Player Constructed Worlds **Game Masters**

Dedicated Game Facilitators **Skills**

Self-Facilitated Games

NARRATIVE STRUCTURES

Games often build on the players unfolding an underlying story within the *Game World*. The following patterns explain some basic characteristics of how these stories emerge within the game.

Narrative Structures

The structures of the stories that are unfolded by playing the game.

Having stories in games gives players both motivations for the existence of goals and challenges in the game and rewards for completing the goals by weaving the consequences of players' actions into an unfolding story. This *Narrative Structure* does not have to be completely fixed; many games for example allow many different kinds of endings or let players achieve goals in many different ways without affecting the overall structure of the story.

> **Example:** *The Sims* does not have an explicit *Narrative Structure* built into the game but allows players to create their own stories by directing the actions of the Sims.

> **Example:** The *Final Fantasy* series has a complex story with personal relations as an important ingredient, and playing the game may be as much for experiencing the story as the gameplay challenges it offers.

USING THE PATTERN The main ingredients of *Narrative Structures* are *Characters* with their goals, *Ultra-Powerful Events* that ensure dramatic points and challenges.

The latter is commonly *Enemies*, with *Boss Monsters* representing points of extra *Tension* and possible *Closure Points*. The *Right Level of Complexity* of a *Narrative Structure* may be achieved by adding *Role Reversals* and *Red Herrings*. *Narrative Structures* require that at least some actions are *Irreversible Actions* for the narrative to move forward and make *Storytelling* affect the game state, with *Cut Scenes* as the strongest form game designers have to control the flow of narrative. *Reversability*, however, is often used to avoid player frustration associated with forcing the players to play the same parts of the game all over again in case of failing to achieve subgoals in the *Narrative Structure*.

The unfolding of the story may be strengthened by not allowing players full knowledge of the events to come, i.e., giving them *Limited Foresight*. This can be done by ensuring *Imperfect Information* or not having *Predictable Consequences*. The former can be achieved by *Levels* or by not providing a good *Game State Overview*. The latter can be done by *Randomness*, requiring players to perform *Leaps of Faith*, or presenting *Incompatible Goals* to players, which they have to choose from. The problems of providing at the same time *Imperfect Information* and using that information without *Dedicated Game Facilitators* make strong *Narrative Structures* more difficult to use in *Self-Facilitated Games*.

Narrative Structures can either be used to explain changes in the *Game World* that give *Varied Gameplay*, or be used to explain players' goals. Explanations of changes often occur at *Closure Points* and may be needed to describe *Rewards* and *Penalties* within a *Consistent Reality Logic*, for example, the reasons of *Ability Losses* or *New Abilities*. When used to explain players' goals, *Hierarchies of Goals* or *Dynamic Goal Characteristics* can be used to gradually unfold the structure of the narrative. *Clues* such as *Achilles' Heels* revealed by the *Narrative Structure* can make it more likely that players complete the goals, modulating the *Right Level of Difficulty* and making it more likely that the story will progress. Common specific goals used to drive *Narrative Structures* include *Rescue*, *Delivery*, *Collection*, and *Traverse*. *Unknown Goals* are essential for *Narrative Structures* if the story is to contain *Surprises* building on *Betrayals*. *Ephemeral Goals* can be used to modify *Narrative Structures* while they unfold, but usually require *Dedicated Game Facilitators*. *Game Masters* are especially suited for this and can intertwine *Player Defined Goals* and *Planned Character Development* into narratives that would be impossible to do otherwise.

Narrative Structures can be enabled by changing player abilities. For example, *Role Reversal* may represent *Character Development* in a story or *Privileged Movement* may allow new areas to be explored and initiate new events in the story. Movement of where *Spawning* occurs is a way to advance the *Narrative Structure* by moving where gameplay action occurs.

CONSEQUENCES *Narrative Structures* are ways to design *Hovering Closures* and *Higher-Level Closures as Gameplay Progresses* and increase the potential for *Tension*

and *Anticipation*. Although much of *Narrative Structures* are *Extra-Game Consequences* in the form of *Illusionary Rewards*, they can describe *Alternative Realities* through *Storytelling* and explain game state changes through *Indirect Information*. This can give players *Immersion* or *Emotional Immersion* in *Game Worlds*, make players feel *Identification* with *Characters*, work as *Goal Indicators*, as well as explain the presences of *Enemies* and *Boss Monsters*. Games that have *Narrative Structures* that rely on *Limited Foresight* and *Surprises* for their *Emotional Immersion* can have problems with *Replayability* due to the possibility of *Trans-Game Information*.

Narrative Structures usually give players a *Limited Set of Actions* that actually advance the story, either explicitly by only providing a few actions that all affect the narrative or implicitly by only advancing the story when the player makes the game state have a specific configuration by performing actions. These limitations on influence may break players' *Illusion of Influence* or make *Freedom of Choice* pointless, as the *Perceived Chance to Succeed* may be the same regardless of what the player does (actually it is more often that the players cannot fail than that they cannot succeed).

It is easier to maintain and effectively deliver a *Narrative Structure* in *Single-Player Games* as the game does not have to try to time events to two different players. However, games that allow players to have *Creative Control* over the *Narrative Structure*, often through *Roleplaying* that is translated into game state change by *Game Masters*, allow for *Player Constructed Worlds* and *Never Ending Stories* in *Persistent Game Worlds*. This is a means for giving players *Empowerment*.

RELATIONS

Instantiates: *Surprises, Immersion, Emotional Immersion, Tension, Higher-Level Closures as Gameplay Progresses, Limited Set of Actions, Right Level of Complexity, Hovering Closures, Anticipation, Identification, Extra-Game Consequences*

Modulates: *Game Worlds, Unknown Goals, Alternative Reality, Consistent Reality Logic, Persistent Game Worlds, Right Level of Difficulty, Achilles' Heels, Single-Player Games*

Instantiated by: *Hierarchy of Goals, Ultra-Powerful Events, Leaps of Faith, Irreversible Actions, Characters, Game Masters, Dedicated Game Facilitators, Storytelling, Cut Scenes, Illusionary Rewards*

Modulated by: *Game State Overview, Player Constructed Worlds, Creative Control, Randomness, Imperfect Information, Rescue, Delivery, Collection, Traverse, Ephemeral Goals, Dynamic Goal Characteristics, Incompatible Goals, Levels, Enemies, Boss Monsters, Clues, Closure Points, Rewards, Role Reversal, Privileged Movement, New Abilities, Ability Losses, Spawning,*

Planned Character Development, Red Herrings, Never Ending Stories, Character Development, Betrayal, Empowerment, Limited Foresight, Varied Gameplay, Trans-Game Information, Reversability, Roleplaying, Indirect Information, Goal Indicators

Potentially Conflicting with: *Ephemeral Goals, Penalties, Ability Losses, Planned Character Development, Self-Facilitated Games, Player Defined Goals, Replayability, Freedom of Choice, Illusion of Influence, Perceived Chance to Succeed*

Tension

The feeling of caring about the outcome of actions or events in a game without having full control over them.

Tension occurs in games that have uncertain outcomes, when players have emotional investments in which of these outcomes occurs but cannot fully control them. *Tension* can be either due to several sorts of interest in the outcome for players: if they are trying to make one of the outcomes occur; if the outcome has an affect on characters in the game that the players care for; or if the outcome has real-world effects.

> **Example:** Having placed most of one's markers in a bet in *Poker* is a classical case where players can feel tension.

> **Example:** The dark and claustrophobic environments in the *Doom* games easily cause *Tension* as players guide their *Avatars* through rooms and corridors, expecting monsters to appear.

USING THE PATTERN The presence of *Deadly Traps, Player Killing, Player Elimination,* and *Enemies* with *Overcome* goals guarantees the existence of forces that are trying to inflict *Penalties* or *Damage* on players, so these can be used to create *Tension*. This can be further modulated by using *Near Miss Indicators*, by making the *Enemies* more powerful over time, as *Boss Monsters* are examples of, or by making *Tied Results* impossible through *Tiebreakers*. The threat of *Early Elimination* is a concrete way to raise *Tension*. *Competition* and *Conflict* between players also creates *Tension*, often more than by the presence of *Enemies*. This *Tension* between the players can be modulated with *Balancing Effects*. When the ways to overcome the *Enemies* or other players depend on *Paper-Rock-Scissors* relations, the *Tension* can be further increased since players may choose ineffective methods. *Consumers* with no positive effects that automatically consume players' *Resources* provide similar *Tension* to players as *Enemies* and opposing players.

Narrative Structures can create *Tension* in games in the same ways as in other narrative mediums, and can be modulated by *Clues* or *Red Herrings*, but can also do so in games through modulating players' *Perceived Chance to Succeed*, typically by giving players an *Uncertainty of Information*. However, when narratives do not contain *Tension*, or when the unfolding of them causes players to have *Downtime*, players are likely to lose any feeling of *Tension*. *Game Masters* can notice these occurrences and adjust the *Narrative Structure* or interaction accordingly.

Putting *Time Limits* on how long players have to try and succeed with actions is an effective way to create *Tension*. This can be done as an explicit *Time Limit* or be achieved implicitly through *The Show Must Go On*. The *Tension* can then be further increased by requiring *Attention Swapping*.

Another way to modulate the *Tension* is by restricting players' powers or freedom, for example, by *Shrinking Game Worlds*, *Limited Set of Actions*, or *Movement Limitations*. The *Tension* caused by dangerous opponents or objects in the *Game World* can be modulated by setting the *Right Level of Difficulty* and can be made to be present before the threats themselves when *Traces* are used.

Forcing players to make commitments and then not letting them affect the outcome, or at least limit how they can affect the outcome, can create *Tension*. *Betting* and *Stealth* are similar in that they are activities that require *Turn Taking*, *Downtime*, and *No-Ops* can create *Tension*, and both are usually combined with *Randomness*, *Tradeoffs*, *Risk/Reward* choices, and the possibility to feel *Luck*. *Geometric Rewards for Investments* can create this form of *Tension* as the invested *Resources* are bound, and failed investments cause not only the already invested resources to be lost but lessen the value of *Resources* that have not yet been invested. This form of *Tension* can be further modulated through the presence of *Progress Indicators* and *Status Indicators* but can be ruined by *Perfect Information* about the evaluation function and all the game state values that affect the function. However, *Tension* can be lost instead of created if the players lose a *Perceived Chance to Succeed* because of necessary *Leaps of Faith*, extended *Downtime*, or *Turn Taking*.

Many activities and goals in games combine several of these aspects, for example, *Combat* or *Aim & Shoot* activities give players opponents and threaten to take players' *Lives*. *Continuous Goals* and *Extended Actions* with *Delayed Effects* can combine the risk of losing ongoing *Rewards* with the threats of *Penalties*, for example, through *King of the Hill* or *Evade* goals and in *Quick Games*.

Many aspects of *Cooperation* and *Social Interaction* where players have to rely on other players' actions give rise to *Tension*. Any interaction where *Uncertainty of Information* or possibility for disinformation exists due to player communication can generate *Tension*, but it is especially likely to occur with *Delayed Reciprocity* or when *Betrayal* and *Bluffing* is possible. Examples when *Tension* can be created in this fashion include *Player-Decided Distribution of Rewards & Penalties* and the

presence of *Shared Resources*. *Tension* related to *Social Interaction* exists in many cases for both the ones that can lose from the actions and the ones that can gain, as is typical in *Social Dilemmas*.

Reversability and the possibility to recreate previous game states through *Save-Load Cycles* lessens *Tension*, as players can replay moments that contained *Tension* and the feeling is less likely to be as strong on subsequent exposures. Therefore, *Tension* does not usually work together with general *Experimenting*, although they can do so when the experimentation is motivated by *Player Defined Goals*.

CONSEQUENCES *Tension* is one of the more direct ways games can be designed to have *Emotional Immersion*. *Tension* can be caused by putting players in the position of missing *Rewards* or in the position of receiving *Penalties*, which either affect themselves or something with which they have *Identification*. Especially *Competition* and questions of *Ownership* can evoke *Tension*, in the latter case either because players have *Gain Ownership* goals or because opponents want to take away *Ownership* of something from players. *Anticipation* is a way to modulate *Tension*; the more *Anticipation* players feel, the more *Tension* they will also likely feel. Feeling forced to perform actions within a certain *Time Limit*, for example, in *The Show Must Go On*, can in some cases be a reason for *Tension* to occur. *Game Pauses* in general have an effect on levels of *Tension*.

Tension can spill from games into the real world as *Extra-Game Consequences*, and the risk for this happening increases with the presence, as especially combinations of, extra-game rewards, *Social Interaction*, and questions of *Ownership*.

Repeated exposure to the same form of events or actions decreases the *Tension* they cause, so *Replayability* and *Tension* are difficult to combine, especially if the *Tension* is caused by *Narrative Structures* or other effects that rely on players not knowing what will occur. This problem of repeated exposure can partly be mitigated by *Higher-Level Closures as Gameplay Progresses*, as for example, naturally occurs in *Tournaments* or can be explicitly designed through *Boss Monsters* or *Narrative Structures*.

RELATIONS

Instantiates: *Emotional Immersion*

Modulates: None

Instantiated by: *Gain Ownership, Evade, King of the Hill, Continuous Goals, Boss Monsters, Lives, Limited Set of Actions, Downtime, Rewards, Penalties, No-Ops, Experimenting, Extended Actions, Shrinking Game World, Movement Limitations, Combat, Turn Taking, Aim & Shoot, Leaps of Faith, Betting, Game Masters, Narrative Structures, Perceived Chance to Succeed, Delayed Effects, Overcome, Betrayal, Tournaments, Higher-Level Closures as*

Gameplay Progresses, Uncommitted Alliances, Player Defined Goals, Delayed Reciprocity, Ownership, Deadly Traps, Damage, Enemies, Tiebreakers, Player-Decided Distribution of Rewards & Penalties, Balancing Effects, Randomness, Luck, Risk/Reward, Right Level of Difficulty, Paper-Rock-Scissors, Consumers, Shared Resources, Competition, Tradeoffs, Player Elimination, Early Elimination, Bluffing, Social Dilemmas, Uncertainty of Information, Conflict, Attention Swapping, The Show Must Go On, Stealth

Modulated by: *Traces, Save-Load Cycles, Game Pauses, Progress Indicators, Status Indicators, Anticipation, Identification, The Show Must Go On, Quick Games, Game Pauses, Red Herrings, Cooperation, Player Killing, Clues, Geometric Rewards for Investments, Near Miss Indicators, Time Limits*

Potentially Conflicting with: *Turn Taking, Replayability, Reversability, Downtime, Perfect Information, Perceivable Margins*

Characters

Abstract representations of persons in a game.

Many games let players control game elements that represent people or creatures that act in the *Game World*. When these people or creatures have characteristics not directly shown in the *Game World* that can change during gameplay, these game elements have an abstract element called *Character*.

> **Example:** Roleplaying games let each player control a character, and one of the main types of achievement in the games is to raise the character's level, stats, or skills.

> **Example:** *Return to Castle Wolfenstein: Enemy Territory* is a first-person shooter where players have characters that can develop between levels by gaining experience points in various skills.

USING THE PATTERN The design of use of *Characters* in games can either be on the level of creating explicit characters or by creating rules for how players can create their own *Characters*. Independent of how *Characters* are created, the game designer can choose whether *Character Development* should be possible and if players should be able to affect it. Allowing players control over *Character Development* increases *Freedom of Choice* as well as creates *Planned Character Development*, which is a form of *Investment*. This planning offers players the chance of *Varied Gameplay* by making use of *New Abilities* to instantiate potential *Orthogonal Unit Differentiation*. *Planned Character Development* gives the possibility for *Team Devel-*

opment in games with *Team Play*. However, unless games make use of *Game Masters*, this kind of *Freedom of Choice* regarding *Characters* may be difficult to combine with *Narrative Structures*.

Creating complete *Characters* lets them fit within an *Alternative Reality* and allows personalized and unique *Avatars* for each *Character*. In games with *Combat* or *Overcome* goals between the players, pre-created *Characters* can be extensively play-tested to ensure *Player Balance*. The use of pre-created *Characters* is common in games either where *Character Development* is not a large part of gameplay or where the *Character*, and any *Character Development*, is closely tied to a tightly controlled *Narrative Structure*.

Typical ways of letting players create *Characters* are based around *Randomness* or *Budgeted Action Points*. These are in turn used to determine the many various characteristics possible: the *Handle* that identifies the character to other players; number values that represent physical or mental abilities or status of measurements such as *Lives*, health, and fatigue; *Skills* that affect the likelihood of succeeding with actions and may give *Privileged Abilities* such as being a *Producer* that can create *Renewable Resources*; advantages, disadvantages, quirks, or other ways of describing character traits and motivating initial *Decreased Abilities, Improved Abilities*, or *Privileged Abilities*; worldly possessions and equipment that represents *Resources* or *Tools*; and occupations, social statuses, and social networks that define the character's place in the *Game World*. In games with *Avatars*, some of these characteristics are usually cosmetic. The variety of values associated with *Characters* then open up for the range of *Rewards*, such as *Improved Abilities* through raised *Skills*, and *Penalties*, such as *Decreased Abilities* through received *Damage*, that can occur during gameplay.

When players have rules for creating *Characters*, this gives them *Freedom of Choice* and *Creative Control* depending on the level of *Randomness* involved in the process, but this increases the possibilities for *Identification* and *Immersion* through *Emotional Immersion* in all cases. The personalization possible also allows players to construct *Player Defined Goals* for their *Characters* as they are created, and can give them the *Illusion of Influence* over how the *Narrative Structure* will develop. However, with a larger amount of *Freedom of Choice* regarding the character creation process, the problem of fitting or adjusting the character to an integral role in a *Narrative Structure* increases also. This problem can be mitigated by the presence of *Dedicated Game Facilitators* that can perform *Negotiation* to make the *Character* suitable to the planned events in the game or modify the *Narrative Structure* to fit the *Character*.

CONSEQUENCES *Characters* provide games with points for *Identification* and through these points *Emotional Immersion*, which can strengthen the impact of, and widen the range of, *Penalties* usable in the game, especially in the case of *Persistent Game*

Worlds. The presence of *Characters* also allows more detailed *Enemies* and richer *Narrative Structure* where social relationships and *Character Development* can be important components. This is especially true in cases where *Roleplaying* the *Characters* or *Storytelling* about the *Characters* is possible.

In games with *Game Worlds*, *Characters* form links between abstract game state values and concrete game state values through their connection to *Avatars*. When no concrete *Game World* exists, *Characters* take the role of *Focus Loci* in replacement of *Avatars*.

In *Multiplayer Games*, having *Characters* with different *Privileged Abilities* allows *Orthogonal Unit Differentiation* and lets players specialize in different *Competence Areas*. However, the differences in abilities may cause *Player Balance* to be disrupted.

RELATIONS

Instantiates: *Narrative Structures, Orthogonal Unit Differentiation, Competence Areas, Identification, Immersion, Emotional Immersion, Focus Loci, Creative Control, Player Defined Goals, Identification, Illusion of Influence, Enemies, Orthogonal Unit Differentiation, Investments*

Modulates: *Player Balance, Multiplayer Games, Alternative Reality, Avatars, Varied Gameplay, Roleplaying*

Instantiated by: None

Modulated by: *Freedom of Choice, Resources, Tools, Skills, Privileged Abilities, Decreased Abilities, Improved Abilities, Storytelling, New Abilities, Improved Abilities, Skills, Game Masters, Lives, Producers, Damage, Penalties, Dedicated Game Facilitators, Character Development, Planned Character Development, Budgeted Action Points, Randomness, Handles, Rewards, Persistent Game Worlds, Renewable Resources*

Potentially Conflicting with: *Narrative Structures*

Character Development

The improvement of characters' skills or knowledge.

Games with characters that can change offer chances for *Character Development*. This can either be in the form of becoming more likely to succeed with actions, or make actions that were previously unavailable possible. The changes can either be described as improvements in skills or changes in attitude toward other characters and the *Game World*.

Example: The characters in *The Sims* have a range of skills and jobs as explicit values of *Character Development*. Other values such as the relationships between characters can be used by the player to read emotional or social character development into the characters, but this is not supported by the game system.

Example: The *Tamagochi* toys can be said to allow players to influence the virtual pets in the game to have *Character Development*.

Example: Some tabletop roleplaying games use skill improvements as a measure of *Character Development*. In these cases, it is common with progressively slower advancement and diminishing return for trying to raise the skill; a common way of achieving this is to require a roll above the skill level to increase the skill level.

Example: Character levels associated with skill improvements are a general way of measuring *Character Development*. These levels are typically raised by gaining experience points and give the players' characters more hit points and abilities.

USING THE PATTERN *Character Development* is defined by two characteristics: what caused the development and what effect the development has. Common causes for *Character Development* are from parts of *Rewards* or *Investments*. The latter is usually done by various forms of *Collecting* to complete *Gain Competence* goals and may be *Planned Character Development* if players had the *Freedom of Choice* to create *Player Defined Goals*. If the effects of *Rewards* that give *Character Development* were known before they were received, they may also give these goals but are more likely to be part of the unfolding of a *Narrative Structure*.

Character Development usually takes the form of *New Abilities* or *Improved Abilities*, which either expands a *Limited Set of Actions* or increases *Skill* levels. The introduction of *New Abilities* or *Improved Abilities* can over time produce *Paper-Rock-Scissors* to give *Varied Gameplay* between playing different *Characters*. More uncommon changes due to *Character Development* are *Ability Losses* and *Extra-Game Consequences*, the latter of which can be evident only in the *Narrative Structure* or purely affect how the *Avatar* is represented. *Character Development*, especially of *Skills*, can be limited by *Balancing Effects* such as *Diminishing Returns* to modulate the increase rates over time; for example, skill increases happen often when one is a novice in the skill and happen rarely when one is an expert.

CONSEQUENCES *Character Development* is a way to make *Characters* advance the *Narrative Structure* of a game. The actual development can be done by explicitly affecting the characters' possibilities to influence the game state, for example, by

Privileged Abilities, *New Abilities*, or *Improved Abilities*, or by modifying the characters' relations to other parts of the *Game World*. The latter may explain *Ability Losses*, for example, not being able to attack innocent bystanders, as a positive development within a *Consistent Reality Logic*. By changing how the *Character* can interact within the game, *Character Development* promotes *Varied Gameplay*, for example, by changing how *Roleplaying* the *Character* should be done. *Character Development* that allows *Varied Gameplay* or affects the chances of performing actions can modulate players' *Perceived Chance to Succeed* but risks losing *Player Balance*.

Character Development between game and play sessions are handled by *Trans-Game Information* that not only passes the original *Character* between the sessions but can also introduce changes. This happens intuitively in games with *Persistent Game Worlds* where the lifetime of *Characters* in general is long enough for reasonable *Character Development*.

RELATIONS

Instantiates: *Improved Abilities, Player Defined Goals, Paper-Rock-Scissors, Varied Gameplay, Extra-Game Consequences, Perceived Chance to Succeed*

Modulates: *Characters, Consistent Reality Logic, Narrative Structures, Persistent Game Worlds, Roleplaying, Avatars*

Instantiated by: *Gain Competence, New Abilities, Skills, Ability Losses*

Modulated by: *Limited Set of Actions, Rewards, Collecting, Planned Character Development, Diminishing Returns, Balancing Effects, Freedom of Choice, Investments, Trans-Game Information, Privileged Abilities*

Potentially Conflicting with: *Player Balance*

Planned Character Development

When Character Development is under players' control and can be planned.

Planned Character Development occurs in games where the game system provides ways for players to influence how characters develop and set up goals for that development.

Example: The computer games *Black & White* and *Creatures* allow players to influence creatures' behavior through positive and negative feedback to what the creatures do in the environment. By choosing their responses, and by affecting what objects and other creatures the creatures meet in the environment, players can plan the creatures' development.

Example: Most tabletop roleplaying games allow players to make an initial choice of how their characters should develop by choosing classes and professions. If the game system allows special abilities to become available after certain prerequisites have been met, players can plan which of these to select and set personal goals for the character.

USING THE PATTERN *Planned Character Development* is made possible by giving players a set of possible options for how their characters can develop and letting them know what goals are required for these options to be instantiated. The goals required need to be *Predefined Goals* so that players can be aware of them, but may have *Dynamic Goal Characteristics* that change as the *Narrative Structure* unfolds. Naturally, the goals required cannot be *Unknown Goals* but they are often *Incompatible Goals* in order to force players into making *Tradeoffs*. The options are often combinations of *Privileged Abilities*, *New Abilities*, *Improved Abilities*, and *Skills* that define a number of different *Competence Areas*.

CONSEQUENCES *Planned Character Development* makes *Character Development* into *Player Defined Goals*, often based upon *Gain Competence* goals, and promotes player *Anticipation*. It gives players *Creative Control* and *Freedom of Choice* but requires them to maintain *Continuous Goals*, which not only require the survival of the characters but may also limit what actions the players may perform.

Deciding what future *Character* options to strive for encourages *Stimulated Planning*, often as *Extra-Game Actions*, and is part of the *Investment* players make undergoing *Planned Character Development*. This *Investment* makes it likely that players' have *Emotional Immersion* in or *Identification* with what happens to their *Characters* and that the *Rewards* that give the *Character Development* are worth more for the players. In games with *Team Play*, *Planned Character Development* always gives *Team Development* and allows for *Team Development* when the rest of the group is taken into consideration, e.g., when planning so that players have individual *Competence Areas*.

Letting players affect *Character Development* in games without *Game Masters* can make the development difficult to include in a *Narrative Structure* except on a general level and as threshold measures. The use of *Game Masters* can make the *Planned Character Development* an integral part of the *Narrative Structure* and either strengthen players' *Illusion of Influence* or allow *Player Constructed Worlds*.

RELATIONS

Instantiates: *Player Defined Goals*, *Competence Area*s, *Stimulated Planning*, *Illusion of Influence*, *Team Development*, *Player Constructed Worlds*, *Continuous Goals*, *Identification*, *Freedom of Choice*, *Creative Control*, *Anticipation*, *Gain Competence*, *Team Development*

Modulates: *Privileged Abilities, Characters, Character Development, Narrative Structures, Team Play*

Instantiated by: *Rewards, New Abilities, Improved Abilities, Skills*

Modulated by: *Privileged Abilities, Incompatible Goals, Game Masters, Predefined Goals, Unknown Goals, Dynamic Goal Characteristics, Extra-Game Actions*

Potentially Conflicting with: *Narrative Structures*

Identification

The characters or parts of the game with which players identify.

For players to feel any attachment to a game, they need something within the game to care about. This does not have to be a concrete game element but can just as well be a goal or type of action, but these also need some concrete game element through which players can try to achieve the goals or actions. Thereby, players need to have some game elements that they have *Identification* with so that they can plan or experience the gameplay through them.

> **Example:** Although players themselves do not feel emotional *Identification* with their king in *Chess*, the events affecting the king affect the players' gameplay, and the opponent probably identifies the king with the other player.

> **Example:** Many of the *Avatars* controlled in games playable by children are small compared to the other inhabitants in the games, especially the enemies. This offers children a view within the game that at least regarding size compares to how they experience the real world.

> **Example:** When playing *Europa Universalis II* or *Civilization,* players do not have *Identification* with individual characters, rather they can identify with countries or cultures.

USING THE PATTERN *Identification* is easily created by using *Characters* and *Avatars* in games that players control. This form of *Identification* can be further strengthened by allowing players *Creative Control* of the appearance and abilities of the *Characters* as well as linking *Ownership* to them.

Although it is common to try and create *Identification* through *Characters* or *Avatars,* the feeling of *Identification* in a game does not have to be with the *Focus Loci* the players have. It can also be created through other *Characters* in the *Narrative Structure* over which players do not have control. When *Identification* is achieved with ones' own *Enemies,* the *Narrative Structure* can be said to have been

able to create an *Alternative Reality* with a high level of *Consistent Reality Logic*. However, not letting players have any connection to the game through *Characters* or *Avatars* is likely to make *Identification* impossible, so *God's Finger,* for example, is difficult to combine with the pattern.

In *Multiplayer Games* with *Persistent Game Worlds*, players can have *Identification* with other players. Giving support for this, often through some form of *Game State Overview*, can be a spurn for *Social Interaction* and can promote the emergence of *Social Organizations* but also modulates *Player Killing*. Mentorship is a social relation that can create *Identification* between players, as the mentor is a form of model for the other player.

CONSEQUENCES Some form of *Identification* is required in games for players to have *Emotional Immersion* in the game or the *Alternative Reality* in which gameplay takes place, and is most often done through *Avatars* or *Characters* or even simple *Handles. Tension* can easily be created in the game once players have *Identification* with the *Avatars* or *Characters* by exposing these to potentially dangerous *Penalties*.

Once the *Identification* has been achieved, it usually strengthens players' willingness to perform *Roleplaying* and the quality of the performance. The events and actions taken in the game strengthen the *Identification* if these events and actions affect the *Characters* and *Avatars*. This is because they have a form of common experiences that is, for example, present through *Planned Character Development*.

RELATIONS

Instantiates: *Emotional Immersion*

Modulates: *Surprises, Tension, Social Interaction, Social Organizations, Penalties, Rewards, Enemies, Consistent Reality Logic, Alternative Reality, Player Killing, Roleplaying*

Instantiated by: *Avatars, Characters, Planned Character Development, Focus Loci, Multiplayer Games, Narrative Structures, Handles, Ownership, Creative Control*

Modulated by: *Game State Overview, Persistent Game Worlds*

Potentially Conflicting with: *God's Finger*

Higher-Level Closures as Gameplay Progresses

Closures that occur progressively become more important as the game is played.

Having *Higher-Level Closures as Gameplay Progresses* is a way to ensure that gameplay can vary and continue to be exciting or challenging. The closures can become more important either because they represent the completion of more difficult

challenges or because their completion has greater effect on the game state or the game story.

> **Example:** *Boss Monsters* in single-player first-person shooters are classic examples of how the enemy met at the end of a level can provide a stronger closure than the earlier enemies.

> **Example:** The first stones placed in *Go* are extremely important for the development of every game session but do not represent high-level closures, as their impact on the game is still uncertain. Examples of higher-level closures in *Go* are instead when groups become with absolute certainty dead through the opponent's actions or become alive through gaining two eyes or connecting to another living group.

USING THE PATTERN Common ways of creating *Higher-Level Closures as Gameplay Progresses* are through *Hierarchies of Goals*, as can, for example, be found in *Tournaments* and especially in those primarily concerned with *Combat* or other *Overcome* goals. Other ways are using the same goal several times but making the consequences of succeeding or failing the goal more important each time, for example, by having *Non-Renewable Resources* or using *Balancing Effects* to make important outcomes be decided near the end of game sessions. Examples of this latter way are *Eliminate*, *Capture*, *Collections*, and *Last Man Standing* goals where simply fewer goal objectives, and thereby a more *Limited Set of Actions*, make the closure more important.

Reuse of the same goal often requires increasing the *Tension*, for example, by *Shrinking Game Worlds*, or that completing the goals becomes more difficult for *Higher-Level Closures as Gameplay Progresses*. In the latter case, the *Right Level of Difficulty* can be maintained if players successively also are given *Empowerment* within the game. A common example of the latter is introducing *Boss Monsters* as targets for *Eliminate* goals after players have had *Eliminate* goals for easier *Enemies*.

Red Queen Dilemmas by their nature create *Higher-Level Closures as Gameplay Progresses*, but since the changes may be incremental, the difference between closures may not be perceived as large.

CONSEQUENCES The primary use of *Higher-Level Closures as Gameplay Progresses* is to maintain *Tension* in games that otherwise would become repetitive. The closures can become higher-level either because of the progression of a *Narrative Structure* or because challenges become more difficult. As *Higher-Level Closures as Gameplay Progresses* changes the gameplay, having the presence of the pattern in games promotes *Varied Gameplay* to a certain degree.

The occurrences of *Higher-Level Closures as Gameplay Progresses* are usually linked to *Closure Points*. For example, *Boss Monsters* are often presented as the final challenge players have to overcome before completing a *Level* and the replacement of most of the game state.

RELATIONS

Subpatterns: *Collection, Closure Points*

Instantiates: *Tension, Varied Gameplay*

Modulates: None

Instantiated by: *Eliminate, Capture, Last Man Standing, Hierarchy of Goals, Tournaments, Closure Points, Shrinking Game World, Combat, Narrative Structures, Boss Monsters, Balancing Effects, Empowerment, Non-Renewable Resources*

Modulated by: *Limited Set of Actions, Overcome, Right Level of Difficulty, Red Queen Dilemmas*

Potentially Conflicting with: None

Surprises

Events and consequences that are unexpected by players and disturb their attention.

Not all things that happen in games can be foreseen by players, and this is often one of the charms of playing games. When these events not only are unpredicted but the possibility of them happening has not occurred to players, these events are *Surprises* and catch the players' attention.

> **Example:** First person-shooters where players cannot have awareness over everything in their surroundings can easily cause *Surprises*, for example, being attacked from an unsuspected direction. Many of these games also include *Surprises* in the form of secret rooms.

> **Example:** One of the strengths of having stories in games is that they allow for *Surprises* to be planned so that they occur at certain points in gameplay.

> **Example:** One of the primary rewards for being a game master in roleplaying games is to be surprised by what the players do with the *Game World* and the story one has constructed.

USING THE PATTERN One requirement for *Surprises* is the absence of *Game State Overview* or the presence of *Imperfect Information* or *Limited Foresight*. Because of this, *Surprises* are most often achieved by having *Dedicated Game Facilitators* such

as *Game Masters. Never Ending Stories* are a way of overcoming the problems of *Narrative Structures* by combining *Surprises* with *Replayability*, thus making the narrative continue and change forever. Relying on the unexpected, *Surprises* are difficult to combine with *Predictable Consequences* and *Replayability* due to *Trans-Game Information* between game instances; and especially difficult when players have *Anticipation* of future events through *Hovering Closures*. Likewise, too many *Surprises* in games can negatively influence players' *Perceived Chance to Succeed* and *Illusion of Influence. Self-Facilitated Games* also are limited in how to create *Surprises* since specific *Surprises* cannot be initiated as reactions to current game states without being known.

Events caused by players that can produce *Surprises* are *Disruption of Focused Attention* events or the revealing of secret tactics or *Secret Alliances*, especially if these cause *Role Reversal* or *Betrayal*. These last cases of *Surprises* can have a stronger impact if players have *Identification* with the *Characters* involved. *Surprises* can be part of *Exploration* or *Construction* activities and the effects of *Deadly Traps, Easter Eggs,* and *Leaps of Faith. Orthogonal Unit Differentiation* can give *Surprises* when meeting opponents since meeting one does not mean that players know the abilities of all future encounters. Completing *Unknown Goals* is an example of a positive *Surprise* and is the completion of any goal where the *Rewards* are unknown. *Red Herrings* are not *Surprises* in themselves but lay the foundation for *Surprises*, often in the form of *Role Reversals*.

The impact of *Surprises* can be increased making them require *Irreversible Actions*. The presence of *God's Fingers, Traces,* and *Outstanding Features* all make *Surprises* more difficult to achieve, while *Save-Load Cycles* lessen the impact of *Surprises* since players can replay the event that caused the *Surprise* and be prepared.

CONSEQUENCES *Surprises* automatically give players *Limited Planning Abilities* although they may not be aware of it. *Surprises* can be planned into the design of *Narrative Structures* and *Levels*, with *Cut Scenes* as an option to completely control the presentation of the events that are intended to *Surprise. Surprises* can either strengthen or lessen *Immersion* in games depending on the type of *Surprise. Disruption of Focused Attention* events usually give *Spatial Immersion* as they often occur within the *Game World* but ruin *Cognitive Immersion* as they cause *Attention Swapping. Surprises* caused by the unfolding of the *Narrative Structure* can cause *Emotional Immersion*, as it can be based upon *Betrayal* or *Role Reversal. Emotional Immersion* can also be caused by *Surprises* with negative effects, for example, *Damage* that affects players' *Characters*.

The use of *Surprises* in games makes *Aim & Shoot* and other *Dexterity-Based Actions* more difficult.

RELATIONS

Instantiates: *Disruption of Focused Attention, Immersion, Spatial Immersion, Emotional Immersion, Attention Swapping, Irreversible Actions*

Modulates: *Exploration, Dexterity-Based Actions*

Instantiated by: *Exploration, Deadly Traps, Game Masters, Construction, Limited Foresight, Role Reversal, Betrayal, Easter Eggs, Leaps of Faith, Unknown Goals, Imperfect Information, Dedicated Game Facilitators, Narrative Structures, Rewards, Never Ending Stories, Cut Scenes, Orthogonal Unit Differentiation*

Modulated by: *Damage, Levels, Limited Planning Ability, Red Herrings, Identification*

Potentially Conflicting with: *Perceived Chance to Succeed, Predictable Consequences, Illusion of Influence, Replayability, Game State Overview, Self-Facilitated Games, Anticipation, Hovering Closures, God's Finger, Traces, Outstanding Features, Save-Load Cycles, Cognitive Immersion, Immersion, Aim & Shoot, Trans-Game Information*

Cut Scenes

Sequences of storytelling where players cannot act within the game.

Cut Scenes are used when games cannot progress the entire game story through actions and events and need to give longer descriptions and explanations to players. These scenes are usually located between sections of gameplay that differ significantly, either because of change of location or type of activities required, or located right before a challenge to make players aware of the challenge.

> **Example:** In *Myst*, the completion of puzzles resulted in video sequences from one of two brothers, and the fragmented parts of the world's history that they told unfolded the whole story for players as the game progressed.
>
> **Example:** *Wing Commander III* has one of the most ambitious uses of *Cut Scenes* in games. These scenes were used in between flight missions to put the player's character in situations of choice and then give indications of the effect of the choices.

USING THE PATTERN To fully control the presentation of *Cut Scenes*, they need to be designed in games with *Dedicated Game Facilitators*. However, the *Cut Scenes* do not have to be fully predetermined: having sets of *Cut Scenes* allows scenes to be chosen due to the current game state; using the game engine to run the *Cut Scenes*

allows minor variations such as the positions of game elements; and using *Game Masters* allows *Cut Scenes* to be fully modulated with the game state and players.

Common places for *Cut Scenes* are in conjunction with *Boss Monsters*, *Traces*, and *Surprises*. The scenes can be used to show the presence of the first two, possibly as *Disruption of Focused Attention* events, while the last can be fully instantiated by *Cut Scenes*. *Cut Scenes* are also commonly used to explain movement between *Levels* and give *Game State Overview* of new *Levels* or other game events.

Cut Scenes do not have to be video segments; *Game Masters* or players in *Self-Facilitated Games* can create the same kind of effects through *Storytelling* that is not interrupted.

CONSEQUENCES *Cut Scenes* stop gameplay, most often in *Real-Time Games*, and thereby are a form of *Game Pauses*. *Cut Scenes* are one of the most controlled ways of *Storytelling* to present *Narrative Structures* and *Alternative Realities* to players. As events that control the game state completely, *Cut Scenes* are *Ultra-Powerful Events*, which cause *Downtime* but may also cause *Disruption of Focused Attention* events. Since it may be difficult to time the suitability of when to enforce global *Downtime* in *Multiplayer Games*, it is easier to time *Cut Scenes* to the events in the game in *Single-Player Games* unless a *Game Master* is used.

Player's *Illusion of Influence* is of course difficult to maintain during *Cut Scenes*, and they may affect the overall impression of influence as well. However, *Cut Scenes* may give *Strategic Knowledge* about how to meet future challenges and may thereby function as *Goal Indicators* and increase players' *Perceived Chance to Succeed*, and give rise to *Stimulated Planning*.

RELATIONS

Instantiates: *Downtime, Ultra-Powerful Events, Disruption of Focused Attention, Strategic Knowledge, Narrative Structures, Game State Overview, Surprises, Stimulated Planning, Storytelling, Game Pauses*

Modulates: *Alternative Reality, Perceived Chance to Succeed, Levels, Real-Time Games, Goal Indicators, Single-Player Games*

Instantiated by: *Dedicated Game Facilitators*

Modulated by: *Game Masters*

Potentially Conflicting with: *Illusion of Influence*

Easter Eggs

Surprises in the game that are not related to the game.

Easter Eggs are surprises put in games that do not necessarily advance the game story or even fit within the reality of the *Game World*. The design of *Easter Eggs* started as programmers' and game designers' ways of protesting against management but soon turned into a gameplay value, encouraging exploration and people to replay the games.

> **Example:** The first documented *Easter Egg* was the text "Created by Robinett." in *Adventure* put there by the programmer Warren Robinett. To find it, players had first to find a single dot object that had the same color as the background of the game and was located in a room that was inaccessible unless you used a special bridge. This dot then had to be carried to a specific wall to let the players enter a secret room which contained the message.

> **Example:** *Super Mario Bros.* included entire levels as *Easter Eggs*, including an underwater world that was seemingly endless.

> **Example:** The whole game *Maniac Mansion* is included as an *Easter Egg* in its sequel *Day of the Tentacle*.

USING THE PATTERN Designing *Easter Eggs* includes choosing where in the *Game World* they exist, what they contain, creating possible *Clues* to ease finding them, and making sure they are *Optional Goals*. Typical contents of *Easter Eggs* include *Games within Games* or *Resources* to modulate the *Right Level of Difficulty*. The use of *Games within Games* and other *Easter Eggs* that effectively change the mode of play may be more suitable in *Single-Player Games*, since there is no need to try and synchronize and explain changes of play mode in these types of games.

CONSEQUENCES *Easter Eggs* are a way of providing *Surprises* in games, which are extra-game rewards in addition to any other benefits they give. Knowledge about their existence provides *Optional Goals* of *Exploration* and may stimulate *Social Interaction* between game sessions to pass *Trans-Game Information*. *Easter Eggs* may even promote *Replayability*, since players can have *Player Defined Goals* to find all *Easter Eggs* even after completing a game. The *Consistent Reality Logic* of an *Alternative Reality* can be negatively affected by *Easter Eggs* unless they only consist of *Resources* or purely aesthetic effects.

RELATIONS

> **Instantiates:** *Surprises, Optional Goals, Player Defined Goals, Trans-Game Information, Replayability*

> **Modulates:** *Exploration, Game World, Right Level of Difficulty, Single-Player Games*

Instantiated by: *Games within Games, Resources*

Modulated by: *Clues*

Potentially Conflicting with: *Consistent Reality Logic*

Additional Pattern

A description of this additional pattern can be found in the Chapter 9 folder on the companion CD-ROM.

Never Ending Stories

10 Game Design Patterns for Social Interaction

Games are social in nature even though the majority of current computer games are in principle single-player games. The social interaction between the player within and outside the game is often also one of the major reasons for players to participate in the game. The interaction between the players is not necessarily always positive; the players' main goal in the game might be to bluff, deceive, and even eliminate other players. The patterns in this chapter cover some of the main ways games offer possibilities for social interaction between the players. Sometimes the seemingly negative, or even evil, social interaction can in the end bring more enjoyment to all the players of the game.

> **Competition:** *Competition, Conflict, Player Killing, Betrayal, Individual Rewards, Individual Penalties, Red Queen Dilemmas*
>
> **Collaboration:** *Cooperation, Collaborative Actions, Shared Rewards, Shared Penalties, Delayed Reciprocity, Competence Areas*
>
> **Group Activities:** *Team Play, Alliances, Roleplaying, Constructive Play, Player Decided Results, Team Development, Social Organizations, Uncommitted Alliances, Dynamic Alliances, Secret Alliances*
>
> **Stimulated Social Interaction:** *Social Interaction, Trading, Bidding, Bluffing, Negotiation, Social Dilemmas, Social Statuses*

COMPETITION

Although social interaction in general is viewed as something where the players do things together, the means to that interaction often involves conflict and competition between the players. This section has some concrete and some relatively abstract patterns that describe how to achieve or increase the conflict between the players.

Competition

Competition is the struggle between players or against the game system to achieve a certain goal where the performance of the players can be measured at least relatively.

Competition can take many forms, with the primary dichotomy being between having to actively engage against other players to win, direct *Competition*, or being able to win without interacting directly with other players, indirect *Competition*. The first case is the most common and is usually aggressive and destructive (e.g., *Chess*) but is also often perceived as the most emotionally engaging. The second can more easily allow for slow-paced games and constructive gameplay. It also puts more emphasis on competing against oneself.

> **Example:** Many games based on race have indirect *Competition* between the players to reach a certain position in the game as fast as possible. The performance of the players is measured by timing each player's race.

USING THE PATTERN The easiest form of *Competition* is *Conflict* with *Enemies*, but any situation where players have *Incompatible Goals*, *Excluding Goals* (possibly through *Tiebreakers*), or *Rewards* (especially *Individual Rewards*), can cause *Competition*. Two forms of *Competition* that require *Conflict* are *Overcome* and *King of the Hill*. Examples of *Competition* without *Conflict* are all forms of *Races* without *Interferable Goals* or *Last Man Standing* goals where the players are not the cause of each other's demise. In these types of *Competitions*, the players are not each other's *Enemies*, but the game may provide other *Enemies* through *Agents*.

Using *Mutual Goals* with *Shared Rewards* in subgoals of the *Competition* reduces the level of competition between the players, as the players can have *Cooperation* with other players in *Alliances*. By encouraging *Dynamic Alliances*, the dynamics of *Competition* and *Cooperation* usually increase the level of *Social Interaction* between the players.

How the *Competition* ends depends on what criteria the different competitors have. *Symmetric Goals* allow players to judge more easily their chance of winning and are often used to create *Player Balance* between players. *Asymmetric Goals* allow different strategies and can create a more varied gameplay and may also promote temporary alliances, although it may be more difficult to balance the game. Further, players may have *Unknown Goals,* which allows for techniques of masquerading one's intentions.

If one player is certain to win a *Competition*, the motivation for other players to continue competing becomes pointless. In the case of subgoals, this can be a temporary setback, which can be offset by winning other *Competitions*, but if the outcome of the overall game becomes apparent, the motivation for continuing to play the game may become pointless.

The final outcome of *Competition* varies as well: the winner may gain *Rewards* in the form of *Resources*, information, *Improved Abilities*, or *Social Status*; the loser may similarly lose *Resources*, suffer *Ability Losses*, or be excluded from the game through *Player Elimination*. Exclusion from the game near the end of the game is usually not a problem, but early exclusion may be. Specific examples of more complex forms of *Competition* for subgoals within games include *Bidding* and *Trading*.

The use of *Agents* allows players to compete without having to risk the social consequences of losing a game to other players. On the other hand, this means loss of opportunities to gain *Social Status* by winning the game. The use of *Ghosts* has similar effects on *Competition* but may still give *Social Status*, as the results between different players can be compared.

CONSEQUENCES Having *Competition* in a game gives a sense of purpose to playing the game and often creates *Tension* during gameplay. If players have chosen to play a competitive game, they have chosen to test their abilities against other players, a computer, or a puzzle. *Competition* can also motivate *Social Interaction* in general, but especially in games where there are dynamics of *Competition* and *Cooperation* between the players, as is the case in *Social Dilemmas* and rivalries in *Social Organizations*.

As *Competition* makes players want to use their *Resources* and abilities as efficiently as possible, the presence of *Competition* discourages *Experimenting*.

RELATIONS

Instantiates: *Conflict, Social Statuses, Tension*

Modulates: *Cooperation, Social Interaction, Alliances, Social Statuses, Dynamic Alliances*

Instantiated by: *Rewards, Incompatible Goals, Excluding Goals, Red Queen Dilemmas, Shared Resources, Bidding, Trading, Last Man Standing, Overcome, Race, Ghosts, Enemies, King of the Hill*

Modulated by: *Player Balance, Mutual Goals, Shared Rewards, Symmetric Goals, Individual Rewards, Tiebreakers, Asymmetric Goals, Unknown Goals, Collaborative Actions, Alliances, Social Dilemmas, Social Organizations, Agents, Cooperation*

Potentially Conflicting with: *Cooperation, Experimenting*

Conflict

In conflict, two or more parties, often players or players against the game system, have goals, that cannot be satisfied together.

Almost all games have conflict situations, as otherwise it would be difficult to motivate the goal structures within the game. This, however, does not necessarily mean that all games are of an aggressive and competitive nature, but that games can be based on different kinds of conflict situations and on different levels. Even highly cooperative games, such as Reiner Knizia's *Lord of the Rings*, have a built-in conflict between the players and the game system. The same applies, of course, to all single-player games, where the players struggle against the game system. However, it can be argued that certain categories of games, especially simulation games, do not have explicit conflict situations and to a certain extent this is true. It is possible to play a simulation game, such as *SimCity* or *The Sims*, in such a way that there is no perceived conflict situation, but as soon as the players set goals for themselves in the game, there has to be conflict, as otherwise there is no game.

> **Example:** The *Conflict* situation in *Tetris* is that the game system creates blocks that start to fall down, and the player tries to keep the screen as clear from blocks as possible.

> **Example:** In *Chess*, the *Conflict* situation is clear: the two players try to checkmate each other's king, and the winner is the first player able to do that.

USING THE PATTERN *Conflict* is almost intuitively part of all games, but determining which kinds of *Conflict* situations and on which levels the *Conflict* appears is a difficult task. Using *Eliminate* and *Overcome* goals or direct *Competition* from *Enemies* in the form of other players or *Agents*, is an easy way to create *Conflict* in games, especially if *Combat* actions are available. The severity of the *Conflict* can be modulated by the use of *Lives* or the possibility of *Player Elimination*.

Gain Ownership through *Transfer of Control* events can either modulate or be the main reason for almost any kind of *Conflict*. *Competitions* with *Individual Rewards* for the players are *Conflict* situations, as only some of the players are able to reach their goals in an adequate manner, especially if *Tiebreakers* are used. *Race*, *Rescue*, *Last Man Standing*, and *King of the Hill* are classical ways of bringing *Conflict* and *Competition* into games and can be modulated by the goals resulting in *Player Elimination*. *Betrayals* that cause *Role Reversals* give *Conflicts* with potentially greater *Emotional Immersion*, since the *Conflict* is unexpected and probably perceived as unfairly motivated. *Tournaments* allow the *Conflict* to extend between game instances.

For *Conflict* to exist, players must be aware that they have opponents, so *Uncertainty of Information* or *Imperfect Information* about the goals of players, or even which players exist, make *Conflict* difficult. Although not required for *Conflict* to exist, *Symmetric Information* can intensify and focus *Conflicts*, especially if players have *Symmetric Goals*.

CONSEQUENCES *Conflict* is a common source in games of *Emotional Immersion*, and *Conflict* naturally creates *Tension* in games as other players or the game system are actively working against oneself. Games use different kinds of *Conflict* situations as the main motivations for the players to play the game and spectators to watch the drama unfold. *Conflict* can happen on several different levels in the game, and even though a game might contain features of *Collaborative Actions* without *Conflict*, there usually is a *Conflict* situation at least on some level, for example, as a *Social Dilemma* or rivalries between the members of the *Social Organization*.

RELATIONS

> **Instantiates:** *Emotional Immersion, Tension*
>
> **Modulates:** *Attention Swapping, Social Dilemmas, Social Organizations*
>
> **Instantiated by:** *Competition, Role Reversal, Combat, Betting, Tiebreakers, Interferable Goals, Preventing Goals, Excluding Goals, Incompatible Goals, Last Man Standing, King of the Hill, Race, Transfer of Control, Overcome, Player Elimination, Betrayal, Competition, Tournaments, Rescue, Enemies, Gain Ownership, Eliminate*
>
> **Modulated by:** *Shrinking Game World, Dedicated Game Facilitators, Individual Rewards, Ownership, Tiebreakers, Agents, Symmetric Goals, Lives, Symmetric Information*
>
> **Potentially Conflicting with:** *Cooperation, Collaborative Actions, Mutual Goals, Shared Rewards, Supporting Goals, Uncertainty of Information, Imperfect Information*

Player Killing

Allows players to intentionally or unintentionally remove players from the game for at least some time.

Games in which the players control only one *Avatar* each make the death of these very influential for players' experiences and success in the game. As players easily identify with their *Avatars*, killing them is usually referred to as *Player Killing* even though it is actually *Avatar* killing.

> **Example:** Early *Ultima Online* was notorious for more experienced players killing other players' characters for looting their items or just for fun. The players who were killed lost the items they were carrying unless they were able to come back to the spot before the player killers looted them.
>
> **Example:** Deathmatch first-person shooters, such as *Quake III*, have *Player Killing* as one of the main goals for the game. The more other players the

player manages to take out, the more points or frags he is awarded. The players who are killed usually lose their gained special items and abilities and are transferred back to a spawn point.

USING THE PATTERN Having or not having *Player Killing* is always an explicit design choice. *Player Killing* is, in effect, *Player Elimination* with the *Spawning* of the players' *Avatars* allowed. Designing *Player Killing* in the game obviously involves deciding the details of *Spawning* and *Penalties* involved for being killed. Usually they are mainly *Individual Penalties* even in games with *Team Play*, and players receive *Decreased Abilities*, *Ability Losses*, and they might lose *Ownership* of *Tools* and other items they possess at the time of killing. Other possibilities include forced *Downtime* or limitations to the number of times a player can respawn due to the use of *Lives*.

Player Killing* can be used as a method of keeping *Score* in both games with *Team Play*, as in games with *Team Elimination*, and without *Team Play*. Games with *Team Play* sometimes allow the players to *Eliminate* their team members, and this can be called unintentional *Player Killing*. On the other hand, some team-oriented games break *Consistent Reality Logic* by not having the possibility of *Player Killing* within the same team in order to avoid internal fighting and possibilities for saboteurs.

CONSEQUENCES *Player Killing* naturally has an effect on *Tension* involved, depending on the actual *Penalties* and *Rewards* for *Player Killing*. The *Tension* involved is usually not as drastic as in games with *Player Elimination* without *Spawning* but is modulated in both cases by how much *Identification* the player has with the controlled *Avatar*. As the early versions of *Ultima Online* demonstrated, if the players are rewarded for *Player Killing*, that is what is going to happen no matter what the social rules of conduct are within the game itself. More recent MMORPGs have solved the *Player Killing* problem either by removing the possibility of *Player Killing*, having special places in the *Game World* where *Player Killing* is allowed, or designing *Penalties* also for player killers, for example, by changing their explicit *Social Status* to outlaws and not allowing them to enter cities. Depending on the solution, *Player Killing* can significantly modify *Risk/Reward* choices for both attackers and potential victims.

RELATIONS

> **Instantiates:** *Downtime, Team Elimination*

> **Modulates:** *Ownership, Tension, Team Balance, Team Play, Player Elimination*

Instantiated by: *Lives*

Modulated by: *Spawning, Penalties, Rewards, Ability Losses, Decreased Abilities, Social Statuses, Risk/Reward, Identification, Avatars*

Potentially Conflicting with: None

Betrayal

One or several players that have an agreement with other players either intentionally fail to do as agreed or otherwise hinder the fulfillment of the agreement.

Players can be put in situations where promises or the expectations of other players may be broken. These acts of *Betrayal* often cause friction between players, and therefore players betraying other players usually have an incentive to do so. This may be due to individual gains received by the *Betrayal*, differences in player positions in the game, revenge for previous injustices, or situations where the game forces players to choose which players they will betray.

> **Example:** Much of the enjoyment and tension of *Diplomacy* is in the possibility to betray and backstab other players. This sometimes leads to very intense diplomacy phases where the players try to get more information about what other players really try to achieve in the game.

> **Example:** The negotiation game *Intrigue* forces players into situations where they sometimes must betray another player due to having made certain promises to several different players that appeared to be unrelated when they were given but later became related.

USING THE PATTERN *Betrayal* requires that one player in the game has some *Committed Goals* whose completion is dependent on other players' actions, even if the commitment may only be a promise and the goals may be *Player Defined Goals*. Thus, *Betrayal* can happen in almost any situation where the players are cooperating in some way, usually toward *Mutual Goals*. Less severe cases of *Betrayal* can happen in *Collaborative Actions* and in situations of *Delayed Reciprocity* such as *Player-Decided Distribution of Rewards & Penalties* or *Trading* with *Delayed Effects*. One way, and perhaps best, to enhance the possibility of *Betrayal* is to give the players at least a perceived chance of reaping *Individual Rewards* for betraying the other players. This form of *Betrayal* is the basis for some *Social Dilemmas*. An example is where *Tied Results* can be perceived and *Rewards* are distributed evenly: in these cases, players may negotiate to have a *Tied Result* in order to use their *Resources* and efforts in other parts of the game but have the possibility of *Betrayal* to gain the whole *Reward* for themselves.

Betrayal is one of the classic themes that can be used to create *Narrative Structures* and *Role Reversal* events. The interplay of trust and deceit is a way to achieve *Emotional Immersion* as *Betrayal* will almost inevitably create strong emotions in both parties involved. *Betrayal* has to come as a *Surprise* for those who are betrayed, or it loses much of its emotional impact. This can be achieved, for example, by having a *Delayed Effect* for *Collaborative Actions* and using *Asymmetric Information* about the actions the players have performed, which also raises the levels of *Anticipation*. In most cases, *Betrayal* is used together with *Bluffing*. The players who are about to betray other players have to conceal their true intentions and in some games, for example *Diplomacy*, *Bluffing* to conceal *Betrayal* is the basis for much of the enjoyment of the game.

CONSEQUENCES The possibility of *Betrayal* in games gives players a form of *Player Decided Results*, and the power this gives most likely increases *Tension* between players and has a negative effect on *Team Play* and possible *Cooperation*. As is the case with *Bluffing*, even the perceived possibility of *Betrayal* can increase *Social Interaction* between players. In these cases, the heightened *Tension* is due to the players trying to find out what the other players' true intentions are. *Betrayal*, in any case, is much more common in *Uncommitted Alliances* than in stable *Alliances* such as teams. The effect of *Betrayal* is more drastic when the other players feel that the *Alliance* is stable. For example, a *Soccer* player perceived as betraying his team in the World Cup finals will probably be treated as a real-world betrayer and suffer the consequences.

For players to put themselves in positions where *Betrayal* of their trust can occur requires them to make *Risk/Reward* calculations and heavily influences how *Negotiation* is conducted. The actual action of putting oneself in the position where one can be betrayed is a *Leap of Faith* and if the *Betrayal* takes place, it is usually the source for *Conflict*.

RELATIONS

Instantiates: *Role Reversal, Social Dilemmas, Leaps of Faith, Surprises, Tension, Emotional Immersion, Uncommitted Alliances, Risk/Reward, Conflict*

Modulates: *Narrative Structures, Anticipation, Tied Results, Social Interaction, Trading, Negotiation, Alliances, Anticipation*

Instantiated by: *Bluffing, Player-Decided Distribution of Rewards & Penalties, Mutual Goals, Collaborative Actions, Individual Rewards, Cooperation, Asymmetric Information, Committed Goals, Player Decided Results*

Modulated by: *Indirect Information, Rewards, Penalties, Delayed Reciprocity, Delayed Effects*

Potentially Conflicting with: *Team Play, Cooperation*

Additional Patterns

Descriptions of these additional patterns can be found in the Chapter 10 folder on the companion CD-ROM.

Individual Rewards

Individual Penalties

Red Queen Dilemmas

COLLABORATION

Games with high social interaction often rely on the players to be able to collaborate and not only to compete against each other. The following patterns describe some of the possibilities and incentives for the players to achieve things in the game together. Often the most interesting social interaction is achieved when both competition and collaboration are present in the game.

Cooperation

Players cooperate, i.e., coordinate their actions and share resources, in order to reach goals or subgoals of the game.

Cooperation in games allows players to divide goals between them and rely upon each other's abilities and resources. It may enable players to perform otherwise impossible actions or may make players feel that they are part of a team. The notion of a fully cooperative game, without any kind of competition or conflict, seems to be a moot point. Games without struggle to achieve some form of goal are not games at all, and any game containing competition or conflict situations automatically introduces struggle and makes full *Cooperation* impossible.

Example: Laying a puzzle together with friends has *Cooperation* between the players, but one can still see the puzzle as containing *Competition* (or even *Conflict*) against the game system or designers of the puzzle.

Example: The members of a *Soccer* team have to cooperate in order to beat the opposing team.

Example: In *Lord of the Rings*, the board game, the players coordinate their actions in order to defeat Sauron. The gameplay in this game is basically fully cooperative since the main goal, defeating Sauron, is common to all players, that is, either the players win the game or they all lose.

Example: MMORPG sections where there is no possibility for destructive player versus player actions, such as attacking or stealing, encourage *Cooperation* as the possibility of *Betrayal* is lessened. Further, a player that does not cooperate can lose compared to the other players if all the other players collaborate.

USING THE PATTERN The simplest way to achieve *Cooperation* is to use *Team Play*, but equal levels of *Cooperation* can be achieved by introducing *Mutual Goals* with *Shared Rewards* to players. This creates incentives for the players to strive toward the goals together, and it has been shown that cooperative groups with *Shared Rewards* perform better, are more strongly motivated, and more willingly engage in *Social Interaction*. The *Mutual Goals*, however, do not need to be the highest level goals in the game; that is, it is possible to have *Competition* and *Conflict* between the players as a high level goal and use *Mutual Goals* as subgoals for reaching the high level goal.

All *Alliances* and *Team Play* are based on *Cooperation* between the players. Even the lowest level of *Alliance*, agreeing not to hinder or harm the other player, is a form of *Cooperation*, as the players coordinate their actions, even though they might not be trying to achieve *Mutual Goals*.

Every mode of play where the players perform actions together for mutual benefit requires *Cooperation* from basic *Collaborative Actions* to *Trading* and even *Bidding*. The benefit does not have to be direct to all the cooperating players but there can be a time delay for the *Individual Rewards* as is described in *Delayed Reciprocity*.

Shared Resources gives players the opportunity to decide between cooperating on how to use the *Resources* as fairly as possible or going into *Conflict* over how to use them.

CONSEQUENCES *Cooperation* increases *Social Interaction* between the players, as they have to coordinate their actions in order to reach the goals of the game. Having, or having the possibility, to cooperate allows players to make use of *Competence Areas* and provides a form of *Constructive Play* as the coordination in itself is a common achievement. *Cooperation* is also the basis for having *Social Organizations* and *Social Dilemmas* in the game. The different perceived *Social Statuses* of the players may lead to spontaneous chains of command in *Cooperation* situations.

Games where *Cooperation* and *Competition* coexist raise the level of *Social Interaction* even further and also increase the *Tension* between the players. When there is a possibility of *Betrayal* for the cooperating players, this also tends to raise the *Tension* and sometimes lowers the motivation for *Cooperation*.

RELATIONS

Instantiates: *Social Interaction, Alliances, Betrayal, Constructive Play*

Modulates: *Team Play, Tension, Competition, Dynamic Alliances*

Instantiated by: *Mutual Goals, Shared Rewards, Collaborative Actions, Team Play*

Modulated by: *Competition, Trading, Bidding, Delayed Reciprocity, Individual Rewards, Social Dilemmas, Social Organizations, Social Statuses, Competence Areas, Shared Resources*

Potentially Conflicting with: *Competition, Conflict, Betrayal*

Additional Patterns

ON THE CD Descriptions of these additional patterns can be found in the Chapter 10 folder on the companion CD-ROM.

Collaborative Actions	**Delayed Reciprocity**
Shared Rewards	**Competence Areas**
Shared Penalties	

GROUP ACTIVITIES

In some games, the players do things together in more or less static groups. These patterns describe these activities and how to design games to support them.

Team Play

Players in a group or a team coordinate their actions, abilities, and roles in order to reach a common goal.

Games may put players on the same team to try to achieve goals together. These teams may be explicitly defined at the beginning of the game sessions, and possibly extended over several game sessions, or they may occur dynamically during gameplay. The former kinds of teams are usually quite stable, or the teams have at least

stable roles for players with different kinds of abilities and competences. Managing the team composition itself is part of *Team Play*.

> **Example:** The players in a *Soccer* team have different roles in the team from goalkeeping to attacking, the players usually have different abilities, and during the match they have to coordinate their actions to beat the opposing team.

> **Example:** Members of teams in roleplaying games usually have different kinds of abilities, and the teams form around players whose abilities complement each other. For example, the classic fantasy roleplaying group consists of a wizard who can cast attack spells, a priest who can heal and cast protective spells, a thief who can open locks and detect traps, and a couple of fighters who can handle the actual combat with the monsters. This kind of *Team Play* is also very widespread in current MMORPGs.

USING THE PATTERN *Team Play* can either be between players in *Multiplayer Games* or simulated through *Units* that are under one player's control. *Team Play* does not require formalized teams as it can exist in *Dynamic Alliances* as well, but it does require that the participants have some form of *Mutual Goal* or *Shared Resource* that has to be managed. The possibility of *Team Play* in games requires that the game designer not only take *Player Balance* into account but also *Team Balance* to balance the game.

Teams involved in *Team Play* are a stable form of *Alliance* and they are governed by the same principles. Often, especially when the teams are stable, they are also *Social Organizations* with the associated *Social Statuses* of the team members and methods of identifying the other team members such as *Handles*. *Team Play* is almost impossible without at least some kind of a *Mutual Goal* for the members of the team. The team members are more committed to reaching the *Mutual Goals* and more committed to the team itself when the individual members feel that their individual contribution is important and significant; that is, that they have an *Illusion of Influence*. One way to accomplish this is to give the members of the team *Asymmetric Abilities* or *Privileged Abilities* and also to design the goals and the opposition in such way that it requires the coordinated use of these abilities, for example, maintaining *Area Control* over several different areas or requiring *Area Control* of one area while at the same time completing some other goal. Another way is to structure gameplay in such fashion that it creates *Orthogonal Unit Differentiation* between the members of the team, as is the case in *Soccer* and *Ice Hockey*. Some goals, such as *King of the Hill*, only need one player to achieve the goal but are easier to achieve if other players provide support. *Individual Rewards* for completing goals that also benefit formalized teams can promote *Team Play*. It is possible

to reward the players during the gameplay with *New Abilities* to heighten *Asymmetric Abilities* and to promote *Team Development*.

The *Rewards* for reaching the *Mutual Goal* of the team are often *Shared Rewards* and the *Penalties* for failures are often *Shared Penalties*, as in *Team Elimination*. In some cases, *Player-Decided Distribution of Rewards & Penalties* can be used to further encourage the *Social Interaction* between team members. *Individual Penalties* for the team members in many cases are at the same time *Shared Penalties* for the whole team if the *Individual Penalty* has an effect on the efficiency of the team.

Even the perceived possibility of *Betrayal* by one or some of the team members can obstruct the *Team Play*, especially when the teams are supposed to be stable. Players who perceive that other players do not do their best, or that they even hinder team performance, lose much of their commitment to the team. It is also obvious that the players who are ready to commit *Betrayal* do not enhance *Team Play*.

If the game has a possibility for *Player Killing*, it has to be decided whether the members of a team can hurt the other members of the team.

CONSEQUENCES *Team Play* is based around some form of formalized *Cooperation*. As members of a team have to coordinate their actions during the actual gameplay, *Team Play* creates *Collaborative Actions* and promotes *Constructive Play*. When teams are maintained between game sessions, they can form stable *Social Organizations* due to the constant *Social Interaction* between the members of the team. The persistence of a team allows for *Team Development* to occur, while the *Social Interaction* within the team allows individual players to gain a *Social Status* and a *Competence Area*. These effects can give players *Empowerment* as can the feeling of taking part in *Collaborative Actions* that otherwise would not be possible.

RELATIONS

> **Instantiates:** *Player-Decided Distribution of Rewards & Penalties, Competence Areas, Constructive Play, Cooperation, Social Interaction*
>
> **Modulates:** *Shared Resources, Multiplayer Games, King of the Hill*
>
> **Instantiated by:** *Alliances, Asymmetric Abilities, Social Organizations, Mutual Goals, Units, Area Control*
>
> **Modulated by:** *Collaborative Actions, New Abilities, Privileged Abilities, Shared Penalties, Individual Penalties, Planned Character Development, Team Development, Shared Rewards, Roleplaying, Player Killing, Social Statuses, Illusion of Influence, Orthogonal Unit Differentiation, Dynamic Alliances, Empowerment, Team Balance, Individual Rewards, Penalties, Handles, Team Elimination, Cooperation*
>
> **Potentially Conflicting with:** *Betrayal*

Alliances

A group of players who have agreed to obey particular and specific rules of conduct toward each other and who, usually, also have a shared agenda.

The rules of conduct, obviously, have to be relevant to the playing of the game and they also have to be optional from the game system point of view, that is, players should be able also to decide not to obey these rules, effectively leaving them out of the *Alliance* (otherwise, every game has an alliance of players agreeing to play the game together). That the rules are particular and specific means that, first, they are effective for a certain amount of time during the game play and for a certain group of players, and secondly, that they are specific enough for determining if a player has breached the contract. The rules being specific enough does not necessarily mean that it is possible to determine conclusively that there is a breach of contract. Especially player defined *Alliances* have a tendency to allow different interpretations, and sometimes the fun comes from arguing whether there is a breach of contract.

The agenda of the *Alliance* defines the reason for having the *Alliance* and is usually concerned about possible goals that the members of the *Alliance* want to reach together. *Alliances* in general are not mutually exclusive. Players can therefore, at least in principle, belong to many different *Alliances* at the same time. *Alliances* can also consist of smaller sub-*Alliances*, which may have their own rules of conduct and agendas. In any case, the player composition is one of the most important, and concrete, characteristics of an *Alliance*.

> **Example:** *Return to Castle Wolfenstein: Enemy Territory* has two teams, Axis and Allies, fighting each other in a World War II first-person–shooter environment. These teams are examples of *Alliances* where the rules of conduct to not shoot, but try to help, members of one's own team, and the agenda of overcoming the opposing team, are clear cut and stable. The player composition in open games, however, might change during the play as players might drop out and new players join on both sides. People may break the rules of conduct, e.g., shooting their own teammates, but the game supports collective actions such as banning offending players by voting.

> **Example:** The computer game *Civilization* allows a player to have different diplomatic relations with other players. The peace relation effectively creates an *Alliance* as the players agree not to attack each other as the defining rule of conduct.

> **Example:** The board game *Diplomacy* does not have explicit *Alliances*, but the players agree upon the rules of conduct outside the game system. These agreements range from the simple "let's not attack each other during this turn" to more complex "we will coordinate the use of our armies and fleets in a way so that we can invade Italy within two years, and we will split the

spoils of war equally." The latter agreement is also a good example of a formulation of the rules of conduct that is open to interpretation.

USING THE PATTERN *Alliances* typically emerge around *Mutual Goals* or common *Enemies. Alliances* differ from *Team Play* in that they do not necessarily promote *Cooperation* but can consist of agreeing not to interfere with actions or goals of the other members in the alliance.

The use of *Shared Rewards* and *Shared Penalties* usually makes the *Alliances* more stable while *Shared Resources, Individual Penalties*, and possibilities of *Betrayal* make them more volatile. *Alliances* make more sense in games where players can have an effect on the progress or game situation of the other players; that is, there are *Interferable Goals* in the game or there are *Player Decided Results*. The rules of conduct of the *Alliance* can be defined in terms of the game itself, and there is at least some benefit for being in an *Alliance*.

Alliances do not have to be explicitly stated or declared within the game system, since it is possible that players define the rules of conduct themselves as illustrated in the previous *Diplomacy* example. *Social Interaction* is typically required for negotiating the *Alliances* unless the game system gives the player a possibility of offering, declaring, and accepting alliance proposals as actions in the game itself, as is the case in the previous *Civilization* example. There are, however, games that are especially based on having *Alliances* without explicit alliance actions or having *Social Interaction* that allows some forms of *Social Dilemmas*. Some of the more common types of *Alliances* are described in more detail in *Uncommitted Alliances, Dynamic Alliances*, and *Secret Alliances* patterns.

CONSEQUENCES *Alliances* can lead to the players automatically creating and maintaining *Social Organizations*, but *Social Organizations* can exist as *Alliances* also with the sole purpose of providing *Social Interaction*.

Stable *Alliances* promote *Team Play*, such as teams in sports, and tend to create strong cohesiveness in the group, especially in cases where there are *Mutual Goals* and a common enemy, the opposing team. These stable *Alliances* or teams also lead to "us" versus "them" feelings, where the players outside the *Alliance* are viewed as inferior or even bad and evil in character. This is especially the case when there is a direct *Competition* between the different teams. The more stable *Alliances* almost naturally get characteristics of *Social Organizations* such as different levels of *Social Status* within the members of the *Alliance* and role-differentiation.

RELATIONS

Instantiates: *Team Play*

Modulates: *Competition*

Instantiated by: *Mutual Goals, Cooperation, Social Interaction, Enemies, Social Organizations*

Modulated by: *Competition, Interferable Goals, Uncommitted Alliances, Secret Alliances, Dynamic Alliances, Shared Resources, Shared Penalties, Shared Rewards, Player Decided Results, Social Statuses, Social Dilemmas, Betrayal, Individual Penalties*

Potentially Conflicting with: None

Roleplaying

Players have characters with at least somewhat fleshed out personalities. The play is centered on making decisions on how these characters would take actions in staged imaginary situations.

Imaginary situations and the nature of the players' characters in *Roleplaying* can be almost anything from Conan-style hack'n'slash fantasy to animals wishing to escape from the zoo to bored housewives in the suburbs. Even though the genre of roleplaying games is more or less centered on fantasy, science fiction, and horror themes, roleplaying in general can take form in any kind of setting.

Example: *Dungeons & Dragons*, perhaps the best known tabletop fantasy roleplaying game, is actually a game system that can be used in different *Game Worlds*. These *Game Worlds* can be totally player-created, but there are also commercial game worlds available. The gameplay is based on the group of players that roleplay members of a party going adventuring in sometimes exquisitely detailed fantasy settings with elaborate plot structures. In *Dungeons & Dragons*, most often only one of the players is the *Game Master* (actually Dungeon Master but *Game Master* is the more generic term) who acts as the game facilitator presenting and resolving the imaginary situations to the players. The gameplay is usually almost wholly based on verbal communication between the players and the *Game Master*. Rules, resolution tables, and dice are used to resolve the conflict situations, which usually involve combat between players and monsters.

Example: In Live Action Roleplaying Games (LARPs) the players act out their characters in real life and not only by sitting around the table talking to each other. The real world is used as the basis for the setting of the game, and sometimes the players put in countless hours of work to make the settings and their characters fit the theme of the game as well as possible, as illustrated in Figure 10.1. LARPs, of course depending on the play style, are usually more oriented on acting out the roles of the characters than tabletop roleplaying games, and some play styles are closer to improvisational theater than playing games.

FIGURE 10.1 Orc warriors in a fantasy live action roleplaying game "I Skuggan av Ringen." Courtesy of Anders Jansson, Samir Ellab, and Hompen.

USING THE PATTERN Two main elements of *Roleplaying* games are the players' *Characters* and the imaginary *Game World*, which is often a *Player Constructed World* and *Persistent Game World*. In immediate *Social Interaction* situations, such as in table-top *Roleplaying* games, the *Game World* itself is in the players' imagination. These *Game Worlds*, however, may have extensive amounts of background information available to the players that may include detailed histories, geographies, novels, short stories, campaign settings, and even movies.

Computerized online roleplaying games, such as MUDs and MMORPGs, have and maintain their *Game Worlds* in digital format. Text-based MUDs also use the players' imagination as an important "game engine" for making the *Game Worlds* come alive while the current MMORPGs shift the focus from the players' imagination to offering *Immersion* in detailed audio-visual representations of the *Game World*.

The players must obviously somehow have access to the *Characters* in the *Game World*. Many games, especially computer roleplaying games, offer ready-made *Characters* with different kinds of *Skills* and abilities for the players, but it seems that the *Emotional Immersion* is more vivid and likely if the players have at least some *Creative Control* over their *Characters* and especially *Character Development* during gameplay. Even seemingly small things, such as changing the color of the hair of an *Avatar*, allow possibilities for further *Identification* with the players' *Characters*.

Roleplaying games are often played by groups of players promoting *Team Play* in general. Games with more stable teams also offer possibilities for not only *Character Development* for single players but for *Team Development* for members of the team.

CONSEQUENCES *Roleplaying*, strictly defined, is based on *Identification* between the players and their *Characters* in situations of *Social Interaction*. As *Roleplaying* requires that both players doing the roleplaying and players watching it accept the acting, *Roleplaying* requires *Cooperation* between the players to create an *Alternative Reality*. It is possible to imagine solitary *Roleplaying* situations, but they are often marginal cases of *Roleplaying* in general. Single-player computer roleplaying games are an example of these situations and they are usually more about *Resource Management* of the *Characters* in the game than proper *Roleplaying*.

Roleplaying games naturally tend to have strong *Narrative Structures* to motivate the existence of the *Characters* and to also widen the possibilities for *Identification* and deepen possible *Emotional Immersion*. Especially *Roleplaying* games with human *Game Masters* are more or less based on *Storytelling*, where players and *Game Master* together create and tell the story. The *Storytelling* in *Roleplaying* games not only drives the game forward but is also a consequence of events in the game and explains events or provides more *Emotional Immersion* to the events taking place. All *Roleplaying* games happen in imaginary *Game Worlds*, with the possible exception of some of the therapeutic uses of *Roleplaying*, and these *Game Worlds* are shared fantasies created during the gameplay by the players themselves. Even in cases where players use commercial *Game Worlds* as the setting for their campaigns, players have to make these settings alive while playing the game, making them *Player Constructed Worlds*.

RELATIONS

Instantiates: *Social Interaction, Emotional Immersion, Creative Control, Storytelling, Alternative Reality*

Modulates: *Team Play, Persistent Game Worlds, Narrative Structures*

Instantiated by: *Game Masters, Storytelling*

Modulated by: *Characters, Game World, Team Development, Identification, Avatars, Character Development, Player Constructed Worlds*

Potentially Conflicting with: None

Constructive Play

Constructive Play is based on putting game elements together to construct new kinds of game element configurations, which might have different emergent characteristics.

Games provide *Constructive Play* when the actions available in games allow players to construct compound game elements or even set their own goals. The different features of *Constructive Play* such as requiring and enhancing imagination, promoting experimental problem solving, and training sensory-motoric skills can all be made part of required challenges in games.

> **Example:** The gameplay of *The Incredible Machine* is based on putting different game elements, such as conveyer belts, cats, and hamsters, together to solve specific puzzles containing dynamic parts. These puzzles are designed in such a way that there is no single correct way to solve them.

> **Example:** *SimCity*, along with the other games in the *Sim* series, is almost purely based on *Constructive Play*. *SimCity* does not even have predefined explicit goals so that the players may engage in *Constructive Play* even in defining their own goals.

> **Example:** *SodaPlay* (*http://www.sodaplay.com*) allows players to build models out of mass points, which can be connected with springs. The system also allows the players to change parameters of the world such as gravity and friction. The players can then let these models loose in animated simulations. Even though the basic elements of the system are simple, the possible combinations are huge.

USING THE PATTERN *Constructive Play* can be created by providing *Construction* actions in games, requiring *Team Play*, supporting *Cooperation* and *Collaborative Actions*, or giving players *Creative Control*.

For *Creative Control* cases of *Constructive Play*, the *Right Level of Complexity* of possible combinations of the game elements used should be large enough to support unobvious *Construction*s. This is usually accomplished in such a way that there are quite a number of different ways of putting two game elements together and that it is possible to add game elements later. It is often the case that the more elements there are in the configuration, the more ways of adding new elements exist. Excellent examples are Lego blocks: they are relatively simple, but there are several ways of putting two of them together; it is possible to add other blocks to the configuration; and the ways of adding new blocks grow almost exponentially, creating a nearly inexhaustible combination space for constructing different things from these simple blocks.

Dynamic systems, such as the cities in *SimCity* and the walkers in *SodaPlay*, bring in another layer of *Cognitive Immersion*, as the player cannot necessarily predict how the system works without *Experimenting* with it. Digital games offer much better possibilities for constructing such dynamic systems than traditional elements do, as computers can handle the complex and fundamentally uninteresting basic relations between elements. The constructed dynamic systems can be made even more interesting by giving the different game elements not only different ways of connecting to other elements but also *Asymmetric Abilities*, such as the different buildings in *SimCity*. *Team Play* is by its nature a dynamic system and can use *Asymmetric Abilities* between players in the same fashion to create the *Right Level of Complexity*.

CONSEQUENCES *Constructive Play* is closely related to *Experimenting*, especially in cases where the amount of possible combinations is large and the *Construction* itself incremental. The manipulation of the game elements used in *Constructive Play* can cause some levels of *Sensory-Motoric Immersion*, especially in cases where the game elements have appealing visual, tactile, or other sensory features, which can be manipulated. The constructions themselves created during *Constructive Play* can give rise to even aesthetic pleasures. *Constructive Play*, where there are at least some elements of problem solving or goal orientation, is also associated with *Cognitive Immersion* as the players have to think ahead and both experiment mentally and physically with different ways of solving the problem or reaching the goals.

Constructive Play can in some cases lead to *Player Constructed Worlds* and the *Construction* itself can be either a specific mode of play or can be intertwined with the actual gameplay. For example, the text-based MUDs were places where some of the players construct the worlds while the other players play in the worlds.

RELATIONS

Instantiates: *Cognitive Immersion*

Modulates: *Experimenting, Player Constructed Worlds, Sensory-Motoric Immersion*

Instantiated by: *Asymmetric Abilities, Construction, Creative Control, Right Level of Complexity, Team Play, Collaborative Actions, Cooperation*

Modulated by: *Player Defined Goals*

Potentially Conflicting with: None

Player Decided Results

Players, or at least some of the players, are responsible for deciding at least some of the results of the player actions. These decisions are not necessarily based on the rules of the game.

Some evaluation functions in games are not mechanically determined by the game state but can be influenced by the wills of players. This makes the results *Player Decided Results* and adds a level of player control to games that can be used to penalize leaders, oppress minorities, or ensure fair distributions depending on the current game situation and what influence different players have.

> **Example:** In tabletop roleplaying games, the ultimate decision maker is one of the players, the *Game Master*. In some more freeform, storytelling-oriented roleplaying games, such as White Wolf's *World of Darkness* series, the other players are more or less responsible for the story progression.

> **Example:** All children's games without a specific game facilitator, such as *Hide & Seek* and *Tag*, rely on the players themselves maintaining the game state, and in case of disputes, deciding the results for themselves.

> **Example:** Other players can vote to kick off and even ban players who behave badly in many online first-person shooters.

USING THE PATTERN The rules for making the decisions can be within the game system, influenced by the game system, or outside the game system. *Player Decided Results* where the rules are within the game system usually involve voting, or other types of *Bidding*, between the players about the possible results, and the result is decided from a set defined by the game system itself. If these situations are frequent, the players have a tendency to form *Alliances* to increase their *Perceived Chance to Succeed*. This can, in some situations, also lead to *Delayed Reciprocity* between the players. When agreements regarding *Player Decided Results* are secret from other players, they can be used to create *Secret Alliances*.

When *Player Decided Results* are influenced by the game system, the players, or usually the *Game Master*, can cancel the result generated by the game system. This is quite common in tabletop roleplaying games where the *Game Master* can, for example, veto the results of a combat system to maintain the *Narrative Structure* and *Tension*. The last category, where the rules for the decisions are outside the game system, contains games that are part game and part other form of entertainment. Freeform games based on *Storytelling* do not necessarily have specific rules for determining the results of most of the player actions, and the players themselves are wholly responsible for making the decisions. Especially the last two categories can have a negative effect on *Predictable Consequences*.

A special case of *Player Decided Results* is the *Player-Decided Distribution of Rewards & Penalties*. Games where the players have active parts in maintaining the game state, as in *Self-Facilitated Games* and games that allow *Player Constructed Worlds*, naturally involve *Player Decided Results*.

CONSEQUENCES *Player Decided Results* give players a concrete form of *Empowerment* within the game. Players who have the power to make the decisions about the results, such as *Game Masters*, naturally have a strong and correct *Perceived Chance to Succeed* as they themselves determine these chances. The thing gets complicated, however, if the *Player Decided Results* are *Collaborative Actions* where more that one player is involved in making the decisions. Even a simple vote to kick off a player from an online game might involve intense *Negotiations* between the players to influence the decisions. Games allowing *Player Decided Results* usually have at least a tendency toward *Social Interaction* between the players during the game. For example, *Player Decided Results* can have *Balancing Effects* that ensure *Player Balance* if no player has sole decision powers but can also enable *Betrayal*. The uncertainty of what result players may choose gives players in games with these kinds of results *Limited Planning Ability*. *Social Organizations* with at least somewhat stable hierarchies of power necessarily involve *Player Decided Results* as players with higher *Social Status* can give commands to lower ranking players.

Player Decided Results are often not useful in games with *Team Balance*, since the most likely result is that players make the predictable choices of supporting their teams, making the results merely depend on the number of players in each team. However, the pattern can become interesting in games with more than two teams or where players have different amounts of influence or motivations for *Betrayal*.

RELATIONS

Instantiates: *Perceived Chance to Succeed, Delayed Reciprocity, Social Organizations, Balancing Effects, Limited Planning Ability, Empowerment, Player Balance, Betrayal, Secret Alliances*

Modulates: *Social Interaction, Alliances*

Instantiated by: *Bidding, Player-Decided Distribution of Rewards & Penalties, Game Masters, Self-Facilitated Games, Storytelling, Player Constructed Worlds, Collaborative Actions*

Modulated by: *Negotiation, Social Statuses*

Potentially Conflicting with: *Predictable Consequences, Team Balance*

Additional Patterns

Descriptions of these additional patterns can be found in the Chapter 10 folder on the companion CD-ROM.

ON THE CD

Team Development	**Uncommitted Alliances**
Social Organizations	**Secret Alliances**
Dynamic Alliances	

STIMULATED SOCIAL INTERACTION

Games played in face-to-face situations tend to have social interaction between the players even though the game itself would not require it. The patterns in this section describe ways to achieve social interaction and especially ways to increase the amount of social interaction between the players or even to require it.

Social Interaction

Social Interaction is when two or more players have two-way communication between each other, i.e., the other players can respond to the individual player's communication.

Social Interaction requires some form of communication, and the lowest level of communication in this context is that at least parts of the game state are common to the players; that is, they have actions available that make game state changes that can be interpreted as meaningful actions by other players. That shows that *Social Interaction* is not only about exchanges of messages but also covers situations of making something together, exchanging gifts, displaying social status and even actions of direct conflict.

The most common situation of *Social Interaction* is when two or more players have gathered in a face-to-face situation to play a game, for example, *Poker* or *Bridge*, or when children set up a game of *Hide & Seek* outside while their parents are playing their own games in the living room. Nowadays, Massively Multiplayer Online Roleplaying Games allow thousands, even hundreds of thousands, of players to share the same virtual world, the game state, and to interact in many different ways within that world.

> **Example:** The board game *Diplomacy* has a specific diplomacy phase each turn where players have a possibility to discuss the game situation. In the board game version, this *Social Interaction* normally happens in a face-to-face situation where the non-verbal signs can be even more important than the verbal communication itself in determining the trustworthiness and the stability of the newly forged alliance. Even in blind *Diplomacy*, where there are no other methods of communication between the players other than by making game state changes, there is *Social Interaction*, as the players share the game state and it is possible to determine the other players' intentions and even to form alliances. *Social Interaction* in this variant of the game is very different when players interact face-to-face.

> **Example:** Many Massively Multiplayer Online Roleplaying Games provide several methods of *Social Interaction* for the players. Those that are *Avatar* based, for example *Anarchy Online* and *Dark Age of Camelot*, allow the

players to customize parts of their repertoire for non-verbal communication through emoting. Even without special emote gestures the non-verbal communication in these games is possible using the *Avatar's* orientation, speed of movement, and basic actions, such as jumping, to convey information about the player's intention (moving toward a target), current feelings (changing direction in rapid fashion to state boredom), and guidance (jumping up and down in the same place to direct other players into a specific location).

USING THE PATTERN To promote *Social Interaction* in games, players need a reason to communicate with each other. Generalizing, reasons for *Social Interaction* can be divided into those where players want something from other players, those that require players to perform *Collaborative Actions* together, or those that affect how such *Cooperation* takes place. Wanting something from other players is often based upon *Asymmetric Resource Distribution* and solved through *Trading* but can also be based on gaining *Social Status*. Coordinating *Collaborative Actions* through *Social Interaction* is usually motivated by *Shared Resources* and *Shared Rewards* but can also be required due to *Player Decided Results* or *Secret Alliances*. This need for coordinating actions is of course common in games with *Team Play*, for example, to make best use of *Privileged Abilities*. *Social Interaction* in these kinds of activities—and others that require *Cooperation*—can be modulated by *Betrayal*, *Delayed Reciprocity*, *Bluffing*, and *Uncommitted Alliances*. Games with *Game Masters* or where players do *Storytelling* automatically have *Social Interaction* between the players.

Social Interaction outside making game state changes requires some kinds of *Communication Channel* between players and can be crudely divided into two categories: natural (or spontaneous) and stimulated [Zagal99]. Natural *Social Interaction* arises from the social situation itself in *Synchronous Games* and, even though the communication might be about the game, the unfolding of the game itself does not require or rely on the *Social Interaction*. This is the case in *Chess* where there might even be intense talking and gesturing between the players but the gameplay itself does not require the players to communicate outside the game or during *Game Pauses*. Games of stimulated *Social Interaction*, on the other hand, require or rely on players to communicate, that is, the game is impossible to play, or the gameplay experience is extremely impoverished, without players having the ability to communicate. *Multiplayer Games* based on dynamics of *Cooperation* and *Competition*, such as *Diplomacy*, and games based on asymmetric communication between players, such as *Pictionary*, are good examples of games that have stimulated *Social Interaction*.

Both natural and stimulated *Social Interaction* require methods of communication between the players. One of the basic rules of thumb to create or encourage

Social Interaction is to provide several different methods of communication for players both within and outside the game. The possibility of *Indirect Information* is very often required to make *Social Interaction* fluid and flexible to the communication styles of people.

The pace of the game, in conjunction with the communication methods available, has a direct impact on the *Social Interaction* of the game. Consider, for example, the differences between the *Social Interaction* in a team-based first-person shooter *Real-Time Game* where the first version allows for natural speech interaction using a walkie-talkie style system and the second only allows typed messages. The second version also illustrates a situation where actions related to communication block actions related to playing the game, that is, both communication and player actions are impossible at the same time, which is an unwanted feature in a game based on fast actions. On the other hand, games based on players performing their actions more or less asynchronously while having a synchronous method of communication, such as the previously mentioned walkie-talkie system, can even hinder *Social Interaction*. *Turn Taking* can slow down *Social Interaction* but gives all players the opportunity to participate.

Social Interaction is of course difficult to have in *Single-Player Games* but can be simulated through *Agents* or be part of *Meta Games* based around a *Single-Player Game*.

CONSEQUENCES *Social Interaction* is one of the most complex activities performed in games and thereby gives players a large *Freedom of Choice* on how to take part in such activities. *Social Interaction* between players is a way to give players *Emotional Immersion*, and if players think that they can affect how other players play the game, it also gives an *Illusion of Influence*. *Social Interaction* is naturally required if a group of players are trying to do *Collaborative Actions* or *Cooperation*. Most forms of *Negotiation*—for example, *Trading*, establishing *Dynamic Alliances*, or maintaining *Alliances*—often use of *Social Interaction*. *Bluffing* also requires *Social Interaction*, and *Social Dilemmas* rely heavily upon it to provide *Emotional Immersion*. *Social Organizations* require frequent *Social Interaction* between the members of the organization to be stable and for members to feel *Identification* with the organization and maintain their *Social Status*. Similarly, *Player Constructed Worlds* need *Social Interaction* to coordinate the construction and maintenance of the *Game World*.

The vast majority of games are played in a social situation where *Social Interaction* between the players is at least as important an aspect of playing the game as the outcome of the game itself, and this is especially common in *Persistent Game Worlds*. *Social Interaction* is in itself sometimes the main reason for playing the game, for example, even hardcore fans of roleplaying games agree that a major part of the fun comes from the pure *Social Interaction* required by *Roleplaying*.

RELATIONS

Instantiates: *Negotiation, Bluffing, Alliances, Collaborative Actions, Social Organizations, Emotional Immersion, Illusion of Influence, Freedom of Choice*

Modulates: *Player Constructed Worlds*

Instantiated by: *Shared Resources, Roleplaying, Cooperation, Communication Channels, Trading, Social Dilemmas, Dynamic Alliances, Persistent Game Worlds, Game Masters, Turn Taking, Storytelling, Team Play*

Modulated by: *Social Organizations, Shared Resources, Competition, Identification, Asymmetric Resource Distribution, Betrayal, Player Decided Results, Social Statuses, Delayed Reciprocity, Bluffing, Uncommitted Alliances, Secret Alliances, Shared Rewards, Real-Time Games, Game Pauses, Synchronous Games, Multiplayer Games, Indirect Information, Privileged Abilities, Agents*

Potentially Conflicting with: *Single-Player Games*

REFERENCE

[Zagal99] Zagal, José Pablo, Miguel Nussbaum, and Ricardo Rosas "A Model to Support the Design of Multiplayer Games." *Presence: Teleoperators and Virtual Environments* (Vol 9, No. 5. pp. 448-462). MIT Press, 1999. Also available online at *http://www.cc.gatech.edu/~jp/Papers/AModelMultiplayerGames.pdf.*

Trading

Players exchange some kind of Resource, be it information, actions, or game elements, between each other or the game system.

Trading in its simplest form is an exchange of some kind of *Resource* between the buyer and the seller. The simplest way this can be achieved is when players buy something from the game system with an in-game currency, for example, gold coins in a fantasy adventure game. *Trading*, however, always requires an incentive to do the exchanges. In most cases, this is achieved by requiring that different kinds of resources are required for player progress but that the basic production of the resources for the player is not balanced, thus giving players an incentive to trade surplus resources for resources they are lacking.

Trading has three distinct phases: initiating the trade by making a trade offer, an optional bargaining phase, and finally resolving the exchange of the *Resources*. The player initiating the trade usually has an option to cancel the trade at any point. *Trading* is usually a specific mode of play in the game and the different phases are sometimes distinct sub-modes of the trading.

Example: In *Zelda: A Link to the Past*, the player can replenish his health and magic levels and acquire useful items, such as arrows and bombs, in shops in exchange for rupees. The rupees are used as the basic currency in the game, and they are gained by performing various short tasks in the game, such as navigating a maze in a certain time, and by killing wandering monsters.

Example: *NetHack*, the classic dungeon crawl traditionally using ASCII-graphics, has different kinds of shops scattered around the dungeons. The player is able to buy different items, ranging from basic food rations to enchanted weapons and magic books, from the shops, and he is also able to sell items to the shop keeper. The basic currency used for such trades in the game is, not surprisingly, gold pieces.

Example: *Settlers of Catan*, a famous German board game, has a specific trading phase where the player can trade the five basic resources of the game—lumber, wool, grain, bricks, and ore—with other players by announcing the resources he needs and what he is willing to give in return. The other players are also free to make their proposals and counter-proposals to the player so the trade also has a bargaining phase. In this game, only the player whose turn it is can initiate trades, which means that the other players may not trade among themselves. There is also an option to trade with the game system, but then the trade usually has a worse return rate than in trades with other players and there is no possibility for bargaining. The trades in the game are open; that is, the other players see what kinds of trades are performed. The design of resource production in the games often make players have unequal production rates between the different resource types, but the progress—building roads, settlements, and cities and buying development cards—requires that the *Resources* are somewhat balanced.

USING THE PATTERN *Trading*, in its essence, is a *Transfer of Control*. When introducing *Trading* in a game, one should decide reasons for players to want *Ownership* and reasons why they should wish to make exchanges with other players.

One of the most effective incentives for *Trading* is to use *Asymmetric Resource Distribution*, either through what *Construction* actions players can perform or what *Resource Generators* they have. This means that players will have a surplus of some *Resources* while lacking others. *Symmetric Resource Distribution* between players does in this case lessen the incentives for *Trading*, but *Symmetric Resource Distribution* of *Resources* owned by one player can be used for progression in the game.

In the case of multiplayer games, the resource distribution should, of course, be asymmetric between the players. For example, player one has surplus of resource A and lacks resource B, and player two has surplus of resource B and lacks resource A. Thus, both players need both kinds of resources in order to achieve their goals. A less common incentive for *Trading*, found for example in the board game *Advanced Civilization*, is to have basically *Symmetric Resource Distribution* but have *Geometric Rewards for Investments* on a single type of *Resource*.

One way to achieve asymmetry of *Resources* is to use *Randomness* for the resource generation and timing the progress requirements in such way that the randomness does not have time to even out. This method is used, for example, in *Settlers of Catan* for creating the incentive for *Trading*. The optional trading with the game system in *Settlers of Catan* is introduced, first, to balance out possible radical asymmetries of resource generation for all players and, second, to avoid strategies for totally blocking player progression.

The next step of designing *Trading* in a game is to determine the exact mechanisms of the three phases of trade: initiation of the trade, agreement in optional bargaining phase, and resolution of the trade, with potential exchanges of *Resources*. The rules for the initiation phase dictate which players can start the trade, which players can be involved in the trade, and finally the circumstances that allow the initiation of the trade. The initiation usually also includes the announcement of either the *Resources* available for *Trading* or the *Resources* sought, or both. These are usually quite simple in single-player adventure games where usually only the player can initiate the trade and this is done by entering a specific area in the game; for example, a shop. The situation is more complex in multiplayer games allowing player-to-player *Trading*. The clearest example is to have a specific *Trading* phase during the player's turn, where only the player whose turn it is can initiate the trades but all players can participate in the *Trading*, as is the case in *Settlers of Catan*. It is, of course, possible to allow also other players to initiate and perform *Trading* with each other during the same phase. Another possibility in this option is to allow players to invite certain other players to the *Trading* session or even to have *Randomness* in the player composition of the trade.

Another common way of resolving this issue, especially in Massively Multiplayer Online Roleplaying Games, is to allow players to initiate trades at any time when located in certain places or in proximity to other players. Here, the question of which players are allowed to participate in the trade is a slightly more difficult issue to tackle: are all players welcome to participate in the trade or are there other mechanisms for excluding players? Free-for-all auctions in specific places seem to be the most common, as they are the simplest to implement. In some cases, there might be a considerable time difference between the initiation of the trade and the next phases, especially in free auctions.

The bargaining or *Negotiation* phase is optional, as in some cases there is need for only simple mechanisms of accepting or refusing the trade offers. However in most cases, the bargaining phase is recommended, as it brings in more *Social Interaction* and also gives the players more control over the *Trading* situation. Bargaining consists of a series of offers and counteroffers between the players participating in the trade. The information patterns can, and should, be used to control how much information about the other players bargaining is revealed, as this control will change the dynamics of the bargaining considerably. For example, when all offers and counteroffers are known to the players participating in the trade, such knowledge will usually lead to a more dynamic and engaging bargaining phase compared to a situation where only the player who initiated the trade gets all the offers. The bargaining phase ends when one of the offers is accepted or the initiating player cancels the whole trade.

The resolving phase starts when the initiating player has accepted one of the offers. The simplest, and most usual, case is that the agreed *Resources* are simply exchanged between the players. This, however, does not need to be the case. First, it is possible to introduce a *Betrayal* in the trade, that is, one or both of the players give something else in return, usually nothing, than was agreed. This can, of course, be made impossible either by rules or by providing *Symmetric Information*. Second, using *Delayed Effects* to have a time delay between the acceptance of the trade and the actual exchange and using *Interruptible Actions* give the other players and the game system a possibility to intervene in the actual trade, to either change the *Resources* in the exchange or, for example, to steal (*Gain Ownership*) or destroy (*Eliminate*) the *Resources* involved in the trade. Third, somewhat related to the previous ones, the players might be required to perform certain actions to fulfill the trade. The most common one is to require players to deliver (*Delivery*) the *Resources* to each other. Resolving trades of actions and information is slightly trickier. The information exchange can use either *Indirect Information* or *Direct Information* patterns. *Direct Information* in this context means that the information is revealed to the player by the game system, for example, if the players trade information about their cards in a card game, they have to show the cards to each other. Trades of *Indirect Information* rely on the players to tell the required information to each other allowing *Bluffing*. *Bluffing* is also possible in trades using *Direct Information* if the game system allows players to modify the information before it is revealed to other players. Trade of actions almost always relies on the players to really perform the required actions. The game system is usually not able to force a player to do the required actions, although in some cases, it is possible to trade the actions as normal *Resources*. For example, in *Settlers of Catan*, there are action cards that, when played, allow players to perform special actions otherwise not available, and players can trade these cards as well as other *Resources* in the game. Even though the

game system would not force a player to perform the required actions, it can indicate the required actions as specific goals (*Goal Indicators*) and it is possible that the system penalizes a player who does not perform the actions involved in the trade within an agreed *Time Limit*.

CONSEQUENCES *Trading* gives players a *Freedom of Choice* to exchange *Ownership* of *Resources* through voluntary *Transfer of Control* actions. At long as the *Resources* are valuable or useful to some players, the possibility for several players to trade with a third party gives rise to *Competition*. Although *Trading* is usually about game elements, it can also concern *Area Control*.

When enacted between players, especially when there is a possibility for *Negotiations*, *Trading* involves *Social Interaction* and is a *Collaborative Action*. Even the somewhat marginal case of totally anonymous auction has, although quite low, *Social Interaction* in the initiation phase where the seller announces the *Resources* he is selling and what he is expecting in return. More often, however, *Trading* is used to increase the amount of *Social Interaction* between the players in the game, and it can be seen as a form of *Cooperation*.

Trading usually gives the players alternative strategies for progressing in the game and can be used for balancing the *Resource* flows within the game as is quite obvious in the *Settlers of Catan* example. Allowing players to buy *Power-Ups* from the game system in exchange for some basic currency gives player *Freedom of Choice* as to how to progress in the game. Also, rare or difficult-to-obtain special *Power-Ups* for sale at a high price give the player *Optional Goals* and, at least in some cases, an incentive for players to keep on doing repetitive tasks, such as killing wandering monsters, thus making the play time of the game longer.

Demanding ransom and giving gifts are special cases of *Trading*. Ransom is an exchange of *Resources*, usually very concrete ones, for future action, such as releasing a prisoner. Gifts are one-sided trades where the giving side does not expect anything in return. The recipient, of course, can also refuse the gift. Both these cases follow the same interaction principles as *Trading* in general. Demanding ransom or proposing to give a gift are the same as initiating a trade, and this can be followed by a bargaining phase (more often in ransom than in gift cases), which can finally end in resolving the exchange or canceling the whole transaction.

RELATIONS

Instantiates: *Social Interaction, Freedom of Choice, Competition, Area Control, Transfer of Control*

Modulates: *Power-Ups, Optional Goals, Delayed Reciprocity, Gain Ownership, Cooperation, Resources, Ownership*

Instantiated by: *Construction, Collaborative Actions, Resource Generators*

Modulated by: *Rewards, Negotiation, Asymmetric Resource Distribution, Symmetric Resource Distribution, Betrayal, Interruptible Actions, Delivery, Indirect Information, Direct Information, Bluffing, Time Limits, Symmetric Information, Geometric Rewards for Investments*

Potentially Conflicting with: *Symmetric Resource Distribution*

Bidding

Players invest resources, usually some kind of a currency, for an uncertain outcome in order to get a reward of some kind.

A *Bidding* instance is a process consisting of several parts: the bidding where players invest *Resources* with the hope to achieve a certain game state, the determination of the outcome of these investments, and the distribution of possible rewards.

> **Example:** In *Poker*, players bid on the value of their card hands. The bidding instance consists of rounds where the players can raise their bids one after another. The player who does not wish to call the last bid matches his bid to the same amount as the last bid, or if he does not wish to raise the bid, he has to fold. The player who folds is out of the *Bidding* instance and he has to leave his bid in the pot. The *Bidding* instance ends when there is only one player left or all the remaining players call the last bid. The player with the best hand, or the only remaining player, in the *Bidding* instance wins the whole bid as the reward.

> **Example:** Kicking out a player from an open game instance of *Return to Castle Wolfenstein: Enemy Territory* requires that a certain amount of players have voted for kicking the player out.

USING THE PATTERN For *Bidding* to be effective in a game, *Resources* used have to be of the *Limited Resource* kind, be it throughout the whole game or just for the specific *Bidding* instance. Although *Resources* in *Bidding* events are usually normal game elements, *Bidding* can also concern *Area Control* or the order in which players should perform *Turn Taking*. Players often have *Direct Information* to what is being bid about, in order to do *Tradeoffs* between what *Resources* they are using in the bidding and what *Resources* they can gain.

Bidding consists of two separate mechanisms: how the *Bidding* is conducted and how the outcome is determined. The mechanisms for conducting the *Bidding* can be separated into two categories, open and closed, based on the information available for the participants. Open *Bidding* means that the players have *Symmetric Information* about the amount of *Resources* the other players have used in the bid,

whereas closed *Bidding* uses *Asymmetric Information*. It is also possible to use a hybrid system, where the size of the pot is known to all the players but the amount bid by individual players is not known.

The necessary decision for *Bidding* is to determine what mechanisms govern the order, if any, of the players doing the *Bidding* and if there is *Negotiation* between the players. The most common way, at least in card and board games, is that players place their bids in a predetermined sequence of *Turn Taking*: a round. Some games using this method also allow a player to pass the round, if need be, and in this case, the player can be out of the *Bidding* instance through *Player Elimination*, as is the case in *Poker*, or still be able to participate in later phases. One *Bidding* instance can have several rounds, as again is the case in *Poker*, or there is a predetermined number of rounds, usually just one. *Bidding* instances with several rounds and some methods of *Social Interaction* between the players can often lead to *Bluffing*. If the *Bidding* does not have a predetermined number of rounds, there has to be some other form of end condition for the *Bidding* instance. Usually the end condition is that all players participating in the *Bidding* decide to end the *Bidding* round.

Another way of conducting the *Bidding* is not to have a specified order for the players but allow them to place the bids in any order. A common way to achieve this is to have just one *Bidding* round where players secretly place their bids, and the bids are revealed as soon as all players have done their bids. In cases where there is a *Dedicated Game Facilitator*, such as a computer program, it is also possible to have more complex versions of this kind of simultaneous *Bidding*, where the players can also change their bids before the end of the *Bidding* instance. Usually this involves some kind of *Asymmetric Information* about the amount players bid or about the whole bid.

The next phase, how the outcome of the *Bidding* is determined, has two variants: that the pot is the reward and who wins it is determined in another way, or that the reward is specified outside the *Bidding* and the bid is used to determine the outcome. *Poker* and other *Betting* games are examples of the first variant: the whole bid is the reward and the value of the cards is used to determine who gets the *Reward*. Examples of the second variant are games using voting or auctions, as in both these cases the *Reward* itself is outside the bid. The first category assumes that the player bids are consumed or transferred after the determination of the outcome. This is not (necessarily) the case in the second category as, for example, in an auction, only the players getting the *Reward* lose their bids. *Bidding*, especially in the form of voting, is often used in *Player Decided Results*.

There are two special cases of *Bidding*: auction and voting. Both auction and voting have characteristics where the game state the players are bidding on is actually the same as the *Reward*. In the case of the auction, the *Reward* is given to the

player who has placed the highest bid, and in the case of voting, the majority of votes decide how the game state should change.

CONSEQUENCES *Bidding* offers a way to achieve *Transfer of Control* of *Resources* through *Collaborative Actions* with *Player Decided Results*. This offers an alternative to *Combat* regarding how to achieve *Gain Ownership* or *Eliminate* goals. As *Bidding* nearly always is voluntarily, winning the bid is a *Player Defined Goal* concerning how much *Resources* one wants to spend on the *Bidding*, and in the case of *Bidding* on different objects, what objects to get.

The act of *Bidding* involves making *Investments* and *Risk/Reward* considerations, and in some cases, can be affected by *Bluffing*. The *Bidding* is often a source of *Competition* between players, and the ability to use certain *Resources* in *Bidding* to gain others can be seen as a form of abstract *Converter*.

RELATIONS

Instantiates: *Player Decided Results, Converters, Competition, Transfer of Control, Area Control, Player Elimination, Tradeoffs, Player Defined Goals, Collaborative Actions*

Modulates: *Turn Taking, Cooperation, Resources, Gain Ownership, Eliminate*

Instantiated by: *Limited Resources*

Modulated by: *Rewards, Turn Taking, Symmetric Information, Asymmetric Information, Negotiation, Betting, Bluffing, Direct Information*

Potentially Conflicting with: None

Bluffing

Players have a possibility to convey false information to other players in order to benefit from the situation.

Usually the basic information for *Bluffing* is something about the current game state, as is the case in *Poker*. It is possible, however, that *Bluffing* concerns other game components such as past events and actions, players' goals, and even players' strategies and intentions. One of the simplest games of this kind of *Bluffing* is an iterated version of *Paper-Rock-Scissors*, where the players try to outguess the other player's action based on previous plays and social clues.

> **Example:** *Poker* uses *Bluffing* as one of the basic characteristics of the game. The players do not have direct information about the other players' hands but try to guess the relative values based on the play of previous rounds, social clues, and how the players are playing the current round. *Bluffing* in

Poker thus means that the player is trying to give a false impression to other players about the actual value of his hand.

Example: The classic board game *Diplomacy* has all the information about positions of the players' armies and fleets available to all players. *Bluffing* in this game is based on giving the other players false information about the current strategies, goals, and agreements between the players. The game even has a specific diplomacy phase for giving the players the ability to scheme against other players.

USING THE PATTERN In order to have the possibility for bluffing, the game should have *Asymmetric Information* together with means of players giving each other *Indirect Information* about game components, that is, the players do not have direct access to the required information but can get it from other players, usually via *Social Interaction*. Games that have *Symmetric Information* as well as *Direct Information* about game elements limit the possibilities for *Bluffing* but can still have it concerning players' goals, strategies, and intentions. This, however, also requires that players have a possibility of some kind of cooperation and that the player actions can have an effect on the other players' position in the game. An example of a game not satisfying these requirements is a *100 Meter Dash*, or almost any other sports race, where *Bluffing* seems to be almost impossible.

Bluffing is possible in almost all cases of *Negotiation* and can be used to avoid situations where *Randomness* would normally let players feel *Luck*, since *Bluffing* can add a level of social skill even on totally random situations. Common examples where *Bluffing* is usually possible include *Trading*, *Betting*, and *Bidding*. An explicit type of game element that can be used for *Bluffing* is *Alarms* when these can be activated by players' actions.

CONSEQUENCES The possibility of *Bluffing* in games creates uncertainty about results and thereby *Tension*, especially for a *Bluffing* player. *Bluffing* modulates *Social Interaction* between players, and players bluffing must be able to control their *Emotional Immersion*, especially if the game is played in a face-to-face situation. Even though a face-to-face situation is beneficial for this type of game, it is not a requirement. As long as the possibilities and channels for *Negotiation* exist, there is a possibility for *Bluffing*. *Bluffing* in most cases leads to at least a possibility of *Betrayal*.

RELATIONS

Instantiates: *Tension, Betrayal, Risk/Reward*

Modulates: *Social Interaction, Trading, Bidding, Emotional Immersion, Alarms*

Instantiated by: *Indirect Information, Social Interaction, Negotiation, Betting, Asymmetric Information*

Modulated by: *Symmetric Information, Direct Information*

Potentially Conflicting with: *Luck, Symmetric Information*

Negotiation

A situation where the players confer with each other in order to reach an agreement or settlement.

Negotiations in most games are specific modes of play where the players have to agree upon something, for example, bargaining over the exact contents of a trade. The actual *Negotiation* can be totally uncontrolled by the game system or can be formalized with rules on what kinds of offers can be made, when the offers can be made, and how breaches in agreements should be handled.

> **Example:** *Diplomacy*, the board game, has a specific diplomacy phase during which the players are able to negotiate alliances and coordinate their actions.

> **Example:** The *Trading* phase of *Settlers of Catan* allows the player whose turn it is to start *Negotiations* with other players about the trade. This *Negotiation* phase can contain offers and counteroffers from all the other players as well, but only with the player initiating the trade. Each *Negotiation* ends when the players have resolved the trade, and the *Negotiation* phase itself ends when the initiating player declares that it has ended.

Using the Pattern *Negotiation* can either be motivated by players wanting *Resources* from other players, wanting players to do or not do specific actions due to *Asymmetric Abilities* between players, or having to make common decisions regarding *Player Decided Results* or *Shared Resources*.

It is usual that *Trading* and *Bidding* or other actions that concern voluntary *Transfer of Control* events have specific bargaining, i.e., *Negotiation*, phases where the players try to reach an agreement. More complex *Collaborative Actions* almost require that players are able to negotiate in order to coordinate their actions properly, for example, before agreeing on pursuing *Committed Goals*. For *Player Balance* and *Game State Overview*, some *Negotiation* is done strictly according to a *Turn Taking* scheme, which however can cause *Downtime*.

Negotiation situations also appear when there are *Player Defined Goals* that are also *Mutual Goals*, as the players have to reach an agreement about the goal they are trying to reach. Usually, reaching these goals requires agreeing upon and coordinating more complex strategies, which also involves *Negotiation*. Establishing and

maintaining the power structures in *Social Organizations*, unless they are predefined and immutable, requires that players negotiate. One way of solving *Social Dilemmas* is to allow players to negotiate their strategies.

Negotiations in games can either be formalized by rules or be handled through *Extra-Game Actions*. Formalized *Negotiations* are usually specific modes of play in the game with three distinct phases: initiation, bargaining, and agreement. The rules for the initiation phase have to take three choices into account: first, which of the players can start the negotiation; second, how the participants of the negotiation are determined; and finally, what kinds of negotiations are possible. In games where players can perform hostile actions against each other, *Negotiation* may be encouraged by having *Safe Havens* especially for these types of actions, and initiation may start by players entering a certain space in the game. *Settlers of Catan* illustrates quite well these phases: only the player whose turn it is can initiate the negotiation, all players can participate in it, and only trades of basic *Resources* are allowed. The nature of the bargaining phase itself depends on the kind of *Negotiation*, but usually it consists basically of the participants making offers and counteroffers, sometimes even threats, and trying to persuade other participants to a certain agreement. It is possible that the player composition of the negotiation changes during this phase. The last phase, how to determine the agreement, has at least the following options: the initiating player decides on the agreement based on the discussion during the negotiation phase; the players agreeing on something end the negotiation by excluding the other players from the negotiation; or a specific *Bidding*, usually some kind of a voting, phase is used to determine the outcome. The effects of the agreement, of course, depend on the nature of the game itself.

The patterns dealing with information can be used to govern how and what kind of information both the participating and non-participating players get about the different phases of the negotiation. For example, it is possible that the player composition of negotiations is known to all players, using *Symmetric Information*, but that the terms and agreements are only known to the participating players, using *Asymmetric Information*.

Player Decided Results, especially *Player-Decided Distribution of Rewards & Penalties* for *Shared Rewards*, usually require some possibility for *Negotiation* and can represent a kind of *Overcome* goal. The presence of *Tiebreakers* can make *Shared Rewards* impossible and thereby close this possibility for *Negotiation* in games.

Negotiation is by its nature an example of *Interruptible Actions* as players can end their bargaining. However, *Negotiations* can also be designed to be *Interruptible Actions* so that third parties can affect the actions, typically by presenting an alternative bid or a motivation why the bargain is not fair to one part.

CONSEQUENCES Having *Negotiation* in a game increases *Social Interaction* unless the form of *Negotiation* is highly formalized or mediated. *Dynamic Alliances*, and especially *Uncommitted Alliances*, usually require *Negotiation* first to create the *Alliance* and later on to maintain the *Alliance* and may require *Leaps of Faith*. *Bluffing* to be efficient requires that there are at least some levels of *Negotiation* in the game while the possibility of *Betrayal* significantly modulates how *Negotiation* is conducted and the willingness of players to negotiate.

The skill of *Negotiation* is one route to *Game Mastery* in games where *Negotiations* can have concrete effects on the game state or affect players' choices of goals and tactics (for example, by completing *Preventing Goals* simply by convincing other players not to pursue specific goals they have), and as such *Negotiation* can be used in *Polyathlons* to spread the types of skills required.

In games with *Game Masters*, *Negotiation* may occur on a meta level to ensure *Player Balance*, for example, through *Ability Losses*. In *Self-Facilitated Games*, *Negotiation* may in a similar fashion be used to decide upon *Handicaps*.

RELATIONS

> **Instantiates:** *Bluffing, Leaps of Faith, Game Mastery, Transfer of Control, Player Balance, Extra-Game Actions*
>
> **Modulates:** *Trading, Bidding, Social Organizations, Player Defined Goals, Player Decided Results, Mutual Goals, Dynamic Alliances, Uncommitted Alliances, Shared Rewards, Ability Losses, Polyathlons, Handicaps, Overcome, Committed Goals, Collaborative Actions*
>
> **Instantiated by:** *Social Interaction, Game Masters, Self-Facilitated Games, Asymmetric Abilities, Player-Decided Distribution of Rewards & Penalties, Shared Resources*
>
> **Modulated by:** *Symmetric Information, Interruptible Actions, Asymmetric Information, Betrayal, Turn Taking, Game State Overview, Preventing Goals, Safe Havens*
>
> **Potentially Conflicting with:** *Downtime, Tiebreakers*

Social Dilemmas

The players tend to compete against each other even though cooperation would be beneficial for all players involved.

Two main *Social Dilemmas*, The Prisoners' Dilemma and The Tragedy of the Commons, are treated here as they share some interesting characteristics from the game design point of view but also differ in interesting ways.

The Prisoners' Dilemma is the classic example of *Social Dilemmas* used in game theory. The story behind this dilemma is that there are two prisoners who are accused of conspiring in two crimes, one minor crime for which their guilt can be proven without any confession, and a major crime for which the guilt can be proven only with one or more confessions. The prosecutor gives both the prisoners the same deal: if both confess, they both go to jail for five years; if only one of them confesses, he goes free and the other goes to jail for 10 years. Finally, if both refuse to confess, they both go to jail for one year. The dilemma here is that even though the option where both refuse to confess is better for all parties involved, there is a chance that one prisoner tries to get free by confessing, and this leads to a situation where both prisoners in the end confess and both end up in jail for five years. The original Prisoners' Dilemma did not allow communication between the prisoners before making the choice. Allowing communication complicates the situation, but the issue of trust, thus the *Social Dilemma*, still remains.

The Tragedy of the Commons [Hardin68] describes a situation where the pasture is free to use for all herdsmen of the village but where the overherding will in the end diminish the capacity of the common pasture. The dilemma arises because the benefits for each herdsman of increasing his flock of cattle is individual but the penalties of overherding are shared between all the herdsmen, and this will usually lead to a situation where overherding will result in the collapse of the whole herding business.

The main thrust of *Social Dilemmas* from the game design point of view is that, even though cooperation would be beneficial in the long run for the participating players, having a possibility to reap shorter term rewards by betraying the trust of the other players will lead to situations where the players have to evaluate the trustworthiness of the other players almost constantly.

USING THE PATTERN Designing *Social Dilemmas* requires designing actions with *Individual Rewards* for the player who performs the action but with *Shared Penalties* to the other players. If the *Penalties* are perceived as *Individual Penalties* or the game state can make the *Penalties* only affect one player, the actions are not guaranteed to be *Social Dilemmas*. An example is when players have agreed to accept *Tied Results* but one player can perform actions leading to that player receiving all the *Rewards*; in this case, the dilemma is either due to the chance of gaining more *Rewards* than otherwise or due to making the other players received the *Penalties* of not receiving the anticipated *Rewards*. Another example is *Social Organizations* where the main *Penalty* may be social rejection and the *Reward* is to be able to spend time and effort on other activities. A third is *Enemies* that are *Enemies* due to misunderstandings that the players are aware of.

When using *Social Dilemma* in the game, one has to consider what kinds of methods for *Social Interaction* there are in the game, as most uses of *Social Dilemma* require that players have to negotiate with other players.

Situations similar to The Prisoners' Dilemma arise when there at least two players who are dependant upon the *Cooperation* between the players. If *Cooperation* is sustained without *Betrayal*, all the participating players progress quite well in the game. The crux of the dilemma is that the first player to stop the *Cooperation* receives a large pay-off at the expense of those players who are still cooperating, and if all players stop the *Cooperation*, all players do worse than when cooperating. To work well, the Prisoners' Dilemma requires *Delayed Effects* of some kind from the actions that determine *Cooperation*, as this will create more *Tension* between the players.

The Tragedy of the Commons requires that there is a *Renewable* and *Shared Resource*, which has an upper limit for the renewal rate, and that initially the use of the resource is potentially unlimited for each participating player. Of course, the use of this resource should lead to something the players perceive as a reward. One common method, and also true to the original dilemma, is to use a *Converter* to create higher level *Individual Rewards* for the players. For example, a player belonging to an *Alliance* in a military strategy game can use the shared cities to create troops for himself.

CONSEQUENCES *Social Dilemmas* give players a *Freedom of Choice* to do actions that have *Individual Rewards* and *Shared Penalties*, but the *Rewards* outweigh the *Penalties* for the individual player. Since performing the actions is likely to cause animosity from other players, *Social Dilemmas* can create *Emotional Immersion* for all partners involved. When other players are aware of a player's *Social Dilemma*, even if it is only potentially a dilemma, this affects these players' *Perceived Chance to Succeed* with actions as well as their *Risk/Reward* choices.

The case of The Tragedy of the Commons where the players are able to communicate with each other, but also able to perceive that the consumption rate of the *Shared Resource* is higher than the renewal rate, seems in most cases to lead to a situation where *Social Organizations* arise spontaneously or *Resources* become depleted. *Shared Resources* and the possibility of communication by themselves support *Social Interaction*, of course, but this kind of dilemma situation can increase it even more. The situation at least in the first phases and without strong outside threat, will also lead to dynamics of *Cooperation* and *Competition* within the group in the form of *Dynamic Alliances*. It is probable that the introduction of an outside threat in this phase will stabilize the group into a *Social Organization*.

RELATIONS

Instantiates: *Social Organizations, Social Interaction, Tension, Emotional Immersion*

Modulates: *Cooperation, Competition, Dynamic Alliances, Alliances, Perceived Chance to Succeed, Risk/Reward, Tied Results*

Instantiated by: *Social Organizations, Shared Resources, Individual Rewards, Delayed Reciprocity, Converters, Betrayal, Shared Penalties, Freedom of Choice, Enemies*

Modulated by: *Conflict, Renewable Resources, Rewards*

Potentially Conflicting with: *Individual Penalties*

REFERENCE

[Hardin68] Hardin, Garret. "The Tragedy of the Commons." *Science* (Vol. 162, Issue 3859. pp. 1243–1248), 13 December 1968. (Also available online at *http://www.garretthardinsociety.org/articles/art_tragedy_of_the_commons.html*.)

Additional Pattern

A description of this additional pattern can be found in the Chapter 10 folder on the companion CD-ROM.

ON THE CD

Social Statuses

11 Game Design Patterns for Goals

Goals give players objectives to aim for when playing games but even if all the goals in games can be described by a few patterns, they take on many different specific forms and affect gameplay differently. Even games with the same basic goals can have very different gameplay due to minor variations in what components are used in the game, what relations exist between the goals and other goals in the games, and how the goals affect the relations between players.

Like most other patterns, these can be modulated by patterns concerning information. In addition, all patterns in this chapter can be modulated by *Reward* and *Penalty*, as these patterns are necessary to define a goal. These two patterns will not be mentioned in the relationships of patterns in the chapter except when they have a specific impact on a pattern.

Goals of Ownership and Overcoming Opposition: *Gain Ownership, Overcome, Stealth, Eliminate, Rescue, Capture, Evade, Conceal, Race*

Goals of Arrangement: *Collection, Alignment, Enclosure, Configuration, Connection, Delivery, Herd, Contact*

Goals of Persistence: *Guard, Survive, Traverse, King of the Hill, Last Man Standing*

Goals of Information and Knowledge: *Gain Information, Gain Competence, Exploration, Reconnaissance*

GOALS OF OWNERSHIP AND OVERCOMING OPPOSITION

These patterns relate to those that require that players have an opposition, either other players or the game system, typically described as goals that are either *Excluding Goals* or *Incompatible Goals* (see next chapter) to the players' goals. The goal

of gaining ownership is placed in this category, as goals of this type typically deal with taking the ownership from someone.

Gain Ownership

This is simply the goal to gain the ownership of a game element.

The goal of controlling a game element, either by possessing it or by controlling the use of it, is common to many games. The ownership may be a reason in itself (as for example controlling space in *Go* or controlling *Flag* points in *Battlefield 1942*), may be a requirement for completing a higher-*Level* goal, or may simply make it easier to complete various types of actions or goals.

> **Example:** Weapons, ammunition, and power-ups are all examples of objectives for *Gain Ownership* goals in first-person shooters such as *Quake*, *Unreal Tournament*, or *Return to Castle Wolfenstein*.
>
> **Example:** *Othello* (also called *Reversi*) has the goal of gaining ownership of a majority of the game pieces, and every turn in the game involves changes in ownership.

USING THE PATTERN The use of a *Gain Ownership* goal tightly links the *Reward* of the goal with the game element that is owned, or part of the *Game World* in cases of *Area Control*. This usually provides players with an increase in *Score*, more *Resources*, *Improved Abilities*, *New Abilities* (and possibly *Privileged Abilities*) from *Tools*, or new information in the form of *Clues*. In many cases, the game element is destroyed or taken out of gameplay with the completion of the goal, in principle making use of the *Converter* pattern.

An important design choice for the *Gain Ownership* pattern is how ownership of the game element is achieved, if it can change after it has been set, and if it can be shared. Ownership can be the immediate result of a subgoal, typically *Stealth*, *Overcome*, *Capture*, or *Contact*, but others are possible, which makes the goals part of a *Hierarchy of Goals*. An interesting exception to this is *Delivery* goals, where the objective is to make someone else in the game succeed with a *Gain Ownership* goal. Other common ways of gaining ownership are the results of *Construction*, *Bidding*, *Betting*, or *Trading* actions. The design of a *Gain Ownership* goal requires either that the ownership has not been determined yet or that ownership can change. Using the possibility of changing ownership makes all the goals that have the same game element as goal object into *Excluding Goals* and supports *Conflict*. Not being able to change ownership may lessen *Conflict* after ownership has been determined but may make it more intense before this is done, as the *Risk/Reward* can be seen as higher. Being able to share ownership can also lessen *Conflict*, can support *Shared Rewards*

instead of *Individual Rewards*, and can force players into *Alliances*, which require *Negotiation* and *Collaborative Action*. *Conflict* over individual *Resources* that are part of a class of *Renewable Resources* typically is less intense than *Non-Renewable Resources*. A variation of how *Ownership* is handled is by using *Indirect Control*: in these cases, the *Ownership* may always be shared, or the *Transfer of Control* may be very easy to achieve.

The ownership, if any, of a game element in a *Gain Ownership* goal does not have to be public knowledge, for discovering who has ownership of the game element may be used as a required *Gain Information* subgoal that is necessary to locate the element or the owner. The same applies after the *Gain Ownership* goal has been completed, either to make changes in *Ownership* more difficult or to heighten *Tension*.

An important distinction to make when creating ownership goals is to determine if the *Ownership* is linked to a removable game element, i.e., if the game element is a *Unit* that moves or a *Pick-Up* that can be moved from its position in the *Game World*. Having game elements that can be moved makes the area where they are located a *Resource Location*, while using an area makes it a *Strategic Location*, or strengthens an already existent one, based on the *Rewards* and *Penalties* associated with the goal.

Choosing *Units* as goal objects makes it possible to link the completion of the *Gain Ownership* goal to *Overcome* and *Capture* goals but may create *Enemies*. The use of *Pick-Ups* makes it difficult to share ownership and easy for players to observe if anybody has completed a *Gain Ownership* goal regarding the game element. If the possession can be detected and the ownership changed, this also allows for emergent *Overcome* or *Capture* subgoals. The ownership of the game element may require the owner to do *Resource Management* between different game elements under the player's control. Further, as these game elements may be difficult to share, the *Reward* for the goal becomes an *Individual Reward*. However, if the use of information contained in the game element is not controlled by the game system, the game element can be passed on without loss of the information, or the information can be spread through a *Communication Channel*.

Having the ownership linked to non-moveable game elements can provide players with *New Abilities* through *Controllers* or *Resources* through *Chargers* or *Resource Generators*. Further, if the game elements are areas in the *Game World*, often marked by *Outstanding Features*, they can function as *Goal Points* for goals of persistence such as *King of the Hill* or *Guard*. *Strategic Locations* can also be the objective for ownership goals and are typically *Optional Goals*.

CONSEQUENCES *Gain Ownership* is the goal of achieving *Ownership* through *Transfer of Control* from other players or the game system to a specific player. The *Ownership* can be regarding game elements or, in the case of *Area Control* of *Strategic*

Locations, about parts of the *Game World*. Being a combination of a goal and the possibility of *Ownership*, *Gain Ownership* provides two motivations for *Emotional Immersion* in games. If the owned game element or area was previously owned by the players and has caused *Ability Losses*, this is even more likely to increase *Emotional Immersion*.

Gaining *Ownership* of game elements creates a sense of progress as players increase the number of owned elements, which can be used as a basis for *Collection* or *Configuration* goals, as well as supporting one of the requirements, gaining new resources, for *Resource Management*. If the *Ownership* gives *New Abilities*, it supports the *Gain Competence* goal, while if it gives access to information, it instead supports *Gain Information*.

Gain Ownership of pieces can be in a form of *Capture*. In this case, the pattern creates *Conflict*, and thereby *Tension*, if there exist actions so that one player can take the ownership of game elements from another player without that player's consent. If only one player can own the game element, goals of having that game element become *Excluding Goals*.

RELATIONS

Instantiates: *Tension, Conflict, Gain Information, Gain Competence, Collection, Betting, Emotional Immersion, Transfer of Control, Area Control*

Modulates: *Resource Management, Converters, Configuration, King of the Hill, Enemies, Ownership, Stealth, Delivery*

Instantiated by: *Capture, Overcome, Contact, Indirect Control, Ability Losses, Construction, Strategic Locations*

Modulated by: *Bidding, Betting, Trading, Clues, Tools, Pick-Ups, Resource Locations, Strategic Locations, Resources, Score, Rewards, Individual Rewards, Shared Rewards, Enclosure, New Abilities, Improved Abilities, Controllers, Resource Generators, Goal Points, Chargers, Renewable Resources*

Potentially Conflicting with: None

Overcome

This is the goal of the player to defeat an opposing force in a test, or a series of tests, involving attributes or performance of low-level actions.

The opposing force in *Overcome* can be other players or other kinds of enemies provided by the game system.

Example: Fighting games, such as *Soul Calibur* and *Tekken*, are almost purely about overcoming the opponent by performing a series of successful attacks the opponent is unable to dodge or block.

Example: *Chess* uses the *Overcome* pattern through a combination of eliminating the other player's pieces and skillful positioning of one's own pieces.

USING THE PATTERN The main design choice of *Overcome* is to select the *Enemies* a player has to compete against; these *Enemies* can either be computer controlled or player controlled, and by providing several different types through the use of *Orthogonal Unit Differentiation*, the *Replayability* of the goal increases. If the *Orthogonal Unit Differentiation* is also applied to allow the player to choose different *Avatars* or *Units*, this creates *Freedom of Choice*. By increasing the difficulty of *Overcome* goals, a game design can guarantee *Higher-Level Closures as Gameplay Progresses*. For example, games using *Levels* often have a *Boss Monster* as the final *Enemy* for each *Level*, which players have to *Overcome* in order to complete the *Level*.

The test of attributes used to see if the *Overcome* pattern is fulfilled can range from simple comparisons (which party has stronger attributes) to a long sequence of tests involving different actions or *Tournaments*. The simplest case can be exemplified by combat resolution in some strategy games: *Units* with more troops automatically defeat the opponent *Units* with fewer troops. The combat resolution tables used in conjunction with *Randomness*, normally *Dice*, are another, slightly more complex, method of evaluating the outcome. The same kind of method is used to determine the fights between the *Units* in current real-time strategy games. The exact nature of the tests involved can represent a number of different fields of expertise, including the use of the following patterns: *Combat, Timing, Rhythm-Based Actions, Dexterity-Based Actions, Memorizing, Negotiation, Puzzle Solving,* and *Luck*. The *Overcome* goal can be one of these, a combination of these, or a player-decided choice. *Tiebreakers* are often used with *Overcome* goals to make it impossible for both players to win or lose simultaneously. Many *Overcome* goals use a *Tournament* format with the same test performed several times to lessen the influence of *Luck* and allow for *Perceivable Margins*. *Achilles' Heels* can be used to give opponents weakness that can be exploited to more easily beat the opponent.

Computer-based games usually automate the evaluations of who won the *Overcome* goal, but others games, especially sports and roleplaying games, make use of *Game Masters* or judges.

The effect of fulfilling *Overcome* goals is commonly to remove a game element or player, resulting in an *Eliminate* goal and *Player Elimination*. An example of this is *Last Man Standing* where the goal is to defeat all other players (or at least to defeat the other remaining player when only two remain). However, other options available to game designers include *Capture* (e.g., *Paradroid*), the fulfillment of a *Gain Ownership* goal through redistribution of resources, or the gain of points used to determine a *Score*. Other common effects of completing *Overcome* goals are the *Transfer of Control* of *Resources* or *Tools* or handing over *Area Control*.

CONSEQUENCES *Overcome* promotes *Conflict*, or at least *Competition*, as the player is trying to be better than another player (or oneself). In the process, it also promotes *Tension*, especially if players have *Immersion* in the game or if the actual determination of the outcome of the goal is preceded by a period of preparation or building up resources and skills. This allows *Overcome* goals to be used as subgoals to inject moments of *Tension* into goals that are not necessarily fast-paced, e.g., *Delivery*, *Stealth*, or *Rescue* goals.

The *Overcome* and *Capture* goals are very often related in a *Hierarchy of Goals* but what goal is subgoal to the other depends primarily on how their *Rewards* are structured and how the players' tactics are constructed.

As *Overcome* has two or more players trying to beat each other, it is often an example of a *Symmetric Goal*. Although individual tests may allow *Tied Results*, the overall goal of *Overcome* goals are *Excluding Goals* so that *Tied Results* are avoided. The exception that allows for a form of *Tied Results*, usually associated with *Shared Penalties*, is when all players fail to *Overcome* each other. Both *Chess* and *Go* have *Overcome* goals that also are *Excluding Goals*. However, *Chess* games can end without any player being able to checkmate the opponent, while *Go* games cannot be drawn if handicap points with using half stone values are given for the advantage of starting.

As *Overcome* goals usually center on one test, they provide focused areas for players to develop *Game Mastery* in. This provided the usual possibilities for social rewards, with the additional facet that the player may have *Overcome* some of the people in the social group.

RELATIONS

Instantiates: *Combat, Gain Ownership, Capture, Tension, Competition, Conflict, Game Mastery, Excluding Goals, Symmetric Goals, Tournaments, Transfer of Control*

Modulates: *Stealth, Rescue, Delivery, Higher-Level Closures as Gameplay Progresses, Player Elimination*

Instantiated by: *Last Man Standing, Enemies, Boss Monsters, Tournaments, Area Control*

Modulated by: *Eliminate, Timing, Rhythm-Based Actions, Dexterity-Based Actions, Advantage of Memorizing, Negotiation, Puzzle Solving, Luck, Game Masters, Orthogonal Unit Differentiation, Tiebreakers, Achilles' Heels, Memorizing, Immersion*

Potentially Conflicting with: None

Stealth

Stealth is the goal to move through a certain area and perform an action without being detected.

Sometimes favorable conditions in a game can be achieved by not having one's actions noticed by other players. When this is the case, players have *Stealth* goals that force them to plan actions that minimize the risks of being noticed while still completing the required actions.

> **Example:** *Thief: The Dark Project* and the other games in the series exemplify a game using *Stealth*. The player is a master thief, Garrett, who lives in a medieval fantasy world and performs his duties by relieving the rich nobles of their riches. The main goal is to collect the valuable items, while the secondary goal is to avoid being detected by the *Guards* while moving around the *Levels*.

> **Example:** Many children's games are based on one person trying to find the other players while at the same time trying to *Guard* an area that is a safe zone for the other players. If the other players, by a combination of stealth and running, make it to the safe zone they are home free and do not have to be the player guarding the safe zone in the next game.

USING THE PATTERN *Stealth* is a compound goal pattern using *Conceal* together with *Evade* with a secondary goal involving *Movement* or other actions from the player, normally *Rescue*, *Traverse*, *Delivery*, *Camping*, or *Gain Ownership* (including gaining *Area Control* simply by being undetected in a particular place). Designing the *Stealth* goal consists not only of choosing between the different design options of these patterns, but also determining what player actions can reveal the players and what the *Tradeoffs* are between the various *Risk/Reward* relations for each action in a given context.

Longer *Stealth* goals can be divided into parts that require short *Stealth* goals to be fulfilled in order to avoid *Guards* and *Alarms*, short bursts of action to *Overcome* enemy *Units* without them activating *Alarms*, and *Tension*-filled moments when the best option for the player is to perform *No-Ops*. The complexity of *Stealth* goals can be increased by letting *Guards* have *Reconnaissance* goals so that players have to take their *Movement* into consideration.

CONSEQUENCES *Stealth* is the goal of trying to *Conceal* one's location while having to move. *Stealth* goals may require players to pace themselves as quick *Movement* may have too high risks, and sometimes any action or *Movement* may cause the goal

to fail. *Stealth* can thus create *Tension* as players may have no *Freedom of Choice* except to perform *No-Op* actions to continue to *Conceal* themselves hoping not to be detected by opponents (which actually represents a form of *Area Control*). The slow tempo and possible pauses in completing *Stealth* goals give players a chance to make use of *Strategic Knowledge*, for example, the locations of *Alarms*, making the game with the pattern have *Stimulated Planning*.

Most cases of *Stealth* rely on opponents having *Guard* or *Reconnaissance* as *Preventing Goals*, making *Stealth* and these goals *Excluding Goals*. Giving players *Stealth* goals combined with *Herd* goals increases the chances of failure and may limit the *Right Level of Difficulty* of the goals.

Relations

Instantiates: *Conceal, Evade, Stimulated Planning, Tension, Movement, Area Control*

Modulates: *Rescue, Delivery*

Instantiated by: *Reconnaissance*

Modulated by: *Overcome, Guard, Alarms, Risk/Reward, Tradeoffs, Safe Havens, No-Ops, Traverse, Gain Ownership, Camping*

Potentially Conflicting with: *Herd*

Eliminate

Eliminate is the goal to remove a game element from its location in the game space.

Games may offer the removal of game elements for several reasons: the game elements may hinder actions, may pose a threat to the player goals, or their removal may simply be a goal in itself that is rewarded. The removal of game elements is not necessarily permanent; the board game *Ludo* lets players reinsert taken pieces, and many multiplayer first-person shooters let people spawn again after being killed, both as ways to allow the same number of *Avatars* or game elements in the game for as long as the game continues.

> **Example:** In *Backgammon*, a single opponent's piece is removed from play when taken, but the piece can be brought back to the game later.

> **Example:** *Counter-Strike* differs from many first-person shooters in that players who are killed are eliminated for the remainder of the match.

> **Example:** The single-player puzzle game *Peg Solitaire* consists of eliminating all game elements from the game board save one.

USING THE PATTERN The main consideration when employing *Eliminate* is choosing what game element can be eliminated. The goal object is usually, but not necessarily, a game element that is controlled by another player or the game system, making *Eliminate* become a subpattern of *Overcome*. Common *Eliminate* goals are to destroy *Resource Generators* or to defeat *Boss Monsters* in order to advance to the next *Level*. The goal to *Eliminate* can easily be made into a *Hierarchy of Goals* by using *Damage* so that several successful actions must be performed before the goal is completed.

Eliminate typically uses another pattern to describe the exact method of elimination. *Combat*, through melee or *Aim & Shoot* actions, is the most common means to achieving *Eliminate* goals. Luring opponents into *Deadly Traps* is another possibility but typically requires more indirect actions. *Backgammon* uses a *Contact* pattern to define how to do the actual elimination, but there are many other possibilities. However, elimination can occur through the non-action of the players controlling the game element, e.g., folding in *Poker* or other games containing *Bidding*. *Tournaments* also typically contain the *Eliminate* pattern as players strive to eliminate each other through *Player Elimination*.

The game elements removed by the fulfillment of the goal do not have to be removed permanently. However, even if elimination only is temporary, it usually involves some sort of *Penalty* for the player who controlled the eliminated game element. This typically takes the form of the game element being transferred back to a *Spawn Point* or having the game element out of play for a certain amount of time, possibly leading to *Limited Set of Actions* or forcing players to perform *No-Ops*. The effect of *Eliminate* can of course be expanded to remove players from game sessions as well through *Player Elimination*.

Strategy games that have cities or other types of *Resource Generators* use *Eliminate* in order to get rid of the produced *Units*. The gameplay in those games is usually about maintaining a steady growth of available *Units* to overwhelm the opponent.

CONSEQUENCES *Eliminate* requires the disappearance of some game element from gameplay, and the player fulfilling such a goal is therefore a form of *Consumer*. If the game elements to be eliminated are controlled by another player, this player can be considered an *Enemy* and usually has the *Preventing Goals* of *Survive* or *Evade*. *Eliminate* easily creates *Tension* and may cause *Conflict* between players, especially if the *Eliminate* concerns game elements that are the effect of other players' *Construction* actions.

Eliminate can also be used to speed up and simplify gameplay in the end phase of a game by successively removing game elements during the early gameplay so that only a few remain at the end of the game. As the pieces that remain have increased

values in this context, this use of *Eliminate* supports *Higher-Level Closures as Gameplay Progresses.*

Eliminate does not necessarily have to be destructive toward players; the *Collection* of *Resources* and *Pick-Ups* in *Real-Time Games* that destroy and change game values are examples of how the *Eliminate* goal is a part of the *Converter* effect of completing a *Gain Ownership* goal.

RELATIONS

Instantiates: *Combat, Tournaments, Higher-Level Closures as Gameplay Progresses, Penalties, Conflict, Enemies, Boss Monsters, Aim & Shoot, Last Man Standing, Player Elimination, Preventing Goals*

Modulates: *Overcome, Capture, Units, Resource Generators*

Instantiated by: *Consumers*

Modulated by: *Contact, Survive, Evade, Deadly Traps, Bidding, Damage, Consumers*

Potentially Conflicting with: *Construction*

Rescue

Rescue is the goal of freeing someone or something that is guarded.

A common plot in games is that an opponent has captured or imprisoned a character that players' characters know or care about. This gives the players a *Rescue* goal, which may consist of finding the location of the kidnapped character as well as *Overcoming* or avoiding the obstacles and enemies on the way there. Games using *Rescue* as the main goal often have the opponent as the final enemy that has to be defeated before completing the goal.

> **Example:** *Donkey Kong* has as an over-arching goal for Mario to *Rescue* the girl that has been kidnapped by the gorilla with the same name as the game.

> **Example:** Some missions in *Counter-Strike* involve scientists that the terrorists have to *Guard* and the counter-terrorist team tries to free and lead to a safe zone.

USING THE PATTERN A *Rescue* goal can be designed as either explicit goals to *Overcome* some *Guards* or to use *Stealth* to avoid being detected, or a combination of both, possibly allowing players the *Freedom of Choice* between the two. In the latter case, *Rescue* goals provide the possibility of several subgoals: *Stealth* goals to enter areas without detection and *Gain Information* goals to learn the layout and posi-

tions of *Guards*, *Alarms*, and *Deadly Traps*. Games using *Rescue* as the main goal often have the character responsible for the kidnapping as a *Boss Monster* that has to be defeated before completing the goal.

Rescues can be constructed so that they are completed as soon as the *Guards* and *Obstacles* are *Overcome* but may also be constructed so that the rescued people have to be moved into a safe area, i.e., places in the *Game World* that are both *Goal Points* and *Safe Havens*. The latter ones allow for opposing *Capture* goals and provide gameplay where the goals may change several times before reaching a final conclusion.

CONSEQUENCES As a *Rescue* goal is defined by overcoming a *Guard* goal, it is a *Preventing Goal* and automatically creates *Conflict*. Although the goal object of a *Rescue* may be a *Character* or *Unit*, possibly controlled by another player, the structure of *Rescue* goals are often struggles over *Ownership*. *Rescue* goals are often used to provide a *Narrative Structure* in a game; the person to be rescued can have vital information or be someone that is loved by the player's character.

RELATIONS

Instantiates: *Conflict, Preventing Goals*

Modulates: *Narrative Structures, Guard*

Instantiated by: None

Modulated by: *Overcome, Alarms, Deadly Traps, Obstacles, Boss Monsters, Goal Points, Safe Havens, Stealth, Ownership*

Potentially Conflicting with: None

Capture

Capture is the goal pattern where the end result is the elimination or change of ownership of an actively resisting goal object.

The *Capture* is done directly by the actions performed by game elements under a player's control; thus, shooting an opponent in a first-person shooter is not an example of *Capture*.

> **Example:** *Go* allows *Capture* by completely enclosing an enemy group of stones.

> **Example:** *Qix* allows the player to catch computer-controlled units by enclosing them in the smaller area of the two areas that are created by outlining a path in the unmarked part of the game area.

Example: Priests in *Age of Empires* can convert pieces controlled by other players as their main offensive action.

USING THE PATTERN The prime design choice regarding *Capture* is to decide if the aim is to *Eliminate* or *Gain Ownership*, but can in both cases be seen as a struggle over *Ownership*. As *Capture* is most often done through the actions of a game element under a player's control, determining what game elements can be used to *Capture* is usually a part of defining the goal.

The game design must support some action that facilitates the *Capture*. In the case of *Real-Time Games*, this typically is *Combat, Maneuvering,* or *Aim & Shoot* promoting skills in *Dexterity-Based Actions. Turn-Based Games* favor the use of *Puzzle Solving,* and thereby *Stimulated Planning,* but can also make use of *Investment* or *Bidding.* The first type of game usually has the subgoal of *Contact* (with *Qix* as an example of *Enclosure*) while the second type of game commonly has subgoals such as *Contact, Alignment, Enclosure, Configuration,* and *Connection.*

CONSEQUENCES *Capture* goals are very often related to *Overcome* goals in the *Hierarchies of Goals.* How they are related to each other depends primarily on their individual *Reward* structures and on players' tactics. *Capture* is often achieved by *Movement* but in *Real-Time Games,* this depends on *Timing,* while in *Turn-Based Games,* it more often is a form of *Puzzle Solving,* as players have to take other players' or *Agents'* actions into consideration due to *Turn Taking.*

Captures combined with *Eliminate* of game elements that are *Non-Renewable Resources* can quicken gameplay as fewer game elements remain and promote *Higher-Level Closures as Gameplay Progresses* since each element represents a greater part of players' *Resources.* When *Capture* allows *Transfer of Control,* this causes *Preventing Goals* such as *Evade* and can trigger retaliating *Capture* goals by an original owner to regain control. The control of a new game element through *Capture* can motivate *New Abilities,* possibly *Privileged Abilities,* to become available.

RELATIONS

Instantiates: *Preventing Goals, Higher-Level Closures as Gameplay Progresses, Transfer of Control, Gain Ownership, Timing, Movement, Combat*

Modulates: None

Instantiated by: *Overcome*

Modulated by: *Eliminate, Contact, Alignment, Enclosure, Configuration, Connection, Evade, Puzzle Solving, Real-Time Games, Turn-Based Games, Aim & Shoot, Maneuvering, Turn Taking, Ownership*

Potentially Conflicting with: None

Evade

This is the goal to avoid being captured or hit.

Many elements in a game—for example, monsters, falling rocks, and bullet shots—are directly dangerous to the game elements controlled by players and are best avoided. This encourages players to try and *Evade* these or suffer the consequences.

> **Example:** *Go* gives an example of a turn-based game in which *Evade* occurs. When playing the game, players may have groups that will be captured unless they manage to *Evade* an enclosure constructed by another player.

> **Example:** *Pac-Man* has the goal of avoiding the ghosts while collecting the yellow dots.

USING THE PATTERN Creating an *Evade* goal involves deciding what *Enemies* should to be evaded and what *Penalties* occur if the goal is not achieved, as typically *Evade* goals have no explicit *Rewards*. *Evade* goals can seldom be completed in themselves, with the exception of *Evade* goals with *Time Limits*, but can often be completed by achieving another goal: that of completing an *Excluding Goal* to whatever goal causes the actions the player is trying to *Evade*. Examples of this are to shoot an enemy that is trying to shoot you or to deactivate a robot that is trying to kill you. The *Penalty* for failing to *Evade* something is closely related to the *Reward* of the *Preventing Goal*, but usually means *Damage*, the loss of a *Life*, or control of a *Unit* (possibly because another player completed *Gain Ownership* of the *Unit*). The *Penalty* can also be that the players are forced into *Committed Goals*, where both succeeding and failing those goals can have negative consequences, for example, having to fight an innocent opponent to the death for having failed a *Stealth* goal.

Evade goals can be *Supporting Goals* for *Traverse* and *Delivery* goals. If the player succeeds with evading the possible *Enemies*, there may be no need to succeed with *Overcome* goals.

Evade goals usually have *Units* or moving game elements with dangerous connotations such as bullets, arrows, or missile-like spells as the game elements to be avoided. Noticing *Aim & Shoot* actions from these trigger *Evade* goals but also of course make the *Aim & Shoot* actions more difficult. However, in games where players' *Units* or *Avatars* constantly move, *Evade* goals can also be constructed around *Deadly Traps*. Any kind of *Movement Limitations* that affect players during evading naturally make them more difficult.

Evade patterns can interact with *Overcome* patterns when one player has both. If the *Overcome* patterns are not used at all, the player with the *Evade* goal cannot make the chaser fail by directly affecting values related to the chaser. When both

Evade and *Overcome* are present simultaneously, they allow players to create tactics of offense and defense, e.g., to strike or dodge in a boxing game. Another option is to let a player have the *Evade* goal until a certain other goal, e.g., *Gain Ownership* of a weapon, is completed and then the player has the possibility to strive for the *Overcome* pattern. This can be used to create *Role Reversal* patterns, as in *Pac-Man*, so the chasers move from having an *Overcome* goal to having an *Evade* goal.

CONSEQUENCES *Evade* goals are based upon not being hit and therefore naturally promote *Movement* in games. The goals are *Continuous Goals* where a player is trying to hinder the completion of another player's *Capture* or *Eliminate* goals or to avoid being hit (which are *Connection* goals). As such, they are *Preventing Goals* and create *Tension* as the player is trying to hinder other players' goals.

In *Real-Time Games*, *Evade* typically requires players to be proficient in *Maneuvering* while *Puzzle Solving* is often the required skill in *Turn-Based Games*.

RELATIONS

Instantiates: *Preventing Goals, Continuous Goals, Tension, Movement*

Modulates: *Eliminate, Capture, Delivery, Traverse, Aim & Shoot*

Instantiated by: *Stealth, Aim & Shoot*

Modulated by: *Maneuvering, Puzzle Solving, Units, Deadly Traps, Time Limits, Lives, Damage, Enemies, Movement Limitations*

Potentially Conflicting with: None

Conceal

Conceal is the goal of trying to hinder other players' ability to gain information.

Having as much information as possible about the game state is usually advantageous, and *Conceal* is the goal of trying to prevent other players from gaining information about part of the game state.

Conceal is not only about preventing or hindering other players from finding out the location of the goal object; the aim of *Conceal* may be to keep certain information associated with a game element from the other players.

For example, in some strategy games, the player can use special actions to hide the actual strength of the unit, but not its location or existence. The exact location can also be partially hidden: the Elven cloak in a roleplaying game may hide the wearer in 80% of the cases, and cloaking devices in space games may show small bits of intergalactic fighters every now and then.

Example: The children's game *Hide & Seek* is the archetypical example of using *Conceal* where all children except one try to *Conceal* their locations.

Example: The game *Zendo* allows the master to secretly make a rule for how differently colored pyramids should be arranged to have Buddha nature, and the goal of the students is to try and extrapolate the rule from experiments.

USING THE PATTERN The information in *Conceal* goals can either be provided to the player or set up by the player, by either following rules or arranging game elements. The possibility to choose or create the information to be hidden allows the pattern to promote *Replayability* and to support *Freedom of Choice* and *Creative Control*.

Using the *Conceal* pattern involves choosing what is hidden, where it can be hidden, and when the action of hiding can be performed. Optionally, the support of producing *Red Herrings* can be introduced in order to let players generate *Asymmetric Information* for other players.

A common use of the *Conceal* pattern is to hide a game element, i.e., its location, but an attribute of a game element can also be hidden. When players have to hide *Avatars* or *Units*, this may give those players *Limited Sets of Actions* as they may only be able to do *No-Op* actions. Further, it may create *Tension* or force players to make *Risk/Reward* choices between using the game elements and giving other players information. As an example, the board game *Stratego* has the position of all pieces as public information, but a player does not initially know the rank of the other player's pieces. Each turn a player must move a piece, which provides *Imperfect Information* about which piece it is since many pieces have overlapping movement abilities.

CONSEQUENCES *Conceal* is a *Preventing Goal* to *Gain Information* but can also be an *Unknown Goal* since other players may not know who has the information. As a *Preventing Goal*, it is also a *Continuous Goal*, but as the information hidden may be context dependent, the player with the goal may choose to abandon the goal as a *Tradeoff* toward completing other goals. An example of this can be to choose to reveal one's position in an ambush when the enemy is sufficiently close to make an attack likely to succeed.

When the failure of *Conceal* can lead to the loss of *Lives*, the goal can be seen as a *Supporting Goal* to *Survive*.

When the information to be concealed can be concealed by a player through *Red Herrings* and suboptimal actions, this offers a form of *Creative Control* to that player. Games with secret tactics naturally have the goal to *Conceal* these from other players. In these cases, players may have to do *Risk/Reward* judgments between the

benefit of making the most optimal action and the risk of revealing what goals and *Resources* they own. The presence of this form of *Creative Control* may be to create *Surprises* when the information is revealed.

RELATIONS

Instantiates: *Preventing Goals, Continuous Goals, Unknown Goals, Replayability*

Modulates: *Gain Information, Survive*

Instantiated by: *Stealth, Imperfect Information, Asymmetric Information*

Modulated by: *Red Herrings, Freedom of Choice, Creative Control*

Potentially Conflicting with: None

Race

The competition between players to be the first to reach a certain goal, often being the first to a certain location following an approved route.

In the context of classical board games, David Parlett [Parlett99] classifies *Races* as being games concerned with being the first to get all pieces back home by traversing a linear track in as few turns as possible, using *Ludo* and *Backgammon* as examples. Modern board games, for example *RoboRally*, show examples of how *Races* can be expanded to include free movement on two-dimensional game areas. Computer-based racing games such as *F-Zero GX* or *Mario Kart Double Dash!!* allow players freedom of movement along the width of the track, and sometimes divide the track into several different tracks that offer different difficulties and advantages.

Although the most common type of *Race* is the one where players try to reach a specific location or place by moving, a *Race* does not need to depend on a spatial goal. Other possibilities include being the first to gain a competence or arranging game elements in a certain order. More generally in a *Race*, the players try to reach, or achieve, a certain game state before other players.

> **Example:** In *Races* using a linear track, 100 meter dash for example, these winning conditions of the race are easy to describe: the goal game state is to be the first person to physically pass a certain distance marker, and this is to be achieved by running.

> **Example:** The winning condition in *Pig* (a simple dice game) is to be the first one to *Score* a predefined amount of points.

Example: The collectable card game *ShadowRun* uses points; each successfully completed mission gives players points, the number depending on the difficulty level of the mission.

Example: *Golf* can be seen as a kind of *Race*. The players try to go through the track in as little game time as possible (bearing in mind that game time in *Golf* is measured by the amount of strokes).

USING THE PATTERN *Race* is a high-level goal that always requires the use of underlying goals to fill in the details of exactly what game state the players are trying to achieve and how the players can proceed to that game state. The most direct type of underlying goal for *Race* is *Traverse*, which is the traditional form of a *Race*, but by using *Score*, most forms of subgoals can be used to form *Races*. When several people can complete *Gain Competence* goals or have *Excluding Goals* that can be fulfilled at certain locations, this can take the form of a *Race* that is a *Supporting Goal*. Players starting with *Shared Resources* with players can exploit to gain *Individual Rewards* for *Races* between the players, for example, claiming *Area Control* of a previously unclaimed area through *Exploration*.

The end of a *Race* can be determined in several ways. The completion of an underlying goal, with *Traverse* as the prime candidate, can be used to determine the end of a *Race*, but the use of *Time Limit* makes the *Race* a matter of distance rather than of speed. By measuring the duration of activities to determine progress, typically by *Score*, *Races* can become *Continuous Goals* that typically go on until a specific resource, typically fuel or *Lives*, has been depleted from all players.

Players' feelings of participation in a *Race* depend heavily on whether they know their position in relationship to the other players. This requires that players have a certain *Game State Overview* so they can have a *Perceived Chance to Succeed*, typically *Progress Indicators* show the progress of all players, but *Status Indicators* can be used for *Races* with *Continuous Goals*. However, if players can perceive that they have very little chance of improving their position, the *Race* loses its *Tension*. To avoid this, one can add a *Balancing Effect* to the game so that trailing players are given various advantages.

The evaluation of who wins a *Race* when two or more players complete it simultaneously can either be done with a *Tiebreaker* or allow for *Tied Results*. Using a *Tiebreaker* increases the *Tension* and forces *Individual Rewards* while *Tied Results* make *Shared Rewards* possible.

Racing games that are *Real-Time Games* commonly use convoluted and winding tracks to add the extra dimension of having to *Maneuver*, making *Strategic Knowledge* of the *Game World* valuable. Requiring players to *Maneuver* makes skills in *Dexterity-Based Actions* important and brings in tactical *Risk/Reward* decisions of how fast the player is willing to speed down a track in relation to his skill.

It is possible to apply *Race* in almost any kind of game by introducing time as the determining factor of an outcome. All players do not have to start the *Race* at the same time, making *Races* possible in both *Asynchronous Games* and *Synchronous Games*, as the prime requirements of a *Race* are that the goals are the same for all players and that the starting conditions are equivalent, with the possible modification of *Handicaps*. The use of *Ghosts* allows for the creation of *Meta Games* that are *Asynchronous Games* based on merging a game instance with a recorded instance.

Some games, however, are better suited for *Races* than others, because there are natural possibilities for players to evaluate the distance between their current position, the goal, and the other players' relative positions. The accuracy of this relative position information may change over time varying the player's *Anticipation* and *Tension* levels as well as supporting *Player Defined Goals*. For example, in many racing games players have direct access to the relative position information if other cars are within the field of vision. Otherwise, they have to rely on a track diagram, which gives *Imperfect Information* through a *Game State Overview*. When an opponent comes into sight, the goal of overtaking that player becomes significantly more present as the possibilities and progress of the goal become easier to perceive.

CONSEQUENCES A *Race* gives players *Symmetric Goals* to strive toward. Further, if the players have means to judge their own progress and to know the progress of the other players through *Progress Indicators*, a *Race* promotes *Competition* and creates a *Conflict* between the players. *Races* are usually *Excluding Goals* through the use of *Tiebreakers* although *Tied Results* allow for *Shared Rewards*.

Traditional *Races* give rise to *Movement* in games and are modulated by *Movement Limitations* of individual players or effects of the environment.

RELATIONS

Instantiates: *Symmetric Goals, Competition, Conflict, Excluding Goals, Supporting Goals, Movement, Area Control*

Modulates: None

Instantiated by: *Traverse, Score, Gain Competence, Shared Resources, Individual Rewards, Exploration*

Modulated by: *Shared Rewards, Interferable Goals, Continuous Goals, Progress Indicators, Status Indicators, Ghosts, Maneuvering, Balancing Effects, Tiebreakers, Time Limits, Tied Results, Strategic Knowledge, Handicaps, Movement Limitations*

Potentially Conflicting with: None

REFERENCES

[Parlett99] Parlett, David. *The Oxford History of Board Games*. Oxford University Press, 1999.

GOALS OF ARRANGEMENT

These patterns deal with the spatial arrangements of game elements, typically offering strong visual clues about their status based on the gestalt law of connectivity. Some may also be used for temporal arrangement, but this use is uncommon and not as easily perceived as arrangements.

Collection

The completion of several goals that together form a coherent unit.

Collection is a high-level goal requiring completion of several subgoals. *Collections* are common in games to give players a better sense of what goals they will have to fulfill, how they have succeeded so far, and how the goals they presently are trying to complete fit in the overall play of the game.

> **Example:** *WarioWare, Inc.* is a *Collection* of small and quick games that have to be completed in sequence.
>
> **Example:** In *Decathlon*, players have 10 events to complete.
>
> **Example:** *Pac-Man* has to gobble up all the pills to finish a level. While eating each pill is a very low-level goal, the goal for each level is the *Collection* of all pills.
>
> **Example:** In *Lotto*, the *Collection* is completed by getting matching numbers during the draw.

USING THE PATTERN The simplest case is to use the *Collection* as the end condition of the whole game, that is, to finish the *Collection* is to finish the game. Other possibilities are to have the completion of a *Collection* as part of a *Hierarchy of Goals* or give *Rewards* that give *New Abilities* or increase a player's *Score*.

Of course, the nature and characteristics of the subgoals have to be defined when designing a *Collection*. These goals can be of the same nature, for example *Gain Ownership* goals to have *Ownership* over several identical *Pick-Ups* or *Eliminate* goals in deathmatch games or *Magic: The Gathering*, but can also be of a totally different nature as in *WarioWare, Inc.* and *Decathlon*. Adventure games often use *Collection* with different types of subgoals for progressing in the game. The player

first has to travel to a castle, find the key to a treasure chest, get the magic sword from the chest, and finally kill the dragon. In these games, the sequence in which the goals are achieved is significant to ensure *Higher-Level Closures as Gameplay Progresses*, and usually the last goal in the sequence is an encounter with a *Boss Monster*. However, games using a *Selectable Set of Goals* to define a *Collection* offer players *Freedom of Choice* and a variety of tactics. Often after finishing one *Collection*, another one is offered to the player, which can be seen as an application of *Dynamic Goal Characteristics*.

Common instances of *Collection* include *Last Man Standing* and *Configuration*. Games using *Last Man Standing*, such as *Magic: The Gathering* and deathmatch games without *Spawning*, use *Collection* to achieve *Team Elimination*.

CONSEQUENCES Achieving a *Collection* is done by performing *Collecting* actions so that players are the beneficiaries of *Transfer of Control* actions. A *Collection* is the easiest possible *Hierarchy of Goals*, a number of goals with an overarching goal. As *Collections* are *Hierarchies of Goals*, they allow the game progression to be structured into smaller sections and can be used to modulate *Tension* in *Narrative Structures*. *Collection* can be recursive so a *Collection* can be a subgoal of another *Collection* in order to create complex structures and hierarchies. The presence of a *Collection* makes the completion of all its subgoals into natural *Save Points*.

RELATIONS

Instantiates: *Hierarchy of Goals, Transfer of Control, Team Elimination*

Modulates: *Narrative Structures*

Instantiated by: *Gain Ownership, Configuration, Last Man Standing, Collecting*

Modulated by: *Selectable Sets of Goals, Save Points, Pick-Ups, Ownership, Dynamic Goal Characteristics*

Potentially Conflicting with: None

Additional Patterns

Descriptions of these additional patterns can be found in the Chapter 11 folder on the companion CD-ROM.

ON THE CD

Alignment	Delivery
Enclosure	Herd
Configuration	Contact
Connection	

GOALS OF PERSISTENCE

These goals are those that rely upon maintaining a certain part of the game state within defined boundaries rather than achieving the change of the game state to a certain subset. As such, their success criteria for the goals are usually defined through the failure of other players' goals or passing of time.

Guard

Guard is the goal to hinder other players or game elements from accessing a particular area in the game or a particular game element.

The nature of a *Guard* goal may range from simply detecting when another player is actively trying to achieve the goal, for example, being within a certain prohibited area, to actively trying to preempt the other player's actions. This blocking of another player's goal may be of an ephemeral nature, e.g., standing in a doorway when there are other doorways, or it may be more permanent, such as killing the player's *Avatar* so the player is out of the game.

> **Example:** The goalkeeper in *Soccer* must *Guard* the team's goal so that the ball does not enter it.

> **Example:** *Chess* and *Stratego* are games that one loses if one fails the mission to guard a specific game element: the king in *Chess* and the flag in *Stratego*.

USING THE PATTERN Creating a *Guard* goal consists of two components: choosing the objective to be guarded and the means by which the objective can be guarded. A *Guard* goal may be made easier through the use of *Alarms* to give the *Right Level of Difficulty*.

The means of guarding can be divided into two main categories: passive and active. Passive actions include changing the environment, e.g., through placing *Deadly Traps* or *Alarms*, or making certain activities impossible for the other player, e.g., by occupying a space and thereby hindering the other player from entering that space, but do not affect the actual game value associated with game elements under the other player's control. Active guarding actions are those that change the value of game elements, e.g., reducing hit points by attacking an intruder. Of course, passive actions can have second-order consequences that affect game elements under the other player's control, e.g., setting off an *Alarm* may call *Guards* that hurt the other player's *Avatar*.

To make the *Guard* goal more complex, some activities to defend the goal may only be performed after certain requirements have been fulfilled, e.g., an *Alarm* has

been tripped or an *Avatar* or *Unit* has to be within a forbidden area. Typically, the distinction is between active and passive activities, before the other player has performed certain "forbidden" actions, only passive actions may be used. Another way to complicate *Guard* goals is to make the area that is to be guarded too large to be watched at one time and using *Fog of War*, forcing players to have *Reconnaissance* goals.

If players are free to position game elements used in the task of guarding, the positioning of them promotes *Stimulated Planning* and allows players to make use of *Strategic Knowledge* about *Strategic Locations*, e.g., elevated positions.

If the goals opposing the *Guard* goal are *Optional Goals* to the opponents, i.e., if they can choose to *Traverse* to the guarded area and *Capture* the guarded game element or do something completely different, the *Guard* goal may never be fulfilled. However, not actively trying to ensure that the *Guard* goal is fulfilled compared to pursuing other goals is a *Tradeoff* to the player with the *Guard* goal between the perceived *Risk/Reward* of the different tactics.

CONSEQUENCES *Guard* requires observation of specific areas, game elements, or players in a game and is thereby affected by how players perform *Camping* actions. The *Guard* goal is a *Preventing Goal*, and as such automatically gives rise to *Conflict*. Further, as it is only completed after there is not a chance of the guarded game element being stolen or a part of the game area entered, it is a *Continuous Goal*. By giving several players the same *Guard* goal, it can be transformed into a *King of the Hill* goal.

Guard goals often make those that have them feel they have *Ownership* over what is guarded, even though it may not be the case in either the game system or the *Alternative Reality* of the game.

RELATIONS

Instantiates: *Interferable Goals, Preventing Goals, Continuous Goals, Risk/Reward*

Modulates: *Stealth, King of the Hill*

Instantiated by: None

Modulated by: *Rescue, Reconnaissance, Strategic Locations, Camping, Deadly Traps, Strategic Knowledge, Alarm, Fog of War, Ownership*

Potentially Conflicting with: None

Survive

The goal of trying to avoid being killed by actions of other players and events in the game.

Many games have effects that capture, destroy, kill, or eliminate game elements depending on the theme of the game. As these events are usually negative for the players who control the game elements, they have the expected goal of trying to make these units *Survive*.

> **Example:** The players are, sooner or later, going to have all their ships destroyed in *Space Invaders* or *Asteroids*, but surviving allows the players to keep on playing to gain enough points to reach a high score position.

USING THE PATTERN Defining a *Survive* goal for a player includes determining what game element should *Survive*, what danger exists and what actions the player can perform to avoid having game elements eliminated. The archetypical game element connected to a *Survive* goal is an *Avatar*, but having a certain percentage of *Units Survive* (as for example in *Lemmings*) can also be used. Gaining knowledge of what dangers exist and how dangerous they are offers possibilities for *Supporting Goals* that can either support *Stimulated Planning* or make the goal to *Survive* easier in itself.

Actions that are used to fulfill the goal can be divided into those that primarily focus on the game element that is to *Survive*, e.g., improving values such as hit points or defense or moving to advantageous locations, possibly using *Conceal* as a subgoal, or those that primarily focus on the dangers, e.g., preempting attacks. *Last Man Standing* is a special case of *Survive* where the goal to *Survive* is combined with *Eliminate* and players have to judge the *Risk/Reward Tradeoff* between being offensive or defensive.

The consequences of failing the goal to *Survive* can range from not being able to continue to play, as in the cases of games with *Player Elimination*, to the penalties determined by the loss of one of one's *Lives*, to simply *Spawning*.

CONSEQUENCES This is the *Preventing Goal* of *Eliminate*: to hinder another player or the system from *Eliminating* one's *Avatar* or *Units*. Games, e.g., old arcade games, that have the elimination of a player's *Avatar* as the end condition, use the pattern *Survive* as one of the high-level goals of the game.

The use of *Survive* is heavily connected with the use of *Lives* or *Parallel Lives*, and the level of threat can be used to modulate *Tension*.

RELATIONS

> **Instantiates:** *Preventing Goals, Continuous Goals*
>
> **Modulates:** *Eliminate*
>
> **Instantiated by:** *Last Man Standing*

Modulated by: *Lives, Avatars, Units, Player Elimination, Conceal*

Potentially Conflicting with: None

Traverse

The goal to try and move a game element from one position in the game to another.

Board games such as *Backgammon* and *Ludo* and all sports *Races* from the 100 Meter Dash to marathons to horse *Races* are examples of *Traverse* used together with *Race*.

> **Example:** Moving one's pawn to the opposite end of the board is a *Traverse* goal in *Chess.*

> **Example:** Platform games such as those in the *Mario* or *Super Monkey Ball* series can be defined as having *Traverse* goals of going from the beginning of a level to the end.

USING THE PATTERN The two main considerations when designing a *Traverse* goal are the actual game space that has to be moved through and the ways in which players can move. The game space can either only allow one specific path to be followed (having one *Goal Point* at the end location), as in *Snakes & Ladders* (players do not have a choice of how to move although the ladders and snakes provide shortcuts and returns to earlier places), or allow players to choose between different paths (having at least one *Goal Point* at the end location and possibly intermediate *Goal Points* that have to be visited). The latter allow players to make plans depending on what *Strategic Location*s exist as well as what *Enemies* and *Obstacles* exist, for example, letting players choose between *Evade* and *Overcome* goals.

The means of *Movement* players have can be linked to *Risk/Reward Tradeoff*s as well as provide different players with different routes to advance on by the use of *Privileged Movement*. The use of intermediate *Goal Points* can create a *Hierarchy of Goals* consisting of various *Traverse* Goals. The *Goal Points* can be used to support *Safe Havens*, and their introduction allows players to get relief from *Tension* and promotes *Stimulated Planning* for the next phase of *Movement*. By making the *Goal Point* initially an *Inaccessible Area*, the *Traverse* goal can be the main goal of a *Hierarchy of Goals*, where several other sorts of activity besides *Movement* need to be performed. When the reason for a *Traverse* goal is to achieve *Area Control* of the *Goal Point*, the *Strategic Location* of the *Goal Point* needs to be considered, as this will modulate the willingness of players to strive for the goal.

Common variants of *Traverse* include *Delivery*, where the goal objects to be moved are not the game elements doing the movement, and *Herd*, where *Indirect*

Control and *Units* are used for moving the goal objects. *Herd* can also be a *Preventing Goal* of *Traverse* when a player's movement can be affected by other players' actions. By giving players *Imperfect Information* about the *Game World* between the starting point and the end point, *Traverse* goals can becomes goals of *Exploration* or *Reconnaissance*.

If some form of *Limited Resource* is consumed by *Movement*, the *Right Level of Complexity* of a *Traverse* goal is affected as choices of which terrain is traversed and what movement styles to employ become important. Racing games usually provide some form of *Charger* or *Pick-Ups* in specific *Resource Locations* and, in *Races,* force players to make *Risk/Reward* choices between saving time and risking not having enough *Resources* or losing time but having *Resources*.

When the player has *Freedom of Choice* regarding *Movement* in a *Traverse* goal, the goal may require that players are given information about where the *Goal Point* is located. *Game State Overview* can be used to support players with this information as can *Traces*, which may be seen as *Supporting Goals* of shorter and easier *Traverse* goals.

Traverse goals can be used to modulate the likelihood for players to attempt different goals in *Selectable Sets of Goals* by having the *Traverse* goals as subgoals that have to be performed before individual goals.

CONSEQUENCES *Traverse* gives players a clear goal to achieve and allows them to judge their local progress by their position in the game space. Although this may function as a *Progress Indicator*, it does not necessarily give a good *Game State Overview*, as the area that has to be traversed can be significantly greater than the player can view at any one time. *Traverse* as a goal requires players to perform *Movement* and uses the *Contact* goal of reaching a target object as the end condition. *Traverse* is very often used as the subgoal for *Races* and required part of *Stealth* goals. The presence of *Save Points* creates *Traverse* goals that break the *Consistent Reality Logic*.

As *Traverse* depends on players moving from one area within the *Game World* to the other, the completion of the goal guarantees that the player has changed environment. This can be used to set up different modes of play or explain variations in repeating goals and progress the *Narrative Structure*.

Trying to achieve *Traverse* goals makes *Aim & Shoot* actions more difficult, regardless of if the players performing the *Traverse* goals are aware of the actions.

RELATIONS

Instantiates: *Race, Goal Points, Progress Indicators, Movement, Contact, Area Control*

Modulates: *Stealth, Narrative Structures, Aim & Shoot, Selectable Sets of Goals*

Instantiated by: *Delivery, Exploration, Reconnaissance, Inaccessible Areas, Save Points*

Modulated by: *Indirect Control, Evade, Herd, Privileged Movement, Strategic Locations, Obstacles, Traces, Safe Havens, Chargers, Enemies*

Potentially Conflicting with: None

Additional Patterns

Descriptions of these additional patterns can be found in the Chapter 11 folder on the companion CD-ROM.

ON THE CD

King of the Hill

Last Man Standing

GOALS OF INFORMATION AND KNOWLEDGE

These goals relate to gaining information or knowledge about abilities and actions. The information can either be *Extra-Game Information*, that is the information spread is not codified in the game system, or controlled by the mechanics in the game, and may in the latter case not be known to any player.

Gain Information

The goal of performing actions in the game in order to be able to receive information or make deductions.

The *Gain Information* goal is simply the task of gaining more knowledge about something in the game. This can be discovering where a certain game element is in the game space, knowing what values game elements have, what abilities other players have access to, or what goals exist. The completion of the goal can either be verified by a game state change that does not require the player to actually understand the information or by requiring the player to perform some activity or complete a goal that indicates that the information has been interpreted by the player. In the first case, this can be by the player gaining an object, e.g., picking up a book, or choosing an action that presents the information to the player, e.g., looking at a sign. In the second case, this can be by observing that the player has done an action that was unlikely to have been performed otherwise, e.g., selecting the right five-digit combination to a safe.

Example: *Gain Information* is the typical goal used in mystery games to drive the unfolding of the story, e.g., the *Gabriel Knight* series.

Example: *Hide & Seek*, the traditional children's game, is the archetypical example of direct use of this pattern. In the game, one of the players is the seeker whose task is to find the other players who have had a certain amount of time to hide themselves.

USING THE PATTERN The prerequisite for using *Gain Information* is that there is *Imperfect Information* in the game, or that there is *Uncertainty of Information* about the information that is known. *Hide & Seek*, for example, does not work properly in a small empty room with three people. Another example, creating *Imperfect Information* through the use of *Asymmetric Information* can be found in card games using *Card Hands*. Games with *Fog of War* often have *Exploration* and *Reconnaissance* as dynamic *Gain Information* goals during the game.

The *Reward* for completing a *Gain Information* goal can either be in the form of *Direct Information* or *Indirect Information*, and both of these often counter *Limited Foresight* players have. The former can be encoded in the game state or be given to the players, but in either case, refer explicitly to the game state, but may ruin *Emotional Immersion* when given to players. Both forms of information can support *Stimulated Planning* when given to players, but *Indirect Information* can require more due to the translation required. Similarly, *Indirect Information* can more easily spawn new *Gain Information* goals to check the correctness of information when there is *Uncertainty of Information*.

The search for *Secret Resources* or other game elements related to *Gain Information* goals requires that the player has at least a rudimentary idea of what is being sought and can include the knowledge in which part of the *Game World* the game element can be found. Limiting the search space can be done by limiting the actual space the player can explore, e.g., through the use of *Level*, or by informing the player about the general whereabouts of the information but not limiting the players' activities to that space, e.g., through a *Helper*. In the latter case, gaining that information can be a *Gain Information* goal in itself.

Gain Information goals occur naturally in games with *Committed Goals* that are also *Unknown Goals* to the other players. In this case, the other players gain an advantage by revealing the *Committed Goal*, and typically game strategies involve figuring out the other players' goals.

Many *Gain Information* goals are *Supporting Goals* to other goals; examples of these types of *Gain Information* goals include finding enemies' *Achilles' Heels*, locating *Strategic Locations*, and finding *Clues*. The completion of these goals thereby promotes players to do *Memorizing* of the information revealed by solving them.

CONSEQUENCES *Gain Information* goals can easily be included as both *Optional Goals* and *Supporting Goals* to make other goals easier, especially *Puzzle Solving* but also for other types of goals, e.g., discovering the *Achilles' Heel* of a *Boss Monster* to more easily *Eliminate* him. *Narrative Structures* can in contrast have *Gain Information* goals that are *Committed Goals* in order to ensure that the player experiences the narrative in the intended way. The use of *Gain Information* creates a *Preventing Goal* when what is sought is something that another player has the goal to *Conceal*.

If the information that is sought is represented by physical game elements, i.e., *Clues*, the completion of the goal can be followed by or combined with a *Gain Ownership* goal. If the amount of required gameplay between the completion of a *Gain Information* goal and a *Gain Ownership* goal of a game element is large, the *Gain Information* goal can be seen as a *Supporting Goal*. When the player has all the physical game elements, the completion of the goal can be traditional *Puzzle Solving* or found by *Experimenting*.

If the player has information about what information is being sought, the *Gain Information* goal can promote *Stimulated Planning*, especially if the goal is an *Optional Goal* or part of a *Collection*, and can support a *Narrative Structure*.

RELATIONS

Instantiates: *Uncertainty of Information, Puzzle Solving, Supporting Goals, Memorizing, Experimenting*

Modulates: *Clues*

Instantiated by: *Gain Ownership, Strategic Locations, Exploration, Achilles' Heels, Card Hands, Reconnaissance, Unknown Goals, Committed Goals, Secret Resources, Imperfect Information, Asymmetric Information, Fog of War, Puzzle Solving, Limited Foresight*

Modulated by: *Conceal, Indirect Information, Perfect Information*

Potentially Conflicting with: *Perfect Information*

Gain Competence

Gaining the ability to perform a certain action within the game.

This is the goal to gain the ability to perform a certain action, either by enabling a game element to perform that action or by gaining control of a game element that can perform that action. Typical examples of games using *Gain Competence* goals are roleplaying games where the players' characters gain skills and real-time strategy games with research.

Gain Competence is not the ability for a player to perform an action skillfully (see the patterns regarding *Game Mastery* and fields of expertise for individual discussions of these player actions).

Example: *Quake* and *Unreal Tournament* have *Gain Competences* goals that are linked to acquiring weapons, since the different weapons have radically different abilities.

Example: Computer-based roleplaying games, such as *Neverwinter Nights* and *Morrowind*, have many abilities, most commonly spells, that are not available to the players. Learning these abilities provides significant help in completing the games, and gaining them may become explicit goals that are the focus of player actions at the expense of the main goal.

USING THE PATTERN The *Gain Competence* goal can be achieved by completing other goals, typically *Gain Ownership* or *Overcome*, but can also be the result of *Investment* or gaining *Resources*.

The *Rewards* from *Gain Competence* are commonly to give players advantages by providing *Privileged Abilities* or *Improved Abilities* (often through *Skills*) that allow for alternative tactics or make the fulfillment of goals easier. If the *Gain Competence* goal is a *Symmetric Goal* so other players also can gain the same competence, this can provide a *Race* or a *Red Queen Dilemma*.

The actions made possible by a *Gain Competence* goal can either be associated directly with the player or with a game element. In the latter case, this can either be modeled as skills of *Avatars* or *Units* that usually cannot be lost except by elimination of the game element itself, or as actions made possible by *Tools* or *Pick-Ups* that can be lost, traded, or disappear after a certain number of uses due to *Limited Resources*. Similarly, *Power-Ups* and *Chargers* can be used to give an *Avatar* or *Unit* a new form of action for a set *Time Limit* or numbers of uses.

CONSEQUENCES *Gain Competence* goals give players offers of *Empowerment* and can be motivated by *Limited Set of Actions* or *Asymmetric Abilities* where the players feel disadvantaged. They are thus common effects of *Planned Character Development*.

Gain Competence goals can often be described as receiving a *New Ability* or *Improved Ability* event as a *Reward*. However, this may only be from the perspective of the current game state: regaining abilities to counter *Ability Losses* is also a *Gain Competence* goal and probably has stronger *Emotional Immersion*.

Gain Competence can be used to provide players with *Smooth Learning Curves*, as players do not have to consider all possible actions in the game in early states of the game and allows for *Varied Gameplay* within a game since new possibilities open up later in the game. Further, it can be used to ensure the *Narrative Structure* and open up new areas in the game. *Gain Competence* is also one way to provide *Character Development*.

RELATIONS

Instantiates: *Race, Character Development, Red Queen Dilemmas*

Modulates: None

Instantiated by: *Gain Ownership, Tools, Power-Ups, Chargers, New Abilities, Improved Abilities, Privileged Abilities, Ability Losses, Asymmetric Abilities, Skills, Planned Character Development*

Modulated by: *Limited Set of Actions, Empowerment*

Potentially Conflicting with: None

Exploration

The goal of learning the layout of the Game World, or locating specific parts or objects in it.

In games where the whole *Game World* is not known at the beginning of the game, it is often advantageous to try and acquire this knowledge during gameplay. Typically examples of this use of *Exploration* can be found in real-time strategy games, first-person shooters, and roleplaying games.

> **Example:** Games in the *Civilization* series start with the players knowing very little about the *Game World* as illustrated in Figure 11.1. A prerequisite for being able to plan on a higher level against the other players or how to expand one's civilization depends on completing as much *Exploration* of the world as possible.

USING THE PATTERN The definition of an *Exploration* goal is by its nature fuzzy. The player is given the task that there is something important to find in an unknown territory in the *Game World*, either specific game elements or *Strategic Locations*, but the exact locations of the *Goal Points* are not known. However, the exact nature of what is to be found does not have to be explicitly known either, giving game designers two different options for *Surprises. Exploration* often makes use of *Supporting Goals* that provide partial information of how to find the main goal of the search.

For *Exploration* to be used, games need to provide a form of *Movement* in the game space that is non-linear, so that a player has to decide in which direction to explore. That said, the area to be explored may be predetermined or be created using *Randomness* or a game board constructed by another player. The latter supports *Replayability* while the former can more easily provide a *Narrative Structure* or *Surprises*.

FIGURE 11.1 The players have to explore the unknown territories in *Civilization III*. Civilization II and Civilization III screenshots courtesy of Atari, Inc. © 2004 Atari, Inc. All rights reserved.

Resources, Outstanding Features, Obstacles, Traces, and *Clues* are typically used in designing the *Game World* to support *Exploration* and give points of reference. *Enemies* and *Deadly Traps* are also commonly used to provide *Optional Goals* or increase the *Tension* at certain points. *Easter Eggs* are special cases that provide extra-game rewards for *Exploration*. The design of the area in which the *Exploration* goal is situated can be postponed by using *Tile-Laying* to create the *Game World* as it is being explored.

Common reasons for *Exploration* besides explicitly given goals are the known existences of *Secret Resources,* for example, *Resources* needed to perform *Construction* actions. When these *Resources* are also *Shared Resources,* they put players in *Races* against each other. The use of *Levels* guarantees a form of *Exploration* goal, since the unvisited *Levels* are unexplored areas. The knowledge that *Resource Generators* exist is a motivation for *Exploration* in real-time strategy games.

CONSEQUENCES *Exploration* is movement in the *Game World* with the aim of finding game elements or charting the *Game World*. It requires *Game World Navigation*

and *Memorizing* the layout unless some *Game State Overview* shows the already-explored areas. As *Exploration* relies upon the environment being unknown to players, it gives players *Limited Foresight* and can be used to create *Surprises*. The possibility of *Surprises*, the feeling of discovering new places, and *Illusionary Rewards* in the form of aesthetically pleasing *Outstanding Features* can all give players *Emotional Immersion*.

Exploration is a special case of combining *Traverse* and *Gain Information* and, like the latter, requires either *Imperfect Information* or *Uncertainty of Information*. *Exploration* differs from *Reconnaissance* in that the places, areas, and area boundaries are not known and the player has to get more information about them when there is *Fog of War*. *Exploration* can be used to move players into new game spaces, either to provide *Varied Gameplay* by the novelty of the area or provide *Surprises* to put the player at a disadvantage, e.g., by the lack of knowledge of *Strategic Locations*.

Single-Player Games that support *Exploration* through *Easter Eggs* and other *Optional Goals* offers players the opportunity to trade knowledge between game instances.

RELATIONS

Instantiates: *Gain Information, Uncertainty of Information, Surprises, Traverse, Emotional Immersion, Game World Navigation, Movement, Race*

Modulates: *Varied Gameplay, Memorizing, Single-Player Games*

Instantiated by: *Levels, Resource Generators, Secret Resources, Illusionary Rewards, Tile-Laying, Construction, Limited Foresight, Shared Resources, Imperfect Information, Game World*

Modulated by: *Strategic Locations, Outstanding Features, Obstacles, Traces, Clues, Enemies, Deadly Traps, Goal Points, Easter Eggs, Surprises, Resources, Fog of War, Game State Overview*

Potentially Conflicting with: *Replayability*

Additional Pattern

ON THE CD A description of this additional pattern can be found in the Chapter 11 folder on the companion CD-ROM.

Reconnaissance

12 Game Design Patterns for Goal Structures

This chapter looks at the game design patterns that affect goals, i.e., patterns that describe gameplay aspects that are closely related to goal patterns but are not goal patterns in themselves. This includes patterns of how goals relate to winning the game, patterns of how goals relate to each other, and patterns of how goals affect players' relations to each other in gameplay. These patterns can either be seen as variations that can be applied to goal patterns or as patterns that describe the intended gameplay on a higher level than actual goals.

As is the case with components and actions, players may not know all details about what goals exist in a game or what goals different players are pursuing or are committed to. This knowledge is governed by applying patterns related to information on the goals available to the individual player. Some games, e.g., *Chess*, *Tennis*, and *Soccer*, have *Perfect Information* and *Symmetric Information* about the goals each player has; that is, every player has full knowledge about what goals all other players have. Note that this does not include complete information about the strategies players have, nor necessarily what goals other players are striving to achieve.

Goal Characteristics: *Predefined Goals, Dynamic Goal Characteristics, Optional Goals, Interferable Goals, Player Defined Goals, Ephemeral Goals, Continuous Goals, Unknown Goals*

Relations Between Goals: *Preventing Goals, Hierarchy of Goals, Tournaments, Incompatible Goals, Selectable Sets of Goals, Supporting Goals, Polyathlons, Excluding Goals*

Relations Between Goals and Players: *Symmetric Goals, Asymmetric Goals, Committed Goals, Mutual Goals*

GOAL CHARACTERISTICS

These patterns focus on the possible variations for basic goals. They can be seen as patterns that can be applied to the goal patterns in the previous chapter to modify them to suit an intended gameplay.

Predefined Goals

Predefined Goals are preset by the game designer, usually arranged in a rigid hierarchy, which can only be adaptable by players' choices or interpretations if the design allows it.

To make goals unambiguous, *Predefined Goals* are described using the components of the game and have *Rewards* described and implemented through the game system. All winnable games, i.e., games where there exists a game state that defines one or several winners, have the predefined primary goal that can be stated as: win the game. This is so common that the existence of such a goal is sometimes used to define what a game is, but examples such as the *Sims*, *Tetris*, and *Pac-Man* show the existence of games that at least question if these definitions are inclusive of all games.

> **Example:** *Chess* has the *Predefined Goals* for each player to checkmate the other player's king.

> **Example:** *Monopoly* has the *Predefined Goal* of eliminating all other players by driving them into bankruptcy.

USING THE PATTERN *Predefined Goals* require that explicit boundaries be set by the game design to what game states are considered successes and how players can reach those game states. However, within these boundaries the player can have some freedom, which can be instantiated by a *Selectable Set of Goals* or by not specifically defining what actions need to be performed to achieve the main goals, nor in which order the actions need to be performed. This is the case in *Planned Character Development* where players must be able to have some *Predefined Goals* to be able to plan but at the same time need some freedom for the plans to be theirs and not the game designers.

Although goals may be predefined, the information about what goals exist (the first time a game is played) or what goals players (which might include oneself) are trying to achieve may be unknown. The combination of *Predefined Goals* with *Perfect Information* and *Symmetric Information* allows players to form more complex strategies allowing *Strategic Knowledge* to be developed, especially in the situation where subgoals are also known to the players. However, this may lead to the *Analysis Paralysis* situation if the game allows too complex strategies to emerge.

The use of *Asymmetric Information* with *Predefined Goals* leads to situations where players try to guess or otherwise get information about the other players' goals in order to formulate their own strategies. The way the goal information is obtained can, of course, vary from game to game, especially if the game allows *Social Interaction* between players.

CONSEQUENCES *Predefined Goals* are a powerful way for game designers to direct players' intentions, both for promoting certain forms of activities of the players and for setting up basic relationships between the players. As such, *Predefined Goals* are common in all games to ensure that all players have a common understanding of the motivations for actions in the game. The simplest case, using *Perfect Information* and *Symmetric Information*, can be found in almost all traditional board games. As players can learn the strategies for completing *Predefined Goals* by playing the game repeatedly, the forms of goals support the development of *Game Mastery*. *Predefined Goals* are by their nature incompatible with *Ephemeral Goals*.

Although *Predefined Goals* may be *Unknown Goals* the first time a game is played, they will not be so in following game instances, making the patterns difficult to combine in games that aim to have *Replayability*.

The direction of action that *Predefined Goals* support can, however, limit players' *Freedom of Choice*, especially if applied to lower level goals or goals that are easy to complete. Imagine a point-based variant of *Chess* where checkmate gives 20 points; capturing a rook, knight, or other second row piece gives 5 points; and capturing a pawn gives 1 point but only before any second row pieces have been taken. Although game sessions of this variant would be contained within what is possible in a normal *Chess* game, these games would probably more often contain captures exchanged and would discourage crowded checkmate situations, which would limit the strategies and tactics normally used in *Chess*. Therefore, *Chess* and other games without many *Closure Points* usually do not have many *Predefined Goals* either. Typically, only the main goals are predefined, while players can choose the low-level goals themselves from a *Selectable Set of Goals* whose rewards are not explicitly linked to the main goal.

RELATIONS

Instantiates: *Hierarchy of Goals, Analysis Paralysis, Strategic Knowledge, Selectable Sets of Goals, Game Mastery*

Modulates: *Planned Character Development*

Instantiated by: *None*

Modulated by: *Perfect Information, Imperfect Information, Symmetric Information, Asymmetric Information, Closure Points*

Potentially Conflicting with: *Freedom of Choice, Ephemeral Goals, Unknown Goals*

Dynamic Goal Characteristics

Certain characteristics of the goals, usually the information available to the players, change during gameplay.

Many games have goals whose requirements change from the players' perspective during gameplay. There are two kinds of changes through which this can occur: either the players gain more information about the requirements or the requirements change. The first case is common in adventure and roleplaying games. In this case, the player may first know only the final goal, e.g., defeat the evil overlord without knowing how this is possible, and the subgoals that make the goal possible are gradually revealed to the player during gameplay. A common way to change the requirements of goals is to define the goals using variables of the game state. Winning most ball sports can be defined as having a higher score than the other team, making the goal definition depend on the other team's score.

The use of *Dynamic Goal Characteristics* to describe a goal can in many games also be done by defining a static high-level goal, which starts with one subgoal and whenever that subgoal is completed, generates a new subgoal that has the same general structure as the previous subgoal. Which is the better description depends on the level of detail needed and on the purpose of the description: the former may, for example, be simpler to use when explaining the rules to someone that is going to play a game, while the latter may be easier to implement in program code.

Example: In the roleplaying game *Neverwinter Nights*, part of the overall goal at the start is to perform a complicated ritual with several non-player characters. When the ritual is finally performed, it turns out that one of the characters doing the ritual is a traitor, and then another goal is revealed to the player: defeat the traitor.

Example: Many children's games, such as *Tag* and *King of the Hill*, can either be described as using *Dynamic Goal Characteristics* or having a static high-level goal with subgoals that switch from avoiding one person to avoiding another person (or being the hunter) in *Tag* and from defense to offense in *King of the Hill*.

Example: The card game *Fluxx* has the current winning goal represented by a played card. Although the game can be said to have the static goal of fulfilling the goal card criteria, the specific winning goal changes as soon as a player plays a new goal card.

USING THE PATTERN The main design choice for using *Dynamic Goal Characteristics* is, of course, to choose what characteristics of the goal are going to be dynamic. As mentioned previously, changing the information related to a goal is often used in adventure games and *Role Reversal* is perhaps one of the most common ways to instantiate *Dynamic Goal Characteristics*. Another common way is to have an *Eliminate* goal related to a certain kind of a game element but having a *Resource Generator* that generates the actual element.

The goal definition can be conditionally dynamic as is the case in, for example, *Squash*. The first goal is to get nine points, but if the player does not have a two-point lead, the goal becomes dynamic in regard to the amount of points required for winning the game. This automatically guarantees that there is a *Perceivable Margin* for the winner. The obvious way of describing the goal is to change the definition from absolute (e.g., nine points are needed) to relative (e.g., at least nine points are needed and two points more than the other player).

Another way to create *Dynamic Goal Characteristics* with changing requirements is to use a *Player Defined Goal* but allow players to change the definition during gameplay according to certain rules. *Planned Character Development* is an example of how *Player Defined Goals* can be combined with *Dynamic Goal Characteristics*: players make plans for their *Characters* based upon their wishes and the current game state but as the *Narrative Structure* unfolds, the game state may change so that the ways to reach the *Planned Character Development* change as well, and may also make the player choose different goals altogether for the development of the *Character*.

CONSEQUENCES The use of *Dynamic Goal Characteristics* to reveal information about a *Hierarchy of Goals* in stages lets the goals of a player be strongly linked to revealing the *Narrative Structure* of the game. This use, common in many adventure games, allows the game to be complex and also increases the play time without confusing the player, especially if used to hide goals that no longer can be fulfilled due to *Excluding Goals*. This kind of use of *Imperfect Information* also leads to more possibilities of dramatic narrative turns in the game. Goals may effectively be *Unknown Goals* if the number of variants allowed by the *Dynamic Goal Characteristics* is large enough.

Having the requirements of a goal change during gameplay can be used to ensure that there is a *Perceivable Margin* between the winner and other players, e.g., requiring that the winner has two more points than the other player in some ball games.

RELATIONS

> **Instantiates:** *Imperfect Information, Perceivable Margins, Resource Generators, Unknown Goals*

Modulates: *Collection, Narrative Structures, Hierarchy of Goals, Excluding Goals, Planned Character Development*

Instantiated by: *Role Reversal*

Modulated by: None

Potentially Conflicting with: None

Optional Goals

There are goals the player does not necessarily have to reach during the game.

Reaching the *Optional Goals* does not advance the player's progress toward the primary goals of the game. However, solving an *Optional Goal* might help the player indirectly by making other goals easier to solve, either by changed values in the game state or through providing the player with the opportunity to train skills.

> **Example:** Collecting extra heart pieces in the *Zelda* series are *Optional Goals* that help the player.
>
> **Example:** In one of the games in the *Ultima* series, one can bake bread, but this is of no use to the player in the game.
>
> **Example:** The secret areas in *Castle Wolfenstein* offer several types of *Rewards* to players but are not required to complete the game. After accidentally finding one, or being informed by other players, the player does not know where these areas are but does know that they exist and can choose to spend time looking for them.
>
> **Example:** The games in the *Final Fantasy* series provide many quests that give experience points and objects when they are fulfilled but they are not necessary to solve to complete the game.
>
> **Example:** The game *Day of the Tentacle* contains the whole predecessor, *Maniac Mansion*, as part of a game console that is within the game. The whole inner game could be finished without providing any advantage to the outer game.

USING THE PATTERN When considering a potential optional goal, one has to analyze if the goal is actually optional or a prerequisite for another goal. Further, should the goals be openly indicated to the players or something that the players have to find? Goals that appear to be required but in effect are optional can serve as a form of *Red Herrings* in a game.

One way to provide *Optional Goals* in games is to include *Easter Eggs* or *Games within Games*, which either provides advantages in the main game depending on how they are completed or simply provides possibilities for additional entertainment.

Another way of providing *Optional Goals* is to support *Player Defined Goals* that are not enforced by the game. These goals are by definition optional but as they are defined and chosen by players, they may be more rewarding than the goals coded into the game.

A goal cannot simultaneously be an *Optional Goal* and a *Committed Goal*.

CONSEQUENCES *Optional Goals* offer the player an increased *Freedom of Choice* about what to do in the game and can also increase the *Replayability* as there may be many unfinished goals even after the game has been finished the first time. This can also provide a *Meta Game*, as one can compare the number of *Optional Goals* the players have completed. Further, most *Optional Goals* can be seen as *Supporting Goals* as many *Rewards* increase the overall likelihood of succeeding with other goals. For example, *Trading* gold for more powerful weapons in roleplaying games helps the players reach their further goals. However, *Optional Goals* can also work as *Red Herrings*, distracting the players from the main goal of a game without helping the overall state of the player.

Optional Goals are often part of *Selectable Sets of Goals* in a *Hierarchy of Goals* to offer players a selection of goals even though they may not have to complete more than one of them. If the *Optional Goals* are not known to players before gameplay begins, they are *Ephemeral Goals*.

RELATIONS

Instantiates: *Selectable Sets of Goals, Supporting Goals, Freedom of Choice, Replayability, Red Herrings, Meta Games, Hierarchy of Goals*

Modulates: *Ephemeral Goals*

Instantiated by: *Games within Games, Player Defined Goals, Easter Eggs*

Modulated by: *Trading*

Potentially Conflicting with: *Committed Goals*

Interferable Goals

The game system or other players can directly influence the player's progress toward the goal.

Many goals of the player can be influenced by other players or the game system. Such goals, defined as *Interferable Goals*, have an end condition or an evaluation function depending on variables in the game state that can be directly affected by others. The pattern is commonly used together with a high-level goal that does not allow the players to have an effect on other players' game elements, in order to create more complex gameplay. Games of direct *Conflict*, such as *Chess* and *Tennis*, always have *Interferable Goals*.

Example: *Backgammon* has the goal of moving your pieces to your own inner table (to be able to start the larger goal of "bearing" them off the board). However, the opponent can interfere with the low-level goals of moving each individual piece to the inner table by "ousting" the vulnerable pieces. *Backgammon* without ousting is not using *Interferable Goals* even though the player can block opponent's progress as the player's actions do not have direct effect on the opponent's game state.

USING THE PATTERN Making a goal interferable consists of choosing in what way the system or other player's actions can affect the game state related to the evaluation function of the outcome. The simplest way is to give other players possible actions that have a direct effect on those attributes that govern the evaluation function of the outcome. The previous example of ousting in *Backgammon* is about having a direct effect on the attribute of how near to the completion the pieces are. It is also an example of using *Capture* to make the higher level *Race* goal interferable. When using *Interferable Goals*, the players have to know something about the other players' game situation, making excessive use of *Uncertainty of Information* and *Imperfect Information* unsuitable and *Symmetric Information* suitable.

If one wants to promote *Conflict* by using *Interferable Goals*, the possibility to interfere can be encouraged in the form of a *Preventing Goal*. Common examples of *Interferable Goals* are *Guard, Overcome, Last Man Standing, King of the Hill*, and maintaining *Area Control*. Choosing to view the completion of *Interruptible Action* as goals allows players to create their own *Interferable Goals* of interrupting those actions.

CONSEQUENCES *Interferable Goals* allow players to be aggressive toward one another, in essence, letting them decide if they want to have a *Conflict* or not. This makes the gameplay more complex and varied as the players have to also take into account other players' intentions and possible actions. These characteristics also make *Interferable Goals* suitable for games with the possibility of *Alliances* between players. *Symmetric Goals* are often also *Interferable Goals* to offer players a wide range of tactics.

RELATIONS

Instantiates: *Conflict*

Modulates: *Race, Symmetric Goals, Area Control, Alliances, Symmetric Information*

Instantiated by: *Guard, King of the Hill, Last Man Standing, Preventing Goals, Interruptible Actions*

Modulated by: None

Potentially Conflicting with: *Imperfect Information, Uncertainty of Information*

Player Defined Goals

Goals and subgoals that players can create or customize within the game itself.

Structured *Player Defined Goals* are possible by providing mechanics to let players determine the requirements, rewards, and punishments of the goals by having explicit game rules that govern these goals. By specifying the end conditions and evaluation functions within the game as conditions of the game state, these *Player Defined Goals* can then be monitored by the game system similarly to other goals.

> **Example:** *Player Defined Goals* are employed in *Diplomacy* in a way that the players can set their own secret goals and strategies, but the impact of the *Player Defined Goals* is more evident when some players agree on acting together against another player. However, the goals are only an agreement between the players and they are not explicitly stated in the game mechanics or rules.

> **Example:** *SimCity* and most of the other *Sim*-games are good examples of games where *Player Defined Goals* are possible and also integral to the resulting gameplay. The gameplay is open as there are no winning conditions provided by the game itself and the game system is complex enough to allow huge amounts of different outcomes. The player is free to choose and pursue as a goal almost any possible game state from building the biggest city to making a strong police state to having fun in bulldozing the suburban areas when they are flourishing.

USING THE PATTERN Players can always decide why they are playing the game, so that in one sense all games have *Player Defined Goals*. One category of goals that can be particularly easily constructed independently of the game state is *Preventing Goals*; players may simply decide that hindering other players from gaining *Rewards* by completing goals are *Rewards* in themselves.

Game designs can encourage *Player Defined Goals* by providing additional forms of *Rewards* in the game that are not explicitly tied to winning or completing the game. Examples of such *Rewards* are *Easter Eggs* and *Illusionary Rewards*, allowing players to perform *Collecting* or *Construction* actions for their own sakes. Creating a *Character* can give players *Player Defined Goals* already before actual gameplay begins and can be continued by allowing the *Character Development* to be *Planned Character Development*.

When creating support for *Player Defined Goals*, game designers can choose not to explicitly encode the goals in the game or to provide mechanics for allowing players to explicitly define their goals together with *Rewards* and *Penalties*. The former case is typically made possible by having a dynamic system governing the flow of the game that is sufficiently complex enough to allow huge amounts of different outcomes. In the latter case, this often means providing many clearly defined closures to choose from and providing *Game State Overviews*. If the goals can be changed during gameplay through *Dynamic Goal Characteristics*, these can offer *Freedom of Choice* but at the same time affect *Player Balance*.

However, the evaluation function of rewards and penalties does not need to be constrained by the game. The digital roleplaying games, be they single player or massively multiplayer, use *Player Defined Goals* in this way. For example, in *Dark Age of Camelot* the players can agree on attacking a powerful monster together, creating a new *Mutual Goal* for the players through a *Negotiation* phase.

CONSEQUENCES *Player Defined Goals* allow players to set their own reasons for feeling *Anticipation* and *Tension*.

The use of *Player Defined Goals* allows players not only to have *Creative Control* of how they play a game, or what they create in a game, but also why they play the game. In all these cases, *Player Defined Goals* support *Constructive Play* as well as *Freedom of Choice*. If the goals are not directly enforced by the game, *Player Defined Goals* can provide *Optional Goals*. A typical example of such an *Optional Goal* that players can define for themselves is if they want to participate in *Bidding* or *Betting*.

Player Defined Goals that are not controlled through the game mechanics are a form of *Extra-Game Consequences*, that is, they are not expressed explicitly within the game system itself. These kinds of goal cannot have *Penalties* for failing to reach the goal besides the already present consequences of failing actions in the game and as the goals are not encoded in the game system there cannot be explicit *Goal Indicators*. The definitions of the goals are expressed as a player's intention (that other players may or may not be aware of) or as two or more players' agreement to reach a certain game state. There is no in-game end condition or evaluation function for the goal, and the possible *Rewards* and *Penalties* are only perceived by the players. These extra-game *Player Defined Goals* are often volatile, as players can during gameplay choose to pursue totally different goals without any in-game punishment. However, *Player Defined Goals* can be encoded into the game mechanics of a *Meta Game*, such as betting on the outcome of another game.

Many classic single-player arcade games, such as *Pac-Man*, *Asteroids*, and *Tetris*, can actually only have *Player Defined Goals* as high-level goals. Since all these games end in the same fashion ("game over") the games do not provide a way of winning the game within the game itself. *High Score Lists* provide a ranking to compare one's result against previous results, but this is outside the gameplay itself and

how one decides to use the possible comparison for *Player Defined Goals* does not affect the actual gameplay from a game mechanical point of view. So, players can set their own goals, which can range from getting into the *High Score List*, beating the previous player, beating their own personal high score, reaching a new level, or just making their game last as long as possible.

Player Defined Goals provide a way of letting players create their own meaning within the game, and since they choose the goals that they subjectively perceive as most rewarding, *Player Defined Goals* can create more involvement and *Emotional Immersion* in the game. The pattern can be used as a subtle way of guiding gameplay; by providing a wide range of *Player Defined Goals* but making some slightly more attractive than others, the game designer can potentially direct the gameplay toward preferred game states. This use can provide the means for directing the players on a large scale without making them feel forced as they make all the decisions on a smaller scale, thus supporting a *Narrative Structure* without limiting the *Freedom of Choice* too much. However, strong *Narrative Structures* are difficult to combine with unrestricted *Player Defined Goals* since the telling of the *Narrative Structure* in these cases represents an opposing will from the game designer of how the gameplay should develop.

RELATIONS

Instantiates: *Meta Games, Creative Control, Preventing Goals, Optional Goals, Extra-Game Consequences, Freedom of Choice, Emotional Immersion, Anticipation, Tension*

Modulates: *Mutual Goals, Rewards, Constructive Play*

Instantiated by: *Ephemeral Goals, High Score Lists, Bidding, Betting, Easter Eggs, Illusionary Rewards, Collecting, Construction, Characters, Character Development, Planned Character Development*

Modulated by: *Rewards, Penalties, Player Balance, Game State Overview, Negotiation*

Potentially Conflicting with: *Narrative Structures, Goal Indicators*

Additional Patterns

Descriptions of these additional patterns can be found in the Chapter 12 folder on the companion CD-ROM.

ON THE CD

Ephemeral Goals

Continuous Goals

Unknown Goals

RELATIONS BETWEEN GOALS

These patterns focus on how goals relate to each other; either by having end conditions that affect each other or by having goals that are defined by their relationship to other goals. They serve two main purposes: to support the creation of new goals given the existence of other goals and to modulate players' chances and intentions of completing goals by the introduction of other goals.

Preventing Goals

Goals where the objective is to prevent a completion of another goal.

Some goals are defined as the aim of preventing another goal to be completed. This can be done by actively working against the other goal or by simply ensuring that the goal is not being pursued.

> **Example:** The goal of the goalkeeper in *Soccer* is to prevent the opposing team's players from scoring goals.

> **Example:** The goal in *Backgammon* is to move each individual piece to the inner table and one can prevent the other player from achieving this in two ways: by hitting the opponent's piece when moving one's own pieces or by blocking the piece by placing two or more pieces on area of the game board. The first case directly affects the opponent's piece as it interferes with the game state (the position of the piece) defining the opponent's goal. The second case indirectly prevents the goal as it does not affect the piece but may block future moves of the piece.

USING THE PATTERN *Preventing Goals* are closely linked to *Interferable Goals* (and thereby *Conflict*) as *Preventing Goals* can be easily constructed by explicitly rewarding the interference of an *Interferable Goal*. However, *Preventing Goals* do not have to require that players actively change the game state, as hindering the change of the game state, rather than changing it, may be enough to complete the goal. Thus, *Preventing Goals* can be completed by simply doing *No-Op* actions if no other player is trying to achieve the goal, which may be the result of successful *Negotiation*.

The creation of a *Preventing Goal* is easily done by choosing a low-level goal that has to be prevented: *Construction* gives *Elimination*, *Elimination* gives *Survive*, *Capture* gives *Evade*, *Gain Ownership* gives *Guard*, *Guard* gives *Rescue*, *Gain Information* gives *Conceal*, *Traverse* gives *Herd*, and so on. The players can always create these, but the game designer can encourage them by encoding *Preventing Goals* with explicit *Rewards*.

The possibility of one player completing a *Preventing Goal* is closely linked to another player's possibility of completing the goal that is to be prevented. As long as there is a theoretical possibility for the other goal to be completed, the *Preventing Goal* is not fulfilled. This means that unless the player has sufficient information (through *Perfect Information* or *Game State Overview*) to determine if the underlying goal is achievable, the state of the *Preventing Goal* is unknown. This can be implemented by having the system indicate when the preventing goal is fulfilled or imposing a *Time Limit* on the prevention of the underlying goal.

CONSEQUENCES The player or *Agent* that has a *Preventing Goal* is automatically an *Enemy* in a *Conflict* with the player who has the goal that is to be prevented. *Preventing Goals* are by their nature *Asymmetric Goals*, *Excluding Goals*, and *Incompatible Goals* to the goals that are to be prevented. As *Preventing Goals* are defined as goals of avoiding specific conditions within game states to occur, which can also be described as maintaining the game state in the inverse of the condition, *Preventing Goals* are *Continuous Goals*. Games with *Symmetric Goals* as main goals, such as *Chess* and *Go*, usually have a set of *Preventing Goals* to the main goal to require players to make *Tradeoffs* between being offensive or defensive.

Naturally, a *Preventing Goal* makes the goal that it is based upon more difficult to complete, affecting the *Right Level of Difficulty* of that goal as well as giving the players with that goal *Limited Planning Ability*.

Players may always choose to prevent other players' goals without explicitly stated *Preventing Goals* with in-game *Rewards*. This means that *Preventing Goals* can always emerge during gameplay as *Player Defined Goals*.

RELATIONS

> **Instantiates:** *Continuous Goals, Interferable Goals, Asymmetric Goals, Excluding Goals, Incompatible Goals, Limited Planning Ability, Conflict*
>
> **Modulates:** *Right Level of Difficulty, Negotiation*
>
> **Instantiated by:** *Perfect Information, Rescue, Capture, Evade, Conceal, Herd, Guard, Survive, Player Defined Goals, Enemies, Eliminate, Construction*
>
> **Modulated by:** *Time Limits, Game State Overview*
>
> **Potentially Conflicting with:** None

Hierarchy of Goals

The goals and subgoals of the game form a hierarchy.

The goals of many games are structured hierarchically, either explicitly using the components of the game or implicitly by having perceivable closures whose fulfillment can

easily be seen to promote the main goal of the game. Single rounds of *Heads and Tails* or *Paper-Rock-Scissor* (without external *Rewards* or *Penalties*) do not have a *Hierarchy of Goals* but otherwise this pattern is present in virtually every game.

In games with *Hierarchies of Goals*, players have to complete at least some of the low-level subgoals in order to proceed. This can be used to increase the value of closures in a game; the closure of a goal has a greater value if the fulfillment is seen as being part of completing a larger goal.

The topology of the hierarchy of goals can vary from a simple linear sequence or a tree to a complex network. The player does not necessarily have full knowledge of the hierarchy at the beginning of the game, but it is usually revealed stage by stage as the gameplay progresses. This gradual revealing of the goal hierarchies is often used in adventure and roleplaying games where the player is given new tasks or quests after completion of the previous one, revealing the total goal hierarchy one goal at the time. One version of this is when the player first knows only the overarching goal (defeat the evil overlord for example) at the beginning and the subgoals are presented to the player one at a time as the player progresses in the *Hierarchy of Goals*.

> **Example:** A good example of a *Hierarchy of Goals* can be found in *Zelda: A Link to the Past*. At the start, Link is given the task of rescuing princess Zelda from the castle. After accomplishing this, Link is presented with a more elaborate quest of overcoming the evil wizard Agahnim. The subgoals of this task, such as freeing the seven maidens, are gradually revealed to the player during the gameplay and, near the end of the game, it is revealed that it is not Agahnim, but Ganon from the Dark World, that Link has to overcome.
>
> **Example:** *Chess* can be seen as a loosely defined implicit *Hierarchy of Goals*. No pieces need to be captured from the opponent, nor any strategic locations occupied, to be able to checkmate the opponent's king. However, it does make the goal of checkmating easier, and nearly all players focus on achieving these subgoals before attempting to achieve the main goal.
>
> **Example:** The rough goal hierarchy in *Pac-Man* is as follows: eat the pills while avoiding the ghosts, get the power pill while avoiding the ghosts, chase the ghosts or eat the pills while under the influence of the power-pill, finish levels by taking all pills on each level, and finally get into the high-score list.

USING THE PATTERN The hierarchy can be established in different ways. The simplest one is a hierarchy of *Collection* where each low-level goal needs to be achieved by *Collecting* actions before the high-level goal can be completed, e.g., in *Pac-Man* where all pills must to be eaten to progress to the next level, but the completion of

as many levels as possible is still the main goal. Also, the simplest method of completing the *Collection* is to force a rigid linear sequence as is the case in almost all single-player modes of shoot-'em-ups.

When constructing a *Hierarchy of Goals*, the game designer has to choose which goals need and do not need to be completed. Requiring a complete *Collection* at each level of the hierarchy ensures longer playing time but can also limit players' *Freedom of Choice*, especially if the collections are not *Selectable Sets of Goals*. Making parts of the hierarchy consist of *Optional Goals* avoids this problem, and may allow *Replayability* if players have strived toward the quickest way toward completing the game.

Providing a static *Hierarchy of Goals* lets the players build *Strategic Knowledge* about the game but if this is not desirable *Ephemeral Goals* can be used, which may also increase *Replayability*. *Hierarchies of Goals* consisting of *Excluding Goals, Unknown Goals*, and *Dynamic Goal Characteristics* where the goals are revealed and when instantiated gradually can be used to combine static forms of the hierarchy with changing goals, and are especially common in adventure and roleplaying games. *Renewable Resources* can be used to modulate these hierarchies, either to constantly provide *Resources* to ease the completion of goals or to generate *Enemies* to create new challenges. Dynamic forms of goal hierarchies typically emerge in complex strategy games where the player has the possibility to spread out resources and focus on several different, but interdependent goals, including the progression in the technology tree, conquering new areas, building new units, and defending production points.

Deep or wide *Hierarchies of Goals* are difficult to achieve in *Quick Games* as it can be difficult for players to have enough time to complete all the goals in the game.

CONSEQUENCES Having *Hierarchy of Goals* in a game provides a structure for the game that can be used for several purposes: to ensure that certain activities in the game are done; to ensure that a *Narrative Structure* is maintained; or to provide players with a clear direction of the gameplay that can support *Strategic Knowledge*. Further, *Hierarchy of Goals* enables *Meta Games* such as *Tournament* by expanding the goals beyond a game instance by using *Extra-Game Consequences*.

The use of a *Hierarchy of Goals* makes the presence of *Higher-Level Closures as Gameplay Progresses* automatic and can be used to pace the *Tension* in a *Narrative Structure*. The clear separation of required gameplay in different goals provides natural *Save Points* after the completion of each goal in the hierarchy.

RELATIONS

Instantiates: *Strategic Knowledge, Narrative Structures, Higher-Level Closures as Gameplay Progresses*

Modulates: *Save Points*

Instantiated by: *Collection, Predefined Goals, Optional Goals, Continuous Goals, Tournaments, Collecting, Renewable Resources*

Modulated by: *Ephemeral Goals, Dynamic Goal Characteristics, Unknown Goals, Supporting Goals, Selectable Sets of Goals, Excluding Goals*

Potentially Conflicting with: *Quick Games*

Tournaments

Tournaments consist of the playing of a series of game instances where the outcome of each instance affects the outcome of the whole tournament.

By making each of a number of games count toward a common score, virtually any kind of game or games can be made into *Tournaments*. *Tournaments* also allow several players to compete in teams even if the individual games do not allow teams, and *Tournaments* may also let more players test their skills against each other than is possible in a single game session. Usually all participants in a *Tournament*, either on a team level or an individual player level, are part of the *Tournament* from the beginning, and changes to the team composition are not allowed as long as the *Tournament* continues.

Some games, particularly games of chance, are played in *Tournaments* where several game instances are completed within a single play session. These games have a short playing time for each instance, and the skill required is most often based on outwitting or outguessing other players' strategies or simply on luck.

Example: In *Poker*, each round is one game instance and, for most people, playing only one round is quite meaningless. That is why *Poker* is very often played in a *Tournament*, such as the *Poker* night, where the outcome is to win money from the other players and to gain insight into the other players' ways of playing *Poker*.

Example: *TransAmerica* is a board game where the goal for each round is to be the first player to connect five American cities with railroad tracks, and the players who still have unconnected cities lose points based on how many tracks are missing from connecting the cities. The cities to be connected are different for each player and they are kept secret from the other players. The *Tournament* ends when one of the players has lost a certain amount of points.

Example: The world cup in *Soccer* is a *Tournament* using elimination of the other teams for determining the final winner. The teams are eliminated from the *Tournament* on the basis of losing single game instances to other teams, and the last team left in play is the winner.

USING THE PATTERN The primary design choice of a *Tournament*, of course, concerns what games the *Tournament* should consist of. Usually this is one game played several different times, either with the same or a different composition of players, but *Tournaments* consisting of other *Tournaments* are also possible, as are *Polyathlons*. If the different events where players compete against each other are sufficiently separate, *Last Man Standing* can be seen as a *Tournament* (as in the game *Unreal Tournament*). Common uses of the *Tournament* structure within *Multiplayer Games* can be found when *Betting* or *Combat* activities occur.

Whatever the choice of games (or sub-tournaments) for the *Tournament*, the results from them must by quantifiable so that they can be incorporated into the state of the *Tournament*. This is usually done by *Eliminate* where the loss of a game means that one is out of the *Tournament*, or by using a *Score* system to postpone the consequences of individual games to a later point. The mapping between the outcome of a single game instance and the final outcome of the *Tournament* can be as simple as a one-to-one mapping between victories and points to more complex systems to influence the way individual games are played, e.g., giving three points for a victory and one point for a draw to penalize safe tactics. The use of *Score* systems can however make the consequences of individual game instances into *Illusionary Rewards* since the overall outcome of a *Tournament* can already be evident. In *Self-Facilitated Games*, *Tournaments* can spontaneously occur as players may ask for rematches in the form of best-of-three suggestions.

Although *Tournaments* typically use *Tiebreakers*, they can also instantiate them, for example, by consisting of uneven number of played games. Playing a game two times in a row but swapping players' roles can create *Player Balance* in games with *Asymmetric Abilities*. In these cases the overall *Tiebreaker*, given that all players won using the same role in the game, is usually to compare the margin by which the winning role won.

Tournaments have either mechanistic or random ways of determining in which order the different game instances will be played. However, the medieval tournaments show the possibility of letting participants influence what game instances are played in which order by allowing them to challenge other participants, in effect using a form of *Selectable Sets of Goals* in *Self-Facilitated Games*.

CONSEQUENCES *Tournaments* are *Meta Games* that have *Overcome* goals and thereby include *Conflict*. They rarely allow *Tied Result* by design, and typically repeat or prolong the underlying activity as a way to create an initial *Tiebreaker*. Since *Tournaments* consist of several different game instances, they give *Replayability* to games automatically and give extra potential for *Tension* between the actual game sessions. They can be used to achieve *Perceivable Margins* on which player has *Game Mastery* since elements of *Randomness* can be removed due to repetition.

Tournaments can be used for two main purposes: either to support the participation of more players than one instance of the game can handle or to remove the influence of *Luck* or temporary variation in performance of players in order to create *Perceivable Margins*. In the first case, it is common to use *Eliminate* to reduce the number of players as the tournament progresses, which can imply *Higher-Level Closures as Gameplay Progresses*. This form of *Tournaments* can be combined with allowing *Team Play* that does not exist in the individual games by defining teams across the game sessions. The second case usually does not use *Eliminate*, since it is common to want the same players to meet each other several times, allowing them to build *Strategic Knowledge*. The second case is common in *Overcome* goals but *Tournaments* can also be used to create *Meta Games* with *Overcome* goals consisting of winning any sort of goal more times than the other players do.

Since *Tournaments* consist of undividable or atomic components, the completion of each game instance is a *Closure Point* from which only a small amount of *Trans-Game Information* is passed on to the *Tournament*. As this provides a means of distributing the activity both in time and space, a *Tournament* allows players not to have to participate in all events of a *Tournament* while still being full participants. The *Tournament* structure used in a single play session with *Quick Games* is at least based partly on *Luck*, which allows for closures of success and failure to virtually all players.

Tournaments demand stronger long-term commitment to the game itself, making the necessary skills of the game more valuable. However, they may also support the distribution of the activity in time, allowing skills and tactics to develop during the progress of the tournament. The use of *Spectators* is common in *Tournaments*, since *Tournaments* function as focal points of interest for a particular game. These characteristics can also create and maintain stable *Social Organizations,* such as *Soccer* clubs, around the game itself.

RELATIONS

Instantiates: *Higher-Level Closures as Gameplay Progresses, Meta Games, Hierarchy of Goals, Strategic Knowledge, Closure Points, Trans-Game Information, Overcome, Conflict, Tension, Tiebreakers, Replayability, Illusionary Rewards, Multiplayer Games, Tied Results, Perceivable Margins*

Modulates: *Asymmetric Abilities, Combat, Betting, Player Balance, Social Organizations, Game Mastery*

Instantiated by: *Overcome, Eliminate, Last Man Standing, Polyathlons*

Modulated by: *Score, Selectable Set of Goals, Spectators, Tiebreakers, Self-Facilitated Games, Quick Games*

Potentially Conflicting with: *Luck*

Incompatible Goals

Two or more goals that cannot be fulfilled simultaneously due to having end conditions that are mutually exclusive.

Making goals for a game in such a way that they cannot simultaneously be fulfilled is an easy and common way to create competition or complexity in games. They also help synchronize the tempo of players' experiences, because if players are near completing a goal it is not only likely to excite them but also those players with *Incompatible Goals*, albeit for other reasons. However, a set of *Incompatible Goals* do not have to be divided between different players, one player can have several goals that are incompatible with each other, and gameplay can focus upon selecting which of the goals to pursue.

> **Example:** In the board game *Time Agent*, six different species try to manipulate the past so that events promoting their species occur and events bad for them disappear out of history. Most of these events have at least one species wanting them to exist and at least one species that wants to erase them.

> **Example:** *Tag*, where the goal of the chaser is to catch the other players, the chaser's goal of tagging cannot be fulfilled at the same time as other players' goals of not being caught.

USING THE PATTERN *Incompatible Goals* are easy to create by basing them on Boolean expressions; one goal may require a game state condition to be true, while the other may require the same condition to be false, thereby making it impossible to complete both at the same time. Or, they may have one and only one state out of a number of states (a tile may be green, blue, red, or yellow, thus benefiting player A, B, C, or D). Another way to make *Incompatible Goals* is to use *Excluding Goals* or *Preventing Goals*. Note that with *Excluding Goals*, the completion of one goal in a set of *Incompatible Goals* does not have to make the others impossible to complete later, just that both goals cannot be fulfilled at the same time. A simple example of this is having two *Traverse* goals with different *Goal Points*; both cannot be fulfilled at the same time if the player cannot be in two locations simultaneously, but one can be completed first and the other later. These goals can of course, as can many other *Incompatible Goals*, be completed simultaneously by *Collaborative Actions* if they are not specific to individual players.

The *Incompatible Goals* between which the player must choose can be constructed to serve several different purposes. First, they can force the player to make *Tradeoffs* between the different rewards offered. Second, they can force the player to make decisions between the *Risk/Reward* of the different goals. And, they can be

used for *Planned Character Development* and limit the openness of a *Narrative Structure*.

CONSEQUENCES If different players have *Incompatible Goals*, it can create *Conflict* or *Competition*, and thus *Tension*, and the goals can naturally not be *Mutual Goals*. If players have several *Incompatible Goals*, the players are required to do *Tradeoffs* from *Selectable Sets of Goals*, which can also be used to ensure *Varied Gameplay*, given that the players can strive for different goals in different game instances. That players can only succeed with one of the *Incompatible Goals* at any given time lets them focus their attention on that goal, thereby limiting the need for *Attention Swapping* between different goals and modulating the *Right Level of Difficulty* in a game.

If a game has a player switching between different roles, and these roles have *Incompatible Goals* in relation to each other, this can increase the *Right Level of Complexity* in gameplay as players have to switch between the goals they are striving for when they change roles.

RELATIONS

Instantiates: *Tradeoffs, Conflict, Varied Gameplay, Collaborative Actions, Competition*

Modulates: *Attention Swapping, Selectable Sets of Goals, Planned Character Development, Narrative Structures*

Instantiated by: *Risk/Reward, Contact, Preventing Goals, Excluding Goals*

Modulated by: None

Potentially Conflicting with: *Mutual Goals*

Selectable Sets of Goals

The player can select the goals he tries to achieve in the game from a set of available goals.

The selection of goals from which players can choose can either be handled within the game system, meaning that players have to explicitly choose the goals, or it can be left open so that players do not have to decide at any given time exactly what goals to strive for. The latter also means that the player is free to change the commitment to different goals during the gameplay.

> **Example:** Traversing the technology tree in the computer game *Civilization* requires players to select goals defining what kind of technology to develop. Beyond what technology to develop next, players can also implicitly

select collections of technology goals to reach as goals in order to match later requirements of advanced technologies.

Example: The different possibilities for scoring in the board game *Settlers of Catan* allow players to select from several different goals to achieve the overarching goal of reaching a certain amount of points.

Example: The different worlds in *Super Mario 64* offer different sets of goals providing players with selectable sets of *Selectable Sets of Goals*. The player is also free to move within these worlds and goals without needing to complete them in any specific order.

USING THE PATTERN If the player is forced to choose one or several *Predefined Goals* from the set, these goals can be seen as *Investments* or as the use of *Risk/Reward* patterns depending on the varying *Rewards* and *Penalties* associated with the goals. An example of this is when the game allows *Area Control* over several different areas if players complete *Traverse* goals to these areas. Knowledge of which goals have been chosen can be *Strategic Knowledge* for other players while giving the possibility of not revealing these options and choices allows for players to have secret tactics. *Selectable Sets of Goals* provide *Varied Gameplay* if the different goals are sufficiently different, for example, by requiring different skill sets.

Using *Selectable Set of Goals* without *Dynamic Goal Characteristics* means that the player has to select the goals at the start of the game and then stick to them. Most games, however, use this pattern with *Dynamic Goal Characteristics* in such a way that the player can modify the set, if need be, during the gameplay. The goals that can be chosen do not all have to exist at the start of the game; some may be *Ephemeral Goals*. The player is, especially in adventure games, seldom given an explicit choice of the available goals but rather has the goals of getting more information about the availability of the others goals.

If the goals within the *Selectable Set of Goals* are unknown but the player somehow knows there are several different solutions, the game can promote *Replayability*, as the player is encouraged to try to find the different goals.

One way to force players to select one or just a few of the possible goals in a *Selectable Set of Goals* is to define the goals as different *Configurations*, which still require the use of the same game elements.

CONSEQUENCES Having a *Selectable Set of Goals* offers players a wide range of activities and thereby makes *Varied Gameplay* possible. The possibility of players to choose goals according to their abilities and *Resources* can be a *Balancing Effect* and can make them plan and work toward certain states before selecting goals.

The choice of goals can either be predetermined before the game starts, allowing the designer to have full control of the set to promote *Strategic Knowledge* for

the players, or the goals can be generated during gameplay, hindering *Predictable Consequences*. The selection of the goals can be used as a *Balancing Effect* by setting the difficulty level of the goals according to the player position in the game.

Selectable Sets of Goals may force players to make *Risk/Reward* choices depending on how the goals relate to each other but also to select the *Right Level of Difficulty*. *Incompatible Goals* may limit the need for *Attention Swapping*, but if the goals are *Excluding Goals*, players need to make *Tradeoffs* between the difficulty of completing the different goals and the rewards they give.

If the player only has to complete one or some of the goals, the other goals will in effect be *Optional Goals* and offer players a *Freedom of Choice* within the limits the game designer chooses. If all goals have to be achieved, the set is an instance of the *Collection* goal pattern, but players may have the option of choosing the order in which to complete the goals, thereby making use of potential *Supporting Goals*.

As the player can have different gameplay experiences depending on the choice of goals, having a set of goals can provide *Replayability*. In all cases, *Selectable Sets of Goals* are parts of a *Hierarchy of Goals*.

RELATIONS

Instantiates: *Freedom of Choice, Replayability, Balancing Effects, Strategic Knowledge, Risk/Reward, Investments, Right Level of Difficulty, Varied Gameplay, Tradeoffs*

Modulates: *Collection, Unknown Goals, Hierarchy of Goals, Tournaments, Excluding Goals*

Instantiated by: *Configuration, Predefined Goals, Optional Goals, Area Control*

Modulated by: *Asymmetric Goals, Ephemeral Goals, Incompatible Goals, Traverse*

Potentially Conflicting with: *Predictable Consequences*

Supporting Goals

Completion of a Supporting Goal helps the player achieve the other, sometimes specific, goals of the game.

Many games have goals that cannot be solved, or are very difficult to solve, before a number of specific other goals have been completed. These other goals, *Supporting Goals*, can either give information, provide game elements, make new actions available, or simply provide more resources, all of which help or make possible the completion of the main goal. Noah Falstein has described similar goal designs of *Supporting Goals* as a part of his Crisis Structure [Falstein99], while Kreimeier introduces a similar concept, *weenie chains* [Kreimeier02], to solve the problem that

players "might lose their sense of direction with respect to how the game world unfolds." Although not defined as goals, these *weenies* act as information carriers to inform players what goals exist in the game.

> **Example:** In the case of *Chess*, the subgoals of capturing the opponent's pieces can be seen as *Supporting Goals* for the higher-level goal of checkmating the king. They are not necessary to achieve the checkmate but make it easier to complete.

> **Example:** Getting the power pill in *Pac-Man* can be seen as a *Supporting Goal* for the goal of taking all the pills as the ghosts cannot capture Pac-Man during the time he is affected by the power pill.

> **Example:** Real-time strategy games, such as *Age of Empires*, have many *Supporting Goals*, from identifying and collecting resources to building defenses and scouting enemy territory, all of which support the goal of defeating the opponents. Much of the skill in those games lies in balancing the struggle toward the different *Supporting Goals* so that the chances of succeeding with the overarching goal are maximized given the particular circumstances of a specific game instance.

USING THE PATTERN Using *Supporting Goals* usually starts by defining a higher-level goal and continues by breaking that goal into smaller goals that are fairly independent of each other. In some cases, e.g., when the goal is to travel to a specific location, the *Supporting Goals* can be incorporated into a *Progress Indicator* as landmarks or road signs indicating the remaining distance.

Another way of using *Supporting Goals* is to provide *Rewards* in a currency that is central to making the completion of other goals easier. One way of doing this is to provide a chance of gaining experience points or money in roleplaying games or providing ammunition and health packs in first-person shooters. In these cases, *Supporting Goals* often take a variety of forms, and several *Supporting Goals* can be chosen independently of each other. For example, if the goal is to defeat a *Boss Monster*, *Supporting Goals* might be to find more powerful weapons, ammunition, or *Gain Information* about the *Boss Monster's* tactics or its *Achilles' Heel*.

These different ways of creating *Supporting Goals* do not necessarily require that they have to be completed to fulfill the high-level goal, i.e., they can be *Optional Goals*. Typical *Supporting Goals* that are not obligatory are to provide *New Abilities*, *Improved Abilities*, or *Resources* by acquiring *Pick-Ups* or *Area Control*. In the example of traveling to a location, it may be perfectly possible to reach the final destination without seeing any road signs, but not following them may lead to the player becoming lost. In the second case, completing the *Supporting Goals* can make

it easier to kill the *Boss Monster*, but it may require more time, which might be a risk in a game with a *Time Limit* or a *Race* between other players.

The main aim when constructing *Supporting Goals* for balancing skill requirements is to spread the goals between different types of challenges. An example of this would be an adventure game with one goal requiring *Dexterity-Based Actions*, a second goal requiring *Puzzle Solving*, and a third goal requiring *Memorizing*. If these goals can be completed in any order and completing one of them makes it easier to complete the others, the net effect is to balance gameplay between different play styles.

CONSEQUENCES *Supporting Goals* are always part of a larger *Hierarchy of Goals*, where completing a set of *Supporting Goals* is needed to achieve the next level subgoal, and then these next level subgoals can support each other forming a nested goal structure. For example, when several players have *Excluding Goals* that can only be fulfilled by actions at a certain place, *Race* becomes a *Supporting Goal* to the primary goals of the players.

Supporting Goals are typically *Optional Goals* and force players to make choices—based upon *Risk/Reward* and *Tradeoffs*—of whether to spend time completing the *Supporting Goals* or working on the main goals. This allows players to select what they perceive as their own *Right Level of Difficulty*.

The different playing styles and skills of different players make some tasks difficult for some players and easy for others. *Supporting Goals*, when designed in such a way that the skill sets or the playing styles required for the goals are different, can make the game more enjoyable for a wider audience and, at the same time, provide *Varied Gameplay*. This use of *Supporting Goals* in *Multiplayer Games* has the potential side benefit of supporting *Player Balance* since the players can choose tactics and strategies according to their skills and playing styles, and it may lessen the *Conflict* between the players.

RELATIONS

Instantiates: *Progress Indicators*

Modulates: *Varied Gameplay, Hierarchy of Goals, Player Balance, Risk/ Reward, Tradeoffs, Right Level of Difficulty*

Instantiated by: *Race, Optional Goals, Gain Information, Achilles' Heels, New Abilities, Improved Abilities, Area Control, Pick-Ups*

Modulated by: *Resources*

Potentially Conflicting with: *Red Herrings, Conflict*

REFERENCES

[Falstein99] Falstein, Noah. "A Grand Unified Game Theory: The Crisis Structure." In GDC 1999 Proceedings.

[Kreimeier02] Kreimeier, Bernd. "The Case for Game Design Patterns." In Gamasutra, March 13, 2002. (Available online at *http://www.gamasutra.com/features/20020313/kreimeier_01.htm.*)

Additional Patterns

Descriptions of these additional patterns can be found in the Chapter 12 folder on the companion CD-ROM.

ON THE CD

> **Polyathlons**
>
> **Excluding Goals**

RELATIONS BETWEEN GOALS AND PLAYERS

These patterns focus on how goals relate to players and how goals can be used to affect the relations between players in the game.

Symmetric Goals

The players have goals with the same definition, for example, to be the first one to reach a certain area or amount of points, solve a problem, find an item, or overcome the opponent.

Symmetric Goals are goals that several different players have that can be generalized to fit the same definition without changing the structure of the individual goal definitions. For example, *Chess* has the goals "capture the white king" and "capture the black king," which although not exactly the same, can be generalized as "capture the other player's king," which has the same basic structure and clarifies what actions are necessary to complete the goal.

> **Example:** An archetypical *Symmetric Goal* is that of a simple race: to be the first player to reach a goal.

> **Example:** A typical example of a *Symmetric Goal* is to surround the highest number of empty spaces in Japanese versions of *Go.*

USING THE PATTERN If the relevant information is available, *Symmetric Goals* can allow players to anticipate other players' strategies, so setting the *Right Level of*

Complexity in a game with *Symmetric Goals* depends on how information is presented. Allowing *Perfect Information* may allow *Strategic Knowledge* but also *Analysis Paralysis* so that a *Time Limit* might be necessary. *Imperfect Information* or *Game State Overview* may support *Strategic Knowledge* to a certain extent but without ending up with *Analysis Paralysis*. Combining *Unknown Goals* with *Symmetric Goals* is difficult, since players may infer other players' goals from the similarity in actions between them.

Further, some *Symmetric Goals* are *Interferable Goals*, e.g., *Last Man Standing* and *King of the Hill*, while others can either be totally under players' control or not, e.g., *Race*. The choice of whether to use *Symmetric Goals* that are also *Interferable Goals* depends on the game designer's choice of having a presence of *Role Reversal*, *Conflict*, or *Competition* in the game.

Goals where players engage in direct competition against each other, for example, *Overcome*, are by their nature *Symmetric Goals*. In contrast, if the *Symmetric Goal* is defined without reference to individual players or their elements, the goal can be a *Mutual Goal*.

CONSEQUENCES *Symmetric Goals* provide one form of *Symmetry* in games, and in traditional games, together with *Symmetric Resource Distribution* and *Symmetric Information*, it has been a common technique in ensuring *Player Balance*. However, to provide a *Right Level of Complexity*, these games usually provide a large possible set of game states with few *Closure Points* and many game states that match the goal states. This usually leads players to develop different strategies and quickly achieve different positions in the game, making the players have *Asymmetric Goals* as subgoals toward each other even though the main goals in a game instance remain symmetric.

Mutual Goals between players are always *Symmetric Goals*.

RELATIONS

Instantiates: *Symmetry*

Modulates: *Conflict, Competition*

Instantiated by: *Overcome, Race, King of the Hill, Last Man Standing, Mutual Goals*

Modulated by: *Interferable Goals*

Potentially Conflicting with: *Unknown Goals, Asymmetric Goals*

Asymmetric Goals

Players have structurally different goals requiring different tactics and actions.

Some games have goals that belong to the same categories, for example, winning conditions, but differ from each other by requiring players to have fundamentally different tactics and strategies in regard to what actions should be taken. These goals can be described as asymmetric and cannot be transformed into each other without changing the structure of the goal definitions. Thus, *Asymmetric Goals* cannot simply be expressed as different goals, for example "gather all blue stones" and "gather all red stones," but require goal states defined by using different categories of actions and components.

> **Example:** In the children's game *Tag*, the chaser has the goal of catching another player, while the other players try to avoid the chaser, making the goals asymmetric.

> **Example:** The collectable card game *Illuminati: New World Order* does have *Symmetric Goals* that all players have, but the game also allows individual players to have secret goal cards, which promote radically different goals, creating an additional set of *Asymmetric Goals* between the players.

> **Example:** The board game *Space Hulk* provides players with many low-level *Asymmetric Goals* by matching slow-moving space marines, which have ranged weapons, against fast-moving aliens, which can only fight in close combat.

USING THE PATTERN *Asymmetric Goals* can be difficult to balance due to the lack of a simple symmetry; this can be mitigated by using *Paper-Rock-Scissor* relations between the goals or by implementing *Role Reversal* to exchange the goals between players as soon as one of the *Asymmetric Goals* has been reached. However, goals can also be qualitatively different and be supported by giving players *Asymmetric Abilities* that are suited for the goals they have.

Asymmetric Goals can be used to encourage players to form *Dynamic Alliances* if these goals cannot be completed without the help of the other players, for example, by giving *Asymmetric Abilities* that do not fit the goals. *Preventing Goals* can be used to easily create *Asymmetric Goals* between players, for example, by letting one player have the goal to *Gain Ownership* of a game element and letting another player have the goal to *Guard* the same game element.

CONSEQUENCES *Asymmetric Goals* promote *Replayability* since players can have different goals for different game instances, requiring different strategies, skills, and actions. Further, if the *Asymmetric Goals* are part of *Selectable Sets of Goals* about which the other players have *Imperfect Information*, they also allow players to bluff about their goals and tactics.

Asymmetric Goals naturally occur in games that have a large *Freedom of Choice* for players even if the main goals are *Symmetric Goals*.

RELATIONSHIPS

Instantiates: *Varied Gameplay, Replayability*

Modulates: *Selectable Sets of Goals, Freedom of Choice, Competition*

Instantiated by: *Preventing Goals, Role Reversal*

Modulated by: *Paper-Rock-Scissors, Asymmetric Abilities*

Potentially Conflicting with: *Symmetric Goals, Player Balance*

Committed Goals

Goals that players have entered a form of contract to try and fulfill.

Although most games have many goals in them, players do not have to accept or strive to complete all of them. However, those goals that players have chosen to strive toward and will result in some form of penalty if not completed are committed. The commitment to a goal may, depending on the goal, be present from the beginning of the game or come later during play.

> **Example:** The winning conditions of games such as *Chess* or *Go* are *Committed Goals* that players have to strive for; if they are not working toward these conditions, they are not playing the game.

> **Example:** In the board game *Ticket to Ride*, players can commit to building a railway line between cities. Once committed, the player will at the end of the game either receive a certain amount of points if successful or be penalized by the same amount if the line is not completed. A similar example can be found in the trick-based card game *Bridge*.

USING THE PATTERN One can separate *Committed Goals* into three different categories, and making a goal a *Committed Goal* requires the game designer to choose which category the goal should belong to. The first category consists of the goals that define the winning condition of the game, or subgoals that are required to solve the main goal of the game. The commitment toward completing the goal is the same as the commitment to try and win the game; if a player is performing legal actions in the game but not committed to such a goal, one can argue that the player is not actually playing the game.

The second category of *Committed Goals* includes the first category and consists of those goals that have explicit *Penalties* within the game if they are not completed.

Designing a goal so that it is in this category lets players judge *Risk/Reward* situations and make *Tradeoffs* between striving to gain the *Rewards* but possibly receiving *Penalties* from other *Committed Goals* or vice versa. A simple way of implementing this category of goals is to require *Investments*, which lets players choose their level of commitment and ties the penalty of not completing the goal (in the sense of misused *Resources*) and the closeness to a closure to the commitment. Formalized *Collaborative Actions*, possibly with *Player-Decided Distribution of Rewards & Penalties*, can be examples of the second category, as can maintaining *Area Control*.

The third category of *Committed Goals* are those that are not implicitly encoded into the game system, either being those that a player has chosen individually or those decided by players in *Uncommitted Alliances*, often regarding *Collaborative Actions* that are not formalized by the game system. The last category has the least commitment from a structural perspective but can be more important than other *Committed Goals* due to *Negotiation*, *Extra-Game Consequences*, and the risk of *Betrayal*.

Those *Committed Goals* that are governed by explicit game mechanics allow for actions to affect what information players have about them. This includes letting them be *Unknown Goals*, opening up for *Gain Information* goals, and modulating the *Risk/Reward* of committing to a goal. *Committed Goals* in the second and third category can be *Ephemeral Goals* and as such they can appear during gameplay and force players to reconsider the *Risk/Reward* of plans and strategies of other goals.

Goals that are *Committed Goals* from the beginning of gameplay cannot be *Optional Goals*. However, *Ephemeral Goals* that are made available to players during gameplay can be both *Optional Goals* and *Commited Goals*; once a player has accepted this form of goal, the player is then committed, but he is not forced to accept the goal in the first place.

CONSEQUENCES *Committed Goals* always have *Penalties* associated with them. They influence the plans and actions of players and, as such, can be used to make players reach *Closure Points* and thereby develop the *Narrative Structure*. If players have information about other players' *Committed Goals*, this increases the *Predictability* of the game as well as opens the way for *Uncommitted Alliances* to enable ganging up. *Committed Goals* that are also *Unknown Goals* for players naturally create *Gain Information* independently of those *Gain Information* goals that are explicitly supported in the game.

RELATIONS

 Instantiates: *Gain Information, Penalties, Betrayal*

Modulates: *Closure Points, Ephemeral Goals, Risk/Reward, Rewards, Player-Decided Distribution of Rewards & Penalties, Area Control*

Instantiated by: *Investments, Collaborative Actions, Extra-Game Consequences*

Modulated by: *Tradeoffs, Risk/Reward, Unknown Goals, Negotiation*

Potentially Conflicting with: *Optional Goals*

Additional Pattern

ON THE CD A description of this additional pattern can be found in the Chapter 12 folder on the companion CD-ROM.

Mutual Goals

13

Game Design Patterns for Game Sessions

The patterns in this chapter deal with the characteristics of game instances and game and play sessions and the limitations, possibilities, and features of player participation in the game.

Game and Play Sessions: *Real-Time Games, Asynchronous Games, Synchronous Games, Single-Player Games, Multiplayer Games, Turn-Based Games, Closure Points, Tick-Based Games, Persistent Game Worlds, Quick Games, Handles, Game Pauses, Reversability*

Player Activity: *Player Elimination, Analysis Paralysis, The Show Must Go On, Agents, Team Elimination, Early Elimination, Time Limits*

GAME AND PLAY SESSIONS

These patterns describe both how the gameplay flows within a play session and how the play sessions of the players form the game sessions and game instances. As such, they also deal with how the game time maps to the real time.

Real-Time Games

The progression of game time during play is tied to the real time.

Real-Time Games do not require player actions to change the game state, as the game system can make these changes based on real time. In one sense, all *Real-Time Games* are self-running simulations in which the players may participate. Some games offer the players a possibility to pause the game or otherwise modify the pace of the game time.

> **Example:** Most arcade games are based on the players being bombarded by hectic and constant challenges from the game system. The gameplay

requires constant attention to what is happening in the game. *Space Invaders* and other shoot-'em-ups challenge the players with ever-increasing waves of attacking enemies, which the players have to destroy.

Example: Real-time strategy games, such as those in the *WarCraft* and *StarCraft* series, modify the usually slow pace of strategy games by making the game system continue without player interaction.

USING THE PATTERN If the players are provided with *Communication Channels* for *Social Interaction* and the gameplay itself would benefit from communication between the players, it is important to consider the characteristics of the *Communication Channels* to appropriately map the pace of required *Social Interaction* to the pace of the game itself. For example, text chatting in fast team-oriented first-person shooters is not necessarily the preferred communication method for the players.

The available player actions must also fit the pace of the game itself. Simple *Maneuvering* combined with *Aim & Shoot* is a classical example of basic actions available in *Real-Time Games*. *Maneuvering* in a *Game World*, even in simple two-dimensional *Game Worlds*, enhances the feeling of *Spatial Immersion*. The most often used actions are, quite naturally, *Rhythm-Based Actions* and *Dexterity-Based Actions*. These cases of *Timing* require that the players match their actions, including *No-Ops*, to the game time, and *Rhythm-Based Actions* in particular can give rise to *Sensory-Motoric Immersion*. *Combat* or *Capture* in *Real-Time Games* is also often based on correct *Timing* of different actions, although in real-time strategy games, the *Combat* between *Units* typically resembles the *Combat* in *Turn-Based Games* and *Tick-Based Games*.

An interesting case of *Budgeted Action Points* can be created in *Real-Time Games*, where the players can save up action points for performing future actions by doing *No-Ops*. This is more often used in *Real-Time Games*, which require more complex actions and planning from the players and the players' strategies require proper *Timing* of the use of the action points.

The progression of game time is often handled by a *Dedicated Game Facilitator*, such as a computer program, unless the game is more or less physical in nature, such as when the game time maps one to one to real time. For example, *Tag* is a *Self-Facilitated Game* where the game time is the same as the real time and, obviously, does not require *Dedicated Game Facilitators* to progress the game time.

CONSEQUENCES *Real-Time Games* almost always require that the players keep constant attention on what is happening in the game during play. As humans have difficulties in keeping focus on several things needing attention at the same time, *Disruption of Focused Attention* can be used in *Real-Time Games* to modify the

Right Level of Difficulty and to provide more *Varied Gameplay*. The UFO in *Asteroids* is a good example of this kind of gameplay modification, and many other games use rapid *Attention Swapping* as one of the basic challenges of the game.

As the game time goes on regardless of the players' actions, this in most cases will lead to *Limited Planning Ability* for the players, of course, depending on the pace of the game time and the complexity of the actions required from the players. *Real-Time Games* naturally give rise to *The Show Must Go On*, even in cases where the players can use *Game Pauses* or other methods of suspending game time, such as *Save-Load Cycles*. The game time is also of a different nature when the gameplay itself is paused during *Cut Scenes*.

Games can have modes of play where the real-time modes are switched between the players by *Turn Taking*. For example, in *Bowling*, the players take turns, but the actual play is in real-time. During these real-time modes of play, there is obviously no *Downtime* for the players. *Synchronous Games* are well suited for *Real-Time Games*, while it is also possible that parts of *Asynchronous Games* have characteristics of *Real-Time Games*.

RELATIONS

Instantiates: *No-Ops, Maneuvering, Aim & Shoot, Spatial Immersion, Sensory-Motoric Immersion, The Show Must Go On*

Modulates: *Social Interaction, Limited Planning Ability, Disruption of Focused Attention, Combat, Turn-Based Games, Tick-Based Games, Synchronous Games, Asynchronous Games, Capture*

Instantiated by: None

Modulated by: *Budgeted Action Points, Self-Facilitated Games, Dedicated Game Facilitators, Rhythm-Based Actions, Timing, Dexterity-Based Actions, Save-Load Cycles, Cut Scenes, Game Pauses, Attention Swapping, Communication Channels, The Show Must Go On*

Potentially Conflicting with: *Downtime, Turn Taking, Turn-Based Games*

Asynchronous Games

Games where the players' game and play sessions do not necessarily overlap in time.

The players in these games can start playing the game regardless of the other players and also choose when they want to have their play sessions.

Example: MMORPGs can have thousands of players in a single game instance. The players can join and leave the game whenever they want, and

particular players do not have to play the game simultaneously, although there almost always are some other players playing at the same time.

Example: The players do not often play the game at the same time in play-by-mail games, even though in many cases their game sessions are the same. Some massively multiplayer play-by-mail games, such as *Quest* from KJC Games, share the characteristics of MMORPGs in that the players' game sessions do not have to overlap.

USING THE PATTERN *Real-Time Games, Tick-Based Games,* and *Turn-Based Games* are all suitable for *Asynchronous Games,* although the play session structure has to be designed differently for each case. *Real-Time Games,* such as existing MMORPGs, allow the players to choose when they wish to log in to the game and have real-time play sessions. *Tick-Based Games* place a certain time pressure on the players, as they usually have to execute their actions within a given *Time Limit* or lose their chance to influence the game state. Depending on the duration of a single tick, these games share characteristics from both *Real-Time Games* and *Turn-Based Games.*

One way to add some of the features of *Asynchronous Games* to *Single-Player Games* is to store a record of a single player's performance in a particular game instance, thus allowing other players to compete against the *Ghosts* of that player's experience.

All *Asynchronous Games* require some form of *Communication Channel* to make it possible for the players to affect the game state and, in some cases, communicate with one another. The use of *Public Information* is restricted by *Asynchronous Games;* information that can be revealed in *Synchronous Games* to *Spectators* because players do not have sufficient time to process the information can become sensitive in *Asynchronous Games.*

CONSEQUENCES Game instances of *Asynchronous Games* typically have quite long lifetimes. The players have, to some extent, *Freedom of Choice* as to when they wish to play the game and to which extent they want to influence the progress in the game. These games almost universally require the use of *Dedicated Game Facilitators* to maintain the game state within a *Persistent Game World.* The main exceptions are games where *Ghosts* are used, although it can be argued that *Ghosts* are persistent parts of the *Game World* over different players' game sessions. The players can scatter their play sessions over a long period of time, in one sense, meaning that there is *Downtime* between the sessions. *Asynchronous Games,* however, are constructed in such way that *Downtime* between the play sessions is not necessarily perceived as such by the players, as they do not have to intentionally wait for the other players to perform their actions.

RELATIONS

 Instantiates: *Downtime*

 Modulates: *Persistent Game Worlds, Freedom of Choice*

 Instantiated by: *Ghosts, Dedicated Game Facilitators*

 Modulated by: *Real-Time Games, Tick-Based Games, Turn-Based Games, Communication Channels*

 Potentially Conflicting with: *Synchronous Games, Public Information*

Synchronous Games

Games in which the players' game and play sessions must overlap in time.

The most common scenario in *Synchronous Games* is that the players' game sessions last as long as the game instance itself, and that the play sessions and the game sessions are one and the same, as is the case with many board and card games. Simply put, the players must play the game at the same time, from start to finish. However, a game can be synchronous and have pauses in the gameplay as long as all players take pauses at the same time.

> **Example:** In *Monopoly*, the players start their game session when the game instance is started, and their play sessions usually also coincide in such a way that the players are playing the game together from start to finish. It is not unusual for individual players to end the game at different times, however, dropping out of gameplay as they lose. Some games offer opportunities for players who have already lost to continue participating and influence the play as a non-player.

USING THE PATTERN *Synchronous Games* are, by definition, also *Multiplayer Games*, and the synchronization of the game state can be done by either *Dedicated Game Facilitators* or by the players themselves in *Self-Facilitated Games*. The real-time nature of sharing the play sessions means that *Real-Time Games* and *Tick-Based Games* are more suitable further characteristics of *Synchronous Games*. *Turn-Based Games* are often played in face-to-face situations, making them in those cases *Synchronous Games* with the associated effects of *Turn Taking* on *Downtime*.

CONSEQUENCES *Synchronous Games* with *Turn Taking* often have *Downtime* for the players who are not taking their turn. It is possible, however, to reduce the negative effects of *Downtime* by minimizing the duration of *Turn Taking*, by making the active player's actions interesting for the observing players, or in some cases allowing the players in *Downtime* to perform some actions that affect the game state.

Synchronous Games are often played in a social situation: the real-time nature of playing the game together, especially in face-to-face situations, naturally causes *Social Interaction* between the players. If the situation is mediated, it is important to provide the players *Communication Channels* that have proper characteristics to match the pace of the game.

RELATIONS

Instantiates: *Downtime*

Modulates: *Social Interaction*

Instantiated by: *Self-Facilitated Games, Multiplayer Games*

Modulated by: *Dedicated Game Facilitators, Real-Time Games, Tick-Based Games, Turn-Based Games, Turn Taking, Communication Channels*

Potentially Conflicting with: *Asynchronous Games*

Single-Player Games

Games where there is only one player in a game instance.

The player in *Single-Player Games* is in a conflict situation with the game system. It is possible, and sometimes even desirable, to analyze these games in such a way that conflict with the game system is framed as a conflict situation in *Multiplayer Games*. This personification of the game system often helps to clear the goal structures and the motivations for the conflict situation.

Example: The vast majority of computer games are *Single-Player Games* where the player is competing against or in conflict with the game system.

Example: Puzzles of any kind can be classified as *Single-Player Games* although they are a borderline case between games and game-like activities, because they do not typically have the conflict situations common to games in general.

USING THE PATTERN The amount of the possible *Social Interaction* can be increased by using, for example, *Score* to measure the performance of the player. This allows players to compare their performances to one another and to use *High Score Lists* to create simple *Meta Games* with multiple players. A more refined method is to have *Ghosts* in the game where players can directly compare their performance between each other during the play.

The goals and conflicts, as previously noted, can even in *Single-Player Games* be structured in similar fashion as in *Multiplayer Games*. For example, by analyzing

Pac-Man as a game between the Pac-Man and the ghosts reveals somewhat surprising similarities with *Tag*, including the *Role Reversals*. Even *Tetris* can be thought of as a conflict between the (computer-controlled) player who is trying to fill the screen and the player who is trying to keep the screen clear. The *Rewards* and *Penalties* in *Single-Player Games* are best crafted as *Individual Rewards* and *Individual Penalties*.

Single-Player Games are free to have player-specific modulations of game time, such as *Game Pauses* and *Cut Scenes*. Other game state manipulations, which are outside the game itself, are trivially possible in *Single-Player Games*. *Reversability* with *Save-Load Cycles* is simple, as all that is required is to store the game state for later use.

The ways to modulate *Right Level of Difficulty* can be done somewhat differently in *Single-Player Games* compared to *Multiplayer Games*. First, by having players complete *Levels*, the game designers can control what sort of challenges the players should meet. Second, it is easier to control what information the player has that can be used to give a player *Limited Planning Ability*.

CONSEQUENCES *Single-Player Games* cannot have *Social Interaction* between the players of the same game instance, but if the game is played in a social situation, such as an arcade machine in a pub, there is a possibility for spontaneous *Social Interaction* with the player and the *Spectators*. Even though the potential players are not sharing the game instance, they do share the *Alternative Reality* provided by the game, and this can, in games with *Narrative Structures* and applications of *Imperfect Information*, especially *Easter Eggs* and *Exploration*, lead to another kind of *Social Interaction* around the game where the players share their experiences and sometimes help each other solve difficult problems and progress in the game.

RELATIONS

> **Instantiates:** *Individual Rewards, Individual Penalties*
>
> **Modulates:** *High Score Lists, Reversability*
>
> **Instantiated by:** None
>
> **Modulated by:** *Meta Games, Ghosts, Downtime, Dedicated Game Facilitators, Spectators, Score, Narrative Structures, Exploration, Imperfect Information, Easter Eggs, Cut Scenes, Game Pauses, Save-Load Cycles, Right Level of Difficulty, Limited Planning Ability*
>
> **Potentially Conflicting with:** *Multiplayer Games, Social Interaction*

Multiplayer Games

Games that have more than one player.

The scope of *Multiplayer Games* is vast, and most games in general are played in social situations, which by their nature require more than one person participating in the game. The number of players varies from just two players competing directly to thousands of players participating in the same game.

> **Example:** *Chess* has two players competing against one another by taking turns.

> **Example:** MMORPGs can have thousands of players playing the same game instance simultaneously and tens or even hundreds of thousands of players participating in the game instance asynchronously.

USING THE PATTERN Although it may seem that the main requirement for *Multiplayer Games* is that the game supports several players, even *Single-Player Games* can be a possible foundation for making *Multiplayer Games.* This can be accomplished by organizing players in *Tournaments*, introducing *Ghosts*, or some other *Meta Game* elements or *Extra-Game Actions*, these games can become *Multiplayer Games* as long as players can affect the gameplay of the other players or compare their individual efforts against each other.

Many design choices are unique to *Multiplayer Games* or are significantly modified by the presence of other players: *Smooth Learning Curves* and providing the *Right Level of Difficulty* can be more difficult to achieve, although *Balancing Effects* can help; *Player Balance* can be achieved not only through *Balancing Effects* but also through *Handicaps* such as differences in *Skills* or *Asymmetric Resource Distribution*, the latter of which can also be the original source of the imbalances; *Game Masters* can be used and can allow the other players greater *Freedom of Choice* and stronger *Illusions of Influence*; *Tiebreakers* may be required to determine winners of *Overcome* goals unless *Tied Results* are to be possible; *Player Elimination* may exist and force individual players to quit their play sessions before the game sessions end due to *Early Elimination*; *Agents* can be used to simulate other players to allow *Multiplayer Games* to be played alone.

Persistent Game Worlds, which by their definition have to be shared between several players, represent one way to achieve *Multiplayer Games* with a potentially limitless number of participating players. These types of *Multiplayer Games* have *Dedicated Game Facilitators* to maintain the game state, but *Self-Facilitated Games* are also possible, although, the number of participating players has to be lower, or else the game state synchronization becomes difficult.

CONSEQUENCES *Multiplayer Games* naturally provide a focus point for *Social Interaction* between the players, and it is impossible to have *Social Organizations*, or have *Identification* with groups, in games without having more than one player

playing the same game instance. Having several players in a game allows the game design to have *Team Play* and modulates *Game Mastery* by making it possible for players to develop specific *Competence Areas* for their *Characters*. *Multiplayer Games* also provide some forms of *Game Mastery*, some of which are not applicable in other games, for example, *Negotiation* and *Creative Control*. *Multiplayer Games* often give players *Limited Planning Ability*, as the goals and plans may be difficult to deduce and they can significantly affect future game states. *Synchronous Games* are by their nature also *Multiplayer Games*, as there must be several players sharing the same game situation.

Save-Load Cycles are more cumbersome to use in *Multiplayer Games*, since players must negotiate when to load previous game states.

RELATIONS

Instantiates: *Identification, Downtime, Synchronous Games*

Modulates: *Social Interaction, Social Organizations, Game Mastery, Meta Games*

Instantiated by: *Tournaments, Persistent Game Worlds*

Modulated by: *Meta Games, Ghosts, Downtime, Dedicated Game Facilitators, Self-Facilitated Games, Competence Areas, Illusion of Influence, Skills, Game Masters, Creative Control, Freedom of Choice, Tiebreakers, Tied Results, Balancing Effects, Limited Planning Ability, Right Level of Difficulty, Smooth Learning Curves, Team Play, Player Elimination, Asymmetric Resource Distribution, Player Balance, Handicaps, Early Elimination, Agents, Characters, Extra-Game Actions*

Potentially Conflicting with: *Single-Player Games, Save-Load Cycles*

Turn-Based Games

The players take turns to make their actions to change the game state, and the progress of game time is not tied to the real time.

The progress of game time in *Turn-Based Games* is not directly linked to real time, and it may be up to the players to pace the game.

Example: In *Chess*, the players take turns to move their pieces on the board. In the basic variant, there is no strict time limit for the players to execute their turns apart from social pressure exerted by the other player.

Example: *Laser Squad Nemesis* and the *Combat Mission* series offer the players modes for hot-seating, switching the player whose turn it is, and sending the turn information via e-mail to the other player.

USING THE PATTERN *Turn-Based Games* may be easily changed to *Tick-Based Games* by simply introducing *Time Limits* to the players' *Turn Taking*. *Turn-Based Games* can be supported by *Dedicated Game Facilitators*, especially when the turn is resolved simultaneously, but they are also at least partly *Self-Facilitated Games*, as completing the turn requires effort from the players, distinct from the actual gameplay.

Combat and *Capture* in *Turn-Based Games* compared to *Real-Time Games* requires more of players' cognitive skills, as they have more time to think, and the *Timing* of actions in *Combat* and *Capture* require more *Puzzle Solving* skills than skills in *Dexterity-Based Actions*.

Some *Turn-Based Games* allow players to pass their turn without making any actions, in principle, making one big *No-Op* action. The actions available to the players during their turn can vary from simple pre-specified actions (such as roll a die and move) to complex action sequences with *Budgeted Action Points*. An interesting alternative is to have *Asymmetric Abilities* that rotate out of sync with the turns. Also in some games, these action sequences can have characteristics of *Real-Time Games* such as *Maneuvering*, although these have otherwise contradictory characteristics.

CONSEQUENCES *Turn-Based Games* almost always have *Downtime* when the other players have to wait for the active player's turn to terminate during the *Game Pauses* for *Turn Taking*, especially in *Synchronous Games*. This effect of *Downtime* in *Asynchronous Games* is often less drastic, as the players have a possibility of some action other than waiting for the other players to complete their turns. It is possible, however, to limit the effects of this *Downtime* by having the players plan and execute their actions at the same time, and the actions are resolved simultaneously when the players have submitted their actions. If the *Turn Taking* is sequential, there are *Role Reversals* when the players change their modes of play from active to passive.

RELATIONS

Instantiates: *Downtime, Role Reversal*

Modulates: *Combat, Tick-Based Games, Synchronous Games, Asynchronous Games, Asymmetric Abilities, Capture*

Instantiated by: *Turn Taking*

Modulated by: *No-Ops, Budgeted Action Points, Timing, Puzzle Solving, Real-Time Games, Self-Facilitated Games, Dedicated Game Facilitators, Game Pauses*

Potentially Conflicting with: *Real-Time Games, Maneuvering*

Closure Points

Closure Points are events in gameplay where the game state is, or can be, reduced in size.

Many games have points where most of the information about game elements and actions performed become irrelevant and are discarded. This is typically the case after important end or evaluation functions have been done, and as such can be called *Closure Points*.

> **Example:** Completing a level in *Quake* discards all the information about where monsters and other game elements are on the level. The only information maintained in the game state from the level are the attributes of the player's character and general stats such as difficulty level.

USING THE PATTERN Common forms of *Closure Points* include *Levels*, where typically only the information regarding game elements moved between the *Levels* is maintained, and *Tournaments*, where only the outcome of individual games is maintained. Additional common types of *Closure Points* include those when *Transfer of Control* occurs. *Closure Points* make natural *Save Points* for players since the planning of tactics is often bounded by the closure of the associated pattern.

The goals leading to *Closure Points* can be made *Committed Goals* to ensure their occurrence, either to maintain the *Narrative Structure* or ensure *Higher-Level Closures as Gameplay Progresses*. *Closure Points* can also easily be created by using *Excluding Goals*, since the completion of one of these goals can make parts of the game state irrelevant.

Closure Points can be difficult to combine with *Never Ending Stories*; either because the stories are created by players and thereby outside the control of the game design or because higher-level closures cannot be infinitely achieved, and the closures risk becoming repetitious.

CONSEQUENCES *Closure Points* are natural points of importance in *Narrative Structures* and typically have some form of *Downtime*, often *Cut Scenes*, in conjunction with the *Closure Points* to let players experience the emotions attached to the *Rewards* or *Penalties* associated with the closure. Since *Closure Points* can affect what is described by the game state, they can be used to ensure *Higher-Level Closures as Gameplay Progresses*. Games without many *Predefined Goals*, e.g., *Chess*, have few *Closure Points*.

Although players may have *Limited Foresight* as to what may happen after a *Closure Point*, as well as what leads to the *Closure Point*, the knowledge that the *Closure Point* must occur gives players some *Predictable Consequences* of gameplay in games with *Closure Points*.

RELATIONS

> **Instantiates:** *Downtime, Higher-Level Closures as Gameplay Progresses, Limited Foresight*
>
> **Modulates:** *Predefined Goals, Narrative Structures, Predictable Consequences*
>
> **Instantiated by:** *Excluding Goals, Save Points, Levels, Tournaments, Transfer of Control*
>
> **Modulated by:** *Downtime, Committed Goals*
>
> **Potentially Conflicting with:** *Never Ending Stories*

Additional Patterns

ON THE CD Descriptions of these additional patterns can be found in the Chapter 13 folder on the companion CD-ROM.

Tick-Based Games	**Handles**
Persistent Game Worlds	**Game Pauses**
Quick Games	**Reversability**

PLAYER ACTIVITY

The patterns here focus on the structures of how the players can participate in the game. The patterns both describe some of the features of how the player participation, and the play sessions in general, are perceived by the players and also how the players' play and game sessions' game have an effect on other players sessions.

Player Elimination

In games with Player Elimination, the players' game sessions can be finished without the players' consent, often as a penalty for failing to achieve something.

Player Elimination determines the evaluation function for an end condition in the game in such way that the player's game session is terminated.

> **Example:** Many arcade games finish the players' game sessions when their lives are exhausted.
>
> **Example:** In *Magic: The Gathering*, the players whose health level drops below zero are removed completely from play, thus ending their game sessions. Here, the end condition is that the health level is below zero and the evaluation function terminates that player's game session.

USING THE PATTERN *Player Elimination*, as the name implies, requires that the players or the game system have a possibility to *Eliminate* other players. This consists of either the explicit goal to *Eliminate* other players or that the players fail in *Survive* goals. *Overcome* basic goal with *Combat* actions is one of the most used compounds for *Player Elimination* and gives rise to *Conflict*, but also other end conditions as basic goals are possible for determining the elimination, for example, completing *Connection* or *Enclosure* goals or the side effects of *Bidding*. For example in *Tetris*, the end condition for the game session is that there is a *Connection* of blocks from the bottom to the top of the game area. *Player Elimination* is an *Individual Penalty*, and quite a heavy one, for the player. In games with *Team Play*, the elimination of one of the team members is also a form of *Shared Penalty*, as the performance level of the whole team suffers from it.

Lives and *Parallel Lives* can be used to give the players, in one sense, additional chances in the game and at the same time have more varied *Tension* structure in the game. Letting eliminated players continue as *Spectators* allows them some compensation for not being able to play since they at least can follow the continued gameplay.

In games with *Closed Economies*, the use of *Player Elimination* may be the only way to ensure that *Resources* are gathered in larger and larger groups as gameplay progresses.

CONSEQUENCES The risk of *Player Elimination* naturally raises the *Tension* level for the player, as the players essentially lose all their efforts and the time invested in the game if the game session is finished without their consent. Many arcade—and other games, too—base the overarching *Tension* and struggle in the game on *Player Elimination*. In these games based on the goal to *Survive*, the players must lose in the end anyway, and their performance is measured by how long they have been able to stay in the game, for example, by using a *Score*. The gameplay of *Multiplayer Games* with *Player Elimination* can force extended *Downtime* on eliminated players, especially if there is a possibility of *Early Elimination*. *Player Killing* is a special case of *Player Elimination* where there is a possibility for the players to continue their game session even after initial elimination. The *Last Man Standing* higher-level goal is based on a player completing a *Collection* of goals of eliminating other players; that is, by being the last surviving player in the game instance. The same principle applies to *Team Elimination*, as the other team has to eliminate the players of the team. *Player Elimination* is also the most drastic version of *Ability Losses*; the player loses the ability to participate in the game.

RELATIONS

Instantiates: *Tension, Downtime, Early Elimination, Individual Penalties, Conflict, Team Elimination*

Modulates: *Survive, Last Man Standing, Shared Penalties, Multiplayer Games*

Instantiated by: *Eliminate, Ability Losses, Combat, Closed Economies, Bidding*

Modulated by: *Lives, Parallel Lives, Score, Spectators, Player Killing, Overcome*

Potentially Conflicting with: None

Analysis Paralysis

The players can spend considerable amounts of time planning their actions, because the consequences of the actions are at least somewhat predictable, and the number of possible outcomes grows exponentially the further in game time the players plan ahead.

The classic case of *Analysis Paralysis* is that the players are unable to make any useful decisions regarding future actions because they attempt to think too far ahead, and the possible game state space is far too large for proper min-max analysis. *Analysis Paralysis* depends also on the players' play style; some players are more prone to *Analysis Paralysis* than the others.

Example: *Chess* and *Go* have been used as prime examples of games where there is a possibility to almost endlessly analyze the possible actions for the future. Both have decision trees, which grow exponentially over game time.

Example: *Diplomacy*, even though the possible actions are quite limited, can cause *Analysis Paralysis* when the players start to think recursively about what the other players are trying to do and how the other players would perceive the players' actions.

USING THE PATTERN *Analysis Paralysis* can be achieved by letting players have *Freedom of Choice* between several actions with *Predictable Consequences*, even if these are *Limited Set of Actions* or players have *Limited Resources*. This forces players to consider *Tradeoffs* and the more difficult the values of the actions are to judge, the more likely *Analysis Paralysis* is to occur. The likelihood can also be modulated by *Irreversible Actions*, as well as *Predefined Goals* in games where the players have *Perfect Information* and *Symmetric Information* about the discrete game states. This allows the players to plan the consequences of their current and future actions. *Irreversible Actions* guarantee that consequences of the chosen action will be effective also in the future, and this makes it possible to plan several actions ahead while at the same time decreasing the chances to perform *Experimenting*. *Budgeted Action Points* provide means of expanding the number of decisions the players have to make in each decision point, in effect, broadening the scope of *Freedom of Choice*, as are open *Discard Piles* in card games, which allow the players to have *Game State Overviews* and may cause *Analysis Paralysis*.

It is possible to lessen the possibility for *Analysis Paralysis* by introducing *Randomness* to the consequences of the actions and thereby giving players *Limited Foresight* and *Limited Planning Abilities*.

CONSEQUENCES *Analysis Paralysis* is caused by *Stimulated Planning* and *Cognitive Immersion*, and is usually a feature game designers try to avoid. That players have *Analysis Paralysis* can be a sign that the game does not have the *Right Level of Complexity* for those players.

In games with *Turn Taking*, the presence of *Analysis Paralysis* leads to excessive *Downtime* for the other players in case some of the players get stuck in planning their turns. The nature of *Analysis Paralysis* situations has a somewhat adverse effect on the *Anticipation* of the uncertain outcome during the play.

The negative effects of *Analysis Paralysis* for other players can easily be avoided by having *Time Limits*.

RELATIONS

Instantiates: *Downtime*

Modulates: None

Instantiated by: *Predefined Goals, Limited Set of Actions, Irreversible Actions, Budgeted Action Points, Turn Taking, Freedom of Choice, Stimulated Planning, Tradeoffs, Right Level of Complexity, Cognitive Immersion, Game State Overview*

Modulated by: *Discard Piles, Perfect Information, Predictable Consequences, Time Limits, Symmetric Information*

Potentially Conflicting with: *Experimenting, Anticipation, Randomness, Limited Foresight, Limited Planning Ability, Limited Resources*

The Show Must Go On

The game state can change without any player actions.

The Show Must Go On is found in games where there are at least some real-time elements in the gameplay that occur even if players do nothing.

Example: In *Tetris*, the blocks fall down the screen regardless of the player's actions.

Example: The balls in pinball after they have been shot to the table move on their own, requiring constant attention from the player or specific actions from the player in order to immobilize the balls.

Example: In real-time strategy games, there is always something happening in the *Game World*, and the players have to switch their attention constantly from one place to another to keep in pace with the game.

USING THE PATTERN The real-time nature of some actions, such as *Maneuvering* and *Aim & Shoot*, make them more suitable for games with *The Show Must Go On* than to other types of games. These characteristics of *Real-Time Games* are the basis for games with *The Show Must Go On*. *Ultra-Powerful Events* where the players can merely observe the unfolding of the event are a good example of how to modulate *Anticipation* with *The Show Must Go On*.

A game state that is dynamic independent of player activity leads to the situation that the players have an inherent possibility for doing *No-Ops*, even without their intent. This also means that there has to be a *Dedicated Game Facilitator* to take care of the game state changes when the players are not performing any actions. *Turn Taking* in general requires player action and is therefore not possible to use in combination with *The Show Must Go On* in the same modes of play.

CONSEQUENCES *The Show Must Go On* creates events with *Hovering Closures* in *Real-Time Games* that can force players to have *Time Limits* and makes time a player *Resource*. This in turn gives *Limited Planning Abilities* and can give players both *Anticipation* and *Tension* if there is no possibility for player-initiated *Game Pauses*.

Games with *The Show Must Go On* require that the players pay constant attention to the happenings in the game. Some games of this type build the internal threat or struggle for the players on the requirement that the players to do *Rhythm-Based Actions* or perform *Attention Swapping* between different parts of a *Game World*. This can increase *Tension* in the game; at least in cases where the pace of the game increases during gameplay or there is *Shrinking Game World* to create pressure.

RELATIONS

Instantiates: *Anticipation, Maneuvering, Tension, Hovering Closures, Rhythm-Based Actions, Limited Planning Ability, Time Limits, Resources*

Modulates: *Attention Swapping, Aim & Shoot, Real-Time Games, No-Ops, Tension*

Instantiated by: *Ultra-Powerful Events, Shrinking Game World, Dedicated Game Facilitators, Real-Time Games, Moveable Tiles*

Modulated by: None

Potentially Conflicting with: *No-Ops, Turn Taking, Game Pauses*

Agents

Entities in games that take the roles of players but are controlled by the game system.

Sometimes one cannot find enough players to make a game playable or enjoyable. To make gameplay possible in these situations, the game design may provide means of simulating players. These simulated players, or *Agents*, can also be used to flesh out team-based games so that the teams are of equal size or simply let players train without having to play against other people.

> **Example:** 'Bots in first-person shooters or real-time strategy games let players simulate multiplayer variants of the game.

USING THE PATTERN Creating *Agents* requires that *Dedicated Game Facilitators* can sufficiently simulate the actions and plans of players, which in many cases requires significant computer power and AI programming. However, the skill of these *Agents* can easily be downgraded once they have been created and this can be used to create *Handicaps* for players.

CONSEQUENCES *Agents* provide the possibility to play *Multiplayer Games* when not enough players are available by providing *Enemies* controlled by the game system. This allows for *Competition*, *Conflict*, and *Tied Results*, and even *Social Interaction* to be present, or at least simulated, in situations where they would otherwise be impossible.

RELATIONS

> **Instantiates:** *Tied Results, Enemies*
>
> **Modulates:** *Multiplayer Games, Competition, Conflict, Handicaps, Social Interaction*
>
> **Instantiated by:** *Dedicated Game Facilitators*
>
> **Modulated by:** None
>
> **Potentially Conflicting with:** None

Additional Patterns

Descriptions of these additional patterns can be found in the Chapter 13 folder on the companion CD-ROM.

ON THE CD

> **Team Elimination**
>
> **Early Elimination**
>
> **Time Limits**

14 Game Design Patterns for Game Mastery and Balancing

This chapter describes some salient features related to how the players can use their skills and abilities in playing the game and how it is possible to balance the gameplay for players with different abilities.

Game Mastery: *Game Mastery, Empowerment, Timing, Rhythm-Based Actions, Dexterity-Based Actions, Memorizing, Puzzle Solving, Luck, Perceivable Margins, Achilles' Heels*

Planning: *Tradeoffs, Randomness, Risk/Reward, Predictable Consequences, Limited Planning Ability, Strategic Knowledge, Stimulated Planning, Limited Foresight, Combos*

Balancing: *Balancing Effects, Symmetry, Team Balance, Right Level of Difficulty, Right Level of Complexity, Handicaps, Paper-Rock-Scissors, Player Balance*

GAME MASTERY

Players have a reason to play the game, and sometimes a significant part of the reason is to prove how skilled they are in the game. Different games often require different skills from the players, and more complex games may require that players in a team have complementary skill sets. The following patterns focus on basic features of how to achieve game mastery.

Game Mastery

That one can clearly distinguish between skillful and incompetent players when they are using all their skills and abilities in a game.

Player skill in games is achieved when players feel that they have an understanding of the game or a possibility to perform actions in the game that were previously not possible. When this skill level is sufficiently far from the initial level, players can feel that they have achieved *Game Mastery*, and those watching them play can recognize this when compared to other players.

> **Example:** The difference in being able to make use of game pieces in *Chess* and stones in *Go* between masters and novices is so large that novices in practice have no chance of winning against an expert.

> **Example:** The actions of moving and shooting in first-person shooters, as well as coordinating activities in multiplayer versions of those games, offer such a wide range of *Game Mastery* that experts can do it mainly subconsciously, while novices might have trouble understanding what is happening in the *Game World*.

USING THE PATTERN Designing games to support *Game Mastery* consists of providing activities in which skill can develop and making it possible for players to train those skills.

The number of possible skill areas in games are of course impossible to enumerate but can be categorized into three main areas: those dealing with dexterity, coordination, and other bodily skills are related to *Dexterity-Based Actions*, *Rhythm-Based Actions*, and require real world *Timing*; those dealing with mental skills are related to *Memorizing*, *Puzzle Solving*, *Experimenting*, *Resource Management* of *Limited Resources*, and *Timing* in games with *Turn Taking*; and social skills, mainly related to *Negotiation*, *Storytelling*, *Paper-Rock-Scissors*, and *Betting*. *Predefined Goals* and *Stimulated Planning* not only support *Game Mastery* in mental skills but modulate other forms of *Game Mastery* by allowing players to prepare before starting the activities.

Games involving *Randomness* can also support *Game Mastery* but do so most commonly through *Strategic Knowledge* about probabilities in the games and not directly through the *Randomness* or any player perceived *Luck*. Games that allow several of these types of challenges to be used for the same purposes not only allow *Varied Gameplay* but allow different forms of *Game Mastery* within the same game, typically due to *Asymmetric Abilities*. This also allows for a compound form of *Game Mastery* where players try to master all types of gameplay, which encourages *Replayability*. In *Multiplayer Games*, this can mean that one has multiple *Competence Areas*, and quickly adjusting to needed *Competence Areas* in *Multiplayer Games* can be an area of *Game Mastery* itself.

Knowing when to perform actions is also a part of *Game Mastery*. Development of such *Strategic Knowledge* may be due to required *Risk/Reward* choices or *Trade-offs*, knowing when to perform *Extended Actions*, and the long-term consequences of *Penalties* and *Rewards*.

The *Right Level of Difficulty* is important for players to be able to train *Game Mastery*. If the game is too difficult to begin with, players will not be able to reach basic levels of skills while, if the game does not continuously provide more difficult challenges, the increasing of skills may stagnate. Having *Smooth Learning Curves* makes *Game Mastery* most likely to occur, and can be instantiated by gradually increasing the *Right Level of Complexity* and overall difficulty. This is most easily controlled by using *Levels*, where the exact amount of *Enemies* and other threats can be set. *Multiplayer Games* allow the difficultly to increase naturally if all players learn at the same rate or players can choose opponents at the same level of expertise. This can be modulated by *Handicap*, so that players have a wider range of suitable opponents.

Illusionary Rewards may be used to promote *Game Mastery*, although players' intentions for performing and training activities will in these cases not always be equal to game designers' intentions of why they should perform these activities.

CONSEQUENCES *Game Mastery* gives players *Emotional Immersion* through *Empowerment*, and the possibility of getting this is in itself a cause for *Replayability* in games. Besides expertise in certain actions, *Game Mastery* often involves some form of *Strategic Knowledge*, most commonly knowledge of the long-term differences between *Tradeoffs* and better understanding of *Risk/Reward* choices. This *Strategic Knowledge* is *Trans-Game Information* passed between game instances, and striving to gain it can be seen as a form of *Investment* from players.

The level of *Game Mastery* in games that support *Cognitive Immersion* or *Spatial Immersion* can often be judged by the level of *Immersion* players have in them. This is because the *Immersion* is often a sign of being proficient in the skills required by the game design. *Emotional Immersion* is not so commonly an indicator of *Game Mastery* since this form of *Immersion* rarely increases players' chances of affecting the game state, the main exception being through *Player Decided Results*.

That players have *Game Mastery* is most usually revealed through *Overcome* goals, *Perceivable Margins*, or *Game State Overview*. *Randomness* and *Balancing Effects* both make *Game Mastery* more difficult to notice, if not to achieve. *Symmetry*, in contrast, is most often used to create *Player Balance* so that difference in outcome between players is more likely to be the result of *Game Mastery* than other effects.

Game Mastery can be maintained past game sessions through *Tournaments* or *High Score Lists* with *Handles*, and can create or increase *Social Status*, especially if

the game design supports *Spectators*. However, this often also gives *Red Queen Dilemmas*, as players need to improve their *Game Mastery* simply to maintain their position against other players. If *Game Mastery* is easily perceivable to other players, cases where players perform *Bluffing* about their skills in the game may emerge, but these forms of *Meta Games* are usually not part of designed gameplay and most often linked to *Extra-Game Consequences* due to *Betting*.

RELATIONS

Instantiates: *Emotional Immersion, Empowerment, Replayability, Investments, Social Statuses*

Modulates: None

Instantiated by: *Overcome, Predefined Goals, Stimulated Planning, Perceivable Margins, Timing, Rhythm-Based Actions, Dexterity-Based Actions, Memorizing, Negotiation, Puzzle Solving, Tradeoffs, Risk/Reward, Strategic Knowledge, Smooth Learning Curves, Paper-Rock-Scissors, Limited Resources, Collaborative Actions, Trans-Game Information, Resource Management, Competence Areas, Betting, Right Level of Difficulty, Right Level of Complexity, Experimenting, Storytelling*

Modulated by: *Levels, Asymmetric Abilities, Extended Actions, Turn Taking, Immersion, Player Balance, Penalties, Rewards, Varied Gameplay, Handicaps, Tournaments, High Score Lists, Handles, Illusionary Rewards, Luck, Symmetry, Spectators, Red Queen Dilemmas, Multiplayer Games*

Potentially Conflicting with: *Balancing Effects, Randomness, Luck*

Empowerment

Players feel that they can affect the events and the final outcome of a game.

Games let players make choices or perform actions that can affect the outcome of the game. This possibility to have an influence over what happens is a form of power and gives players a feeling of *Empowerment* simply by playing games. Playing a game can thereby be seen as an agreement among all players to give each other clearly defined powers within a game session that are described by the rules of the game. However, this *Empowerment* is bounded by the rules of the game and the wills and actions of other players, so the level of *Empowerment* depends upon the specific game design of a game and upon who the other players are.

> **Example:** Gaining new weapons in first-person shooters or gaining access to new units in real-time strategy games empowers players either by letting them perform actions they could not perform before or by making their actions have more powerful effects.

Example: Roleplaying games allow players the highest levels of *Empowerment*, as players and game masters can construct entire worlds, invent and play out stories within them, and change the rules to fit the participants of the game.

USING THE PATTERN *Empowerment* can be designed in games both as being present from the start of gameplay and as something that grows as players complete goals.

Self-Facilitated Games always have a high presence of *Empowerment* on a meta level throughout the entire gameplay, since the enactment of rules is only enforced by the players, and the rules may be changed at the will of the players. This is also the case in games with *Game Masters*, but here the *Empowerment* is more formalized and also affects gameplay directly through *Player Decided Results*, although the players may not be aware of the changes on either of the levels. Judges have a similar, but more restricted, form of *Empowerment* as *Game Masters* but these powers may only lie within certain areas of the game or be available until a certain *Time Limit* has expired. Other ways of empowering players throughout gameplay but within the rules include *Player Constructed Worlds*, *Creative Control*, and voting.

Incremental *Empowerment* can be used to enable *Higher-Level Closures as Gameplay Progresses* and synchronize these with the development of *Narrative Structures*. Common ways to incrementally give players *Empowerment* during gameplay are through *Improved Abilities* and *New Abilities*, especially if they are *Privileged Abilities*, or the power to choose how to use *Producers* or *Converters*. *New Abilities* can further empower players by giving them a larger *Freedom of Choice*, and *Privileged Abilities* can empower individual players by giving them *Competence Areas* in games with *Team Play*. *Red Queen Dilemmas* can easily emerge from designs where players are competing against other players regarding *Empowerment*, commonly based on *Social Status* or *Gain Competence* goals.

CONSEQUENCES Players that have *Empowerment* in games often have a larger *Freedom of Choice* than other players and easily have *Emotional Immersion*, as they can help develop the course of the game in the direction they choose. *Empowerment* is usually achieved through games providing the *Right Level of Difficulty* and players achieving *Game Mastery*, but levels of it can also be provided through *Stimulated Planning* or even by players *Memorizing* the *Strategic Knowledge* in the game.

Unless *Empowerment* is provided or given equally, it may disrupt *Player Balance*. This can partially be mitigated through *Time Limits*, *Role Reversals*, and ganging up. In *Team Play*, the effects of unequal *Player Balance* between players on the same team may not be a problem as long as *Team Balance* exists, but *Social Status* within the game may give another form of *Empowerment*.

RELATIONS

> **Instantiates:** *Emotional Immersion, Higher-Level Closures as Gameplay Progresses, Competence Areas*
>
> **Modulates:** *Narrative Structures, Team Play, Red Queen Dilemmas, Gain Competence*
>
> **Instantiated by:** *Game Masters, Freedom of Choice, Player Constructed Worlds, Stimulated Planning, Game Mastery, Memorizing, Strategic Knowledge, Game Mastery, Player Decided Results, Privileged Abilities, New Abilities, Improved Abilities, Creative Control, Self-Facilitated Games, Right Level of Difficulty, Producers, Converters, Social Statuses*
>
> **Modulated by:** *Time Limits, Role Reversal*
>
> **Potentially Conflicting with:** *Player Balance, Team Balance*

Timing

> *The effect on gameplay that actions have to be performed at certain points in game time to be performed at all or that the direct effect of actions varies greatly depending on when they are performed.*

The effects of actions in games often differ depending on when they are performed. This can occur because actions that always have the exact same direct effect have additional effects due to the game state or because the evaluation function for the effect depends on the current game state. In either case, the differences in effect make it possible for players to try and have *Timing* when they perform actions, so that they take maximum advantage of the possible actions.

> **Example:** Platform games such as *Super Mario Sunshine* allow special variants of actions to be performed if the *Timing* between two presses of the same button on the game controllers is correct.
>
> **Example:** Fighting games such as *Soul Calibur* or the *Tekken* series put heavy emphasis on *Timing*: it is required to successfully attack opponents before they parry and it is also required to parry incoming attacks. Further, special actions are triggered by the right *Timing* of what would otherwise be normal actions.

USING THE PATTERN The advantage of *Timing* is present in both *Turn-Based Games* and *Real-Time Games*. For *Turn-Based Games*, the question of *Timing* is usually linked to making best use of *Privileged Abilities* and *Delayed Effects*, as well as efficiently using *Geometric Rewards for Investments. Real-Time Games* offer more

variety in the ways of requiring *Timing*: *Combat* usually requires *Timing* through *Combos* or *Aim & Shoot* to succeed with *Overcome* goals; *Capture* and *Configuration* can require *No-Ops* and *Aim & Shoot*; and successful navigation to *Deadly Traps*, *Obstacles*, and *Moveable Tiles* requires *Timing*. In *Real-Time Games*, the requirement of *Timing* several times concurrently with fixed intervals between gives rise to *Rhythm-Based Actions*.

CONSEQUENCES Actions that can be executed with *Timing* allow for *Game Mastery*. In *Turn-Based Games*, the *Timing* is achieved by *Stimulated Planning*, often concerning how to use game elements together for *Collaborative Actions*. In *Real-Time Games*, the *Timing* is achieved by performing *Dexterity-Based Actions* skillfully.

RELATIONS

> **Instantiates:** *Game Mastery, Rhythm-Based Actions*
>
> **Modulates:** *Turn-Based Games, Real-Time Games, Overcome, Configuration*
>
> **Instantiated by:** *Moveable Tiles, Deadly Traps, Obstacles, Collaborative Actions, Combat, Aim & Shoot, Delayed Effects, Stimulated Planning, Capture, Combos, Geometric Rewards for Investments*
>
> **Modulated by:** *Privileged Abilities, Stimulated Planning, No-Ops*
>
> **Potentially Conflicting with:** None

Rhythm-Based Actions

Actions that require players to time their actions several times in a row.

Real-time games require players to act due to events that occur in the game. When these required actions occur in rhythm, they force players to perform *Rhythm-Based Actions*, where the timing and stability over time can be just as important as performing the right action.

> **Example:** *PaRappa the Rapper* as well as dancing games such as *Dance Dance Revolution* require players to hit various buttons in certain combinations while following certain rhythms. Gameplay is eased by having music or songs that have the same rhythm the players must follow.
>
> **Example:** Early computer sports games such as *Decathlon* primarily simulated sports by requiring players to perform long sequences of *Rhythm-Based Actions* and judging the outcome from how well the players kept the rhythm.

USING THE PATTERN *Rhythm-Based Actions* are basically sequences of *Extended Actions* that require *Timing* in *Real-Time Games*. Depending on the nature of the actions, feedback to players takes different forms in *Rhythm-Based Actions*: where the actions represent dancing and other non-dangerous activities, *Progress Indicators* and *Illusionary Rewards* usually provide feedback to how well players are executing the actions, but few *Rewards* or *Penalties* that affect the actual activity are given; where the actions are related to *Overcome* goals or *Combat* actions such as *Combos*, failing to keep the rhythm often ends *Extended Actions* but has no further *Penalties*; and where the *Rhythm-Based Actions* have to do with movement-related *Combos*, the effect of failing to keep the rhythm often means that players have to suffer the *Penalties* associated with *Deadly Traps*.

Ultra-Powerful Events, *Moveable Tiles*, and *Enemies* with *Reconnaissance* goals can all be used to require *Rhythm-Based Actions* in games. The *Right Level of Difficulty* of these actions can easily be modulated by the tempo that has to be followed and by providing the *Right Level of Complexity* of the actions that have to be performed in that tempo.

CONSEQUENCES *Rhythm-Based Actions* are actions performed with the intentions of achieving temporal *Configuration* goals in *Real-Time Games*. The motivation for the *Rhythm-Based Actions* often comes from *Game Worlds* where *The Show Must Go On*, and the players are either supposed to follow the rhythm of an *Agent* giving mentorship or to avoid dangers in the world.

By requiring repetitious actions, either in tempo or in type of action, *Rhythm-Based Actions* can give *Sensory-Motoric Immersion* and is one type of player skill that can be the basis for *Game Mastery* in games and give variation to *Polyathlons*.

RELATIONS

Instantiates: *Sensory-Motoric Immersion, Game Mastery*

Modulates: *Overcome, Polyathlons, Real-Time Games, Configuration*

Instantiated by: *Deadly Traps, Timing, Ultra-Powerful Events, Combos, Extended Actions, Moveable Tiles, The Show Must Go On*

Modulated by: *Right Level of Difficulty, Right Level of Complexity, Illusionary Rewards, Reconnaissance, Progress Indicators*

Potentially Conflicting with: None

Dexterity-Based Actions

Actions whose success or failure depends on some form of dexterity, in most cases, eye-hand coordination.

Dexterity-Based Actions are those actions whose effects are determined by how the player physically performs them. The effects of the actions do not have to be directly connected to what the player is manipulating for actions to be dexterous: billiards and computer games are examples of how games can be manipulated through indirect control.

> **Example:** Most sports require skillful *Dexterity-Based Actions* as part of *Game Mastery*, and this is often used to define what a sport is. The question of whether *Chess* is a sport shows that this definition is not fully accepted by everyone.

> **Example:** Moving *Avatars* in first-person shooters can be seen as a *Dexterity-Based Action*, since players can get feedback quickly enough to feel immersed in the virtual environment.

USING THE PATTERN *Dexterity-Based Actions* are present in both traditional games and computer games, but are mediated in computer games. However, they must be *Real-Time Games*, and response times from computer systems can affect *Dexterity-Based Actions* negatively; if actions take much time before they are enacted—typically above 100 milliseconds—they do not seem to be the immediate effect of player actions and thereby do not seem to be *Dexterity-Based Actions*. This can somewhat be mitigated with games that have few *Surprises* and either use *Timing* for single actions together with *Progress Indicators* or use *Rhythm-Based Actions* where the delays can be ignored for the internal rhythm that players can maintain.

Examples of actions that require *Dexterity-Based Actions* are *Movement* that require *Maneuvering*, especially to avoid *Obstacles*, and various forms of *Combat* or games with *Overcome* goals, with *Aim & Shoot* being a particularly common form in computer games. The difficulty of *Dexterity-Based Actions* can be modulated by making players manipulate game elements through *Indirect Control*.

The difficulty of *Dexterity-Based Actions* is dependent on how the players perceive the *Game World*. Although *First-Person Views* give players *Spatial Immersion* and thereby a perception of the game state, which is directly related to the actions that are to be performed, *Third-Person Views* can sometimes be easier, since they make it easier to see the relation between their *Focus Loci* and the environment. For example, timing the jump over a chasm can be easier with a *Third-Person View* than a *First-Person View*, as players can see exactly when to push off while still seeing where one is going. Likewise, *Maneuvering* a vehicle can be easier from a *Third-Person View*, as one can see the distance to other objects more easily and can have a better sense of scale.

Surprises make ongoing *Dexterity-Based Actions* difficult, and the success of *Dexterity-Based Actions* is easily destroyed by any *Disruption of Focused Attention*

events. For non-mediated *Dexterity-Based Actions* in sports, e.g., archery, the high levels of *Game Mastery* can be described as being able to ignore all *Disruption of Focused Attention* events, including the ones generated by one's own thoughts.

CONSEQUENCES *Dexterity-Based Actions* are present in *Real-Time Games* where either *Timing* or *Extended Actions* is required; in the latter case, with a granularity so small that players do not notice the end of one action and the start of another action. Performing these forms of actions gives *Sensory-Motoric Immersion* and *Spatial Immersion* in games with a *Game World*. Mastering *Dexterity-Based Actions* often forms the core of *Game Mastery* in *Real-Time Games*, and various forms of *Dexterity-Based Actions* are common as the basis for games in *Polyathlons*.

RELATIONS

Instantiates: *Sensory-Motoric Immersion, Game Mastery, Spatial Immersion*

Modulates: *Overcome, Polyathlons, Real-Time Games*

Instantiated by: *Obstacles, Movement, Maneuvering, Combat, Aim & Shoot, Extended Actions*

Modulated by: *Progress Indicators, Indirect Control, Surprises, First-Person Views, Third-Person Views*

Potentially Conflicting with: *Disruption of Focused Attention*

Memorizing

Games where players gain benefit by remembering facts about the game or game state.

Knowing what can happen in games is an advantage to players, and when players are shown information temporarily, they have an advantage of *Memorizing* that information.

Example: Many card games give players benefits for *Memorizing* played cards, as this allows them to predict what cards they will be dealt or what possible card hands other players can have. Although not forbidden by the rules of the games, casinos have rules that forbid card counting and ban players who are identified *Memorizing* the cards.

Example: The games in the *Simon* toy by Mattel show patterns to players by playing sounds and showing lights. The players' goals are to repeat the patterns, which makes *Memorizing* the primary game skill.

USING THE PATTERN *Memorizing* can either be applicable for all game sessions of a game or be specific for individual game sessions. The first type is the learning of *Strategic Knowledge,* such as the distributions of effect determined by *Randomness,* and is present in all games, but may be explicitly encouraged by game design where players receive *Extra-Game Information.* If this form of information can be used to directly solve specific goals, for example those related to *Puzzle Solving,* the possibility of *Memorizing* lessens the *Replayability.* Explicitly supporting *Memorizing* in games is usually done by having *Imperfect Information* that becomes *Perfect Information* for a while and then reverts to *Imperfect Information* as presented by the game system.

Whether they change between game sessions, the locations of *Deadly Traps, Invisible Walls,* and *Strategic Locations* are typical aspects of games worth *Memorizing,* and may be made into explicit goals of *Exploration.* The initiation of events with *Delayed Effects* can also require *Memorizing,* if the game does not provide *Progress Indicators* for when the effect will take place.

Changing the game state so new memorization is required for each game session can be achieved by *Reconfigurable Game Worlds,* using closed *Discard Piles, Randomness* of the placement of game elements, and using *Fog of War* to hide other players' actions. When using new information for each game session, *Memorizing* is one of the design options available to game designers for designing *Overcome* goals or *Polyathlons.*

CONSEQUENCES *Memorizing* can give players *Cognitive Immersion* in games and is a skill that can determine *Game Mastery.* The use of *Memorizing* is not totally dependent on either *Imperfect Information* or *Perfect Information* but rather players' gameplay is affected by a lack of knowledge, which can be how to use information present in the game.

The lack of knowledge can be either regarding the game state or regarding the rules of the game and can create additional challenges to the rewards from *Gain Information* goals, if access to the gained information is not provided continuously by the game.

Memorization of the rules is not usually a designed feature of games but nevertheless affects gameplay. Smooth execution of *Self-Facilitated Games* requires that players spend time *Memorizing* the rules, but may be eased by providing *Book-Keeping Tokens* and handouts. Players are motivated to do this since failure to remember rules gives them a *Limited Set of Actions* compared to other players, and failure to follow rules may cause rule arguments, which can usually not be corrected if the game state has changed too much. The presence of *Game Masters* makes *Memorizing* most of the rules optional to the players but may still be interesting for reasons of *Empowerment.* Computer-based games allow players to start playing the

games without any knowledge of rules and make the learning of them a combination of *Exploration* and *Memorizing*.

RELATIONS

Instantiates: *Cognitive Immersion, Game Mastery, Empowerment*

Modulates: *Overcome, Polyathlons*

Instantiated by: *Deadly Traps, Invisible Walls, Discard Piles, Delayed Effects, Self-Facilitated Games, Gain Information, Reconfigurable Game World, Randomness, Fog of War, Extra-Game Information, Puzzle Solving, Strategic Locations, Randomness, Strategic Knowledge*

Modulated by: *Imperfect Information, Perfect Information, Exploration*

Potentially Conflicting with: *Progress Indicators, Book-Keeping Tokens, Replayability, Limited Set of Actions*

Puzzle Solving

Actions that can be solved through deductive or inductive reasoning.

Some goals in games do not have apparent solutions. This may be because players do not have all the game elements or information required, but can also be because the solutions require multiple actions performed consecutively and in an order that is not intuitive. In both cases, the activity players need to perform to find the solution is a form of *Puzzle Solving*. In some cases, the solutions may be drawing conclusions from the available information and, in others, testing hypotheses and rejecting impossible ones.

> **Example:** The gameplay in *Myst* consists of solving a number of puzzles. Besides that, the only actions players can perform are to move in the environment that also moves players between the puzzles.

> **Example:** *Sokoban* is a pure *Puzzle Solving* computer game where the only challenge the players have is to figure out how to push a number of boxes into the right parts of a maze.

USING THE PATTERN The prime challenge in designing a puzzle is to achieve the *Right Level of Complexity* for it. However, the difficulty of the puzzle can be modulated regardless of complexity by constructing the puzzles so that they can either be solved through reasoning or through manipulation, the latter being easier. Puzzles solvable by manipulation require that players have access to *Direct Information*, while those that can be solved through reasoning can make use of direct or *Indirect*

Information. Puzzles that can be solved through manipulation of the game environment are a form of *Configuration* goal requiring *Movement* that can actually be solved by simply trying all combinations. Although this may cause players to do repetitive actions, it cannot be avoided even with *Irreversible Actions* or depletion of *Non-Renewable Resources* if players can perform *Save-Load Cycles*.

Puzzle Solving can start with complete or incomplete puzzles. Complete puzzles let players start with the *Puzzle Solving* at once, while incomplete puzzles require players to first complete *Gain Information* goals to gain the necessary *Traces*, *Clues*, or game elements. If players do not know if they have a complete or incomplete puzzle when they begin, they have to make *Risk/Reward* choices between trying to solve the puzzle or trying to look for more clues.

The design of *Puzzle Solving* has some additional possibilities depending on if the puzzles are part of *Real-Time Games* or *Turn-Based Games*. The *Tension* and *Right Level of Difficulty* of *Puzzle Solving* can be modulated in *Real-Time Games* by introducing *Time Limits*. *Overcome* goals can be based on *Puzzle Solving* in *Real-Time Games*, as players have to try and be quicker than the other players in finding a solution, or try to find opponents' *Achilles' Heels* while avoiding their attacks. For *Turn-Based Games*, many of the activities in *Real-Time Games* can be transformed into puzzles, for example, by having turn-based *Movement* creating *Capture* and *Evade* goals.

CONSEQUENCES Completing goals of *Puzzle Solving* is a form of *Stimulated Planning*, as the challenge lies in finding the right combination of actions rather than performing the actions. This planning, although it may be partly externalized by arranging game elements, makes *Puzzle Solving* incompatible with *Limited Planning Abilities*. If players have restricted or no *Game State Overview*, *Puzzle Solving* requires *Memorizing*, while it promotes *Experimenting* if players have *Limited Foresight* but the game supports *Reversability*. Whatever the exact type of activity required to do the *Puzzle Solving*, it provides opportunity for *Cognitive Immersion*, and being skillful in solving puzzles is a form of *Game Mastery*.

Puzzle Solving has low *Replayability* unless the puzzle changes between game sessions. This can be achieved through the use of *Randomness*, but requires that the *Randomness* guarantee that at least one solution exists. The existence of several solutions can add some *Replayability* to games but primarily if they offer alternative developments of *Narrative Structures* or have *Perceivable Margins* compared to each other.

RELATIONS

 Instantiates: *Cognitive Immersion, Stimulated Planning, Game Mastery, Memorizing, Gain Information, Experimenting*

Modulates: *Overcome, Evade, Capture, Turn-Based Games*

Instantiated by: *Configuration, Gain Information, Traces, Movement, Direct Information, Indirect Information, Achilles' Heels*

Modulated by: *Time Limits, Limited Foresight, Game State Overview, Irreversible Actions, Reversability, Non-Renewable Resources, Right Level of Complexity*

Potentially Conflicting with: *Replayability, Save-Load Cycles, Limited Planning Ability*

Luck

The feeling that random effects are not random but favorable to the player.

Many events in games are impossible for players to control in a predictable and repeatable fashion. However, when players feel that they can affect this event anyway, either through how they perform the action or what they wish for when the effect of the action is being determined, they may feel that they have *Luck*.

> **Example:** Letting players roll dice in any game is motivated primarily by letting players experience the possibility of *Luck*; the main other reason is that nobody else should have to perform the physical actions for the players' game action.

> **Example:** The high level of *Luck* in gambling games lets most people start playing the games easily and feel that they are competent players, even though *Game Mastery* might be very difficult to achieve.

USING THE PATTERN *Luck* is hard to explicitly design players to experience unless the game system cheats. This can be instantiated by *Game Masters* to provide maximum *Tension* but is a *Risk/Reward* choice, because if players notice the cheating, they will lose all *Illusion of Influence*.

Designing for the possibility for players to feel lucky is much easier, most often simply some form of *Randomness* is sufficient. Typical ways of letting players feel *Luck* are through letting them roll *Dice*, giving them hidden *Card Hands*, or letting *Near Miss Indicators* show them how close they were to being affected by dangers. For *Betting*, actions based around *Skills*, or *Overcome* goals that are determined by *Randomness*, players may base their *Risk/Reward* choices upon how much *Luck* they feel that they have.

Parts of *Polyathlons* that appear to depend on *Luck* add elements not depending on player skills and that may have less *Predictable Consequences*.

CONSEQUENCES *Luck* gives players an *Illusion of Influence* in games and can create *Tension* when perceived in actions that have *Delayed Effects*. Games, which rely heavily on *Randomness*, or at least lack *Predictable Consequences*, often make it possible for players to feel that the outcome depends on *Luck*, and thereby give these games deceptive *Smooth Learning Curves*. Games depending totally on *Randomness* can be said to depend solely on *Luck* and have no *Game Mastery*, but many games with high levels of *Randomness* can have *Game Mastery* through *Bluffing* or *Strategic Knowledge* about probabilities, although *Meta Games* and *Tournaments* or other forms of playing many game sessions may be required to notice the *Game Mastery*.

RELATIONS

> **Instantiates:** *Illusion of Influence, Tension, Risk/Reward, Smooth Learning Curves*
>
> **Modulates:** *Overcome, Polyathlons, Near Miss Indicators, Game Mastery*
>
> **Instantiated by:** *Dice, Betting, Skills, Randomness*
>
> **Modulated by:** *Delayed Effects, Game Masters*
>
> **Potentially Conflicting with:** *Tournaments, Game Mastery, Bluffing, Predictable Consequences, Strategic Knowledge, Meta Games*

Additional Patterns

ON THE CD Descriptions of these additional patterns can be found in the Chapter 14 folder on the companion CD-ROM.

> **Perceivable Margins**
>
> **Achilles' Heels**

PLANNING

The following patterns deal with ways either to encourage the players to plan their actions beforehand or to limit the scope of planning to balance the gameplay.

Tradeoffs

That players must choose between several different options and compare values against each other.

For choices to be interesting in games, they need to be challenging. One way choices can be difficult to do is if they have different sorts of advantages or the advantages are coupled with disadvantages. In this case, there does not have to be one choice that is easily identifiable as the best, and players have to do *Tradeoffs* instead.

> **Example:** The various technologies that can be gained in the computer game *Civilization* not only have different advantages but also are prerequisites for different, more advanced, technologies. When playing the game, players must make *Tradeoffs* between what technologies they need, often depending on the local surroundings and the goal of gaining certain advanced technologies.

> **Example:** All roleplaying games where players can distribute values for statistics or skills require players to do tradeoffs, such as whether they want characters that are strong and dumb or weak and smart, clumsy but charming or agile but unpleasant, and so on.

USING THE PATTERN There are several ways to create *Tradeoffs* in games, but all rely on a *Freedom of Choice* for players: if various areas in the game have different properties, players have to do *Tradeoffs* concerning *Area Control*; the *Perceived Chance to Succeed* may differ between different actions and force *Tradeoffs* between the *Risk/Rewards* choices; *Cameras* may force players to do *Tradeoffs* on what to view or how to perform *Attention Swapping*; *Player-Decided Distribution of Rewards & Penalties* forces players to give advantages to some players and disadvantages to others; *Time Limit* and *Budgeted Action Points* let players choose between many actions but force them to do *Tradeoffs* between which to perform, and similar analysis needs to be done for *Resource Management*; *Bidding* forces players to make *Tradeoffs* between the cost of the bid and what can be gained from the bid; and *Supporting Goals* can make the main goals easier but may deplete *Resources* or take time.

All these forms of *Tradeoffs* can be modulated with *Risk/Reward* when they are linked to goals by making these *Committed Goals*. Especially *Resource Management* requires many different types of *Tradeoffs* and commitments: most commonly which *Resources* to use in a variety of *Consumers* and what *Renewable Resources* to produce from a variety of *Producers* or *Converters*. *Incompatible Goals* can also make the *Tradeoff* choices more important and can be used to create *Tradeoff* situations of choosing which goals players should strive for.

Tradeoffs can also be between what goal in a *Selectable Sets of Goals* to pursue, especially if other players can complete the other goals. This gives *Tension* and a sort of *Balancing Effect*, since one player cannot fulfill all the goals.

Common activities that require players to do *Tradeoffs* between different actions at the spur of the moment include *Stealth* and *Combat*.

CONSEQUENCES *Tradeoffs* make games contain *Stimulated Planning* and *Cognitive Immersion*, and knowing the values of different *Tradeoffs* may be *Strategic Knowledge* that offers the opportunity for *Game Mastery*. However, as with any activity that gives *Cognitive Immersion*, it may also encourage *Analysis Paralysis*. Providing players with choices between challenges with different *Tradeoffs* can allow them to select the *Right Level of Difficulty*.

Having to make *Tradeoffs* can cause *Tension* if the results of the *Tradeoffs* have *Delayed Effects*. It also increases the *Tension* regarding the use of *Limited Resources*, with the amount of *Tension* proportional to the scarcity of the *Limited Resources*.

RELATIONS

Instantiates: *Stimulated Planning, Game Mastery, Analysis Paralysis, Strategic Knowledge, Balancing Effects, Tension*

Modulates: *Stealth, Committed Goals, Cognitive Immersion, Perceived Chance to Succeed, Right Level of Difficulty*

Instantiated by: *Incompatible Goals, Combat, Budgeted Action Points, Freedom of Choice, Time Limits, Resource Management, Risk/Reward, Player-Decided Distribution of Rewards & Penalties, Area Control, Resources, Consumers, Converters, Renewable Resources, Selectable Sets of Goals, Delayed Effects, Bidding, Producers*

Modulated by: *Supporting Goals, Cameras, Producers, Attention Swapping, Limited Resources*

Potentially Conflicting with: None

Randomness

Effects or events in the game cannot be exactly predicted.

Randomness is the process of making effects and events unpredictable in games. It does not necessarily make games totally unpredictable, as the *Randomness* usually has a structure where players can know the chances for certain effects and events.

Example: Very few card games do not randomize the cards by shuffling them before giving the players their cards. Not doing so would ruin nearly all games, and especially games that include *Betting*.

Example: Many roleplaying games use random encounters to spice up the *Game World* and give the players the impression that there is more to the *Game World* than they experience.

USING THE PATTERN *Randomness* can be introduced into games to lessen *Predictable Consequences* and give players *Limited Foresight* and *Limited Planning Abilities*. This is usually done for two reasons: either to simulate events in the real world that are chaotic and unpredictable or to generate essential *Asymmetric Resource Distribution* or *Imperfect Information* in the games.

Examples of real-world concepts that are often modeled in games partially through *Randomness* include *Combat*, and especially *Damage*, and the starting conditions for *Characters*. The use of *Skills* that represent many actions or actions done in hazardous situations also make use of *Randomness* to abstract complex situations into a manageable situation in game terms. The use of *Randomness* in these cases often causes *Tension*, as it is part of actions that players have initiated but they do not control, and initiating them becomes a *Risk/Reward* choice for players.

Generating *Asymmetric Resource Distribution* and *Imperfect Information* can be done either before the actual game play begins, as for example in many games with *Betting*, but can also find use during gameplay. The time until *Delayed Effects* take place is one example of how *Randomness* can be used during gameplay. A more complex use is to randomize future events in the *Narrative Structure* to create *Never Ending Stories*.

Common game elements used to create *Randomness* are *Dice* and *Cards*, in the latter case, often to create randomized *Card Hands* through *Drawing Stacks* or dealing out *Cards*. The main difference between them is that of memory and static distribution. The roll of *Dice* is unaffected by previous rolls, so the randomization process can be seen as having no memory and the chances for any result are exactly the same as they were the previous time. *Cards*, on the other hand, use outcome like a form of *Non-Renewable Resources*, so *Memorizing* what *Cards* have been used allows players to have better chances of predicting what cards have not been used yet. Further, *Cards* allow the distribution to be changed explicitly during gameplay by adding or removing *Cards* from those that are randomly selected. Tiles can also be used to create *Randomness*, most commonly through *Tile-Laying*.

In computers, *Randomness* is typically generated through pseudo-random sequences that are not random but seem random. In *Self-Facilitated Games*, low-level uses of *Paper-Rock-Scissors* can serve the same purpose for generating *Randomness*.

CONSEQUENCES *Randomness* makes it impossible to have *Perfect Information* about the effects of actions in the game. *Randomness* also allows players to have a *Perceived Chance to Succeed* that does not depend on any skill they have, and thereby reduces pressure on their performance. It does this while still allowing players to have an

Illusion of Influence and feel like they have or lack *Luck*, as long as they have some influence on how the randomization is done. As long as players feel this *Illusion of Influence* or are emotionally affected by the outcome, *Randomness* can provide *Tension*, as is often done in *Quick Games*.

Randomness makes the *Predictable Consequences* in games vaguer and makes players have a bounded *Uncertainty of Information*. This can encourage players to perform *Memorizing* of the distributions to gain *Strategic Knowledge* that can be used to make better *Risk/Reward* choices. The presence of it in games is a weak form of a *Balancing Effect*, as it is not affected by any players' skills and affects all players impartially. This tends to lessen the chance for *Perceivable Margins* depending on players' skills in games, makes *Game Mastery* less noticeable, and can lessen the risk (or chance) of *Analysis Paralysis*.

As the *Randomness* used in games typically is bounded within certain values and has a static probability distribution, the use of *Randomness* can support *Strategic Knowledge* in that players that have played the game before can know the distribution of the *Randomness* and use it in their planning.

Randomness can create an unstable form of *Player Balance*. It is unstable because all players may have equal chances to receive what is randomized, but as soon as the outcome becomes apparent, players may feel disadvantaged. The use of *Randomness* to determine effects can limit the power of *Game Masters* if the process is conducted so that all players can see it.

Relations

Instantiates: *Balancing Effects, Strategic Knowledge, Tension, Risk/Reward, Luck, Limited Foresight, Memorizing, Imperfect Information, Limited Planning Ability, Player Balance*

Modulates: *Card Hands, Betting, Characters, Skills, Narrative Structures, Never Ending Stories, Perceived Chance to Succeed, Illusion of Influence, Delayed Effects, Predictable Consequences, Asymmetric Resource Distribution, Quick Games, Uncertainty of Information, Game Masters*

Instantiated by: *Dice, Damage, Combat, Cards, Paper-Rock-Scissors, Drawing Stacks, Tile-Laying*

Modulated by: *Non-Renewable Resources*

Potentially Conflicting with: *Game Masters, Perceivable Margins, Game Mastery, Analysis Paralysis, Perfect Information*

Risk/Reward

That the chance for receiving a Reward in the game is linked to some risk of receiving a Penalty if the player fails to acquire the Reward.

Interesting choices in games must have the potential for both advantageous and disadvantageous effects. Although players do not normally strive to have the disadvantageous effects, these may be unavoidable, and performing the actions at all can depend heavily on the chance of gaining the *Reward* and the risk of gaining the *Penalty*. This kind of decision-making is based on *Risk/Reward* choices.

> **Example:** Choosing to fold, follow, or raise in *Poker* is a classic example of *Risk/Reward*: what is the chance of winning compared to the size of the pot?

> **Example:** Lotteries present simple *Risk/Reward* choices where often a small investment gives a small chance of winning a large *Reward* but the only risk lies in losing the initial investment. That the sum of small investments are more than the large *Reward* seldom discourages players to feel tension or luck influence, and this may be the only way for the players to have any chance of getting the large *Reward*.

USING THE PATTERN *Risk/Reward* requires that the game does not have completely *Predictable Consequences* regarding a certain part of gameplay. Thus, the prime variables a game designer has when designing *Risk/Reward* are the probabilities of getting the reward and receiving the penalty. These, together with the actual *Penalties* and *Rewards*, produce the final basis for players to make choices. The basis can only in rare or simple cases be evaluated regardless of player situation and game context. Note that players may not be in direct control of the actions leading to the *Rewards* and *Penalties*: letting another player perform actions is a *Risk/Reward* choice in itself. *Meta Games* can modulate *Risk/Reward* choices beyond the current game state, as for example is the effect of introducing *Betting* on the outcome of a game.

The three main ways of introducing risk of failing to gain the *Reward* is through *Randomness*, performing the wrong action, and the possibility of other players to affect the outcomes. *Randomness* can provide the simplest forms of *Risk/Reward* choices since players may know distributions and exact chances to succeed with actions, for example, through *Skills*. *Randomness* in these choices allows for players to feel *Luck*, where doing *Leaps of Faith* is one such example. The possibility of performing the wrong actions depends on players having *Imperfect Information* or *Freedom of Choice*, and commonly exists in *Experimenting* and *Combat* activities, as well as goals requiring *Stealth*. *Supporting Goals* and *Incompatible Goals* allow players to make choices that give them *Rewards*, but these may not be as coveted as other *Rewards* when they finally are received. Common ways to allow other players to affect the outcome are through *Player Killing*, *Interruptible Actions*, *Player-Decided Distribution of Rewards & Penalties*, or *Social Dilemmas* such as *Betrayal*. *Uncommitted Alliances*, especially with *Individual Penalties*, increase the risk of participating in such

activities, as *Penalties* do not necessarily exist for negatively affecting other players by *Betrayal*.

The possibility for *Risk/Reward* choices in games is infinite, but examples include: risking *Damage* to gain *Rewards* or perform actions; choosing which *New Ability* to get; using *Resources* to perform actions even if this will lead to future *Decreased Abilities*, especially when *Limited Resources* are involved; how to do *Resource Management* in general, for example, what *Investments* to make, what area of several to *Guard*, whether to stay on *Chargers*, whether to enter areas with *Movement Limitation*, selecting the location for *Spawning*, choosing what part of the *Game World* to try and achieve *Area Control* over, trying to orchestrate *Role Reversals*, and deciding for how long to use a *Mule*.

Risk/Rewards can be modulated in several ways to make the choices have long-term effects. Having a *Selectable Sets of Goals* forces players to choose the order in which to complete the goals; *Bluffing*, *Betting*, and other *Extended Actions* that are part of *Committed Goals* make players initiate actions and not reveal the result until later; *Committed Goals* not only may force players to make *Risk/Reward* choices but make them estimate the *Risk/Reward* of the choices after a while of gameplay. The *Risk/Rewards* of having to place *Resources* in *Investments* is lessened by *Arithmetic Rewards for Investments*, as the *Investments* can be split into several without losing efficiency while *Geometric Rewards for Investments* are increased for the opposite reason.

CONSEQUENCES *Risk/Reward* choices automatically cause *Tradeoffs* to exist in games: either between actions or between performing actions or not. They cause *Stimulated Planning* in games and affect *Cognitive Immersion* by adding additional aspects that have to be considered regarding actions. Being good at correctly judging *Perceived Chance to Succeed* in actions that contain *Risk/Rewards* is often a part of *Game Mastery*, and especially being able to do so in games where one is under *Emotional Immersion*.

The presence of *Risk/Reward* in games naturally creates *Tension*, as players may fail to gain the *Rewards* they want. *Reversability*, however, has a negative effect on this kind of *Tension*.

RELATIONS

> **Instantiates:** *Incompatible Goals, Stimulated Planning, Game Mastery, Tradeoffs, Tension*
>
> **Modulates:** *Committed Goals, Stealth, Mule, Chargers, Cognitive Immersion, Perceived Chance to Succeed, Player Killing, Geometric Rewards for Investments, Investments*

Instantiated by: *Selectable Sets of Goals, Experimenting, Role Reversal, Extended Actions, Interruptible Actions, Player-Decided Distribution of Rewards & Penalties, Area Control, Combat, Leaps of Faith, Betting, Freedom of Choice, Randomness, Luck, Betrayal, Bluffing, Limited Resources, Uncommitted Alliances, Movement Limitations, Resource Management, Guard, Imperfect Information*

Modulated by: *Committed Goals, Supporting Goals, Damage, New Abilities, Decreased Abilities, Skills, Emotional Immersion, Penalties, Rewards, Spawning, Meta Games, Geometric Rewards for Investments, Arithmetic Rewards for Investments, Individual Penalties, Social Dilemmas, Reversability*

Potentially Conflicting with: *Predictable Consequences*

Predictable Consequences

Players can predict how the game state will change if they perform actions, or possibly sequences of actions.

When players can understand how actions and events affect the game state of a game, those actions and events have *Predictable Consequences*. A game can have *Predictable Consequences* without players being able to exactly predict what action is going to be performed or what effect an action can have. A game can be predictable if players can anticipate the set of possible actions another player can perform, and an action can be predictable if players can imagine the set of possible future game states its effects can create.

> **Example:** The actions in first-person shooters often contain no elements of chance and thereby have totally *Predictable Consequences*. However, being able to perform these actions is not easy for a player, especially when one has to anticipate other players' actions and these actions often have the intention of disrupting the player.

> **Example:** The actions in *Chess* and *Go* have totally *Predictable Consequences*, and skillful playing of these games consists on being able to predict opponents' actions and planning many actions ahead.

USING THE PATTERN How *Predictable Consequences* actions and events are used in game designs depends mainly on who performs or influences them: the game system or players. The predictability of game systems can vary as much as that of the predictability of opponents but can also be fixed so that players are aware of them before the actions or events are initiated. Providing the *Right Level of Complexity* is also important when considering *Predictable Consequences*: games that have *Predictable Consequences* for individual actions and events can lose that predictability

when the complexity increases, for example, by having few *Closure Points* that reduce the potential game space or allowing long and dynamic *Producer-Consumer* chains.

The most *Predictable Consequences* (although maybe only in the short term) are the players' own actions when they have *Perfect Information* of the game state and the evaluation function is static. If the evaluation of the action uses some amount of *Randomness*, the action can still have *Predictable Consequences*, but since the outcomes are bounded within a number of possible outcomes, players have *Uncertainty of Information* about the exact outcome. The same applies to *Indirect Control* if the time difference between the action and the outcome is great enough. If players have *Imperfect Information* about a part of the game state that affects the outcome of the action, the predictability immediately is significantly reduced.

After that, the most predictable actions and events are *Ultra-Powerful Events* controlled by the game system. Effects that require *Perceivable Margins* are *Predictable Consequences* in one sense, since players may observe that the margin is close to being fulfilled. *Damage* and other *Penalties* usually also have very predictable consequences since experiencing unexpected *Penalties*, especially *Individual Penalties*, may cause players to simply stop playing the game. *Investments* also usually have a range of *Predictable Consequences*, even if the chances of gaining on the *Investments* may be small, as players otherwise would be unwilling to make the *Investments*. *Surprises* caused by the game system, which the first time they are experienced are intended not to be predictable, actually also easily become predictable after the first encounter. The effects of *Leaps of Faiths* and *Irreversible Actions* are likewise difficult to predict the first time they are done but then might become easy to predict.

Effects of games that can either be easy to predict or completely impossible due to player perception of the game state include *Selectable Sets of Goals*, *Paper-Rock-Scissors*, *Player-Decided Distribution of Rewards & Penalties*, and *Player Decided Results*. The use of *Randomness* can give more *Predictable Consequences*, especially when used together with *Skills*, than actions from other players since the distribution of the *Randomness* can be known in advance. This means that even games that are initially associated with *Luck* can become very predictable and have *Strategic Knowledge*, especially regarding *Betting*.

Predictable Consequences from game systems can be achieved indirectly through *Consistent Reality Logic*, *Alternative Reality*, and *Illusionary Rewards*. In these cases, players experiencing them can understand how future actions and effects will affect the game state without necessarily having experienced the actions and effects themselves. In contrast, *Outcome Indicators* provide a means to give players *Direct Information* to support *Predictable Consequences* within a game, but this violates the *Consistent Reality Logic*.

Games with *Limited Planning Ability* have some part of their game design constructed so that players cannot accurately foresee future game states, and thereby cannot have *Predictable Consequences* regarding at least part of the game state.

CONSEQUENCES *Predictable Consequences* let players predict future game states and thus have *Anticipation* and notice *Hovering Closures* in games. Being able to understand the consequences of other actions and events in the game, players can also achieve a more correct *Perceived Chance to Succeed* and make more informed *Risk/Reward* choices, which can provide *Strategic Knowledge* and support *Stimulated Planning, Cognitive Immersion*, and create *Uncommitted Alliances. Predictable Consequences* are a requirement for *Investments* and are most apparent in games using *Arithmetic Rewards for Investments*.

When games have *Predictable Consequences* of the immediate actions that players can perform but *Limited Foresight* to the complex effects of the actions combined, this can encourage *Experimenting* and lead to *Surprises. Predictable Consequences* can in some cases cause *Analysis Paralysis* as the players can better plan ahead.

RELATIONS

Instantiates: *Cognitive Immersion, Perceived Chance to Succeed, Anticipation, Hovering Closures, Stimulated Planning, Uncommitted Alliances, Investments, Experimenting*

Modulates: *Strategic Knowledge, Surprises, Analysis Paralysis, Individual Penalties, Betting*

Instantiated by: *Consistent Reality Logic, Alternative Reality, Illusionary Rewards, Damage, Ultra-Powerful Events, Penalties, Arithmetic Rewards for Investments, Outcome Indicators, Perfect Information, Investments, Perceivable Margins*

Modulated by: *Randomness, Skills, Limited Foresight, Right Level of Complexity, Closure Points, Uncertainty of Information, Imperfect Information*

Potentially Conflicting with: *Leaps of Faith, Irreversible Actions, Indirect Control, Player-Decided Distribution of Rewards & Penalties, Player Decided Results, Surprises, Luck, Risk/Reward, Paper-Rock-Scissors, Producer-Consumer, Limited Planning Ability, Selectable Sets of Goals*

Limited Planning Ability

Players cannot make plans about what future actions to perform due to characteristics inherent in the game design.

Many games do not let players plan their actions accurately beyond a certain point. This *Limited Planning Ability* can exist because players do not have all the information, because future actions and events are difficult to foresee, or because players simply do not have the time to do the planning. It may force players to take chances, quicken gameplay, and give players unexpected experiences.

> **Example:** Deathmatches in multiplayer first-person shooters give players very little chance to plan while playing the game, since all other players are actively trying to eliminate them.

> **Example:** The planning in most gambling games is very limited with the exception for long-term strategies regarding money.

USING THE PATTERN *Limited Planning Ability* can be achieved through several different approaches: limiting the amount of things that can be planned, making events unpredictable, or limiting the time players have to plan. The first approach can easily be achieved by giving players a *Limited Set of Actions* but does not in itself give *Limited Planning Ability* if players have any *Freedom of Choice*.

The second approach, *Limited Foresight*, can either be achieved by making the effects of actions difficult to predict or by limiting the information available to judge the values of different actions and plans. The former relies on *Imperfect Information*, *Uncertainty of Information*, or actions that do not have *Predictable Consequences*, with *Randomness* and *Multiplayer Games* being the most common ways to achieve this. The latter does not automatically make consequences more difficult to predict, but the difficulty to do so can be increased by using *Secret Resources*, *Preventing Goals*, *Player Decided Results*, and *Player-Defined Distribution of Rewards & Penalties*.

The third approach is easily implemented through *Time Limits*. *Real-Time Games* can be used to create *Limited Planning Ability*, as they put a natural *Time Limit* on how much time players have until either they must react to other players' actions or before the game state has changed so much due to *The Show Must Go On* that the previous planning is outdated.

CONSEQUENCES *Limited Planning Ability* makes gameplay mentally easier as focus is shifted from planning to doing, which limits the likelihood of *Analysis Paralysis* to occur. Limiting the planning can thereby make *Cognitive Immersion* less common but makes already existing possibilities for *Spatial Immersion* easier. Depending on the intended gameplay, this can be used to have the *Right Level of Complexity* by modulating how much players can plan. However, *Limited Planning Ability* gives players less *Freedom of Choice* and can thereby negatively affect any *Illusion of Influence*.

When players have *Limited Planning Abilities* in *Multiplayer Games*, this limits the likelihood that *Downtime* occurs for the other players. In *Single-Player Games*, the use of *Limited Planning Abilities* usually sets the *Right Level of Difficulty* or allows players to have *Surprises* due to *Limited Foresight*.

Puzzle Solving is usually incompatible with *Limited Planning Ability*, since solving a puzzle often entails finding a correct plan of execution.

RELATIONS

Instantiates: *Spatial Immersion*

Modulates: *Multiplayer Games, Single-Player Games, Surprises, Right Level of Difficulty*

Instantiated by: *Preventing Goals, Limited Foresight, The Show Must Go On, Time Limits, Randomness, Player Decided Results, Player-Defined Distribution of Rewards & Penalties, Right Level of Difficulty, Right Level of Complexity, Uncertainty of Information, Secret Resources*

Modulated by: *Limited Set of Actions, Real-Time Games, Imperfect Information*

Potentially Conflicting with: *Analysis Paralysis, Downtime, Illusion of Influence, Freedom of Choice, Puzzle Solving, Cognitive Immersion, Predictable Consequences*

Strategic Knowledge

Knowledge based on processing information about the game elements, rules, possible actions, or evaluation functions of a game without regard to a specific game state.

Many games are easier to win if players have information about how the actions and events work, even though it is not necessarily required to be able to play. When this information is usable for all game sessions of the same game, the information is *Strategic Knowledge* about the game.

> **Example:** The locations of power-ups and pick-ups in first-person shooter deathmatches are essential knowledge for players to successfully compete against each other.

> **Example:** The knowledge of long sequences of combos in fighting games such as the *Tekken* or *Dead or Alive* series are *Strategic Knowledge* to players, even if they may not have the skill to successfully perform them.

USING THE PATTERN Providing players with *Strategic Knowledge* about rules is necessary in *Self-Facilitated Games* but can be used to create *Smooth Learning Curves* in other games. Besides rules, *Strategic Knowledge* can be about the configuration of the *Game World*, the value of different goals, how to perform certain actions, and the likelihood of different actions and events to take place in a game.

Knowledge about the *Game World* consists of knowing where *Strategic Locations* are, for example *Shared Resources* or *Power-Ups*, and can help *Game World Navigation* and winning *Races*. The knowledge about the correct values of goals consists mainly of knowing the *Tradeoff* values between various *Resources, Rewards,* and *Penalties*. This can be used to influence choices in *Selectable Sets of Goals* and *Hierarchies of Goals*, and knowing when to strive for *Transfer of Control* or what areas to try and achieve *Area Control* over. In cases of *Unknown Goals*, knowing what *Predefined Goals* exist is *Strategic Knowledge* in itself. Examples of *Strategic Knowledge* related to information about actions are how to perform *Combos*, what *Achilles' Heels* enemies have, and what places are most important to *Guard*. Knowing the likelihood of events and actions mainly consists of knowing all the possible *Predictable Consequences* in games or the probabilities of *Dice* and other randomizers in games with high degrees of *Randomness*. The easiest knowledge in these cases are predetermined *Ultra-Powerful Events* such as *Moveable Tiles* or *Shrinking Game Worlds*. Knowledge of the exact effects of *Damage* or *Delayed Effects*, and the *Tradeoffs* between *Risk/Reward* choices (especially in *Betting*) are also part of these types of *Strategic Knowledge*.

A typical way of letting players acquire *Strategic Knowledge* is through *Game State Overviews, Cut Scenes, Experimenting,* or being *Spectators* to games played by others. This becomes easier when the information presented is *Perfect Information* and, in the case of *Spectators*, requires that the information is *Public Information*.

CONSEQUENCES *Strategic Knowledge* about a game gives players *Empowerment*, and if it can successfully be applied to actions performed, it can provide an opportunity for *Game Mastery*. It encourages *Stimulated Planning* both during gameplay and before gameplay begins. The possibility to have *Strategic Knowledge* about a game allows *Extra-Game Actions* specifically for extracting and *Memorizing* that knowledge, and communicating the knowledge between players makes it into *Extra-Game Information* if done through *Storytelling* within the game or *Trans-Game Information* if done by other means outside the game. The possibility also gives an incentive for *Replayability* in the game to learn and make use of the *Strategic Knowledge*, for example, in *Tournaments*.

Strategic Knowledge affects players' *Illusion of Influence* depending on whether players actually have any influence. It typically removes players' ability to feel that they have *Luck* in the game but can be used to create knowledge-based *Meta Games*.

RELATIONS

> **Instantiates:** *Game Mastery, Memorizing, Empowerment, Replayability, Trans-Game Information, Extra-Game Actions, Stimulated Planning*
>
> **Modulates:** *Race, Betting, Illusion of Influence, Self-Facilitated Games, Smooth Learning Curves, Replayability, Shared Resources, Guard*
>
> **Instantiated by:** *Selectable Sets of Goals, Hierarchy of Goals, Tournaments, Moveable Tiles, Power-Ups, Dice, Strategic Locations, Ultra-Powerful Events, Shrinking Game World, Transfer of Control, Rewards, Penalties, Game World Navigation, Area Control, Delayed Effects, Randomness, Tradeoffs, Combos, Achilles' Heels, Resources, Experimenting, Cut Scenes, Spectators, Trans-Game Information, Meta Games, Game State Overview, Predefined Goals, Extra-Game Information*
>
> **Modulated by:** *Damage, Storytelling, Predictable Consequences, Public Information, Perfect Information, Unknown Goals*
>
> **Potentially Conflicting with:** *Luck*

Stimulated Planning

> *Games that encourage players to plan about certain aspects of the game.*

Some games provide players with the opportunity to know with some certainty the outcomes of actions and thereby be able to plan what to do thereafter. The certainty of the outcomes and the number of possible future game states after a couple of actions decide if these games can be said to encourage *Stimulated Planning* amongst players.

> **Example:** Real-time strategy games that provide different types of units and special abilities encourage players to plan how they are going to play before actually starting to play the games.
>
> **Example:** Games such as *Go* and *Chess* that provide players with perfect information and no unpredictability to the effects of actions provide ample support for *Stimulated Planning*.

USING THE PATTERN *Stimulated Planning* requires that players have a *Freedom of Choice* between different actions and that those actions have *Predictable Consequences*. Besides making these two requirements exist in a game design, *Stimulated Planning* requires reasons for doing the planning and means for players to be able to do the planning. *Direct Information* and *Perfect Information* supports *Predictable Consequences*, either by allowing players to know the game state with certainty and

thereby the possible actions, or by giving players exact feedback on actions. *Symmetric Information* can provide players with information about other players' goals and game elements, thereby stimulating planning, with the added feature that players know what other players know. *Public Information* can provide players with information about other players' goals or tactics, thereby also increasing the possibility of having *Predictable Consequences* of the players' own actions and tactics. *Near Miss Indicators* can help players readjust their planning, either by noticing their own failures or by becoming aware of other players' actions. *Cut Scenes* can provide players with overviews of the challenges they will later face.

Activities that require planning include *Resource Management*, *Puzzle Solving*, or completing *Stealth* goals. Especially *Resource Management* can provide a great variety of possible actions that can stimulate planning of how to make use of *Limited Resources*: which *Resources* and *Units* should be created by *Producers* or *Converters*, what *Investments* to make, and which *Resources* should be saved in *Containers*. Further, many sorts of actions promote planning: *Extended Actions* may require planning, and plans on when other actions could be started instead of continuing the actions; actions with *Delayed Effects* may require planning to make full use of *Timing*, but *Timing* may also be created by planning; having to choose between possible *Rewards*; and the long-term consequences of *Irreversible Actions* may require more planning than other actions. Coordinating activities into *Collaborative Actions* also requires planning, as does fighting against *Enemies* with *Orthogonal Unit Differentiation* or making use of one's own forces with various *Privileged Abilities*. Any *Risk/Reward* choices or choices that require *Tradeoffs* promote *Stimulated Planning*.

Planning is made possible through providing information to players and giving them the time to use it. Examples of ways players can be supported with *Public Information* to do planning include *Book-Keeping Tokens* or other *Game State Overviews*, public *Scores*, or open *Discard Piles*. *Turn Taking*, *Safe Havens*, and *Ultra-Powerful Events* can all give players *Downtime*, which can be used for *Stimulated Planning*.

The *Right Level of Complexity* of *Stimulated Planning* depends on how many actions and players have to be considered, as well as how far into the future gameplay the planning should be done. Number of players in a game is easy to design, and number of actions can be regulated by *Limited Set of Actions*. How many actions ahead players can move is more difficult, as players usually want to plan as far ahead as possible, but can be modulated by *Limited Foresight* or avoiding too *Predictable Consequences* from actions. The complexity can be further modulated by requiring players to do *Attention Swapping* between different areas of gameplay.

Stimulated Planning can be promoted by the *Extra-Game Actions* of *Save-Load Cycles*, which allows players to explore the game first and then try to overcome challenges or to do *Experimenting*.

CONSEQUENCES *Stimulated Planning* gives players a sense of *Empowerment* and is the effect of *Predictable Consequences* and either *Freedom of Choice* or an *Illusion of Influence*. The activity of planning also gives *Cognitive Immersion* but may cause *Analysis Paralysis* if the *Right Level of Complexity* is not achieved. Being able to make efficient use of *Stimulated Planning* without having *Analysis Paralysis* can be a measure of *Game Mastery*. *Stimulated Planning* can also be caused by giving players *Creative Control*, for example, through *Planned Character Development*, or by letting them do *Experimenting*.

When games support planning between game instances or game sessions if players have *Strategic Knowledge*, this is a form *Stimulated Planning* through *Extra-Game Actions*.

RELATIONS

> **Instantiates:** *Game Mastery, Cognitive Immersion, Analysis Paralysis, Empowerment, Timing*
>
> **Modulates:** *Timing*
>
> **Instantiated by:** *Stealth, Discard Piles, Score, Safe Havens, Privileged Abilities, Limited Set of Actions, Rewards, Ultra-Powerful Events, Extended Actions, Irreversible Actions, Collaborative Actions, Turn Taking, Planned Character Development, Freedom of Choice, Delayed Effects, Experimenting, Creative Control, Tradeoffs, Risk/Reward, Puzzle Solving, Resource Management, Illusion of Influence, Predictable Consequences, Orthogonal Unit Differentiation, Resources, Save-Load Cycles, Extra-Game Actions, Container, Producers, Converters, Strategic Knowledge, Book-Keeping Tokens, Game State Overview, Direct Information, Perfect Information, Investments, Units, Discard Piles, Cut Scenes, Symmetric Information*
>
> **Modulated by:** *Downtime, Attention Swapping, Right Level of Complexity, Limited Foresight, Near Miss Indicators, Public Information, Limited Resources*
>
> **Potentially Conflicting with:** None

Additional Patterns

Descriptions of these additional patterns can be found in the Chapter 14 folder on the companion CD-ROM.

> **Limited Foresight**
>
> **Combos**

BALANCING

The following patterns describe ways to balance the gameplay between players, or between individual players and the system, in order to create meaningful play experiences.

Balancing Effects

Rules and effects in games that lessen the differences of value used to measure competition between players.

For games where players play against opponents, the players need to feel that they can affect the outcome of the game. If a game is designed with a certain game time or amount of gameplay, and players feel powerless, these players have two possibilities: endure gameplay that is uninspiring or suffer gameplay breakdown due to the players' desire to stop playing. To avoid these situations, games can have *Balancing Effects* built into them so that all players are more likely to feel that they have a chance to win over their opponents until the intended conclusion of the competition.

> **Example:** Power-ups in *Monkey Race 2* in *Super Monkey Ball 2* give speed boosters only to the players that are not leading the races. Further balancing effects can be added by players through the option that makes the leader have a lower maximum speed than the other players.

> **Example:** Multiplayer online first-person shooters often have possibilities to force teams to be balanced in numbers. Some, such as *Return to Castle Wolfenstein: Enemy Territory*, have functionality that can automatically re-assign teams based on experience to try and balance the teams further.

USING THE PATTERN *Balancing Effects* can be designed in a game to be preemptive or correcting. Preemptive *Balancing Effects* try to maintain *Player Balance* so that imbalances do not occur, while correcting *Balancing Effects* try to correct imbalances when they have occurred. An alternative to *Balancing Effects*, which can be used together with them, is *Limited Foresight*. This also gives players a *Perceived Chance to Succeed* but in this case, it may only be an *Illusion of Influence*.

Handicaps are preemptive *Balancing Effects* that are put into effect before gameplay begins. Making *Extended Actions* into *Interruptible Actions* is a form of preemptive *Balancing Effect* as other players can interfere with the actions, especially if they do not have any effect before they are completed. *Delayed Effects* in general have a certain *Balancing Effect*, as they give players the possibility to prepare for the

effects. Other ways of creating preemptive *Balancing Effects* consist of designing *Illusionary Rewards*, requiring *Tradeoffs*, allowing players to choose *Selectable Sets of Goals* that best fit their abilities, or providing *Diminishing Return* to players that otherwise could become clear leaders. If the effects are direct, these effects can ruin the *Illusion of Influence* for players and even make them avoid trying to achieve what should be goals for them. Having *Balancing Effects* affect the players indirectly can solve this, for example, through *Character Development* or making *New Abilities* additions to those already used with *Budgeted Action Points*.

Examples of correcting *Balancing Effects* include giving *New Abilities* or *Improved Abilities* to disadvantaged players and giving *Ability Losses* or *Decreased Abilities* to advantaged players. The classic case used in *Races* is a *Decreased Ability* in the form of *Movement Limitation* giving a lower maximum speed. To avoid players losing *Illusion of Influences*, the positive effects are usually *Rewards* to the disadvantaged players for completing goals, while the negative effects are usually *Penalties* to the advantaged players for failing goals. The evaluation function that determines the *Balancing Effects* is for the same reason often hidden from players, for example, by making all *Pick-Ups* look the same though they have different effects, or by hiding the actual rolling of *Dice* to be able to fudge the results. Another example of a correcting is to decide the order of *Turn Taking* so that disadvantaged players are given the most advantageous positions.

Transfer of Control can also be used to correct imbalances, but these are often linked to the *Rewards* or *Penalties* of any of the players. A common solution is to have forced *Shared Rewards*, so that the player who gains the *Reward* must share it with someone else, typically the most disadvantaged player. Controlling how *Spawning* occurs can also be corrective, either placing disadvantaged players at *Strategic Locations* or placing advantaged players at bad locations.

Games with more than two teams or players competing against each other automatically have some corrective *Balancing Effects*. Players in these games perceived as leading may be the starting point of *Mutual Goals* for *Uncommitted Alliances*, which have the intentions of ganging up against the leader. This is common in games with *King of the Hill* goals but can also be found in games that allow *Player Decided Results* and *Player-Decided Distribution of Rewards & Penalties*. Sufficient *Game State Overviews*, for example, public *Scores*, so players can notice leaders, are required for this form of *Balancing Effect* to occur.

Game Masters, as *Dedicated Game Facilitators* that have constant access to the complete game state and can enforce their own *Player Decided Results*, can perform both preemptive and corrective balancing effects during gameplay.

Games using primarily *Randomness* to judge outcomes can easily be designed to have *Balancing Effects* over time or when considering several game sessions together. However, games with *Dedicated Game Facilitators* can fake the *Randomness*,

for example, the results of *Dice* rolls, to explicitly create *Balancing Effects* during gameplay.

CONSEQUENCES The presence of *Balancing Effects* strengthens or prolongs players' *Perceived Chance to Succeed* but lessens the *Perceivable Margins* of the game and removes feelings of *Game Mastery* in the game. *Balancing Effects* often provide the *Right Level of Difficulty* and *Smooth Learning Curves* in games by making challenges sufficiently difficult.

Balancing Effects are used in Multiplayer Games to avoid too large differences of *Asymmetric Abilities* between players. They can achieve *Player Balance* or *Team Balance* during gameplay, often to maintain *Tension* as long as possible in the game and to allow *Higher-Level Closures as Gameplay Progresses*.

RELATIONS

Instantiates: *Perceived Chance to Succeed, Tension, Higher-Level Closures as Gameplay Progresses, Player Balance, Team Balance, Right Level of Difficulty, Smooth Learning Curves*

Modulates: *New Abilities, Ability Losses, Improved Abilities, Decreased Abilities, Asymmetric Abilities, Spawning, Transfer of Control, Rewards, Penalties, Multiplayer Games, Dice, Character Development, Pick-Ups, Turn Taking*

Instantiated by: *Movement Limitations, Game Masters, Tradeoffs, Diminishing Returns, Illusionary Rewards, Player Decided Results,* Player-Decided *Distribution of Rewards & Penalties, Interruptible Actions, Delayed Effects, Randomness, Handicaps, Score, Shared Rewards, Dedicated Game Facilitators, Budgeted Action Points, Rewards, Extended Actions, King of the Hill*

Modulated by: *Mutual Goals, Game State Overview, Uncommitted Alliances*

Potentially Conflicting with: *Game Mastery, Perceivable Margins*

Symmetry

Symmetrical relations exist between players regarding the goals, resources, and actions they can perform.

Symmetry is a common feature in games to ensure that players have equal opportunities. In these cases, the outcome of the games are either dependent on the players' skills or *Randomness*, since the game system does not put any player in a favorable position.

Example: The game pieces that each player has and the setup of them are symmetrical in *Chess* to minimize the differences of playing one side or the other.

Example: The placement of initial settlements in *Settlers of Catan* is symmetrical in a fashion: the player who is first to place the first settlement is the last to place the second settlement while the player who is last to place the first settlement is the first to place the second settlement, and thereby gets to place two settlements in a row.

USING THE PATTERN Creating *Symmetry* in games mainly consists of ensuring the same abilities, *Symmetric Resource Distribution*, and *Symmetric Goals*. Conversely, *Asymmetric Abilities*, *Asymmetric Resource Distribution*, and *Asymmetric Goals* all hinder *Symmetry* as does any way of introducing *Handicaps*. However, games with *Team Play* or *Orthogonal Unit Differentiation* can have *Symmetry* on a higher level while not having it on a lower level by making sure that whatever exists for one player or team exists for the other.

Symmetry can also be used to create *Outstanding Features* in the *Game World*, or provide *Configuration* goals with strong *Hovering Closures*.

CONSEQUENCES *Symmetry* in games can provide *Player Balance* and *Team Balance* but also provides a form of *Consistent Reality Logic* since it can easily be assumed by players. Although *Symmetry* in player relations can allow balanced starting positions, it does not in itself ensure *Player Balance* or *Team Balance* during gameplay. In fact, success can more easily become derived from skillful execution or *Luck* in the beginning of these games as it might be easier to judge all players' positions. In games where *Randomness* plays little role in the outcome, *Symmetry* provides a basis for showing and observing *Game Mastery*.

Paper-Rock-Scissors patterns provide a complex form of *Symmetry* between the usefulness of actions and tactics in a game.

RELATIONS

Instantiates: *Consistent Reality Logic, Team Balance, Outstanding Features, Hovering Closures, Player Balance*

Modulates: *Game Mastery*

Instantiated by: *Symmetric Goals, Symmetric Resource Distribution, Paper-Rock-Scissors*

Modulated by: *Orthogonal Unit Differentiation, Configuration*

Potentially Conflicting with: *Orthogonal Unit Differentiation, Asymmetric Abilities, Handicaps, Asymmetric Resource Distribution*

Team Balance

Teams have equal chances of succeeding with actions in a game or winning a game.

Games with teams are usually balanced the same way as games where players play against each other. This *Team Balance* is usually enforced only in the beginning of the game and does not usually take into consideration players' individual skills or how good they are at collaborating.

> **Example:** Common way of creating teams in friendly team games is to let two players alternate between choosing team members, thereby making it possible for the best and second best players to be in different teams and so on.

> **Example:** Some multiplayer online first-person shooters have systems for automatically arranging teams based on some value, commonly number of kills or experience points, so that the teams overall have equal scores in these values.

> **Example:** Changing sides after half-time in *Soccer* can be seen as a way to achieve balance between the teams by minimizing the influence of variations of the field or the direction of the sun.

USING THE PATTERN Achieving *Team Balance* has many aspects in common with achieving *Player Balance*, for example, by possibly being ruined by *Privileged Abilities* or being achieved through *Handicap*, and consists of setting up a balanced starting position, and, if needed, having *Balancing Effects* during gameplay.

Team Balance can be enforced by creating total *Player Balance* between all players in all teams, but unless more than two teams are playing a game, *Player Decided Results* do not work, as votes, etc. tend to become draws when the teams have the same amount of players. However, *Team Balance* differs from *Player Balance* by being able to allow *Orthogonal Unit Differentiation* and individual *Competence Areas* and *Privileged Abilities* as long as these are present in all teams through *Symmetry*. Further, in games with *Player Killing*, teams can still continue to be balanced by the use of *Spawning*.

CONSEQUENCES *Team Balance* gives whole teams a *Perceived Chance to Succeed* and promotes *Collaborative Actions*. It encourages *Team Play* as individual players' actions can give the team a lead and thereby *Social Status*. Individual players may lose the feeling of *Empowerment* when *Team Balance* is present, either because their *Competence Areas* are countered by other players' disadvantages in the team or because *Balancing Effects* lessen the impact of their actions.

Team Development negatively affects *Team Balance* in the same way *Character Development* can negatively affect *Player Balance*.

RELATIONS

Instantiates: *Social Statuses, Perceived Chance to Succeed*

Modulates: *Competence Areas, Privileged Abilities, Collaborative Actions, Team Play*

Instantiated by: *Symmetry, Balancing Effects, Player Balance, Handicaps*

Modulated by: *Player Killing, Spawning, Orthogonal Unit Differentiation, Team Development*

Potentially Conflicting with: *Privileged Abilities, Empowerment, Competence Areas, Player Decided Results, Team Development*

Right Level of Difficulty

That the level of difficulty experienced by the player is the one intended by the game design.

For the challenges in games to be interesting to players, they need to have the *Right Level of Difficulty*. If the challenges are too easy, players may be bored while if they are too difficult, players may give up playing the game.

> **Example:** *Go* can be played on boards of different sizes; 9×9, 13×13, and 19×19 are the most common. Players can choose the difficulty of a game by choosing the size of the board, as the difficulty (and length) of a game grows with the size of the board.

> **Example:** *Zelda: The Ocarina of Time* starts with easy quests that require mastery of very few actions and pose few threats. As players complete the quests, they move on to more challenging quests, and the game can thereby increase the level of difficulty as players show that they have mastered the current level of difficulty.

> **Example:** Adventures that can be bought for many types of tabletop role-playing games are categorized after which levels the players' characters should have. Although a *Game Master* may use any adventure for any group of characters, the *Right Level of Difficulty* will most probably only occur if the players have the right levels.

USING THE PATTERN Although the difficulty of a game is individual to each player, games can be designed so that players can progress according to their own learning

curve. Setting the *Right Level of Difficulty* in games can either be done by making challenges easier, by making challenges more difficult, or by controlling which challenges players have to meet.

Challenges can be made easier, either by providing information about how to solve the challenge or by making the actions of overcoming the challenge easier to perform, for example, by the presence of *Achilles' Heels*. Information can be given by *Clues, Traces, Extra-Game Information*, or by letting players discover it themselves through *Experimenting*. Making challenges easier usually requires some form of *Tradeoff* for players and can be done through *Selectable Sets of Goals* or *Supporting Goals*. Having to choose one goal from a *Selectable Set of Goals* where the different goals have *Varied Gameplay* allows the player to choose the goal with the perceived *Right Level of Difficulty* but makes the other goals impossible to complete. The *Right Level of Difficulty* in a game can also be created by *Varied Gameplay* to require players to use different competences. *Supporting Goals*, for example, trying to find *Easter Eggs*, do not have to make other goals impossible but take extra time to perform and may deplete *Resources* for the player.

Making challenges more difficult can be done by introducing opposition or by making the required player actions more difficult to perform. Opposition can take the form of *Enemies* or *Preventing Goals* of *Agents* or other players in *Multiplayer Games*. General ways of making challenges more difficult are by making the game have the *Right Level of Complexity* to have a certain difficulty and give players *Limited Planning Abilities*, introducing *Time Limits* for the challenges, distracting the players through *Disruption of Focused Attention* events, or forcing players to choose how to perform *Attention Swapping*. Temporary *Ability Losses* or *Decreased Abilities* (for example lowering *Skills*) can be used to make an otherwise easy challenge have the *Right Level of Difficulty*. A more specific way to make challenges more difficult in games requiring *Maneuvering* is through the introduction of more *Obstacles* or simply increasing the speed in *Rhythm-Based Actions*.

Control of what challenges players meet depends on whether games are *Single-Player Games* or *Multiplayer Games*. *Levels* are the most common way of controlling difficulty in *Single-Player Games*, simply by having the *Levels* vary in difficulty and letting players gain access to them when they show that they have mastered the previous *Levels*. Games that are played alone can have their overall difficulty easily modified by the player through difficulty levels. In games with strong *Narrative Structures*, having the *Right Level of Difficulty* not only means adjusting to player skills but also the development of the plot, for example, allowing *Higher-Level Closures as Gameplay Progresses*.

In *Multiplayer Games*, the *Right Level of Difficulty* must be designed with consideration to *Player Balance*. This can be done through *Handicaps* before gameplay

begins to make all players have equal possibilities in the game or through *Balancing Effects* during gameplay, for example, *Player-Decided Distribution of Rewards & Penalties*. Having one of the players take the role of a *Game Master* allows the *Right Level of Difficulty* to be granted at all times, as long as the *Game Master* can gauge the merit of players' plans and adjust the difficulty accordingly.

As *Reconfigurable Game Worlds* and *Ephemeral Goals* are constructed during, or immediately before, gameplay their use can make pre-designed ways of achieving the *Right Level of Difficulty* less effective. *Game Masters* can be used to mitigate this problem, as they can adjust the difficulty level on the fly.

CONSEQUENCES Providing the *Right Level of Difficulty* in games allows players to feel *Tension* as there is a risk that they may fail, while giving the *Empowerment*, since they have a *Perceived Chance to Succeed* and *Illusion of Influence*. If the *Right Level of Difficulty* is continuously provided for players, it gives them a *Smooth Learning Curve* and increases the likelihood that players progress to having *Game Mastery*. If this *Right Level of Difficulty* is due to *Competition*, the learning is enforced by a *Red Queen Dilemma*.

RELATIONS

Instantiates: *Game Mastery, Empowerment, Perceived Chance to Succeed, Tension, Smooth Learning Curves, Illusion of Influence, Limited Planning Ability*

Modulates: *Maneuvering, Higher-Level Closures as Gameplay Progresses, Rhythm-Based Actions, Single-Player Games, Multiplayer Games, Player Balance, Red Queen Dilemmas*

Instantiated by: *Balancing Effects, Handicaps, Game Masters, Time Limits, Right Level of Complexity, Selectable Sets of Goals, Achilles' Heels, Varied Gameplay*

Modulated by: *Preventing Goals, Levels, Enemies, Obstacles, Clues, Traces, Extra-Game Information, Attention Swapping, Disruption of Focused Attention, Ability Losses, Decreased Abilities, Skills, Easter Eggs, Experimenting, Supporting Goals, Tradeoffs, Limited Planning Ability, Narrative Structures, Reconfigurable Game World*

Potentially Conflicting with: *Reconfigurable Game World, Ephemeral Goals*

Right Level of Complexity

That the level of complexity by the player in the game is the one intended by the game design.

Games can be complex in many ways: requiring the understanding of many rules, being able to understand the consequences of immediate actions in the long run, or being able to plan many actions ahead. All these forms of complexity in games together give an overall complexity for every game, and for games to offer the right level of challenge—and the right type of challenge—the *Right Level of Complexity* needs to be achieved for the intended game design.

> **Example:** The size of a *Go* board determines the number of possible combinations that a single game session can take and thereby the complexity of the game.

> **Example:** Real-time strategy games and advanced simulations such as *Europa Universalis II* are only playable because computers can handle the complexity of the rules and interactions between huge amounts of game elements. Some also allow players to modify how much complexity they should have to handle by offering ways of automating certain actions.

USING THE PATTERN The *Right Level of Complexity* of a game depends on the intended gameplay style. Games that strive to have *Cognitive Immersion* through *Stimulated Planning* have higher complexity but also risk *Analysis Paralysis*. Games that wish to minimize the risk for *Downtime* among players or simply make the game easy to play usually have less complexity, but this may give *Limited Planning Ability* if the game also does not provide *Predictable Consequences*. The complexity of the game often also affects the influence players can have and thereby the *Illusion of Influence* they have. Effects of actions that require a certain level of complexity to be possible at all include *Experimenting* and *Creative Control*.

The level of complexity affects all types of actions, but the *Right Level of Complexity* can most easily be set for *Rhythm-Based Actions*, by increasing tempo or number of required actions, and *Puzzle Solving*, by increasing the number of game elements that need to be considered. *Combos* can be used to control the complexity in a game, since the difficulty of combining actions does not have to depend completely on the difficulty of performing the individual actions.

The prime way of modulating complexity is through modulating the number of game elements that players have to interact with or the number of relations between game elements that players have to consider. The relationships can easily become more complex through the use of *Converters* or *Producer-Consumers*, modulating the complexity of *Resource Management*. This information about the game elements can further be used to modulate the *Right Level of Complexity* through either *Direct Information* or *Extra-Game Information*.

Besides simply increasing the number of game elements or how they affect evaluation functions, complexity can be modulated through *Attention Swapping*,

Indirect Control, or *Ability Losses*. *Attention Swapping* increases the complexity, as players must shift their attention from one area to another and create an impression of the local game state. *Indirect Control* is an example of how both the number of game elements and relations increase, since players need to consider both the game elements they control and those they do not control but can indirectly affect, as well as what relations the game elements have to each other. *Ability Losses* may not remove complexity but can make it irrelevant since players cannot affect it!

Another way to modulate the complexity in the game, which may or may not affect how difficult the game is to play, is through the *Narrative Structure* of the game. This can be done through *Red Herrings* and *Role Reversals*, and can make *Puzzle Solving* based upon the story more complex.

CONSEQUENCES Having the *Right Level of Complexity* in a game usually strongly influences if the *Right Level of Difficulty* is achieved in a game design. When the complexity increases with the increase in player skill, providing the *Right Level of Complexity* gives the game a *Smooth Learning Curve* and thereby makes *Game Mastery* easier to achieve.

The *Right Level of Complexity* in a game can be one that gives *Limited Foresight* of long-term effects of actions even though they have short-term *Predictable Consequences*. This level of complexity supports *Experimenting*, and can promote *Constructive Play*, as it gives players a form of *Creative Control* within the vastness of potential game spaces given by the complexity of the game.

RELATIONS

Instantiates: *Game Mastery, Right Level of Difficulty, Smooth Learning Curves, Cognitive Immersion, Analysis Paralysis, Limited Planning Ability, Constructive Play, Experimenting, Creative Control*

Modulates: *Puzzle Solving, Downtime, Stimulated Planning, Rhythm-Based Actions, Predictable Consequences, Limited Foresight, Illusion of Influence*

Instantiated by: *Narrative Structures*

Modulated by: *Attention Swapping, Indirect Control, Decreased Abilities, Red Herrings, Role Reversal, Combos, Converters, Producer-Consumer, Perfect Information, Resource Management, Ability Losses, Extra-Game Information*

Potentially Conflicting with: *Resource Management*

Handicaps

Making gameplay easier for certain players in order to make all players have the same chance to succeed.

In some games, players may be aware of differences in their playing skills. In order to make the outcome as uncertain as possible within the game rules and thereby more interesting, players may decide on *Handicaps*. These either make some actions easier for some players or allow those players other advantages so that the greater skills of other players are balanced and all players have equal chance of succeeding in the game.

> **Example:** Fighting games such as the *Tekken* or those of the *Dead or Alive* series allow players to choose starting health by percentage, for example, 80% or 140%. This allows one player to have a handicap against another player.

> **Example:** *Golf* is one of the most well-known sports to make use of *Handicap*. In this case, the *Handicap* does not only serve to equal gameplay but also to indicate mastery of the sport.

> **Example:** *Go* uses a *Handicap* system of allowing the weaker player to place a certain number of stones in the handicap points before the actual game begins in such a way that both players are challenged while playing.

USING THE PATTERN Providing *Handicaps* for players can either be done by making it possible to set individual *Right Levels of Difficulty* (possibly by changing the skills of *Agents*), giving certain players more *Resources* or abilities (where differences in *Non-Renewable Resources* give greater *Handicaps* than other *Resources*), or limiting or ignoring negative consequences for certain players. Being able to change the *Resources* in a game with a *Game World* makes the game one with a *Reconfigurable Game World*, although the differences in configurations may not be that large from a structural point.

Individual levels of difficulty can be set by having different thresholds for evaluation functions, providing various bonuses to *Score* values, giving a head start in *Races*, or giving *Skill* advantages. The use of *Asymmetric Resource Distribution*, *Asymmetric Abilities*, or *Privileged Abilities* can have *Balancing Effects*, as players may not have to be as efficient or may have a larger *Freedom of Choice* than other players. In *Self-Facilitated Games*, the use of *Handicaps* is usually the result of *Negotiation* before gameplay begins, and a special form of *Handicap* in these games is to allow novice players *Reversability* by taking back their actions and performing other actions.

CONSEQUENCES *Handicaps* can be used to give individual players the *Right Level of Difficulty* in *Multiplayer Games* and at the same time provide *Player Balance* or *Team Balance*. The presence of *Handicap* systems in games provides a form of *Trans-Game Information*, which can be a form of *Score* in a *Meta Game*. *Handicaps*

are incompatible with *Symmetry* but are often used for the same reason: to achieve *Player Balance.*

As *Handicaps* are a form of *Balancing Effect*, they give all players a *Perceived Chance to Succeed.* If the levels of *Handicap* are gradually lowered as players become more skillful, their use provides a *Smooth Learning Curve* for players to achieve *Game Mastery.*

RELATIONS

Instantiates: *Right Level of Difficulty, Player Balance, Team Balance, Balancing Effects, Meta Games, Smooth Learning Curves, Perceived Chance to Succeed*

Modulates: *Skills, Race, Game Mastery, Score, Self-Facilitated Games, Resources, Multiplayer Games*

Instantiated by: *Asymmetric Abilities, Asymmetric Resource Distribution, Reversability, Reconfigurable Game World*

Modulated by: *Trans-Game Information, Non-Renewable Resources, Negotiation, Agents*

Potentially Conflicting with: *Symmetry*

Paper-Rock-Scissors

Sets of three or more actions form cycles where every action has an advantage over another action.

This pattern is based on the children's game with the same name in which players try to outwit each other by guessing what the other ones will do and by tricking other players into take a wrong guess on one's own action. The original game is very simple; after a count to three, both players make one out of three gestures, depicting rock, paper, or scissors. Rock beats ("smashes") scissors, scissors beat ("cut") paper and paper beats ("covers") rock. That there is no winning strategy is the essence of the pattern: players have to somehow figure out what choice is the best at each moment. In general, this may be detectable through variations in the game state or through knowledge about players' tactics and plans.

Example: The relations between monsters and weapons in *Quake* form a *Paper-Rock-Scissors* relationship, so no weapon was best against all monsters, and players had to switch between weapons to make maximum use of the weapons.

USING THE PATTERN Games with immediate consequences of choices related to *Paper-Rock-Scissors* usually have these kinds of choices often in the game to allow people to keep records of other players' behavior. *Quick Games* using the pattern, such as the game that lent its name to the pattern, usually are played repeatedly so some form of *Meta Game* can be used to allow players to gain knowledge of their opponents' strategies.

A common way to implement the pattern for having long-term effects is through *Investments* to gain *Asymmetric Abilities*, either through *Units* or *Character Development*. For this kind of use of the pattern, players can be given knowledge about other players through *Public Information* or, in the case of games with *Fog of War*, through sending *Units*.

CONSEQUENCES *Paper-Rock-Scissors* introduces *Symmetry* between actions or tactics in a game. It can be implemented either so its choices have immediate consequences (as in the game that gave the pattern its name) or so it has long-term effects. In both cases, it promotes *Tension*, either until the moment when the choices are revealed or until the success of the chosen strategies is evident. A *Paper-Rock-Scissors* pattern introduces a form of *Randomness* and limited *Predictable Consequences* unless players can either gain knowledge about the other players' current activities or keep record of other players' behavior, as otherwise a player has no way of foreseeing what tactics are advantageous. If the game supports knowledge collection, the correct use of the strategies allows for *Game Mastery*.

RELATIONS

> **Instantiates:** *Randomness, Player Balance, Tension, Game Mastery, Meta Games, Symmetry*
>
> **Modulates:** *Investments, Asymmetric Goals, Asymmetric Abilities*
>
> **Instantiated by:** *Asymmetric Abilities, Units, Character Development*
>
> **Modulated by:** *Public Information*
>
> **Potentially Conflicting with:** *Predictable Consequences*

Additional Pattern

A descriptions of this additional pattern can be found in the Chapter 14 folder on the companion CD-ROM.

ON THE CD

Player Balance

15 Game Design Patterns for Meta Games, Replayability, and Learning Curves

This chapter deals with issues that are outside the playing of a single game instance.

Meta Games: *Meta Games, Games within Games, Extra-Game Consequences, Trans-Game Information, Extra-Game Actions, Spectators*

Replayability and Learning Curves: *Replayability, Varied Gameplay, Smooth Learning Curves, Orthogonal Unit Differentiation*

META GAMES

These patterns describe features that can support player, and non-player, participation outside the play of a single game instance.

Meta Games

A game based on the effects and outcomes of other games.

Some games are constructed around what happens in other games. These "indirect" games are *Meta Games*, and as such, they usually put totally different demands on the participants than do the underlying games. In some cases, for example, in betting on horse or dogs races, the underlying game may not be a proper game (and the participants may not be aware that they are participating in a game), but the participants of the *Meta Game* treat the activity as a game.

> **Example:** *Tournaments* are a common form of *Meta Game* where individual results of games are used as input to the *Tournament*. For some sports, for example, *Soccer*, *Hockey*, and *Basketball*, playing the game in *Tournament* form is the normal way of organized games.

Example: Betting on the outcome of games is a classic form of *Meta Game*. In these *Meta Games*, the skill required by players ranges from having the actual actions used in the games to having knowledge about the current condition and tactics of the participants in the game being bet upon.

USING THE PATTERN *Meta Games* can either be designed to be part of the underlying game or be designed independently of the underlying game.

Design elements in games that support *Meta Games* are usually based around *Score* or *Handicap* systems. The actual *Meta Games* are, in these cases, created by passing these as *Trans-Game Information* to other games, for example, by *High Score Lists*, explicitly supporting *Tournaments*, or letting the inner games of *Games within Games* affect the outer games. Games that have *Optional Goals*, for example, *Easter Eggs*, can be completed in several different ways. In these games, players can have a *Meta Game* that consists of trying to complete as many *Optional Goals* as possible, and the number of *Optional Goals* completed may, in turn, form a kind of *Score*.

One of the main reasons for independent *Meta Games* is based around guessing the outcome of the underlying games before the game session has ended or, in some cases, even begun. This makes the skill of playing the *Meta Game* into a kind of *Strategic Knowledge*, whatever the skill of playing the underlying game is. A common way to create an independent *Meta Game* is to have *Betting* on the outcome of a game affect *Ownership* of real-world objects, creating *Extra-Game Actions* and *Player Defined Goals* if done by the participants themselves.

The other main reasons for independent *Meta Games* is to create *Perceivable Margins* or minimize the effect of *Luck*. This is usually done by creating *Tournaments* where the goal is to win a certain number of individual games. One of the simplest forms of *Meta Game* based upon this format is a *Tournament* of *Quick Games,* such as a best-of-three game of *Paper-Rock-Scissors*. *Meta Games* are also a way to change *Single-Player Games* to *Multiplayer Games* by allowing players to compare results of separate game instances or in other ways have an effect on other players' game instances.

CONSEQUENCES *Meta Games* make the underlying games have *Extra-Game Consequences* that affect the *Meta Games* through *Trans-Game Information*. It can modify players' *Risk/Reward* choices in the underlying game and allow *Spectators* of one game to be players in another game.

As people can create *Meta Games* based on any game design, outside the game designer's influence, these forms of games are examples of how players can create *Player Defined Goals*. Games that allow for *Team Development* can, for example, easily create *Meta Games* around planning and trying to develop the team's skills.

RELATIONS

Instantiates: *Trans-Game Information, Strategic Knowledge, Perceivable Margins*

Modulates: *Spectators, Multiplayer Games, Risk/Reward, Single-Player Games*

Instantiated by: *Player Defined Goals, Optional Goals, Tournaments, Score, High Score Lists, Betting, Paper-Rock-Scissors, Handicaps, Extra-Game Actions, Extra-Game Consequences, Games within Games, Team Development*

Modulated by: *Multiplayer Games, Quick Games, Ownership*

Potentially Conflicting with: *Luck*

Additional Patterns

ON THE CD Descriptions of these additional patterns can be found in the Chapter 15 folder on the companion CD-ROM.

Games within Games	**Extra-Game Actions**
Extra-Game Consequences	**Spectators**
Trans-Game Information	

REPLAYABILITY AND LEARNING CURVES

Most games can be played several times while still offering meaningful challenges for the players each time. The patterns in this section describe these features and offer insights on how to achieve such challenges.

Replayability

The level to which a game provides new challenges or experiences when played again.

Many games are designed to be played many times. In order for these to be interesting, the game must offer new challenges to players or give players new experiences that are perceived as entertaining enough to merit continued playing. The degree to which a game provides these incentives determines its level of *Replayability*.

Example: *Chess* and *Go* have so many possible outcomes that players have very little chance of ever playing two games that are exactly the same. This means that every game session will have new challenges in which players can test their skills.

Example: The multiplayer first-person shooters *Team Fortress Classic* and *Return to Castle Wolfenstein* and the *Battlefield* series allow players to choose a character class to play. This gives them special abilities, which means that beyond the normal differences in gameplay due to varieties in players and levels, players also have different possibilities of what to do and have different roles on their teams.

USING THE PATTERN *Replayability* can be achieved by letting the challenges differ between game instances, by letting challenges be solved in several different ways, or by letting players compare results between games through *Trans-Game Information*.

Games that provide *Cognitive Immersion* and have a huge potential game state space seldom offer players exactly the same challenges and thereby provide one form of *Replayability*. *Dedicated Game Facilitators* that are aware of players who have played the game before can change the setup of the particular game instances to provide another way to achieve *Replayability* by altering the challenges. This can, for example, be achieved through *Reconfigurable Game World*, although some games allow the players to reconfigure the *Game World* without the presence of a *Dedicated Game Facilitator*. Different challenges are also provided in games that give *Varied Gameplay* by having roles that players have to choose before gameplay proper begins, and by arranging that these roles have *Asymmetric Goals* or *Asymmetric Abilities*.

Letting players complete the game or parts of the game in different ways can be done through *Selectable Sets of Goals* or otherwise through the support of *Varied Gameplay* within the game. *Optional Goals* give *Freedom of Choice* of how to try and solve the overall game. The *Replayability* of such games increases by letting the players measure how many *Optional Goals* they have completed, for example, by using a *Score* or having *Easter Eggs* that give access to *Inaccessible Areas*.

Replayability is often acquired by supporting players to measure the level of their successes or failures. *Score* and *High Score Lists* can be used for this in *Single-Player Games*, and allow the players to have a measure of their *Game Mastery*, either to let players measure their own skill or to allow a *Social Status* among other players. *Tournaments*, with the exception of *Polyathlons*, allow for a similar type of *Replayability* as a game is typically played several times to create the outcome of the *Tournament*. *Near Miss Indicators* can show players how close they were to succeeding, encouraging them to try again and possibly also increasing their chances of succeeding by the information the indicators provide.

Save-Load Cycles and *Reversability* provide *Replayability* on a fundamental level within games. These allow players to do *Experimenting* and to choose the length of play sessions, but they have little effect, or negative effect, on *Replayability* of the game as a whole.

Games that are challenging or provide experiences based upon the lack of knowledge of players, i.e., *Imperfect Information*, are difficult to combine with *Replayability*. This is due to the *Trans-Game Information* players acquire when they successfully perform *Memorizing* of what happens in the game, i.e., when they can apply specific facts learned in one game instance in another game instance. This information can affect *Replayability* in many ways: *Surprises* in *Narrative Structures* will no longer be *Surprises*, *Tension* will be less effective when players experience the same situations, *Puzzle Solving* will become trivial if it is not changed between game instances, *Unknown Goals* will be known in later game instances, and *Exploration* will be pointless since the environment is already known to the player. An exception to this is presented by *Conceal* goals in *Multiplayer Games*, as the challenges in these are to find new hiding places.

CONSEQUENCES *Replayability* in a game offers players enjoyment of a game beyond a single game session. For games that require player skill, *Replayability* becomes automatic as players strive to achieve, test, and show *Game Mastery*. Similarly, when players have *Strategic Knowledge* in games, the games have a certain level of *Replayability*, as players can make use of *Strategic Knowledge* and improve it between game sessions as *Trans-Game Information*.

RELATIONS

Instantiates: *Trans-Game Information*

Modulates: *Inaccessible Areas*

Instantiated by: *Conceal, Optional Goals, Selectable Sets of Goals, Asymmetric Goals, Asymmetric Abilities, Reconfigurable Game World, High Score Lists, Easter Eggs, Freedom of Choice, Game Mastery, Varied Gameplay, Save-Load Cycles, Reversability, Tournaments, Score, Strategic Knowledge*

Modulated by: *Dedicated Game Facilitators, Strategic Knowledge, Cognitive Immersion, Near Miss Indicators, Imperfect Information*

Potentially Conflicting with: *Surprises, Narrative Structures, Tension, Puzzle Solving, Trans-Game Information, Memorizing, Exploration, Unknown Goals*

Varied Gameplay

The game provides variety in gameplay, either within a single play session or between different play sessions.

All games must provide a certain level of *Varied Gameplay* to be interesting, as the outcome must differ between game instances. However, some games have varying

types of actions required in different parts of the game so that players feel that the challenges are qualitatively different. Other games allow players to create characters or select teams with radically different abilities. In both these cases, games provide a greater amount of *Varied Gameplay*, which not only affects the configuration of the game state but players' gameplay experience.

> **Example:** Roleplaying games, primarily live or tabletop variants but also computer-based variants that provide great freedom for players such as *Morrowind* or the *Fallout* series, provide *Varied Gameplay* between game instances; i.e., how players create their characters strongly affects what kind of gameplay they will have.
>
> **Example:** *Deus Ex* was designed to have several ways of completing each level. This allows players to choose between trying to sneak past opposition, openly challenge it, or try to overcome it in indirect ways.

USING THE PATTERN *Varied Gameplay* can be designed so that it occurs within a game instance or between game instances. Within a game, *Varied Gameplay* can be achieved by letting players choose between different goals and by letting players be able to perform different sorts of actions; both alternatives offer players a *Freedom of Choice*. By gradually increasing the possibility of *Varied Gameplay* as gameplay progresses, players have not only a large set of actions to choose from later in the game, but the number of possible actions also varies. Between game instances, *Varied Gameplay* can be achieved by providing players a *Freedom of Choice* as to what type of *Asymmetric Abilities* they should have, either by choosing a team or letting players create their own *Characters*. *Social Organizations* provide additional actions in games and give players opportunities to plan how to divide the actions, thereby providing *Varied Gameplay* both within game instances and between them.

Within game instances, there are many ways to create *Varied Gameplay*, with the variation of goals and variation of actions being the two major categories. *Selectable Sets of Goals* or *Incompatible Goals* give players different types of goals to fulfill within the game, while *Polyathlon* includes goals of trying to win different types of competitions. The completion of *Supporting Goals* may offer alternative ways of completing goals, for example, exploiting *Achilles' Heels*. *Games within Games* can provide completely different gameplay within one and the same game.

Having choices between what actions to perform can be done in several ways: by *Budgeted Action Points*; by varying how *Resources* are used, e.g. through *Converters* and advanced *Producer-Consumer* chains; by providing sets of *Skills*; by having *Transfer of Control* of *Tools* or *Controllers*; or by having *Units* with *Orthogonal Unit Differentiation*. *Dynamic Alliances* allow players to vary the other players with whom they collaborate. Even *Ability Losses* can provide *Varied Gameplay* as players have to figure out new ways to solve problems or meet familiar challenges.

When designed within a game, the *Varied Gameplay* can be forced upon players to modulate the *Right Level of Difficulty* and synchronize the type of gameplay with the unfolding of the *Narrative Structure*. This is typically achieved by *Levels* or by *Character Development*. *New Abilities* can make it possible for players to directly affect the game state in new ways and thereby provide *Varied Gameplay* and make *Higher-Level Closures as Gameplay Progresses*.

Varying gameplay between game instances can be done by either changing the *Game World* or changing players' overarching objectives. The former can be achieved by *Reconfigurable Game Worlds*, for example, by *Tile-Laying*, and allows *Exploration* to coincide with *Replayability*, while the latter consists of providing players with selections that give them *Asymmetric Abilities*, *Asymmetric Goals*, and *Incompatible Goals*. The selections often take the form of choosing a team, country, or factions as described by the *Alternative Reality* or creating a *Character* with different *Privileged Abilities* or *Skills*. *Non-Renewable Resources* and *Diminishing Returns* may cause players to have to specialize in how they try to achieve goals, or which goals they try to achieve. A simple way to achieve *Varied Gameplay*—at least temporarily—is to use dynamically created *Red Herrings* to distract players and provide some variation to the usual gameplay.

Symmetric Resource Distribution may lessen the impact of both changes to the *Game World* and players' objectives but is not totally incompatible with *Varied Gameplay*, since the types and amounts of *Resources* may change between game instances even though they are symmetrically distributed.

Varied Gameplay is not compatible with extensive, repetitious actions, and this makes games with high degrees of *Varied Gameplay* difficult to combine with *Sensory-Motoric Immersion*.

CONSEQUENCES When *Varied Gameplay* is required to complete a game, it raises the difficulty of achieving *Game Mastery*, as more skills must be mastered. *Varied Gameplay* adds value to the *Replayability* of a game when the variation in gameplay can be selected by players. If the choice is done before gameplay begins, *Varied Gameplay* offers players the opportunity to develop *Competence Areas* and lets players have several different types of *Game Mastery* in the same game. This is often difficult to achieve in simple *Quick Games*, which are based on the players performing only a few actions.

RELATIONS

Instantiates: *Replayability, Right Level of Difficulty*

Modulates: *Game Mastery, Competence Areas, Narrative Structures*

Instantiated by: *Polyathlons, Incompatible Goals, Asymmetric Goals, Reconfigurable Game World, Levels, Units, New Abilities, Asymmetric Abilities,*

Transfer of Control, Budgeted Action Points, Skills, Freedom of Choice, Higher-Level Closures as Gameplay Progresses, Achilles' Heels, Orthogonal Unit Differentiation, Character Development, Selectable Sets of Goals, Social Organizations, Dynamic Alliances, Games within Games, Converters, Producer-Consumer, Ability Losses, Resources, Tile-Laying

Modulated by: *Exploration, Supporting Goals, Levels, Characters, Red Herrings, Non-Renewable Resources, Diminishing Returns*

Potentially Conflicting with: *Camping, Sensory-Motoric Immersion, No-Ops, Quick Games, Symmetric Resource Distribution*

Smooth Learning Curves

Games designed to provide players with the possibility of smoothly progressing from novice to master.

Most games can be played at different levels of difficulty or become more and more difficult as gameplay progresses. In order for players to have as full an experience of the game design as possible, the design of these games may support players in developing game skills. When learning the skills is felt to be part of gameplay, and sometimes an enjoyable experience, the game is said to have *Smooth Learning Curves* and these smooth curves can minimize the risk of players getting stuck at particular points in the game.

> **Example:** The *Zelda* and *Super Mario* series provide signs and characters that give players hints about what they can do. They explain all the options players have and minimize the risk that players get stuck in the game because they do not know what they should do.

> **Example:** Many first-person shooters can be played both alone and against opponents through the Internet. In these games, the single-player game usually provides *Smooth Learning Curves* that can be seen as a preparation for playing the multiplayer versions.

USING THE PATTERN Designing games with *Smooth Learning Curves* involves making players have the *Right Level of Difficulty* whatever their skill levels, and thereby giving them a *Perceived Chance to Succeed* and an *Illusion of Influence*. When this is done in a way that is perceived as being in competition against some other player, it causes *Red Queen Dilemmas* to occur. Adjusting the difficulty of challenges to player skills can be done in three ways: providing information to players on how to overcome the challenges, explicitly adjusting the challenges to the players' skills, or letting players make the adjustments themselves.

Information about challenges can either be explicit *Extra-Game Information* provided in the form of *Clues* or *Helpers* or be implicit through *Consistent Reality Logic*. In either case, information can allow players to build *Strategic Knowledge* and reduce *Limited Foresight*, which can either be useful within the same game instance or in all game instances.

The difficulty of challenges can be designed to provide *Smooth Learning Curves* either by changing the difficulty of individual challenges during gameplay or by designing the challenges so that the easier ones are encountered earlier and the players gradually get *New Abilities* to overcome the later, more difficult challenges. Changes during gameplay require the use of *Dedicated Game Facilitators* or *Balancing Effects* while *Levels*, and other forms of *Inaccessible Areas* that later become accessible, are the common ways to make sure players have the easiest challenges first.

Ways players themselves can adjust the difficulty of challenges include deciding on *Handicaps* in *Multiplayer Games*, setting a difficulty level in games that provide the *Right Level of Complexity* or right level of opposition, or simply choosing to play with opponents of the same skill levels. The presence of *Combos* can allow players to try and overcome challenges either through easier and less effective normal actions or more difficult and more effective actions. Games that depend on *Luck* can give *Smooth Learning Curves*, as players can perform actions and try to complete goals without their *Perceived Chance to Succeed* being close to their actual chance to succeed. *Save-Load Cycles* allow players to control their learning process themselves by giving them the possibility to do *Experimenting*.

CONSEQUENCES *Smooth Learning Curves* allow players to experience challenges whatever their skill levels in a game and help them develop *Game Mastery*. Providing *Smooth Learning Curves* allow games to provide *Immersion* from the point when players are novices until they have mastered gameplay.

RELATIONS

> **Instantiates:** *Game Mastery, Immersion*
>
> **Modulates:** *Illusion of Influence, Perceived Chance to Succeed, Multiplayer Games*
>
> **Instantiated by:** *Consistent Reality Logic, Experimenting, Dedicated Game Facilitators, Luck, Right Level of Difficulty, Right Level of Complexity, Combos, Clues, Helpers, Extra-Game Information, Balancing Effects, Save-Load Cycles, Handicaps, Red Queen Dilemmas, Limited Foresight*
>
> **Modulated by:** *Levels, Inaccessible Areas, Strategic Knowledge, New Abilities*
>
> **Potentially Conflicting with:** None

Additional Pattern

ON THE CD A description of this additional pattern can be found in the Chapter 15 folder on the companion CD-ROM.

Orthogonal Unit Differentiation

Appendix

A Further Reading

This appendix contains references to books, papers, and other information resources used when researching game design patterns for this book. As most game design patterns do not contain references to specific external sources, none are included here; to do this in a useful way for all patterns would require the following list to be expanded by hundreds of references.

REFERENCES

[Adams03] Adams, Ernest and Andrew Rollings. *Ernest Adams and Andrew Rollings on Game Design*. New Riders Publishing, 2003.

[Alexander77] Alexander, Christopher et al. *A Pattern Language: Towns, Buildings, Construction*. Oxford University Press, 1977.

[Avedon&Sutton-Smith71] Avedon, Elliot M. and Brian Sutton-Smith (Eds.). *The Study of Games*. John Wileys & Sons, Inc., 1971.

[Avedon71] Avedon, Elliot M. "The Structure of Games." In *The Study of Games*, edited by E.M. Avedon and B. Sutton-Smith. John Wileys & Sons, Inc., 1971.

[Björk03] Björk, Staffan and Jussi Holopainen. "Game Design Patterns." Game Developers Conference, International Game Developers Association, San Jose, 2003.

[Borchers01] Borchers, Jan. *A Pattern Approach to Interaction Design*. John Wiley and Sons Ltd., 2001.

[Brasch86] Brasch, Rudolph. *How Did Sports Begin?* Tynron Press, 1986.

[Caillois01] Caillois, Roger. *Man, Play, and Games*. University of Illinois Press, 2001.

[Church99] Church, Doug. "Formal Abstract Design Tools." *Game Developer Magazine* (August 1999). (Also available online at *http://www.gamasutra.com/features/19990716/design_tools_01.htm.*)

[Costikyan94] Costikyan, Greg. "I Have No Words and I Must Design." *Interactive Fantasy 2*. Hogshead Publishing, 1994. (Also available online at *http://www.costik.com/nowords.html*.)

[Costikyan02] Costikyan, Greg. "I Have No Words and I Must Design: Toward a Critical Vocabulary for Games." In *Proceedings of Computer Game and Digital Cultures Conference*, edited by F. Mäyrä. Tampere University Press, 2002.

[Crawford84] Crawford, Chris. *The Art of Computer Game Design*. McGraw-Hill Osborne Media, 1984. (Also available online at *http://www.vancouver.wsu.edu/fac/peabody/game-book/Coverpage.html*.)

[Dear91] Dear, William. *The Dungeonmaster: The Disappearance of James Dallas Egbert III*. Bloomsbury, 1991.

[DeMaria02] DeMaria, Rusel and Johnny L. Wilson. *HIGH SCORE! The Illustrated History of Electronic Games*. McGraw-Hill Osborne, 2002.

[Ericsson04] Ericsson, Martin. "Play to Love—Reading Victor Turner's Liminal to Liminoid, in Play, Flow, and Ritual: An Essay in Comparative Symbology." In *Beyond Role and Play—Tools, Toys, and Theory for Harnessing the Imagination*, edited by M. Montola and J. Stenros. Ropecon Ry, 2004.

[ESA04] Entertainment Software Association. "Essential Facts about the Computer and Video Game Industry—2004 Sales, Demographics and Usage Data." Available online at *http://www.theesa.com*.

[Fagen81] Fagen, Robert. *Animal Play Behavior*. Oxford University Press, 1981.

[Falstein99] Falstein, Noah. "A Grand Unified Game Theory: The Crisis Structure." In GDC 1999 Proceedings.

[Falstein02] Falstein, Noah. "Better by Design: The 400 Project." *Game Developer Magazine* (March 2002).

[Fox88] Fox, Jonathan (Ed.). *The Essential Moreno: Writings on Psychodrama, Group Method, and Spontaneity*. Springer, 1988.

[Fullerton04] Fullerton, Tracy, Christopher Swain, and Steven Hoffman. *Game Design Workshop: Designing, Prototyping, and Playtesting Games*. CMP Books, 2004.

[Gamma95] Gamma, Erich et al. *Design Patterns—Elements of Reusable Object-Oriented Software*. Addison-Wesley, 1995.

[GDPP] Game Design Patterns Project. Available online at *http://www.gamedesignpatterns.org*.

[Hardin68] Hardin, Garret. "The Tragedy of the Commons", *Science* (Vol 162, Issue 3859. pp. 1243–1248). 13 December 1968. (Also available online at *http://www.garretthardinsociety.org/articles/art_tragedy_of_the_commons.html*)

[Huizinga50] Huizinga, Johan. *Homo Ludens: A Study of the Play-Element in Culture*. Beacon Press, 1950.

[Hunicke04] Hunicke, Robin, Marc LeBlanc, and Robert Zubek. "MDA: A Formal Approach to Game Design and Game Research." *Proceedings of the Workshop on Challenges in Game AI*, Nineteenth National Conference on Artificial Intelligence (AAAI-2004), San Jose, California, July 25–29, 2004. (Also available online at *http://www.cs.northwestern.edu/~hunicke/pubs/MDA.pdf.*)

[IDSA03] Interactive Digital Software Association. "Essential Facts about the Computer and Video Game Industry—2003 Sales, Demographics and Usage Data." Available online at *http://www.idsa.com.*

[IH03] International Hobo. "My Karma Ran Over Your Dogma." *Develop 27* (April 2003). (Also available online as "Zen Game Design" at *http://www.ihobo.com/articles/mag_zen.shtml,* July 15, 2004.)

[Jones92] Jones, John C. *Design Methods,* 2nd Edition. John Wiley and Sons, Ltd., 1992.

[Juul03] Juul, Jesper. *Half-Real: Video Games Between Real Rules and Fictional Worlds* (Doctoral dissertation). IT-University of Copenhagen, 2003.

[Kent01], Kent, Steven L. *The Ultimate History of Video Games.* Prima Publishing, 2001.

[Knizia99] Knizia, Reiner. *Dice Games Properly Explained.* Elliot Right Way Books, 1999.

[Koster02] Koster, Raph. "Online World Timeline." Available online at *http://www.legendmud.org/raph/gaming/mudtimeline.html.*

[Kreimeier02] Kreimeier, Bernd. "The Case for Game Design Patterns." Available online at *http://www.gamasutra.com/features/20020313/kreimeier_03.htm* (March 2002).

[Kreimeier03] Kreimeier, Bernd. "Game Design Patterns." Game Developers Conference, International Game Developers Association, San Jose, 2003.

[Levison99] Levison, David and Karen Christensen (Eds.). *Encyclopedia of World Sports—From Ancient Times to the Present.* Oxford University Press, 1999.

[Mason04] Mason, Paul. "In Search of the Self—A Survey of the First 25 Years of Anglo-American Roleplaying Game Theory." In *Beyond Role and Play—Tools, Toys, and Theory for Harnessing the Imagination,* edited by M. Montola and J. Stenros. Ropecon Ry, 2004.

[Mulligan00] Mulligan, Jessica. "History of Online Games." *Imaginary Realities* (online journal, Vol. 3, Issue 2, February, 2000). (Archive available online at *http://www.mudworld.org/archives/IR.*)

[Parlett90] Parlett, David. *The Oxford Guide to Card Games.* Oxford University Press, 1990.

[Parlett99] Parlett, David. *The Oxford History of Board Games.* Oxford University Press, 1999.

[Parlett00] Parlett, David. *The Penguin Encyclopedia of Card Games.* Penguin Books, 2000.

[Preece02] Preece, Jenny, Helen Sharp, and Yvonne Rogers. *Interaction Design: Beyond Human-Computer Interaction.* John Wiley and Sons Ltd., 2002.

[Salen04], Salen, Katie and Eric Zimmerman. *Rules of Play: Game Design Fundamentals.* The MIT Press, 2004.

[Simon96] Simon, Herbert A. *The Sciences of the Artificial,* 3rd Edition. The MIT Press, 1996.

[Sutton-Smith97] Sutton-Smith, Brian. *The Ambiguity of Play.* Harvard University Press, 1997.

[Tinsman02] Tinsman, Brian. *The Game Inventor's Guidebook.* Krause Publications, 2002.

[Walz03] Walz, Steffen P. "Delightful Identification and Persuasion: Towards an Analytical and Applied Rhetoric of Digital Games." In *Proceedings of Level Up Digital Games Research Conference,* edited by M. Copier and J. Raessens. University of Utrecht, 2003.

[Wikipedia] Wikipedia. Available online at *http://www.wikipedia.org.*

[Winter04] Winter, David. "PONG-story." Available online at *http://www.pong-story.com.*

[Wolf03] Wolf, Mark J.P. and Bernard Perron (Eds.). *The Video Game Theory Reader.* Routledge, 2003.

[Witgenstein58] Wittgenstein, Ludwig. *Philosophical Investigations.* Oxford: Basil Blackwell, 1958.

[Zagal99] Zagal, José Pablo, Miguel Nussbaum, and Ricardo Rosas. "A Model to Support the Design of Multiplayer Games." *Presence: Teleoperators and Virtual Environments* (Vol 9, No. 5. pp. 448-462). MIT Press, 1999. (Also available online at *http://www.cc.gatech.edu/~jp/Papers/AModelMultiplayerGames.pdf.*)

About the CD-ROM

This CD-ROM contains additional material regarding Patterns in Game Design. The material consists of three parts:

- Full pattern collection
- Pattern cards
- Presentation slides

THE GAME DESIGN PATTERN COLLECTION

We have put our current pattern collection, including all the patterns from the book, on the CD-ROM. The patterns are in HTML-format and are cross-referenced to make them easy to use with a standard Web browser. The patterns can be accessed either alphabetically or by chapter. The pattern collection is located in the collection folder and is best accessed by opening index.htm or pattern_list_by_chapter.htm file in that folder with your Web browser.

PATTERN CARDS

For those who want to use card versions of patterns, we have provided concise pattern descriptions that can be printed as individual cards. These short descriptions do not contain all the information about how to use the pattern nor consequences of using the pattern, but are instead aimed at being used as reminders and pointers to the full descriptions. A PDF file with all the patterns as cards exists in the cards folder.

PRESENTATION SLIDES

The last additional material is a set of PowerPoint™ slides that the authors have used at workshops. The reader is free to use these slides, as a whole or individual slides, for presentations or workshops. The slides are located in the slides folder.

For the latest information about the project please go to *http://www.game designpatterns.org*, or *www.charlesriver.com/titles/patternsgmdes.html*.

SYSTEM REQUIREMENTS

Windows 95/98/NT/2000

- Pentium Processor+
- CD/HardDrive
- 32 mb RAM

Mac OS 7.61+

- PowerPC+
- CD/HardDrive
- 32 mb RAM or any other similar system which can run the required programs.

In addition, you will need a Web browser, such as Mozilla *(http://www.mozilla. org)* or Microsoft® Internet Explorer, to browse the pattern collection; PDF reader, such as Adobe® Reader™, for viewing and printing out the pattern cards; and PowerPoint™ to use the slides.

INSTALLATION

To use this CD-ROM, you just need to make sure that your system matches at least the minimum system requirements.

Index